RANDOM HOUSE NEW YORK

AMERICAN MUSIC

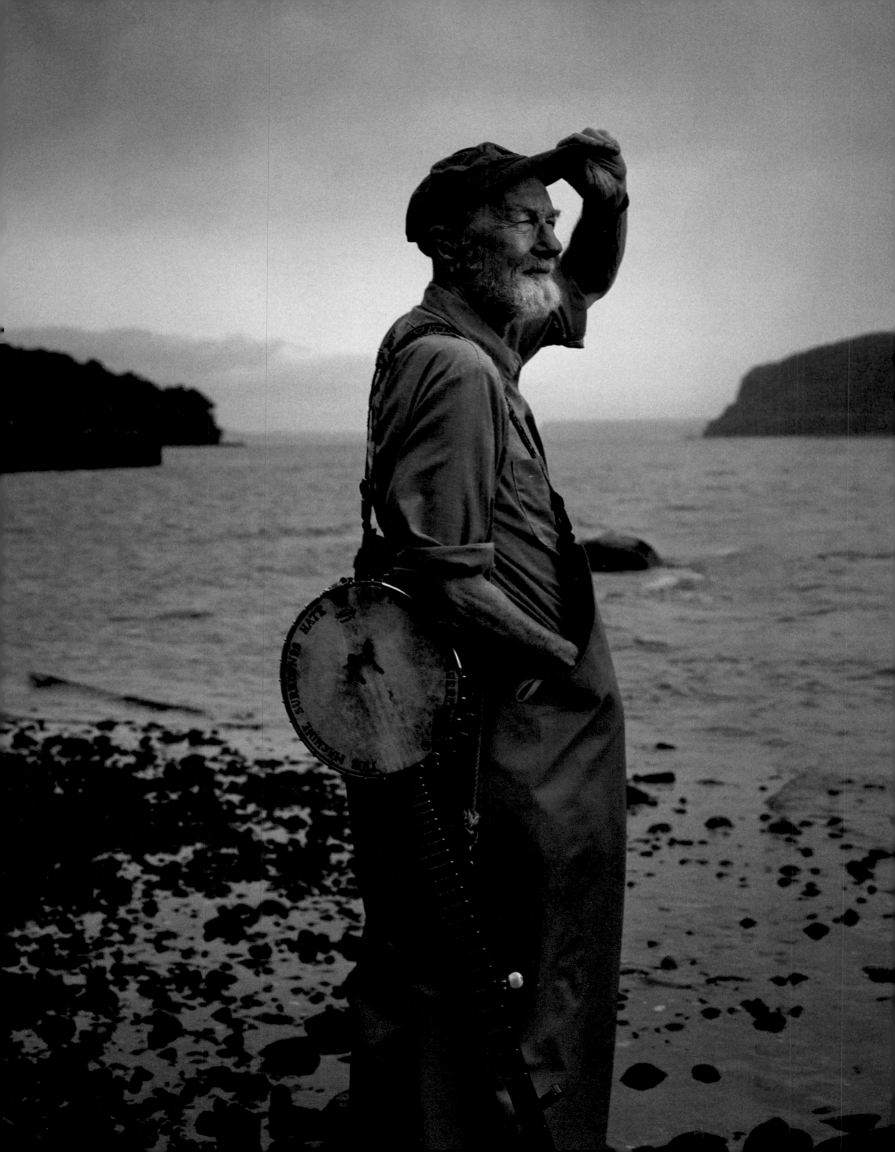

ANNIE LEIBOVITZ

AMERICAN MUSIC

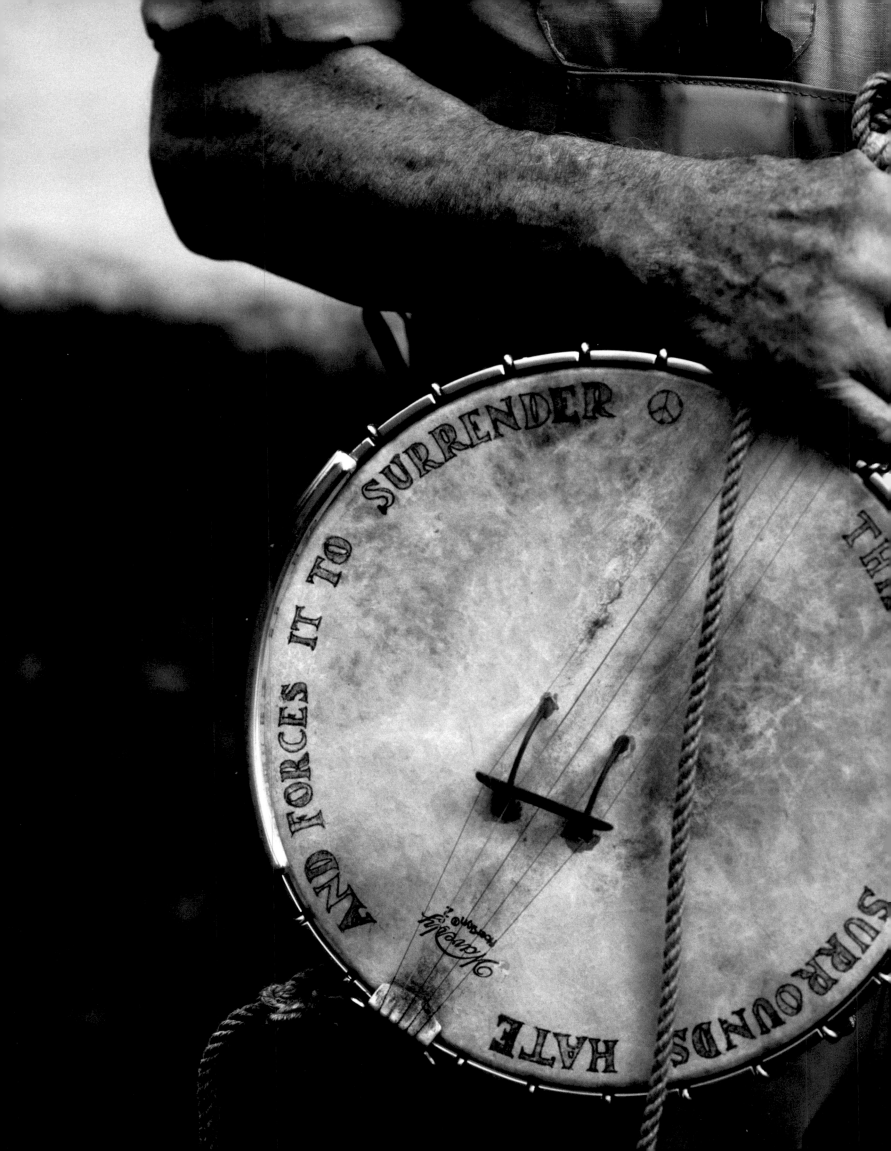

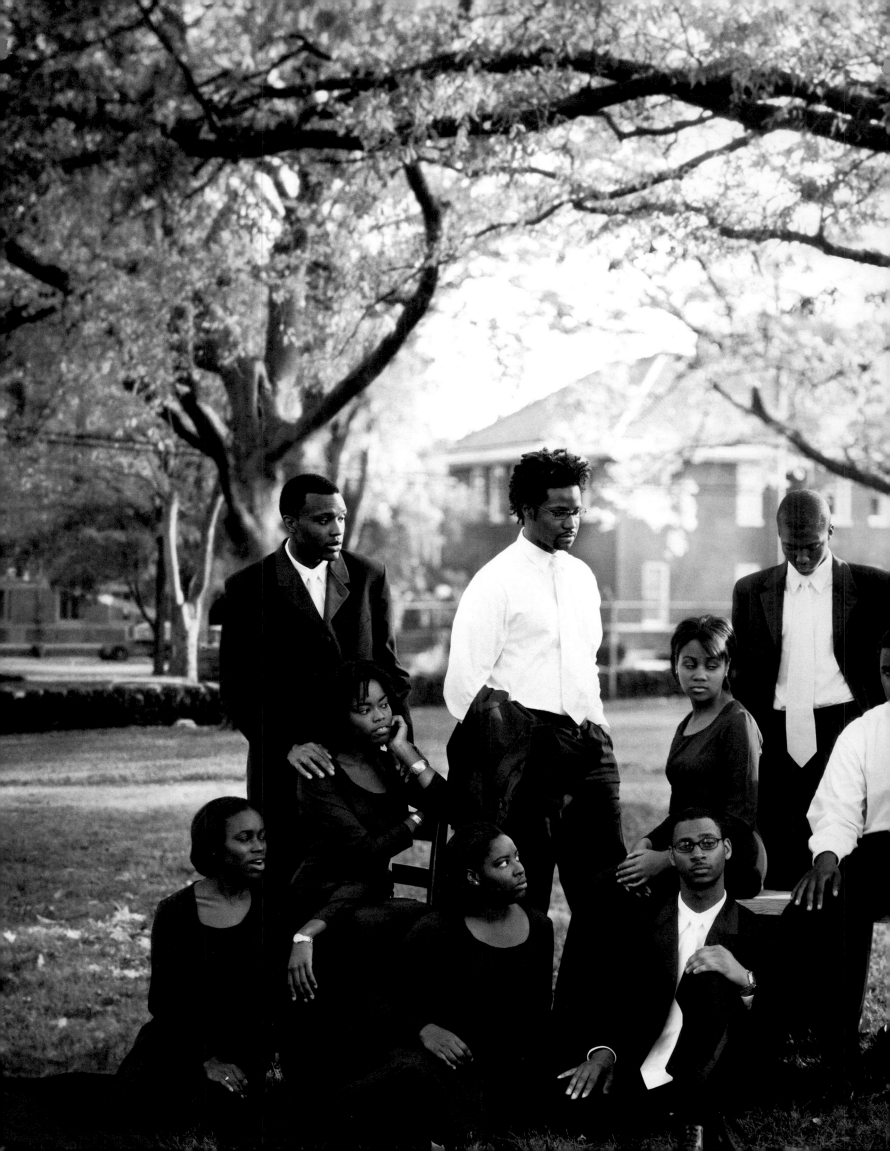

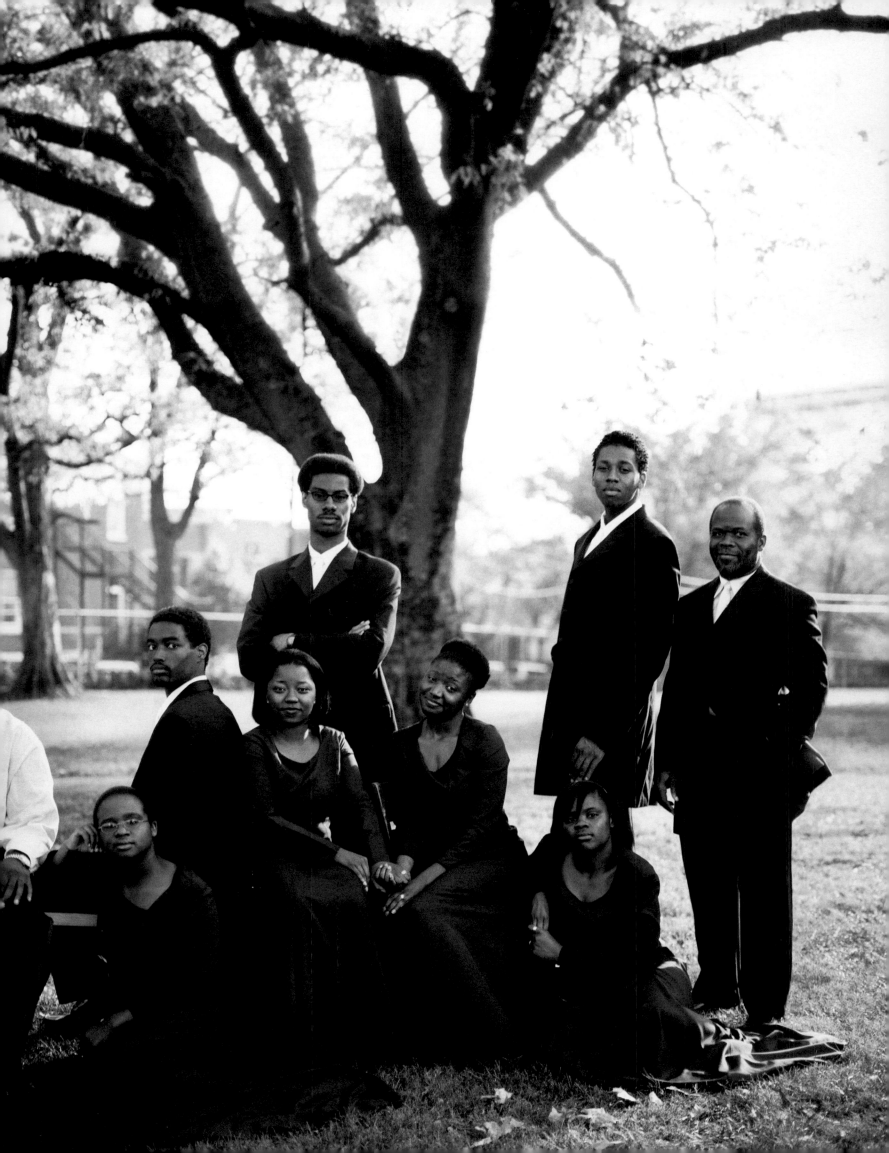

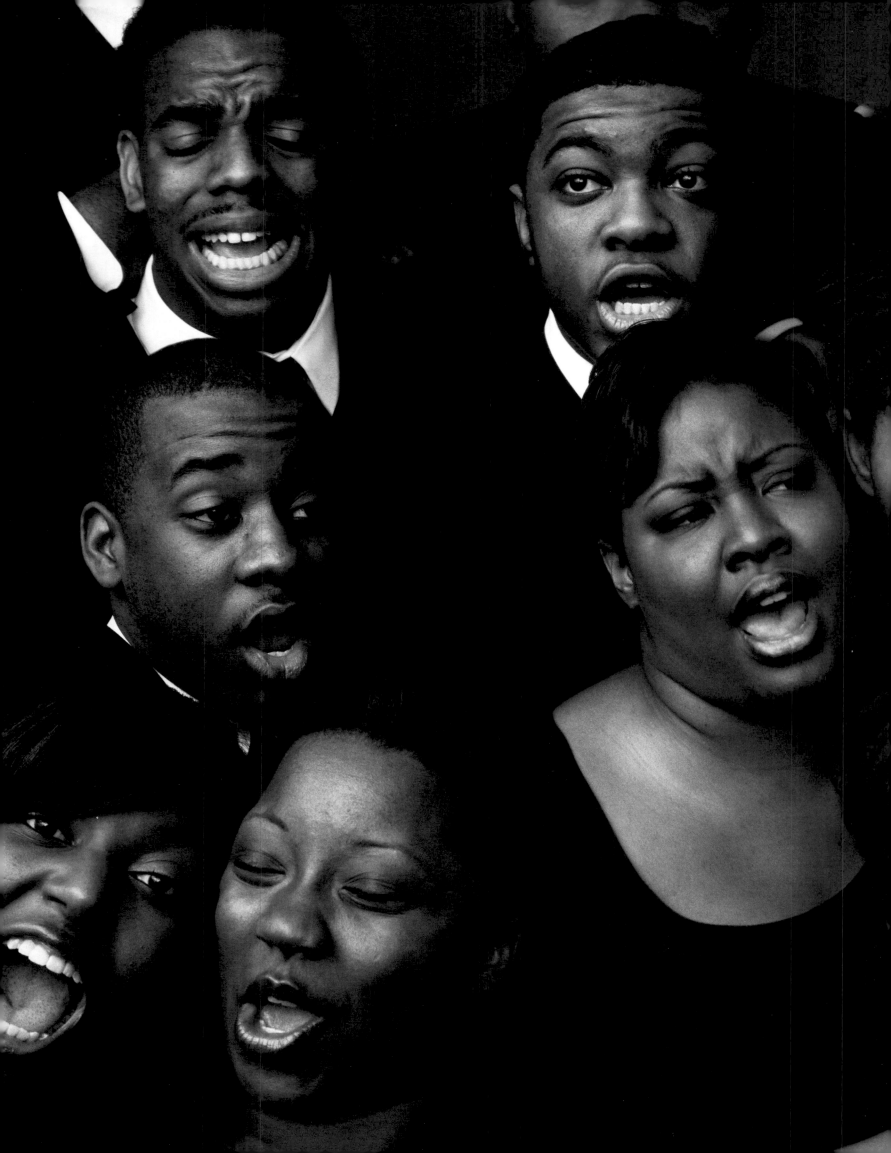

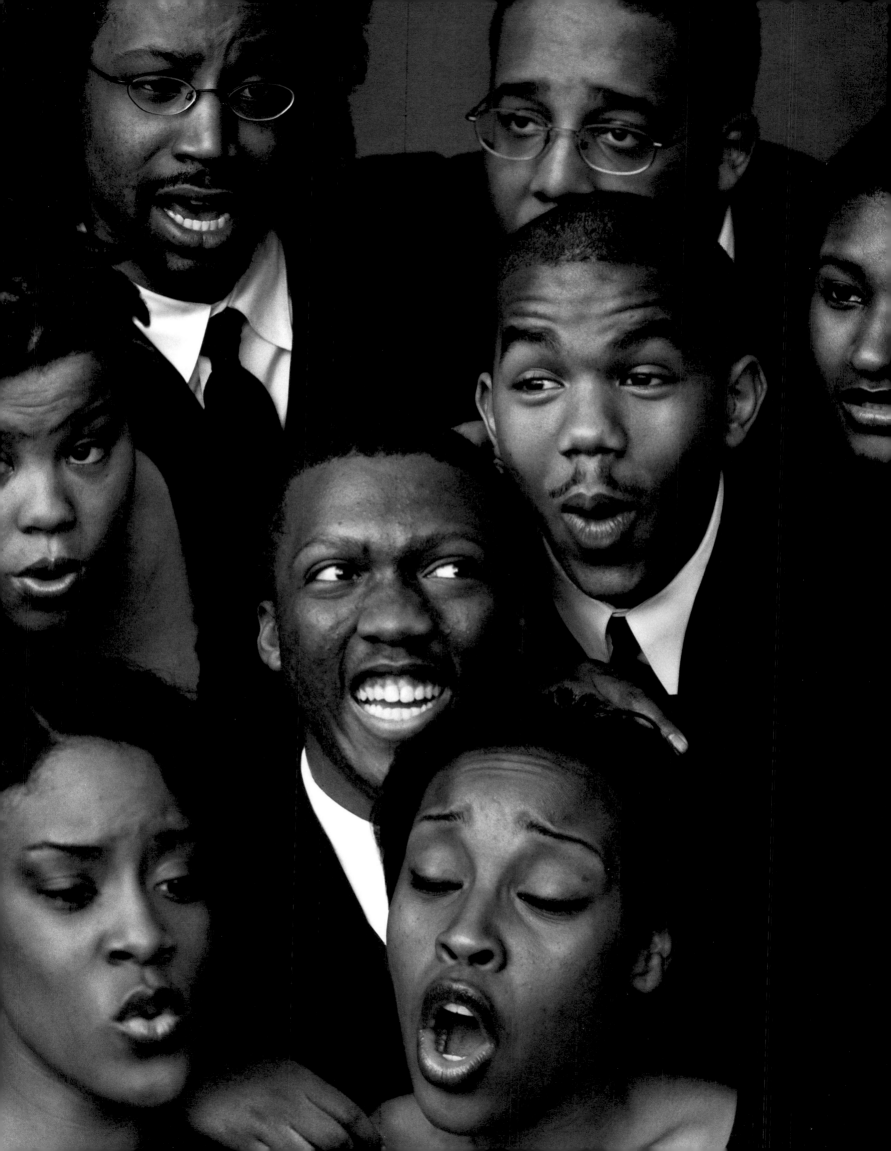

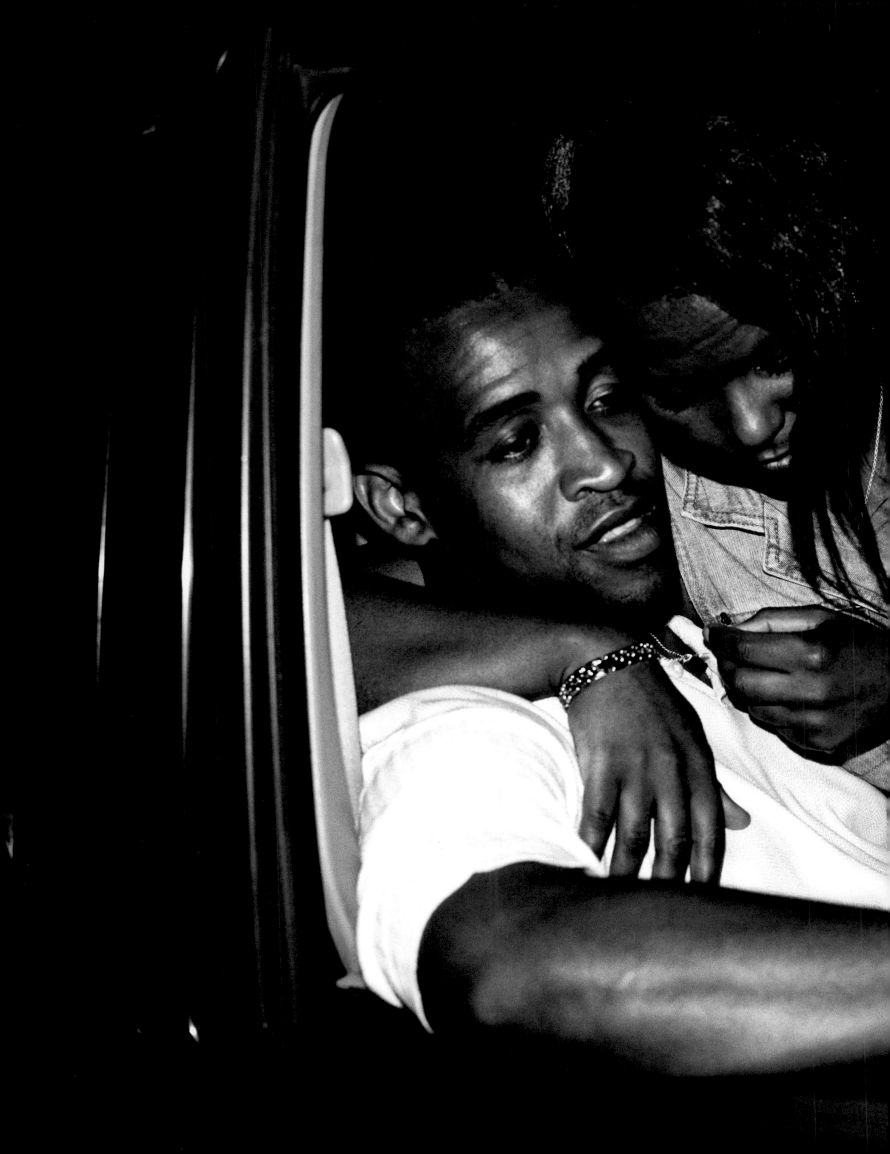

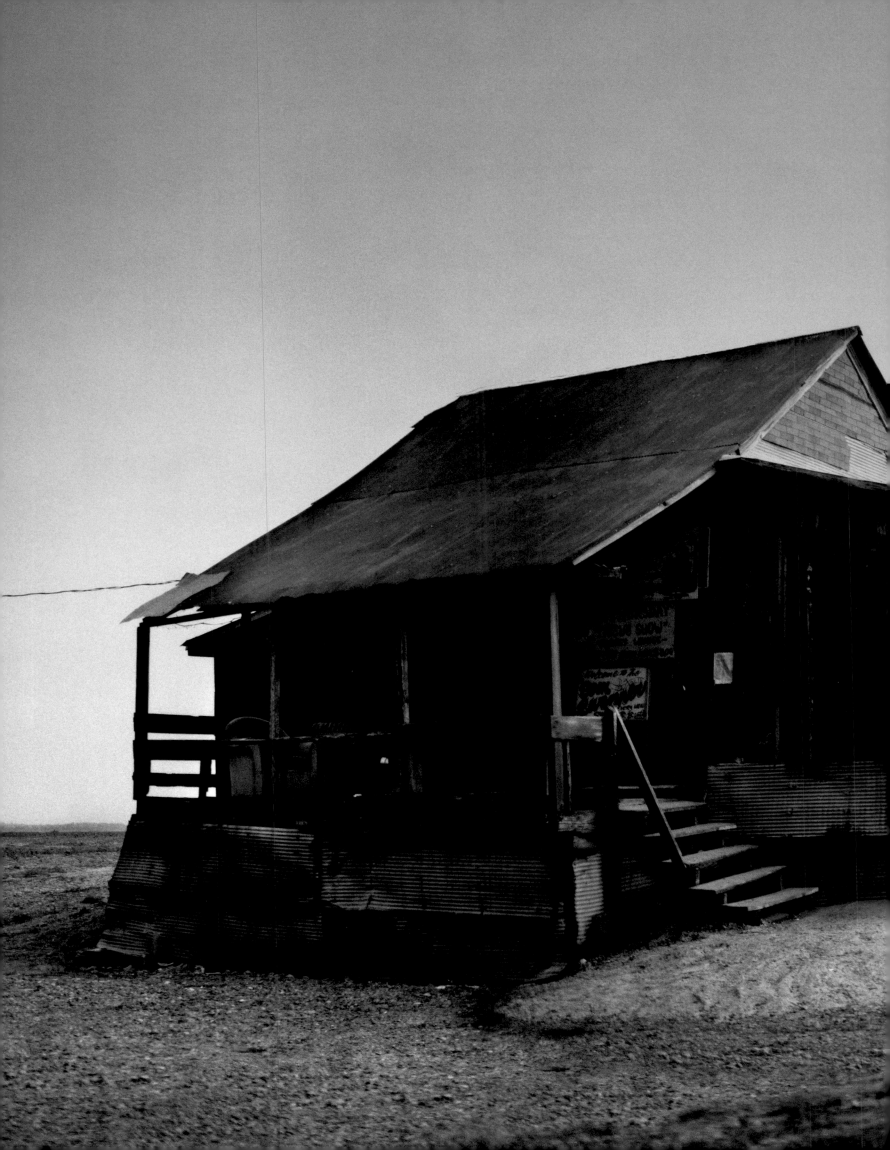

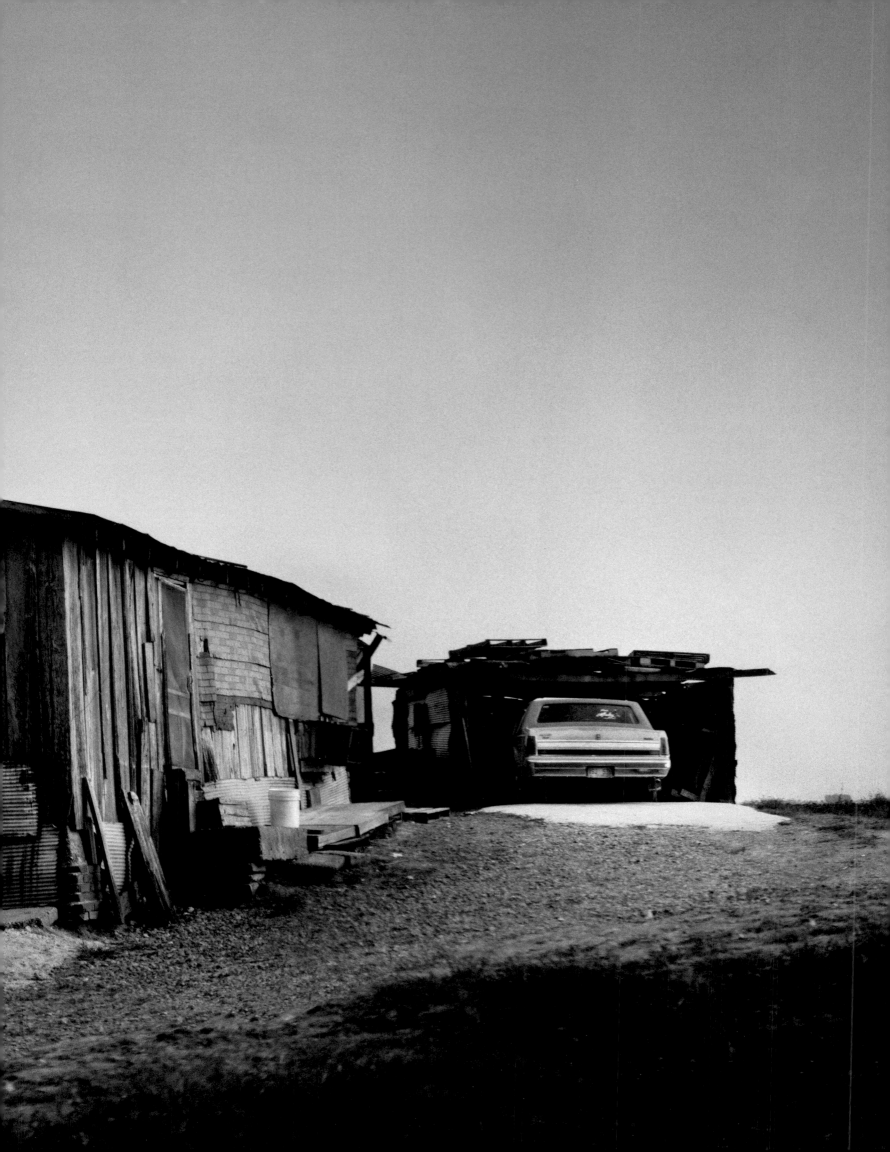

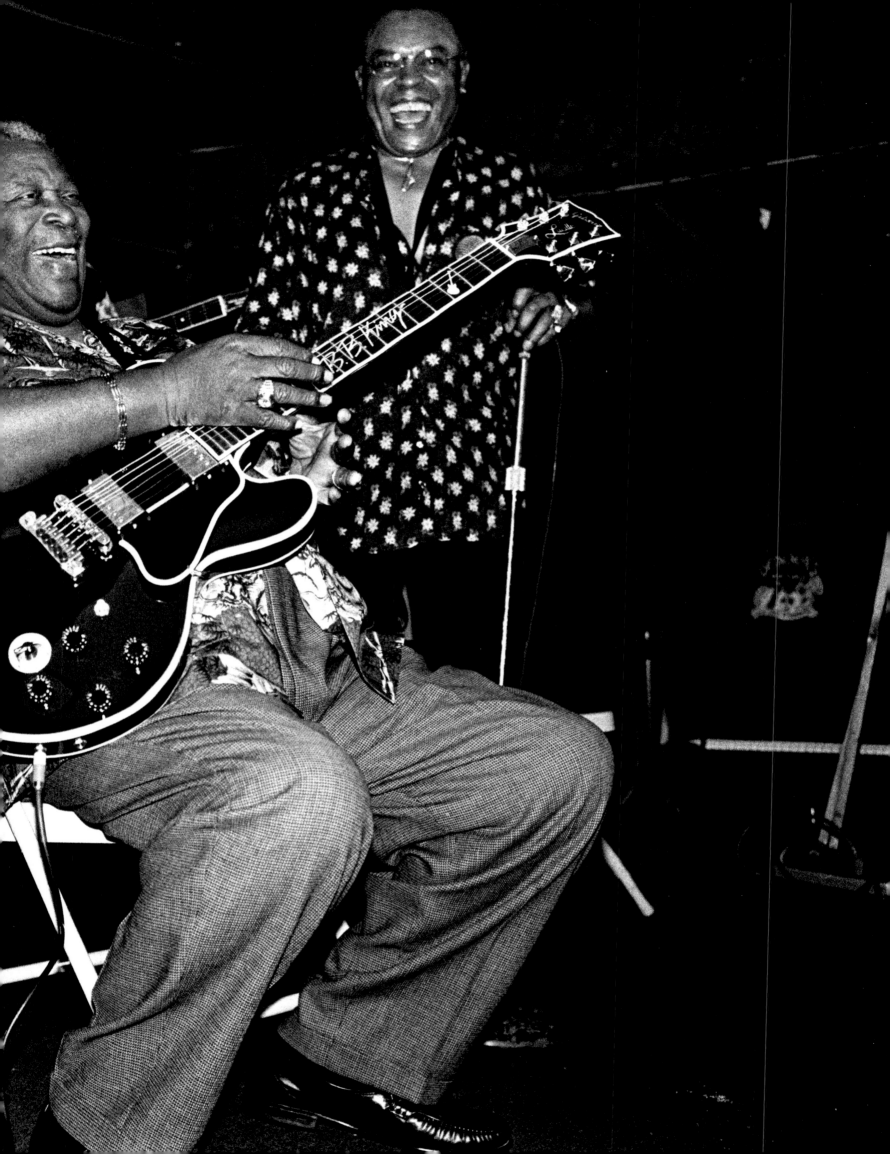

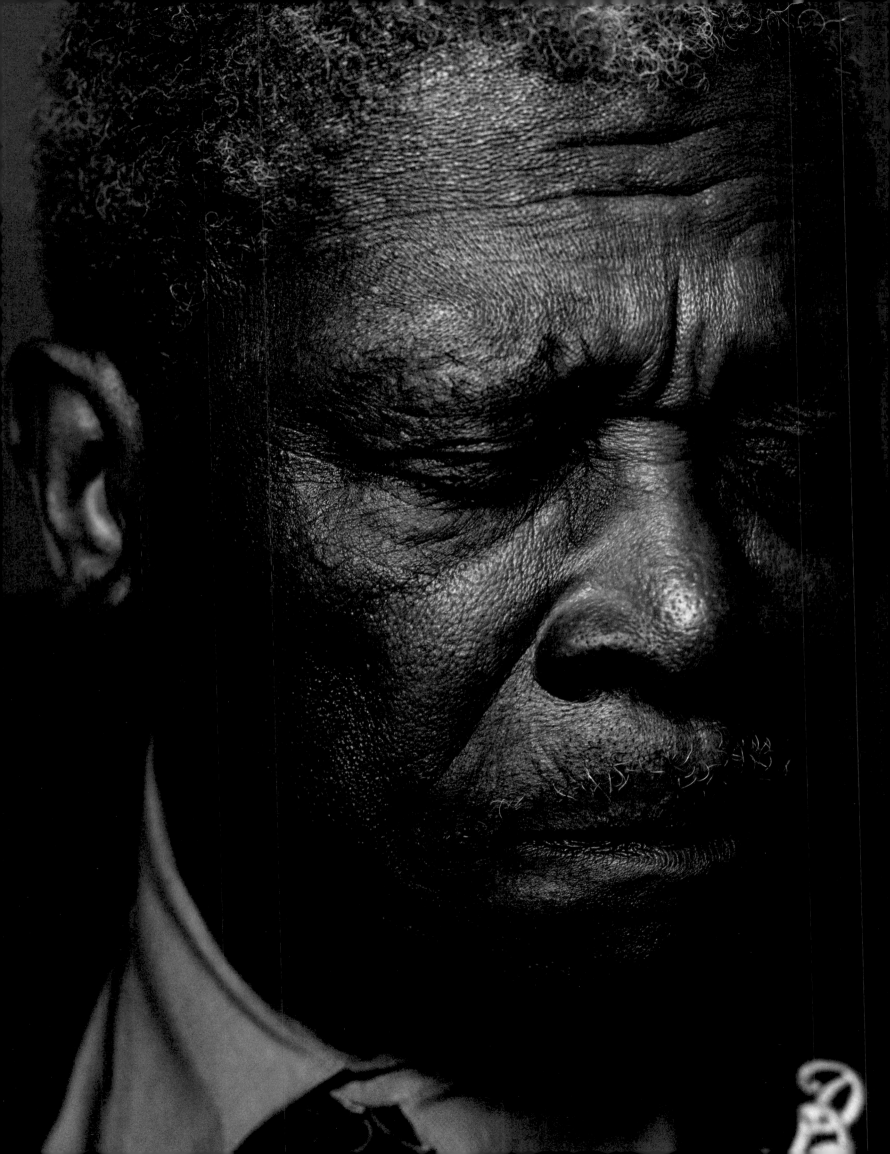

When I was a child, I longed to play my grandmother's spinet. I would sit on my father's small steamer trunk and gaze at it, imagining that I could invoke her spirit if I pressed my hands upon the keys. The piano remained locked, and I awoke one morning to find it gone, having made way for my new-born brother's cradle. I consoled myself by turning my attention to the trunk, which represented something about my father in the mysterious time before I was born. Prying open its heavy lid, I was greeted by mea-ger contents: military ribbons, a helmet, a somewhat battered bugle, and a slim black scrapbook labeled "1941–1945." Grainy souvenirs of World War II. Twenty or so pages of tipped-in photographs of Fort Jackson, New Guinea, the Philippines, aircraft carriers, and the men in his unit. Slipped in also, almost as an after-thought, were pages torn from *Life*—aerial views of famous targets and the inhuman aftermath. Hiro-shima. Nagasaki. Our American legacy. The ribbon and the bomb.

It was difficult reconciling the images of Hiro-shima with the image I had of our country. When I questioned my father, he would say, "I did my duty, but the rest is man's inhumanity to man." He seldom talked about the war, but on Memorial Day he served in the color guard, and after the parade and a prayer for fall-en soldiers we would celebrate in the field surrounding the Veterans Hall. Our mothers served hot dogs and potato salad. Our fathers played horseshoes. When the sun went down, we gathered around a bonfire, roasting marshmallows and singing. We sang of the railroad, the Dust Bowl, and the Erie Canal. We sang "Heart of My Heart" and "Buddy, Can You Spare a Dime?" We sang

about Jesus and Davy Crockett. It was the end of the fifties and everyone seemed happy.

But the world was not an altogether happy place. I grew up in a rural community, relatively unsophisticated, and I kept in step with the rapidly changing social and political climate through poets and musicians. They were wide awake to the events of our time, and they provided a voice to protest racial discrimination, nuclear testing, the destruction of the environment. Confrontational artists like Woody Guthrie, Pete Seeger, Nina Simone, Joan Baez, and Phil Ochs drew us from complacency to consciousness. Music disseminated truth, and in the mouth of one such as Bob Dylan, became a weapon of mass instruction.

Our music is family unrelated by blood. As Whitman might say, it contains multitudes. The purity of a child in her Sunday-go-to-meeting dress. The chaotic debauchery of a rock-and-roll star's hotel room. The emotional and physical release of gospel and R&B. It is the sound of the hill country, impoverished and free. It is the transient whistling his way through a sad, postindustrial terrain. It is the internal landscape of John Coltrane. The sensuous agony of Etta James. It is three chords into hell. Our music grants us a coat of invulnerability, a spring in which we bathe with abandon, methods of response, moments of respite, and a riot of self-expression. It is the porch song. Plunging youth. It is thick-veined hands squeezing clusters of notes from an equally thick neck. It is the Les Paul. The tenor sax. It is a platter spinning in space, etched with the words "Tutti Frutti."

Some years ago, my children's great-grandmother passed away. She was ninety-two. A service was held for her at a Church of Christ in West Virginia. After the

minister spoke of her life of love and toil, members of the congregation came forward to sing. There were no instruments. Their voices joined in country hymns as we bowed our heads. They sang, and it seemed like all the tears in the world were flooding that small hall. Standing there holding my baby girl, I recalled singing in Bible school. Whirling the Virginia reel. Dancing anarchistic to a Bo Diddley beat. Strapping on an electric guitar in pursuit of a new language. And here, in this West Virginia church, I was moved by the humble human voice. I opened my eyes just for a moment to look at her lying there. She had eleven children. Her daughter, Kathleen, married a Kentucky bluegrass boy named Dewey Smith, who sang like Hank Williams. Their son, Fred "Sonic" Smith, cofounded the MC5, contributing to the history of rock and roll. He died young. He had a son named Jackson and a daughter named Jesse. These children are my own and we remember him through the power of music.

After my father died, I once again opened his trunk. I sat there looking at the things that had filled him with pride but troubled his heart, and I added my own mementos—guitar strings, old 45s, and a somewhat tattered peace flag that I wrapped around his scrapbook with the pages torn from *Life*. Another side of the legacy. Rhythm and the bomb.

We must be vigilant. We must be citizen soldiers, stripped of fear. Our optimism is magnified in our music. We are all Walt Whitman. We sing of ourselves. The songs we create, which address our own condition, will ultimately sing of another. And another.

PATTI SMITH
New York City

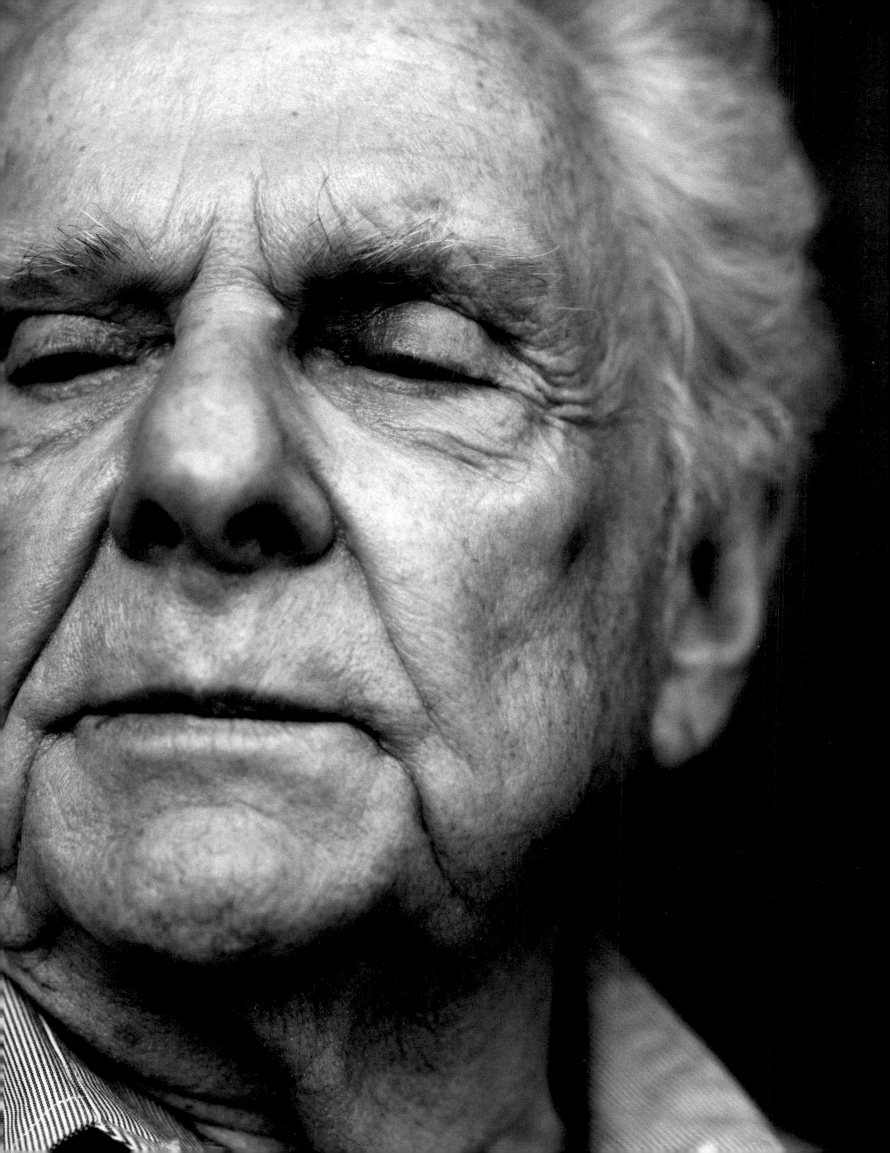

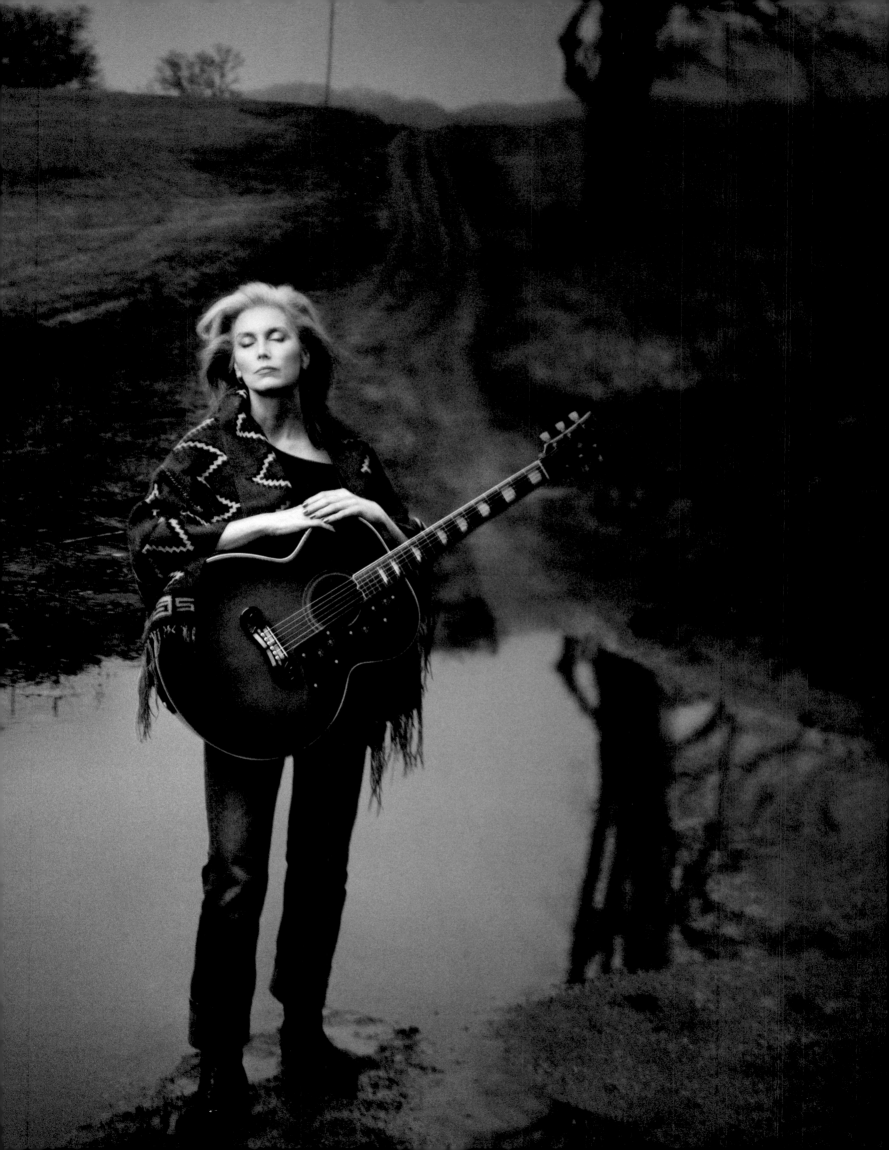

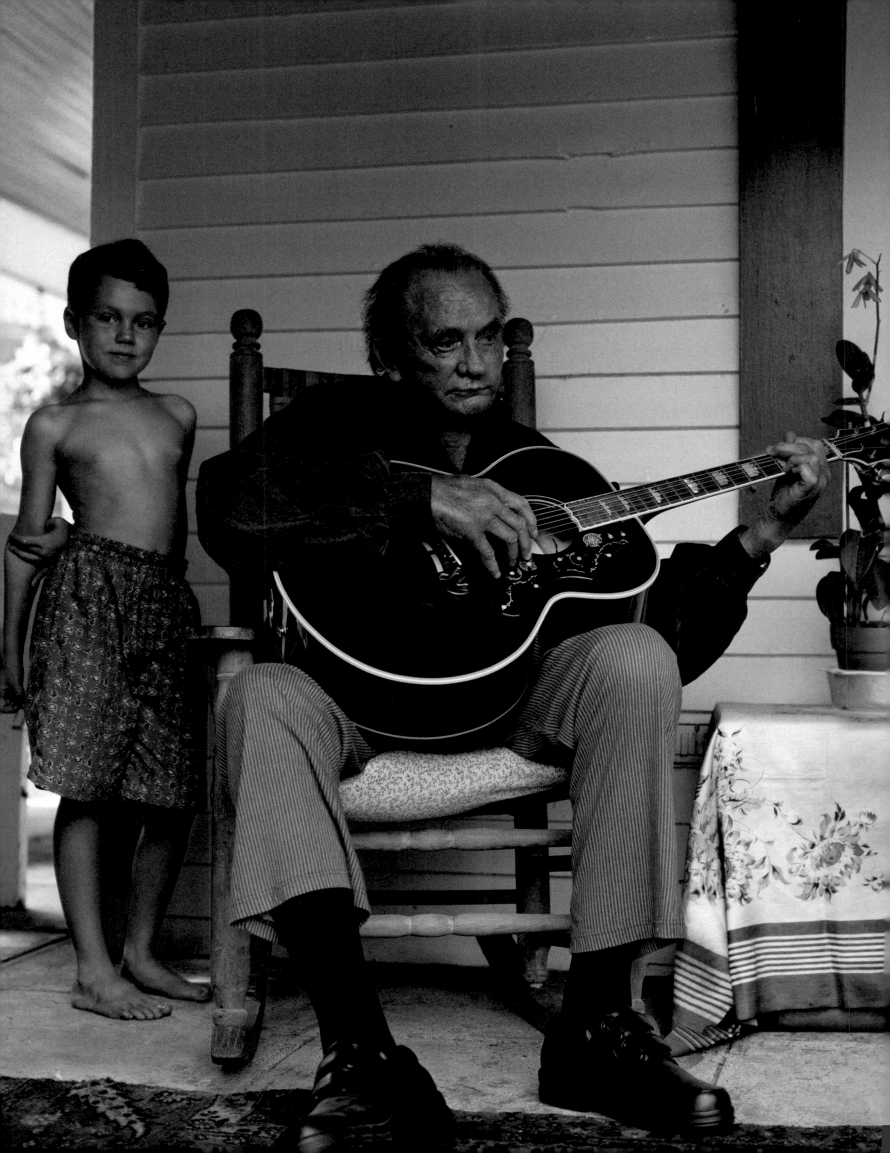

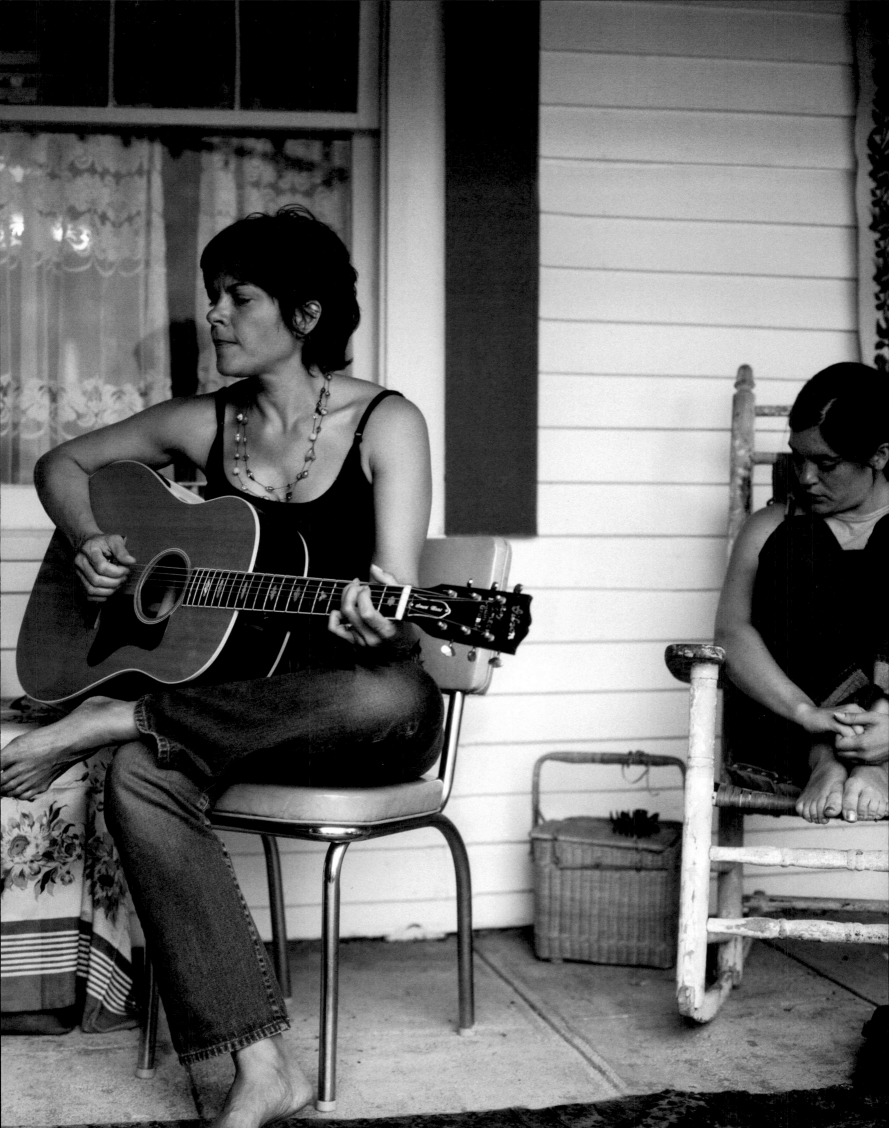

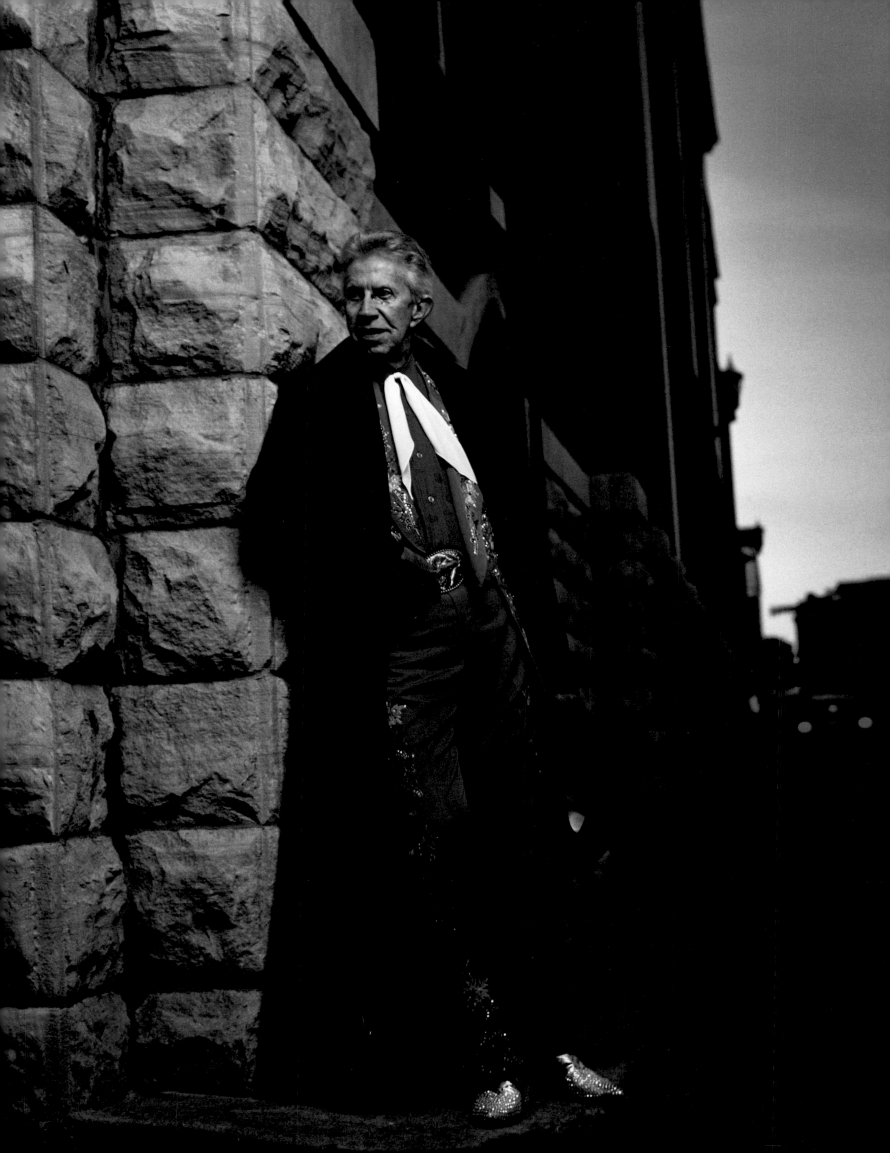

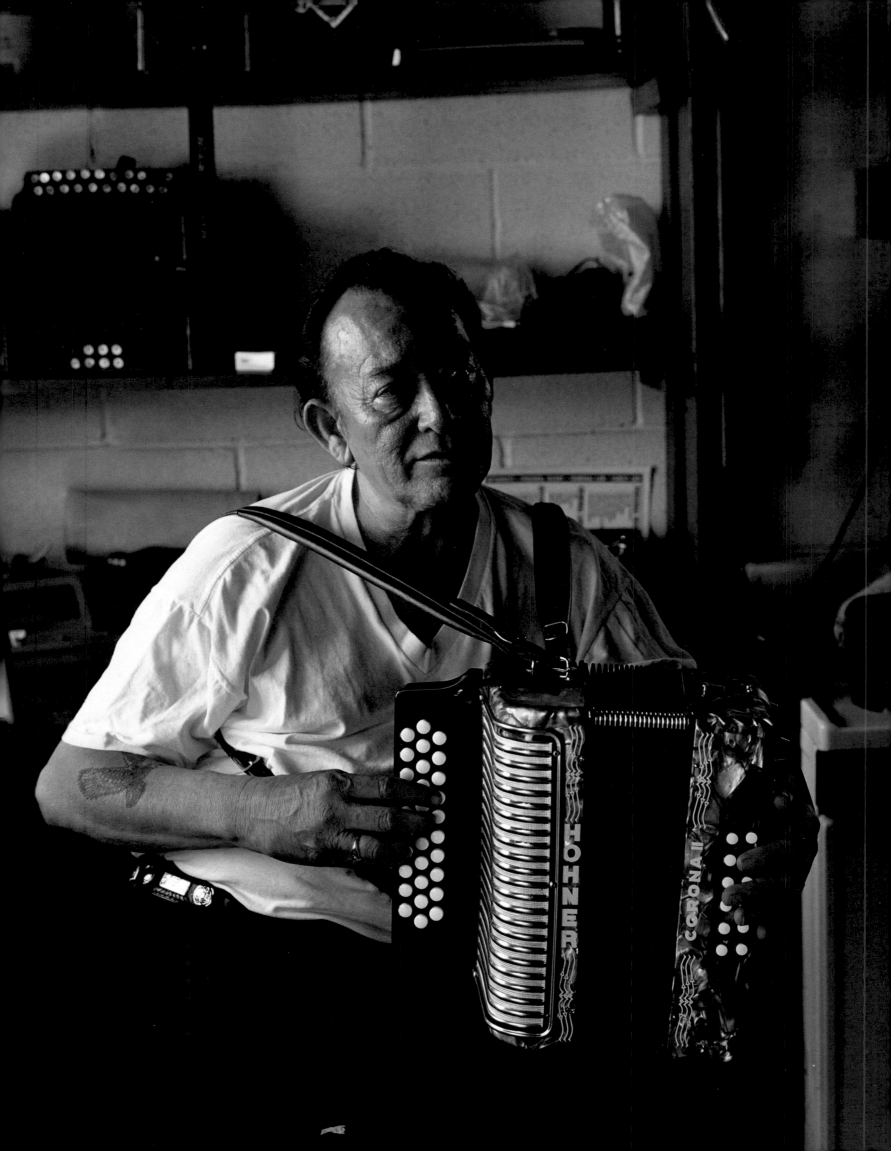

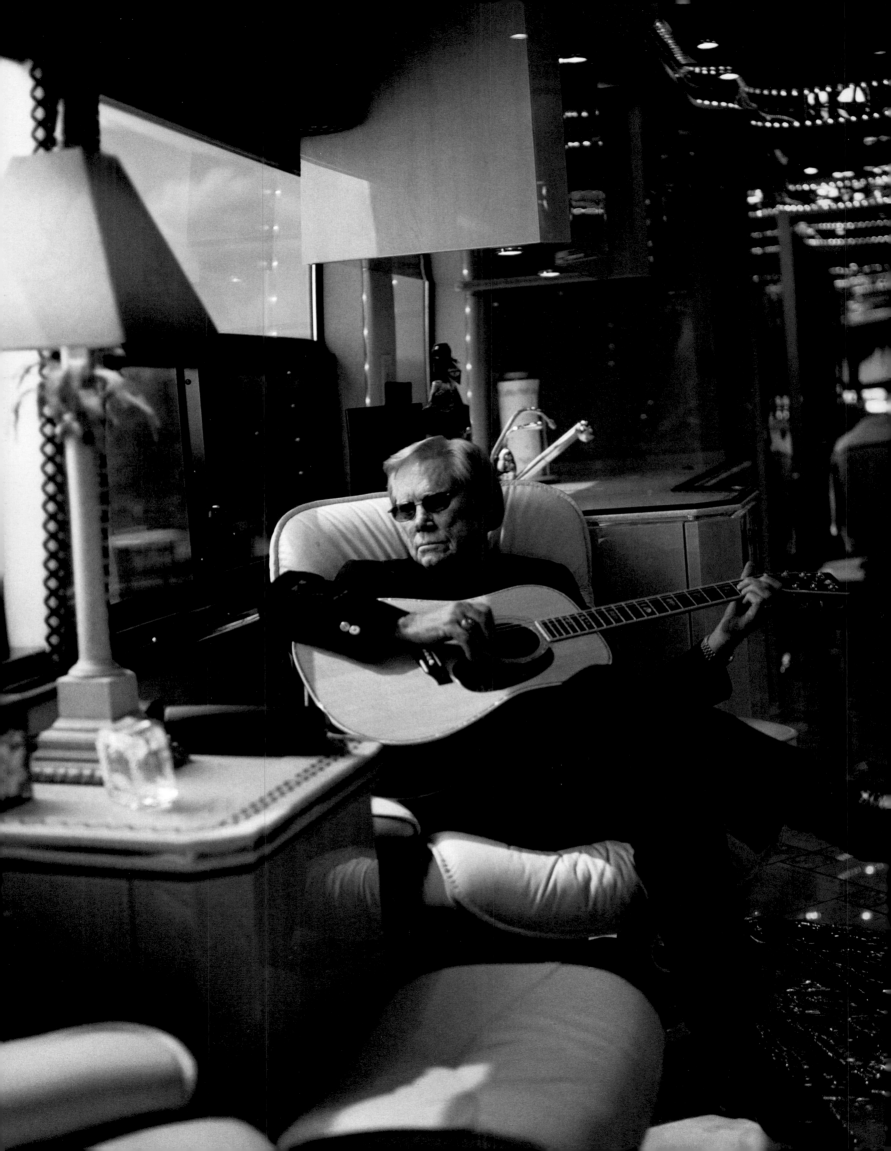

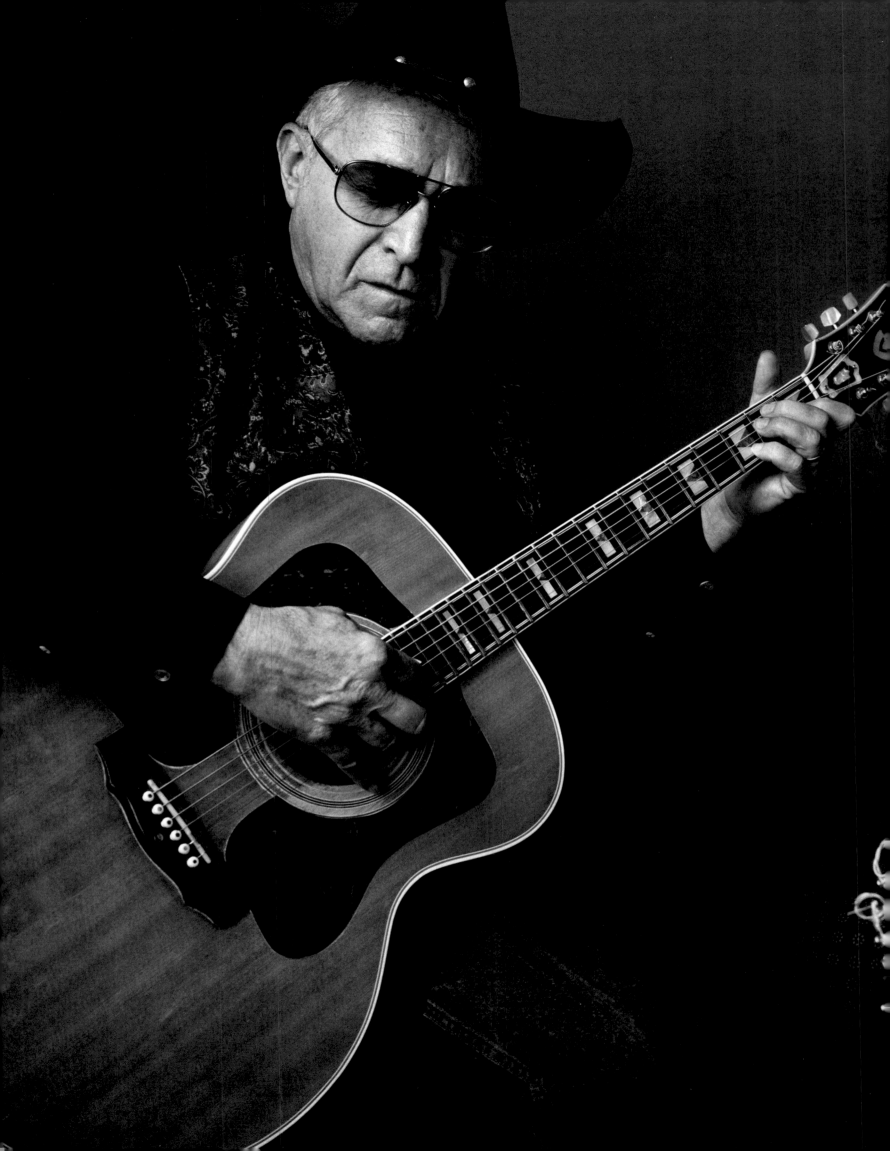

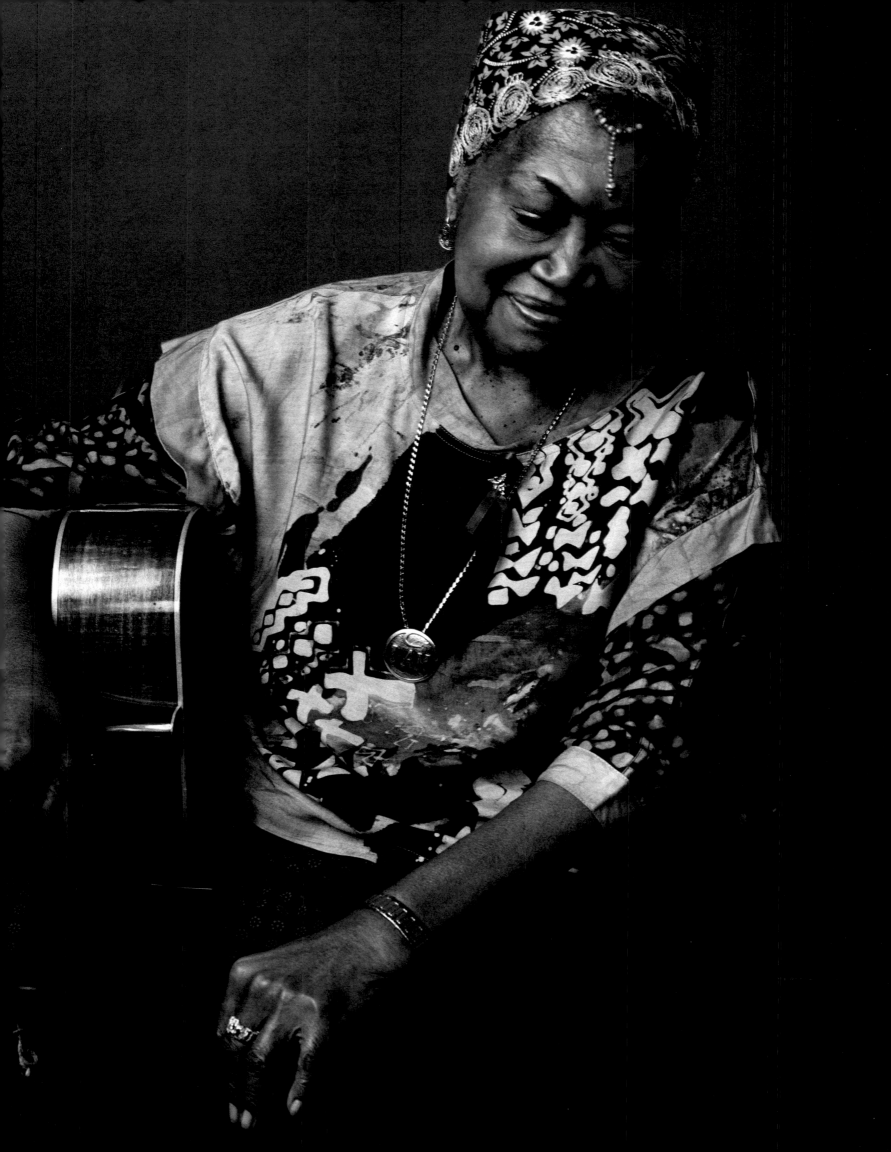

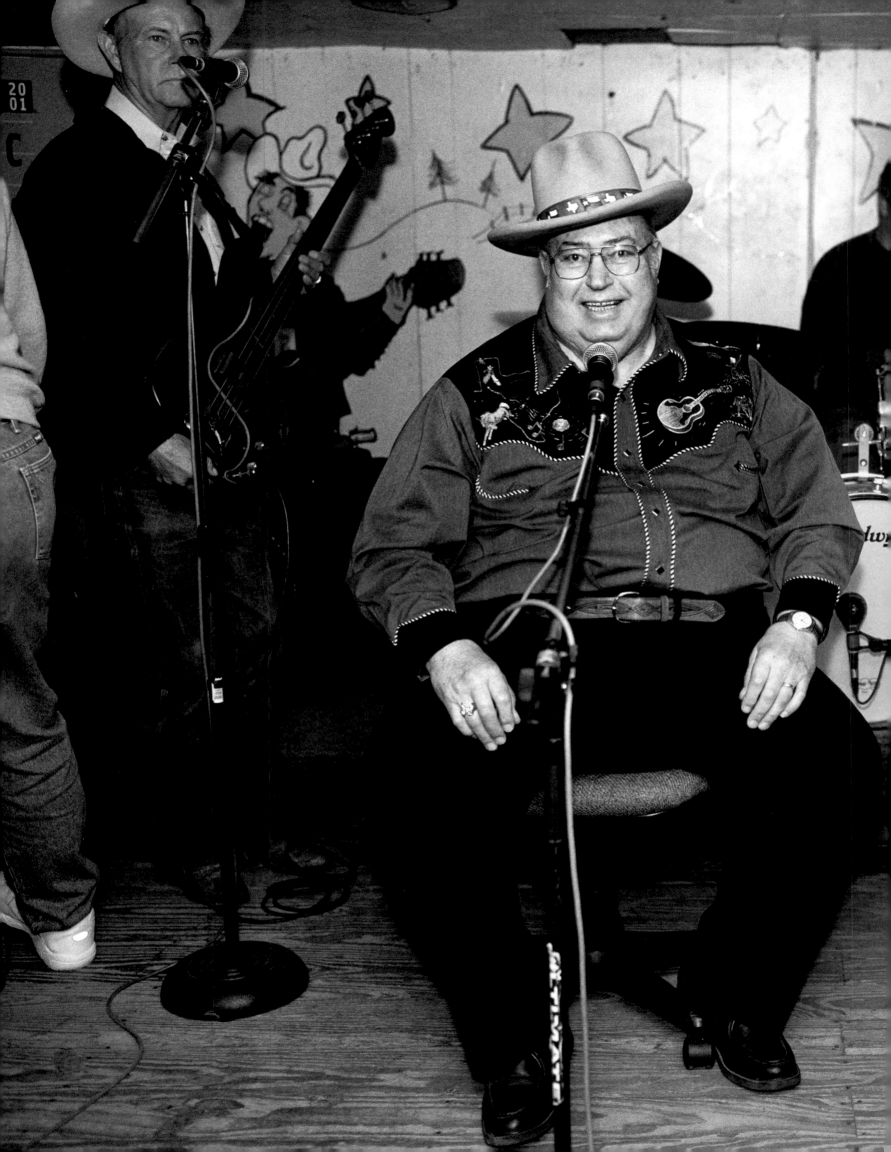

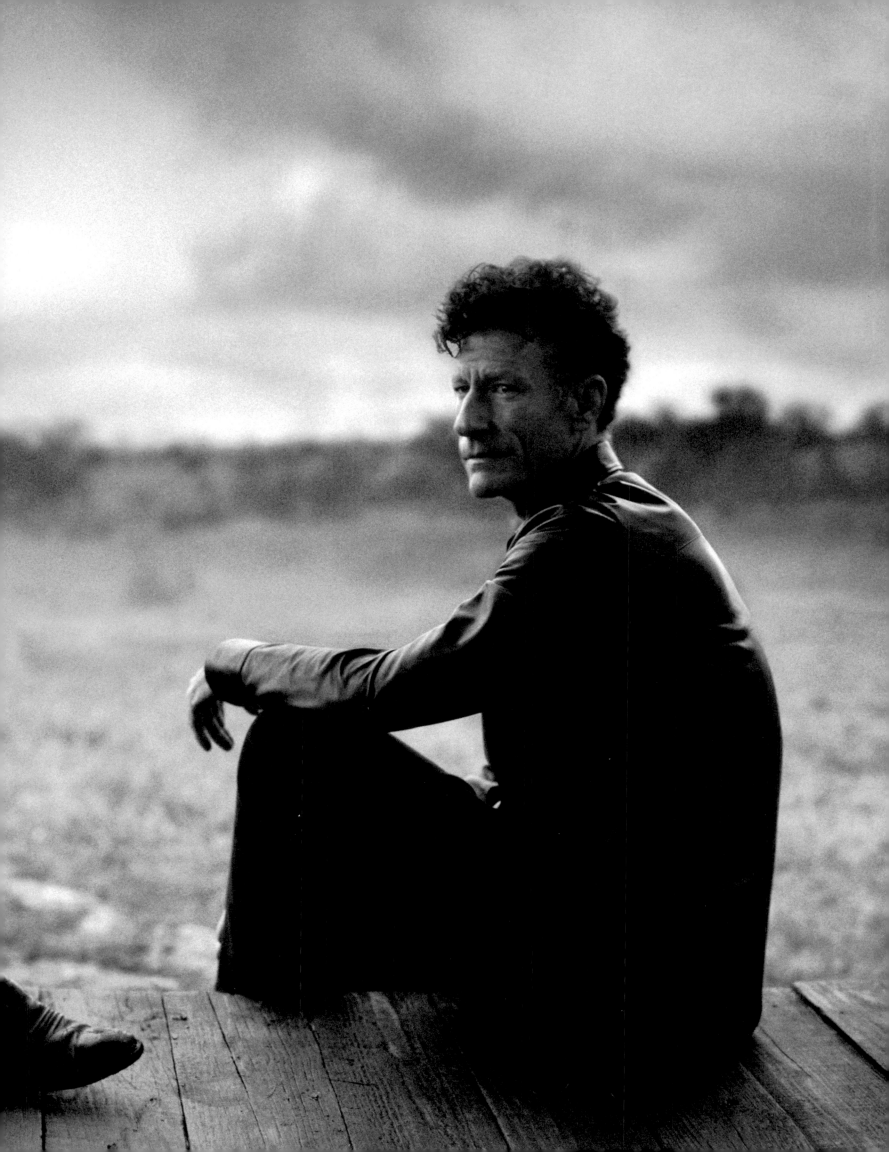

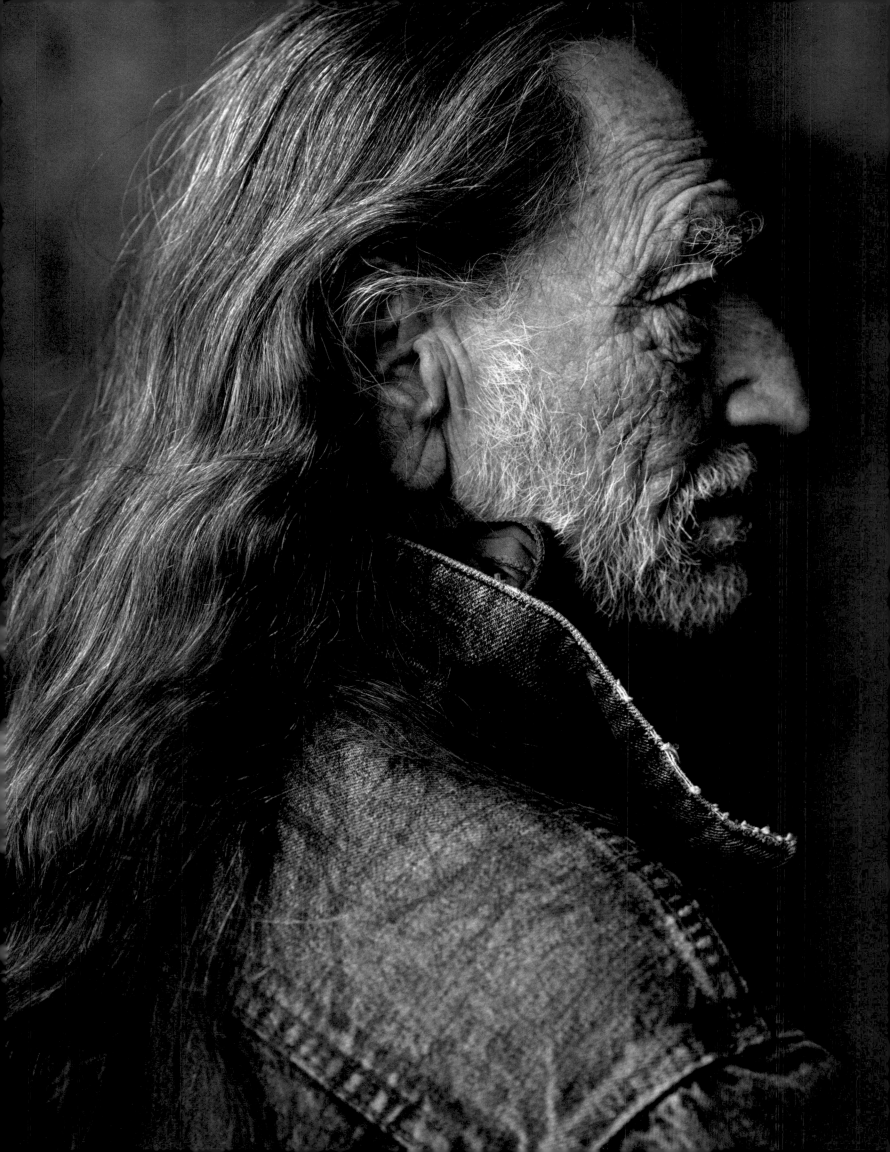

Know this. Bill Monroe was a hipster, and bluegrass, the music that he invented, is the Southern rural equivalent of bebop. Like jazz, it's an experimental art form that, at its best, balances on a knife edge, constantly pushing ahead musical frontiers while never turning its back on the centuries of tradition that gave it life. Monroe used to talk about the "ancient tones." Echoes of Ireland and Scotland and Africa. He believed that they could be heard in the hollers of his native Kentucky if only you knew how to listen. Then and only then are you ready to pick up a mandolin, a fiddle, or a five-string banjo and bring the music down from the mountain.

When I arrived in Nashville, in 1974, I fell in with the Texas Crowd, a motley crew of expatriates drafting behind the Outlaw Movement of Willie Nelson and Waylon Jennings. We were loud, proud, well read, and we didn't keep regular hours. We imported our own culture, hand-creasing our hats and congregating in each other's homes to cook chicken-fried steak, chili (without beans), and Mexican food. When we went out, we traveled in packs, occupying the entire front bar at the Exit/In or the back room at the Gold Rush, across the street. We lived on the margins of the mainstream music business, but we saw ourselves as above all of that. It was our own little hillbilly version of Paris in the twenties, and we were the new bohemians. As cliquish as we were, we occasionally encountered kindred spirits in the night. There were song-writers from both Carolinas who shared our left-of-center vision.

There was a Memphis contingent and various assorted refugees from New York and L.A.

And then there were the bluegrass players. They had their own thing going on, up by the park at the Station Inn and downtown at the Old-Time Pickin' Parlor. From a distance they appeared unapproachable and aloof, stoic when they performed onstage, communicating by means of sideways glances and barely perceptible nods and winks. Up close, they were even more intimidating, speaking softly when they spoke at all, in a language all their own. In a word, they were cool . . . an advanced level of cool that we had never encountered before.

We were fascinated. So we hung out and we listened and after a while, when we kept coming back, night after night, and we didn't request "Rocky Top" or "Fox on the Run," the players began to warm up a little. They appreciated the serious listeners scattered among the tourists and they cultivated that audience on a personal level. We got it and they got that we got it. Most of the paying customers were out-of-towners who had been told that if they went to the bluegrass joints they could hear "real country music" played by real live hillbillies. They hooted and hollered when the banjo pickers and the fiddlers landed their solos, but they didn't truly appreciate the dark beauty in the music, the dignity and artistic integrity that oozed from every pore of the musicians. They were clueless, but they paid the cover charge and therefore they were welcome.

Not that we were ever really insiders. As much as we had lived and breathed music and art for all our lives, in the bluegrass world we were merely voyeurs, relegated to the sidelines, where we could only look on in awe. We were fans and patrons and some of us would become real aficionados, but never in our wildest dreams would we step up to the microphone and take our solo, our fifteen seconds of glory, and then slip back into the rhythm section to the barely discernible approval of our peers. These were musicians who had made a conscious decision to dedicate their lives to an art form and lifestyle that offered only two promises: that they would never master their craft and that they would never get rich. They were the purest artists that we had known or would ever know.

I flirted with the high lonesome sound from the time I began making records in the mid-eighties. I built my first two albums around the drone of a bluegrass G chord. My third and bestselling record to date, *Copperhead Road,* opened with a sampled bagpipe and attempted to marry mandolin to hard-rock guitar sounds. It included a track recorded in London with the Pogues and another with the "newgrass" supergroup Telluride. With each record I rocked a little harder and toured a little farther afield, and I continued to shamelessly steal from every exciting new form of music that I encountered, but again and again I returned to bluegrass for inspiration. I lost my way out there for a while but when I found the trail again my old friend Peter Rowan was waiting to lead the way.

It was Pete who showed me the Tao of bluegrass. He had been a Bluegrass Boy and toured with Monroe and stood on the mountaintop at the Master's side and listened. It was Pete who took me out to meet Bill Monroe himself during a break in the recording of *Train A Comin'* and then, a year later, invited Bill to hear Pete, Roy Huskey, Jr., Norman Blake, and me play the Tennessee Performing Arts Center in Nashville. That night I played guitar behind Bill Monroe while he and Pete sang "Walls of Time" and "Uncle Penn." Somewhere in the middle of "Blue Moon of Kentucky," it dawned on me. I was doing it. I was no longer a spectator. I was standing behind the Master and I was playing bluegrass.

It took a few more years for me to summon up the audacity to actually write and produce a record for traditional bluegrass instrumentation, but when I did I returned to the source. "The World Famous Station Inn," as the sign out front declares, was and is Bluegrass Ground Zero, so I suited up and showed up on Tuesday nights to sit in with the Sidemen, an amalgamation of players from some of the best bands in bluegrass. They were patient and gracious teachers to a man. The rest of the week, I'd hunker down at my house in Williamson County and write. When the songs were finished, I recruited the best bluegrass band on the planet to help me make *The Mountain,* a record that to this day stands as the most profound learning experience of my career. Later that spring, when I took the stage at the Station with the great Del McCoury Band for the first

night of a sold-out, six-night stand, there were whispers that I had "gone bluegrass" and would never touch an electric guitar again. Some things never change. There's always somebody in the crowd who doesn't get it.

That night stands as the pinnacle of my career, and even today when I listen to the board tapes I'm amazed that I was ever a part of that music that I had once considered out of my reach. We stayed up all night reveling in our triumph and accepting congratulations from friends and families.

Then the sun came up, and in the light of day I looked in the mirror and I knew that even if I could fool some of the people that listened to bluegrass some of the time, I was still a tourist. I was, by my very nature, too restless to focus on the music that I loved most in the world to ever keep up with the men and women who had dedicated their lives to it.

I toured the world with the McCoury band and then immediately went to work on *Transcendental Blues,* a return to recording with my own brutally loud little four-piece rock band, and it felt good to be home. There was one new bluegrass song that I had written during the *Mountain* tour, so I put together a bluegrass band of my own. For two tracks, I traveled to Dublin to record with Sharon Shannon and her band, some of the best traditional musicians in Ireland, and was not surprised, this time, to find that the experience, as great as it was, made me neither Irish nor traditional. I did manage to incorporate some of what I learned in my adventures into what I do best and to keep my ears and my heart open for any new sound that I might encounter in my travels. And then I hit the road again.

So, what am I looking for out on the long straight highways and across the ocean?

That's easy. I'm just listening for the ancient tones, and once I've learned to listen, I mean really listen, I'll come down from the mountain and make a record as loud as New York City and as lonesome as the Cumberland Gap. Then I can die. Believe that.

<div align="right">

Steve Earle
Nashville

</div>

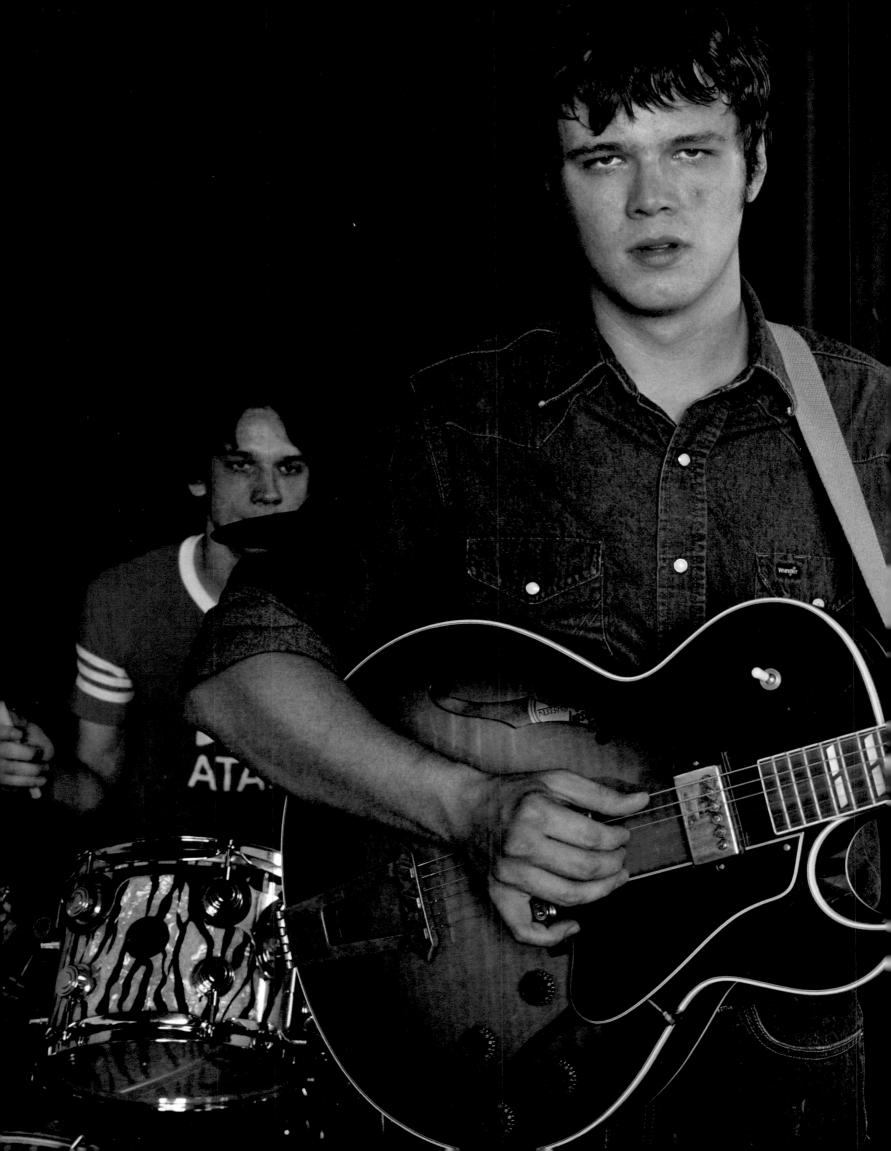

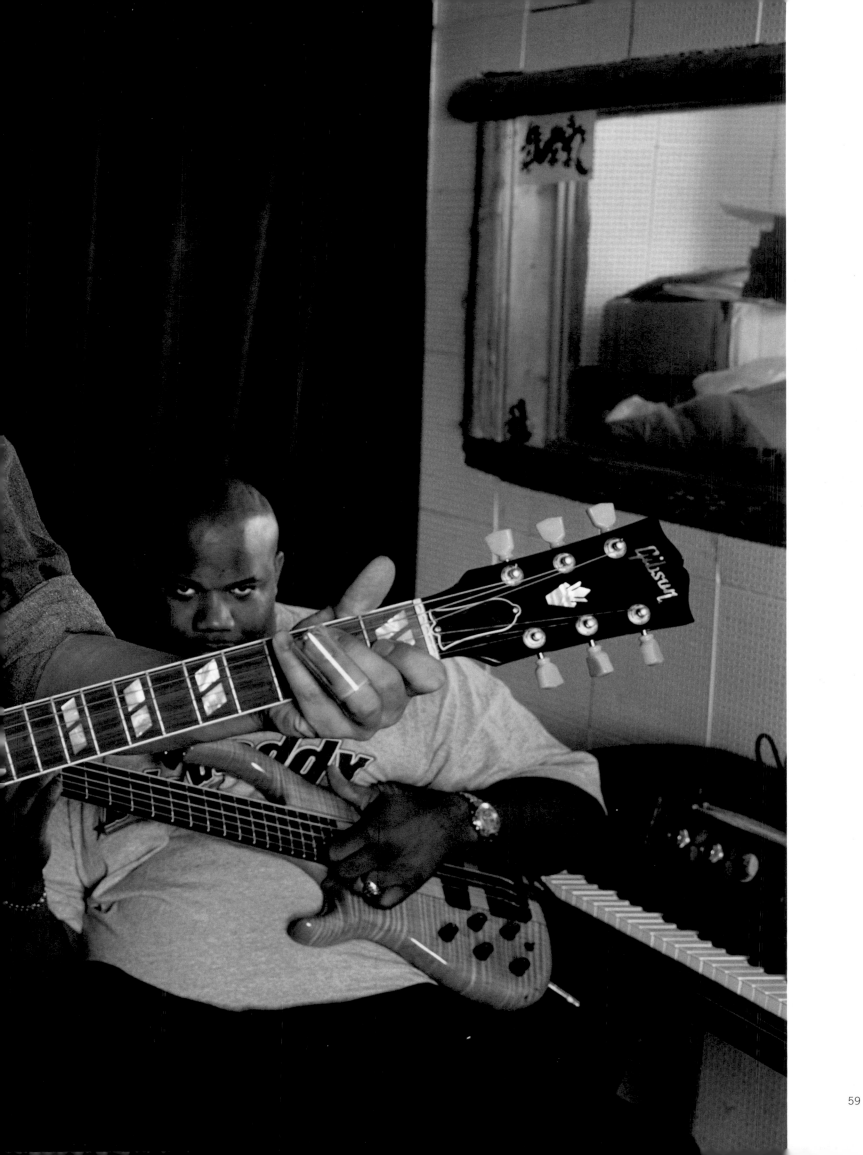

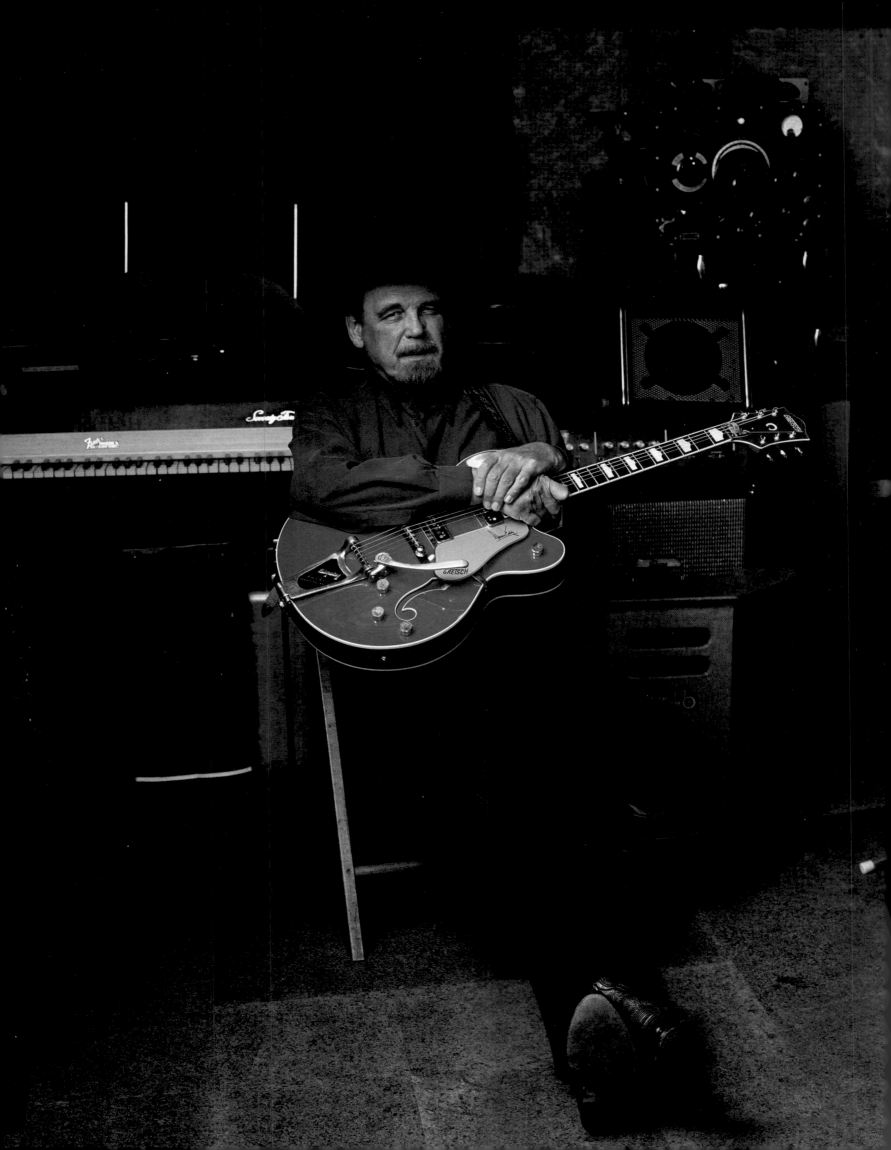

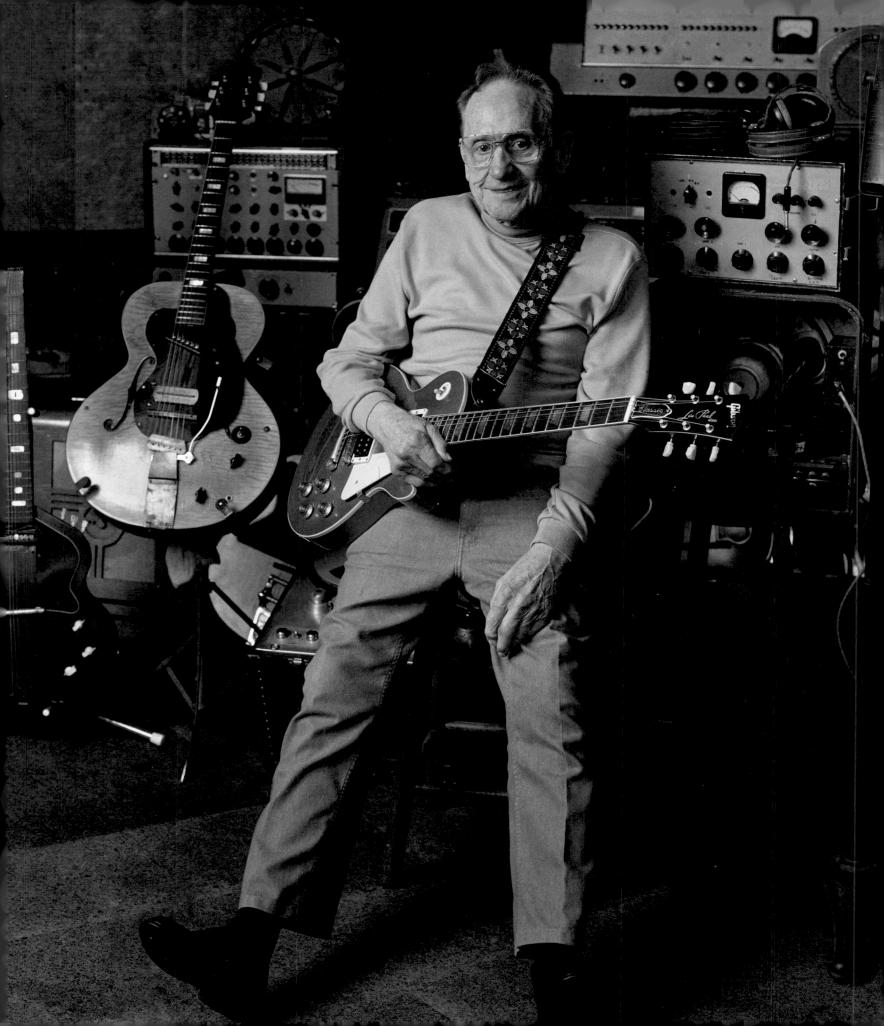

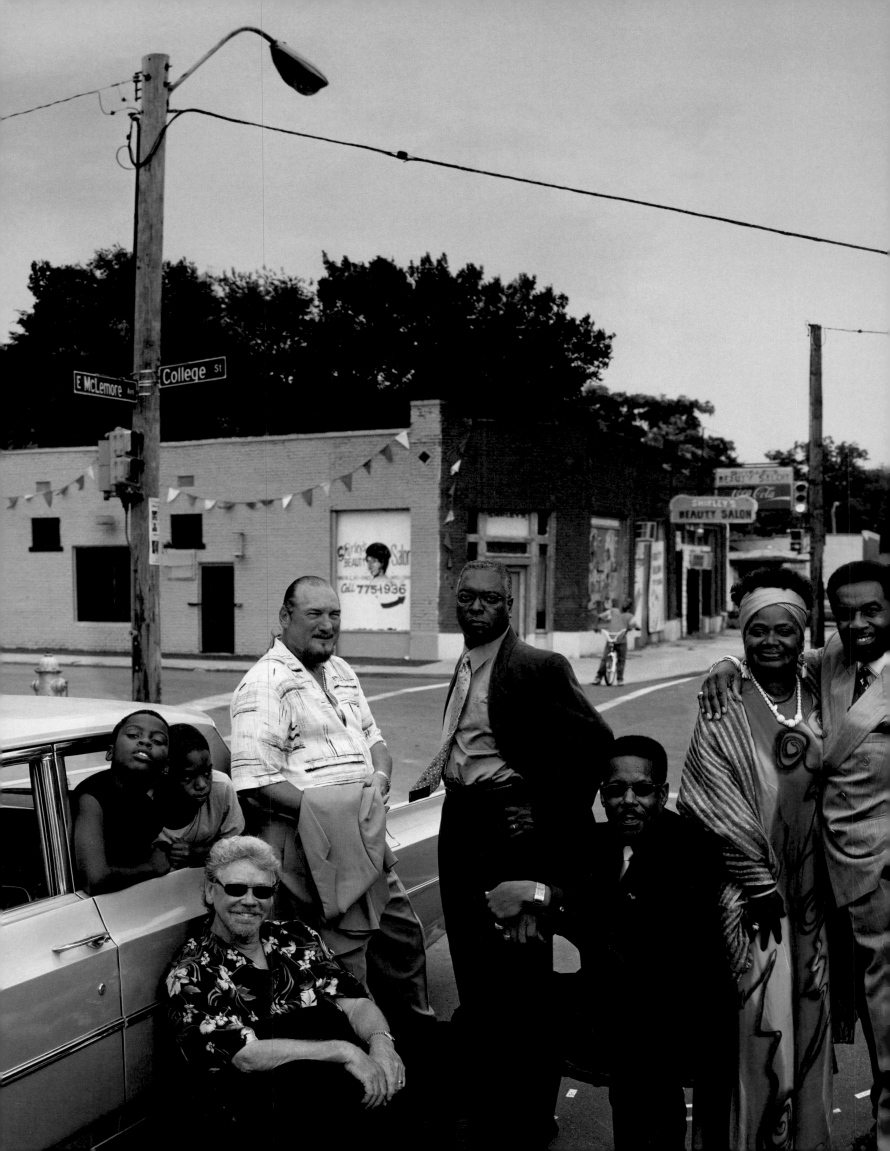

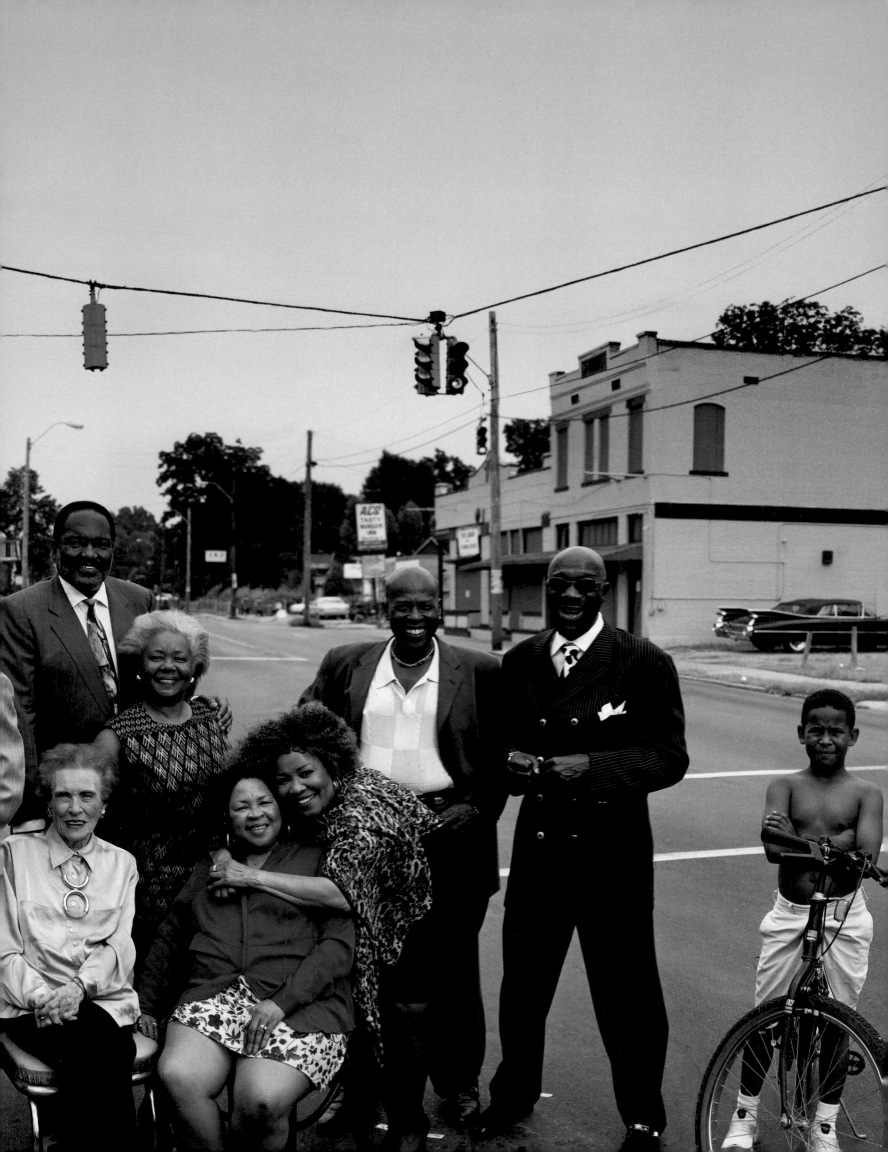

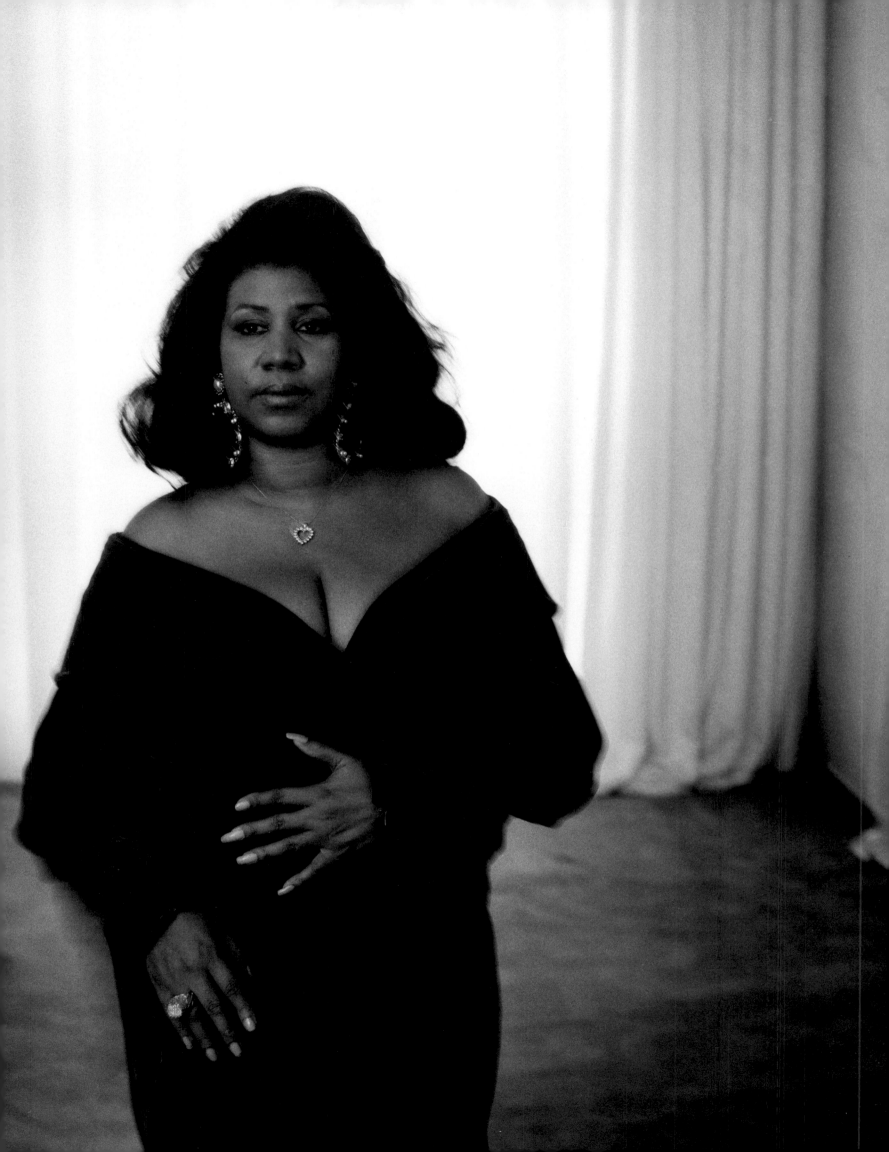

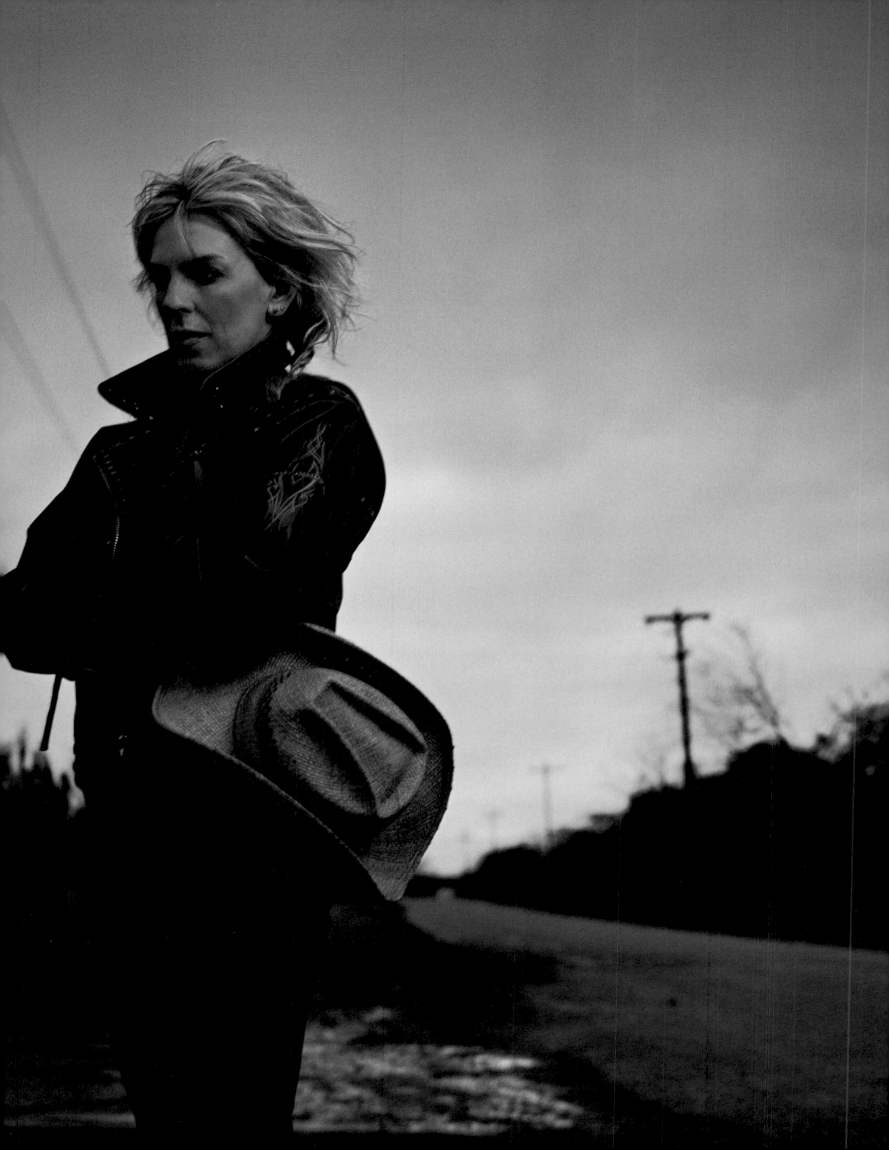

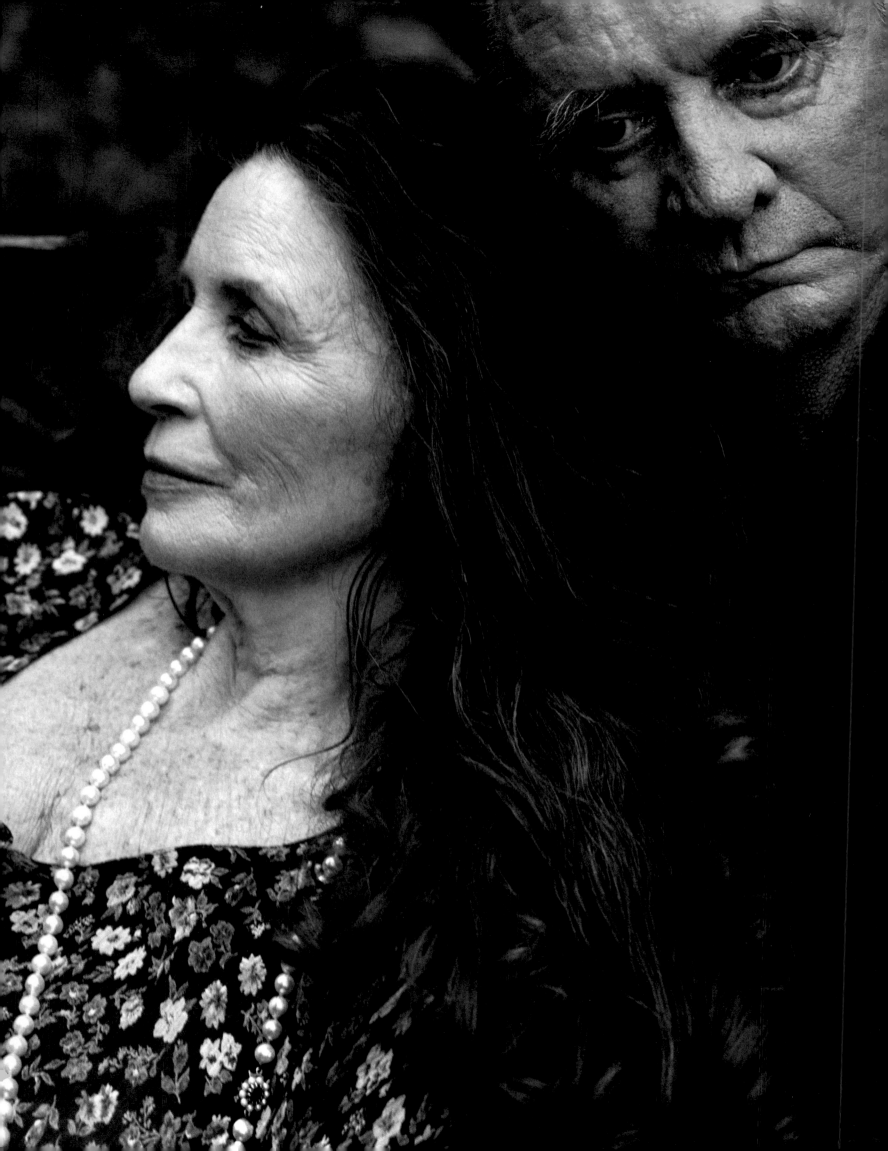

When I was in my late teens, I spent two and a half years on the road with my father. I had a permanent chair in the wings at stage right, and I sat, night after night and town after town, and watched him perform a few hundred shows. I didn't park myself there just for the songs, which I knew by heart—every phrase, word, and note. And it wasn't entirely to check out the chemistry of any particular audience, although that was always of interest. It was the look of his back. He stood in sharp shadow and light, a spotlight bearing down on him like a steady explosion, his guitar slung across his back sometimes throughout entire songs. I could drift away looking at his iconic outline and feeling his voice vibrate to the future or to the distant past. I began to understand what the word "timeless" meant: it meant that my dad could have shown up in a minstrel gallery in the medieval court of a Scottish king—perhaps one of his ancestors— and leaned over the railing to call out "Hey, Porter," and the crowd would have gone wild. It meant that he could be dropped into the twenty-fourth century —black suit clean and pressed, high black boots polished, guitar slung backwards—and planted himself in some liquid neon and delivered his raw essence with absolute equanimity.

As I began to understand the idea of timelessness, the agony of my childhood loss of my father to the road, to drugs, to another home, began to surface and then fall away. He belonged to more than me; he belonged to the world and to the perpetual expression of great art. He was nonlinear. But I was a girl who was bound to my particular moment, and there was no escaping to the past or the future for me. Eventually, I had to leave that endless tour and my seat in the wings. I turned twenty years old and I wanted to grow up. I moved across the Atlantic Ocean to try to let my ideas of timelessness and generosity of spirit settle in, work their way into my heart and bones. Two decades would pass before I could say, with grace, "He belongs to history, not just me, and I am happy to share."

I kept, as a gift and a tutorial, the sound and look of a lone dark figure with a guitar. An unadorned voice and the rhythm of six strings ringing together have a power, a magic, and an almost mythic presence for me. What is it, exactly, that causes my heart to swell to near bursting and my nerve endings to catch fire when I see a picture of Robert Johnson, bent sadly over his guitar, or Bob Dylan, holding his instrument like a weapon, or Springsteen, practically straddling the neck, or John Lennon (a stiff-legged rhythm guitarist in his youth; hunched over, with a cup of tea and a pack of cigs handy, in early middle age), or Mother Maybelle Carter, or Steve Earle, or Emmylou Harris, or my husband, or my father—or even myself—embodying the myth, in pictures or in person? I did a show with Joan Baez once, and I sat in the wings and listened to the familiar, melancholy voice, and watched her fingers skid unconsciously over her strings. At the end of the performance, we all went out

to join her for a finale. She turned and looked at me and I walked to her and we put our arms around each other, wordlessly. We didn't want to let go, and the crowd started cheering. We had never met before, but we already knew what was most important about each other. The roots of my longing and passion go deep, into my early childhood, I suppose, when the imprint of my father on my little-girl's brain contained the shape of his guitar, the keening of his voice, the beat of his melodies, and his back, turned away from me and toward the spotlight. There is something about that image that speaks of love, and the unknowable, and endless travel, and the manifest soul. There is nothing in music that moves me more than this.

On that tour I took with him back in my teens, what was always yearned for, but not known, became conscious for me, slowly, over the course of a couple hundred shows. What I yearned for was him, but there was a conundrum: he himself embodied the yearning. I yearned for the yearning. I don't think I will ever stop. It is too fierce. My own body is shaped nearly like a Martin D-28, my voice links to the deepest recesses of my heart, by way of a touch of his DNA and my own rocky experience, and I am part of a tradition, which is the last stop before timelessness.

In the catalog of archetypes, just after the Hero, the Warrior, and the Great Mother, perhaps someday there will be added that of the Singer-Songwriter: a solitary figure with a resonant voice, singing the depths of human experience with words that rhyme, picking out a handmade tune on a burnished guitar under a relentless circled stream of white light.

Rosanne Cash
New York City

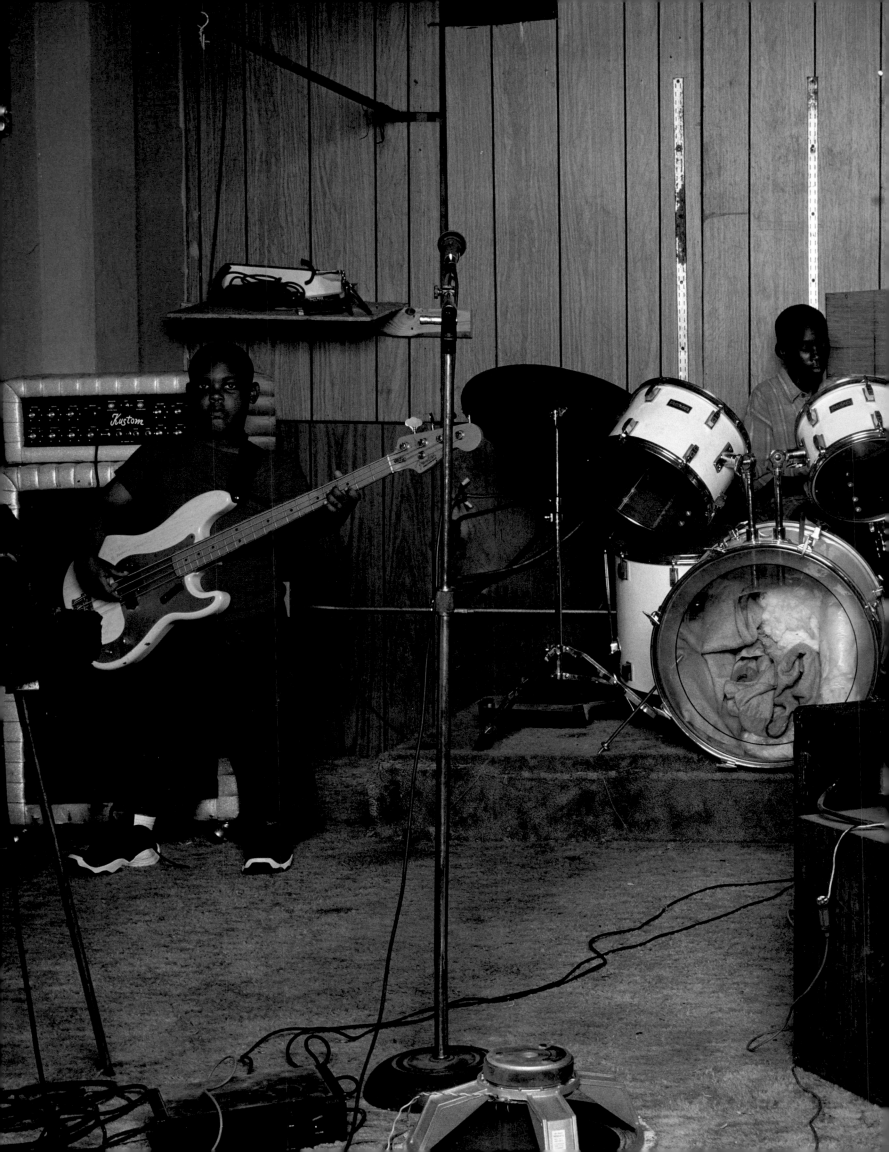

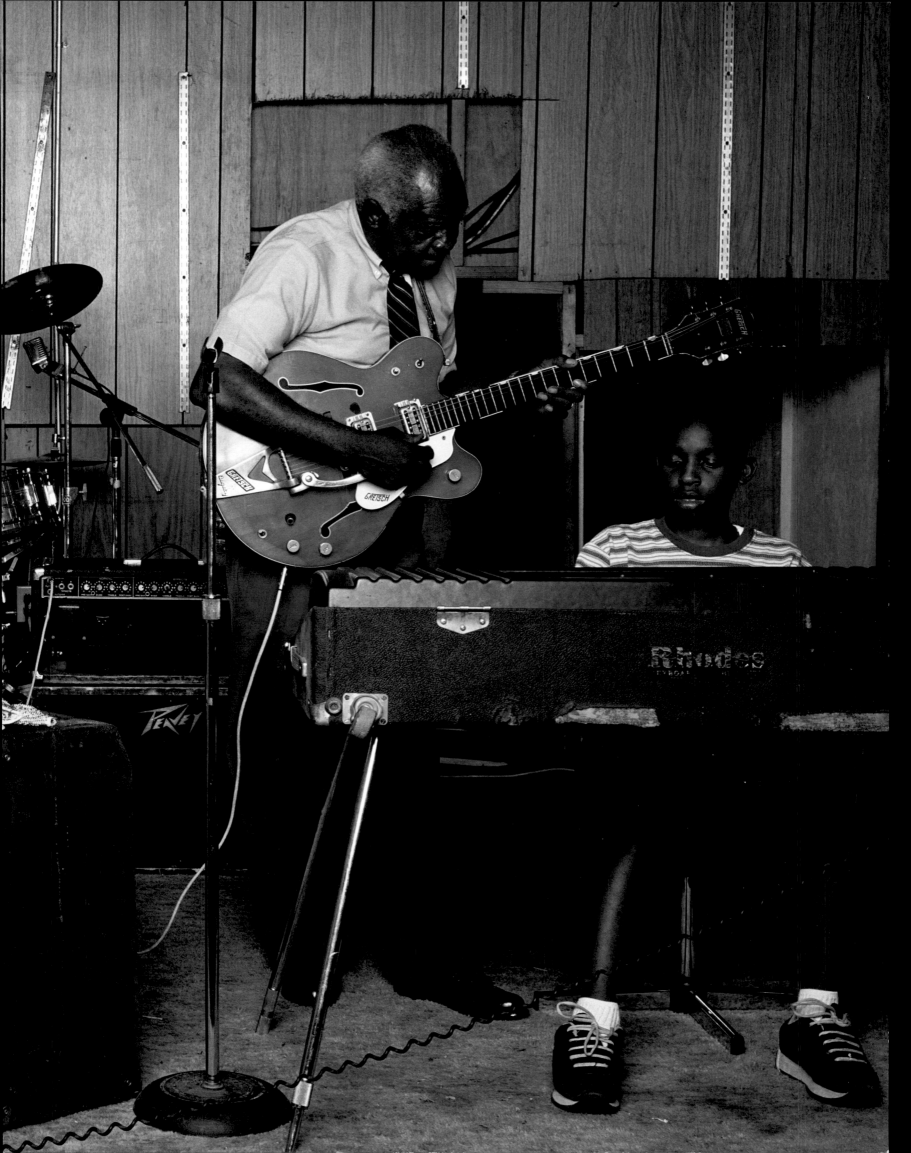

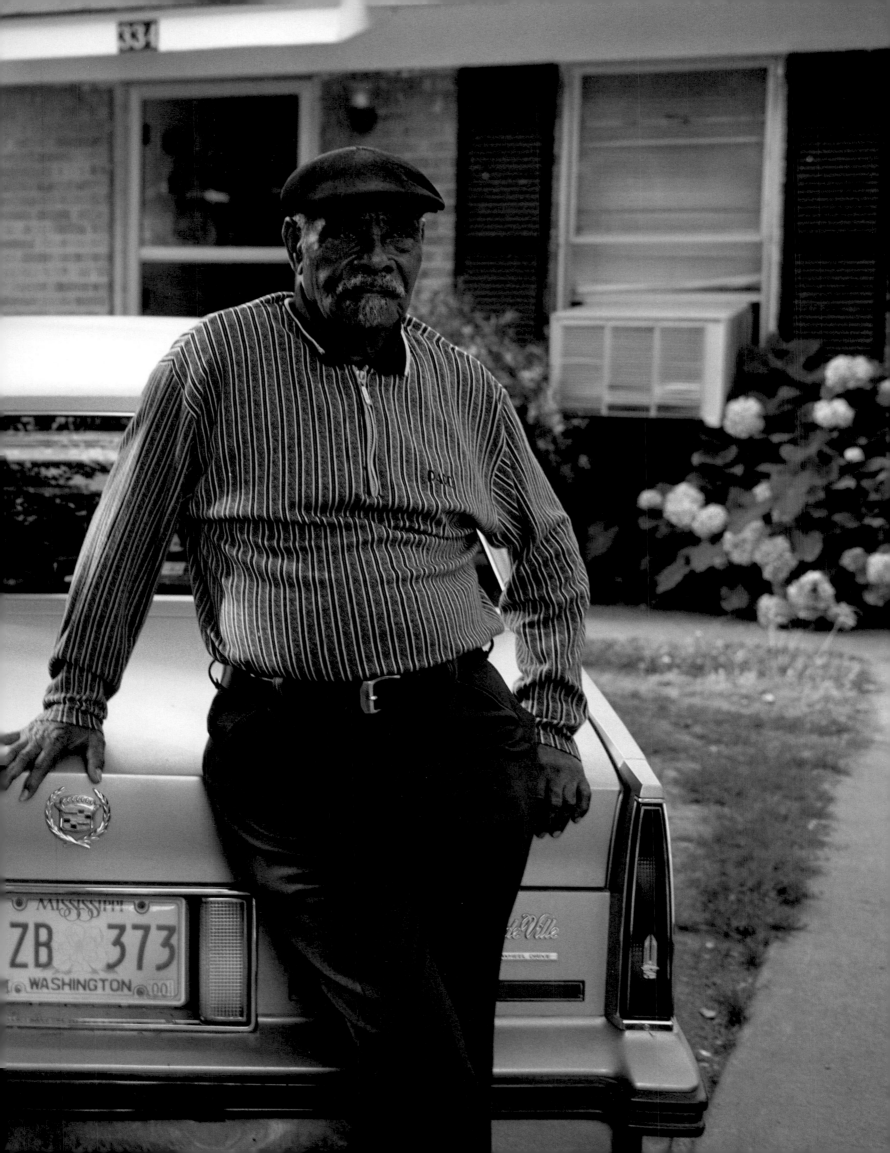

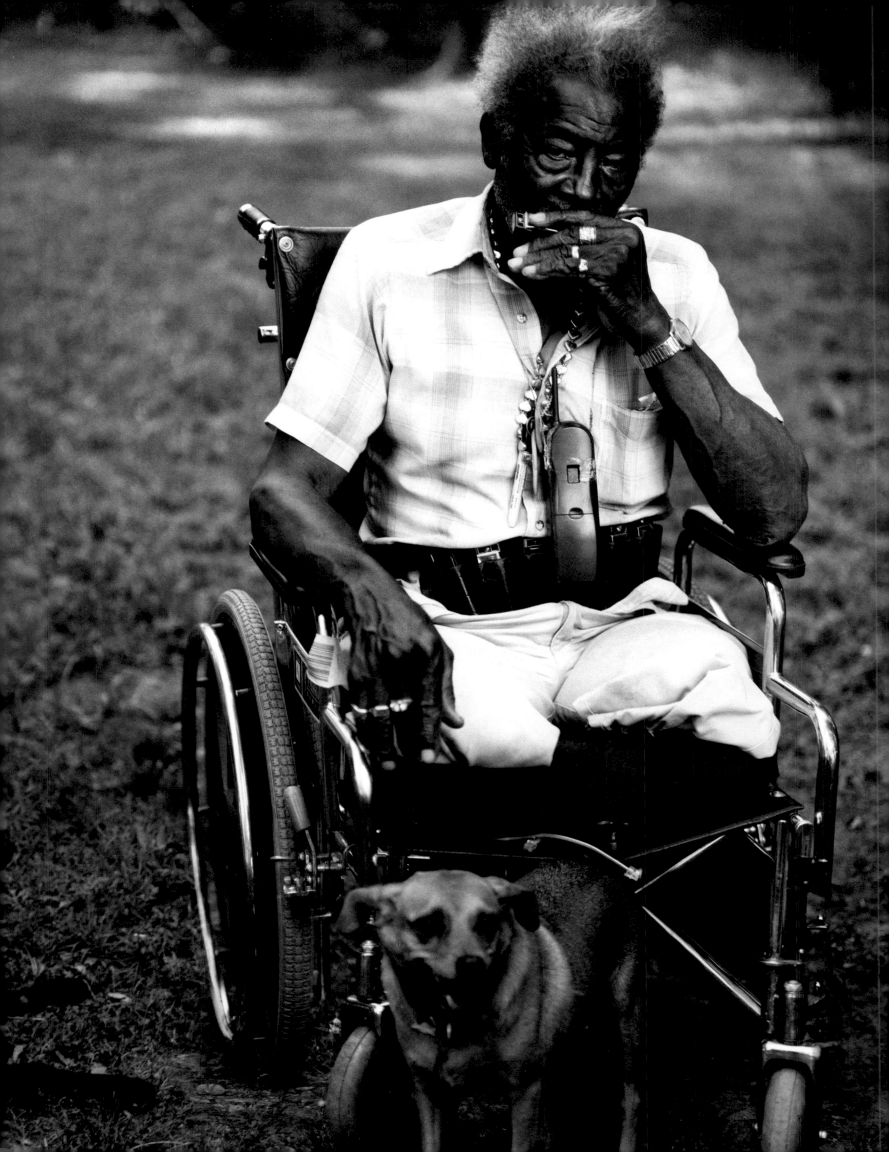

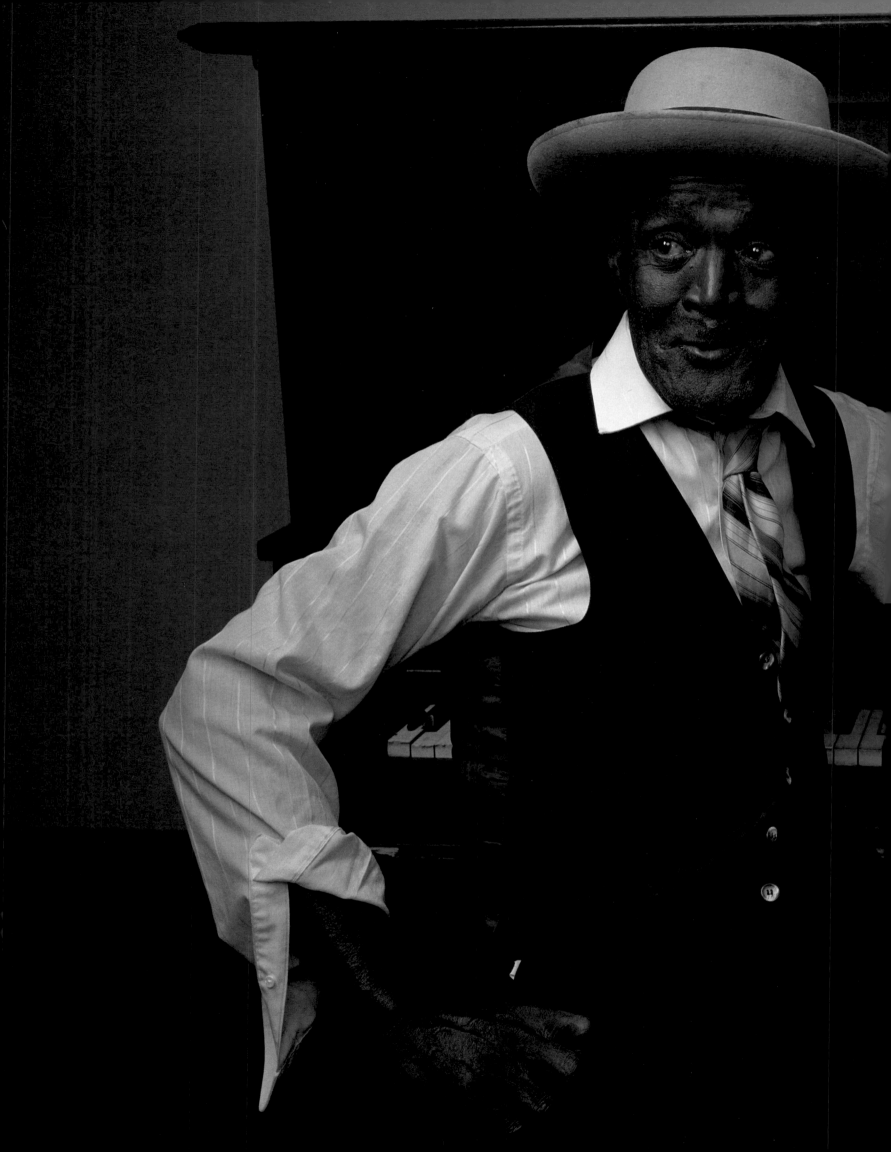

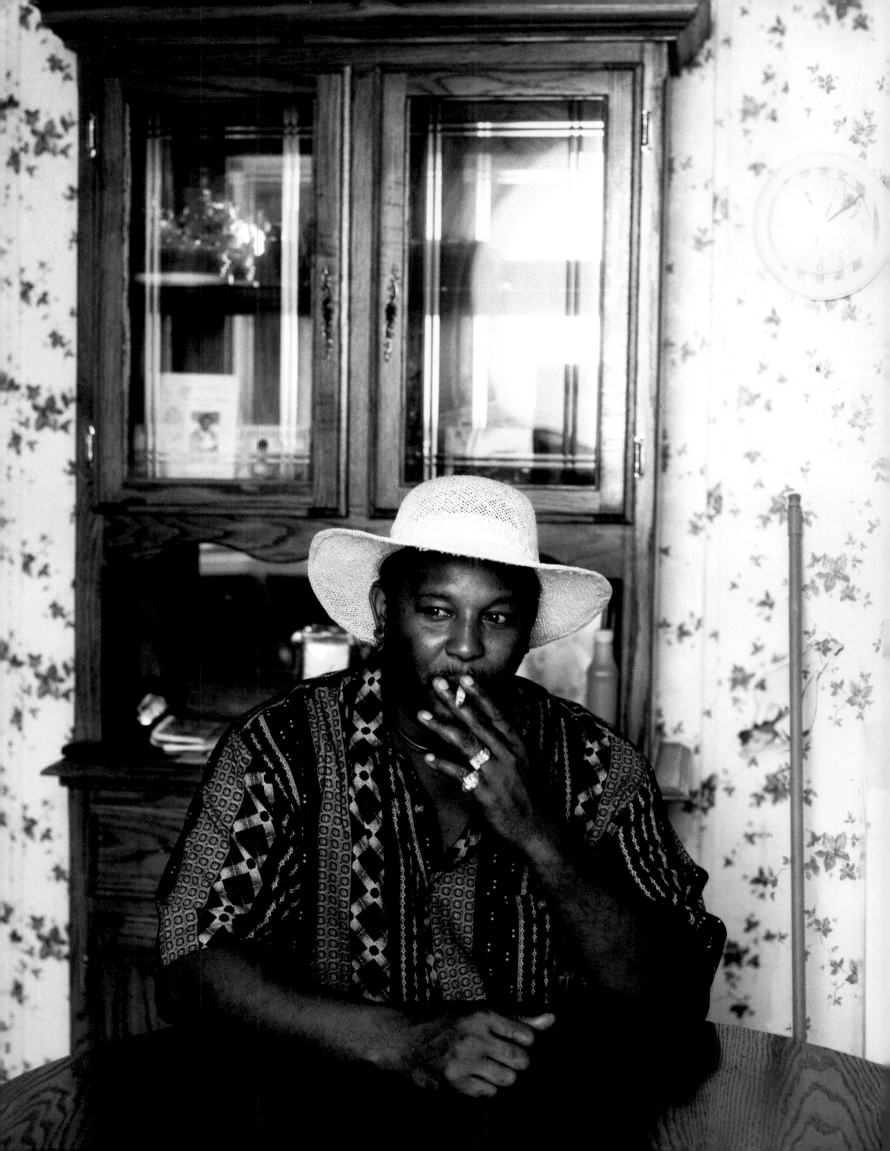

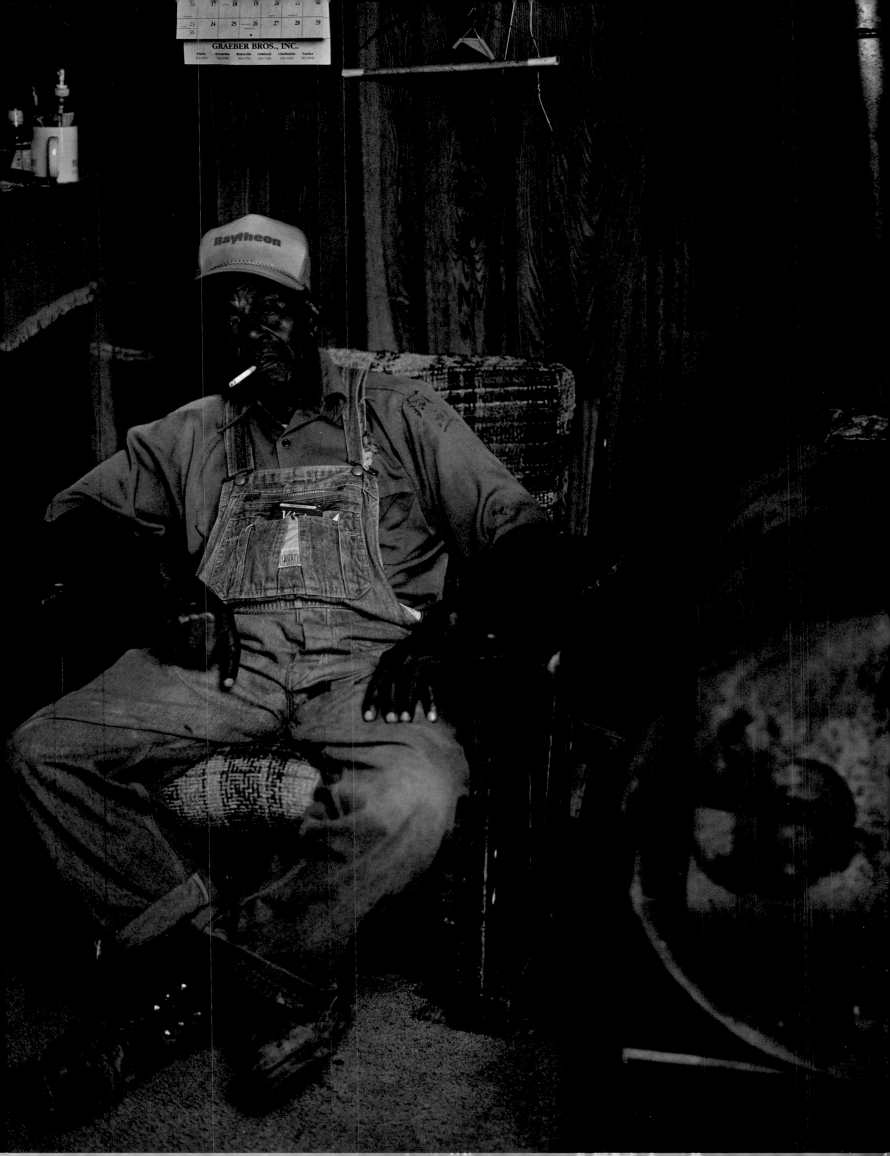

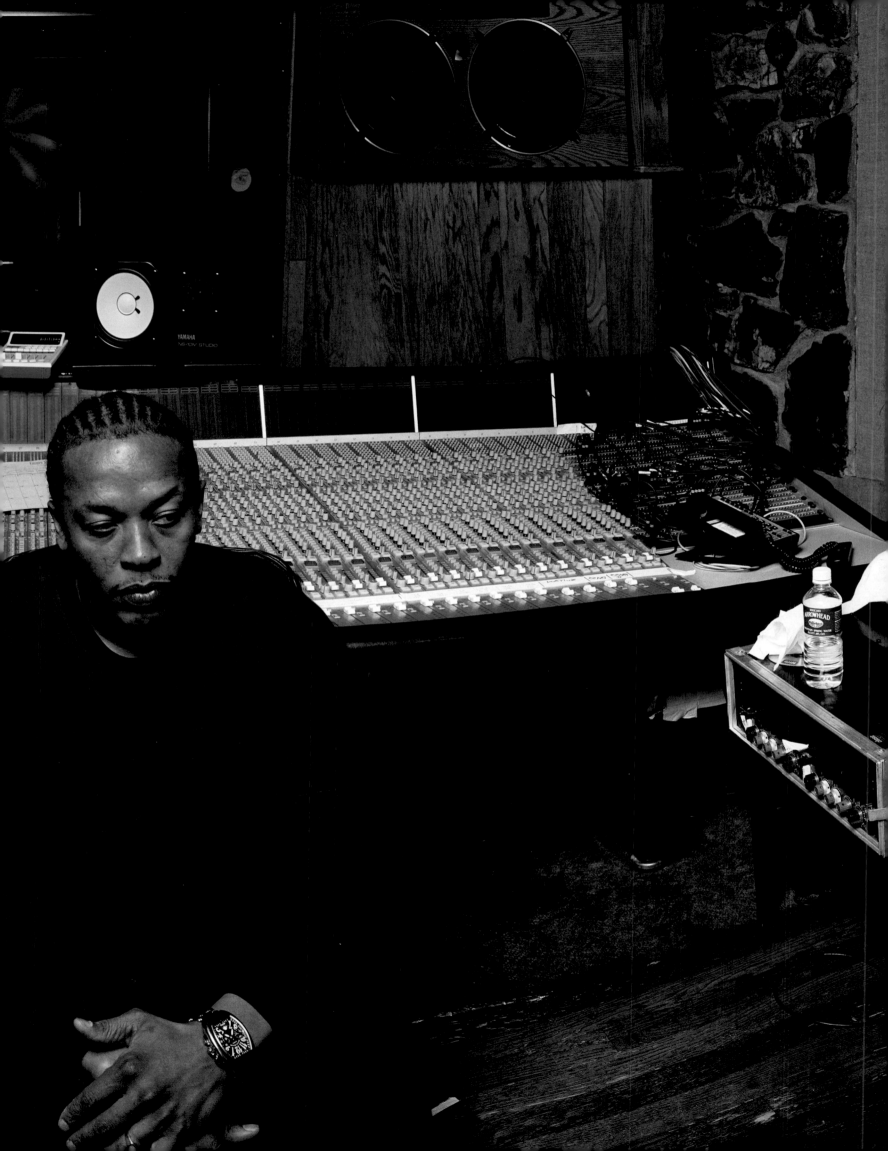

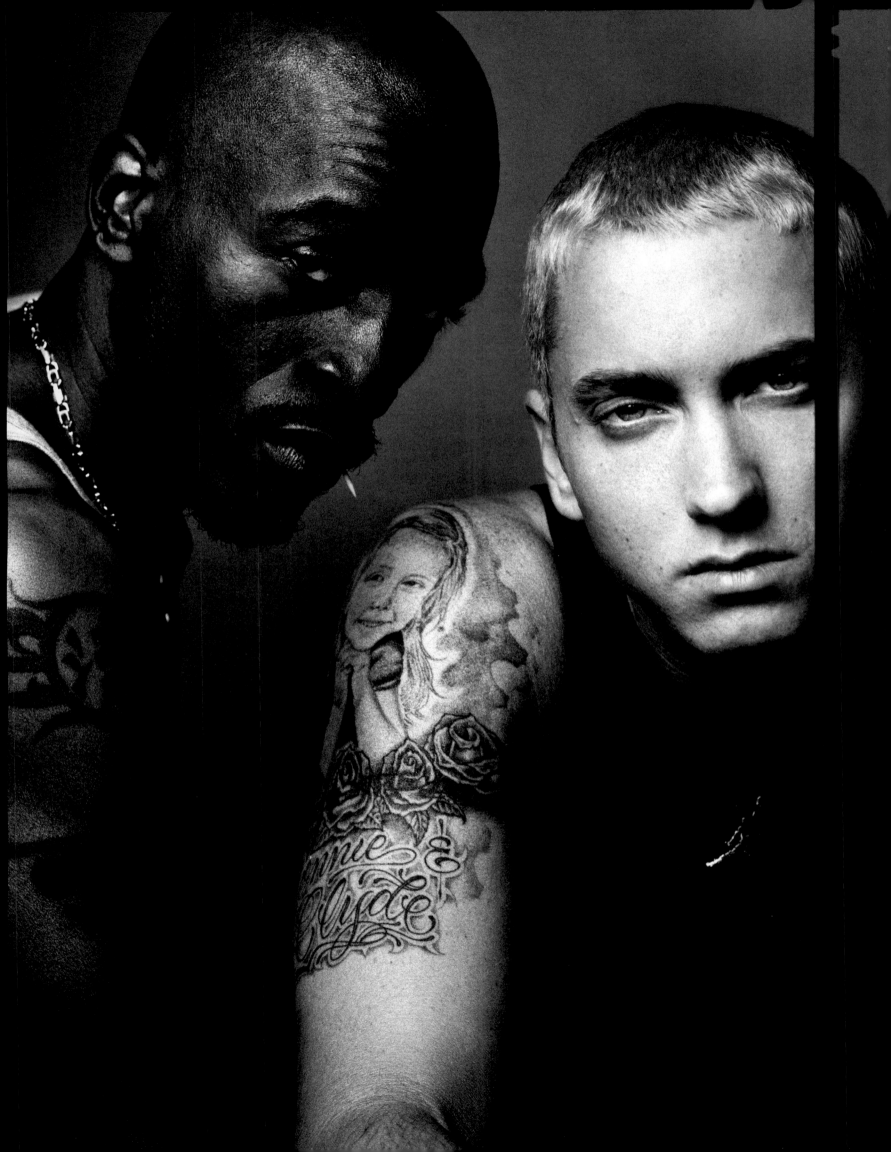

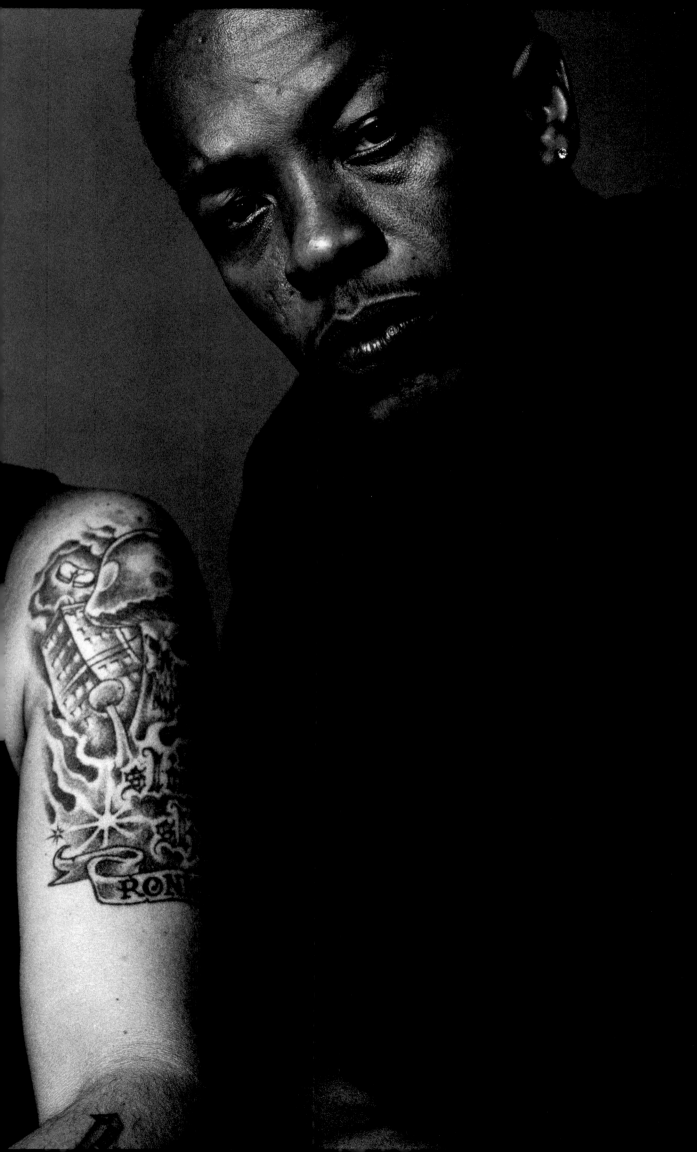

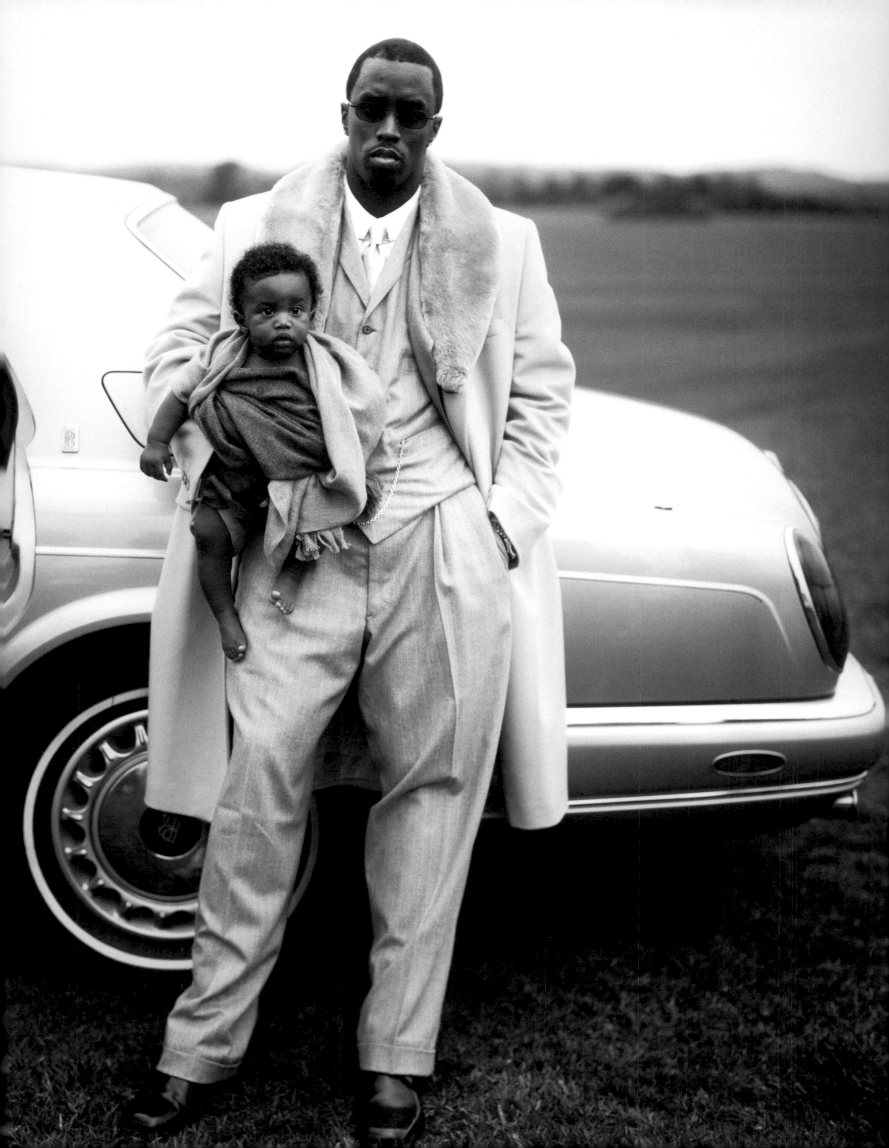

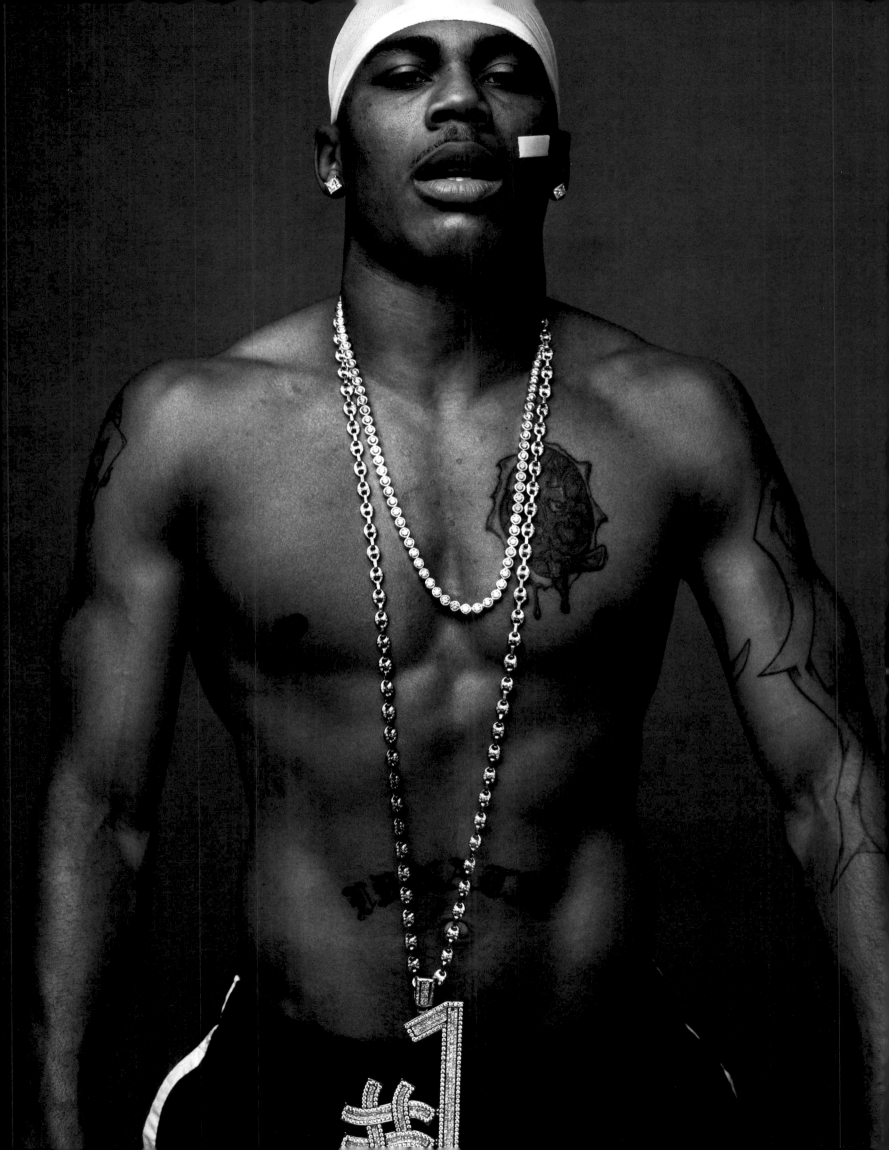

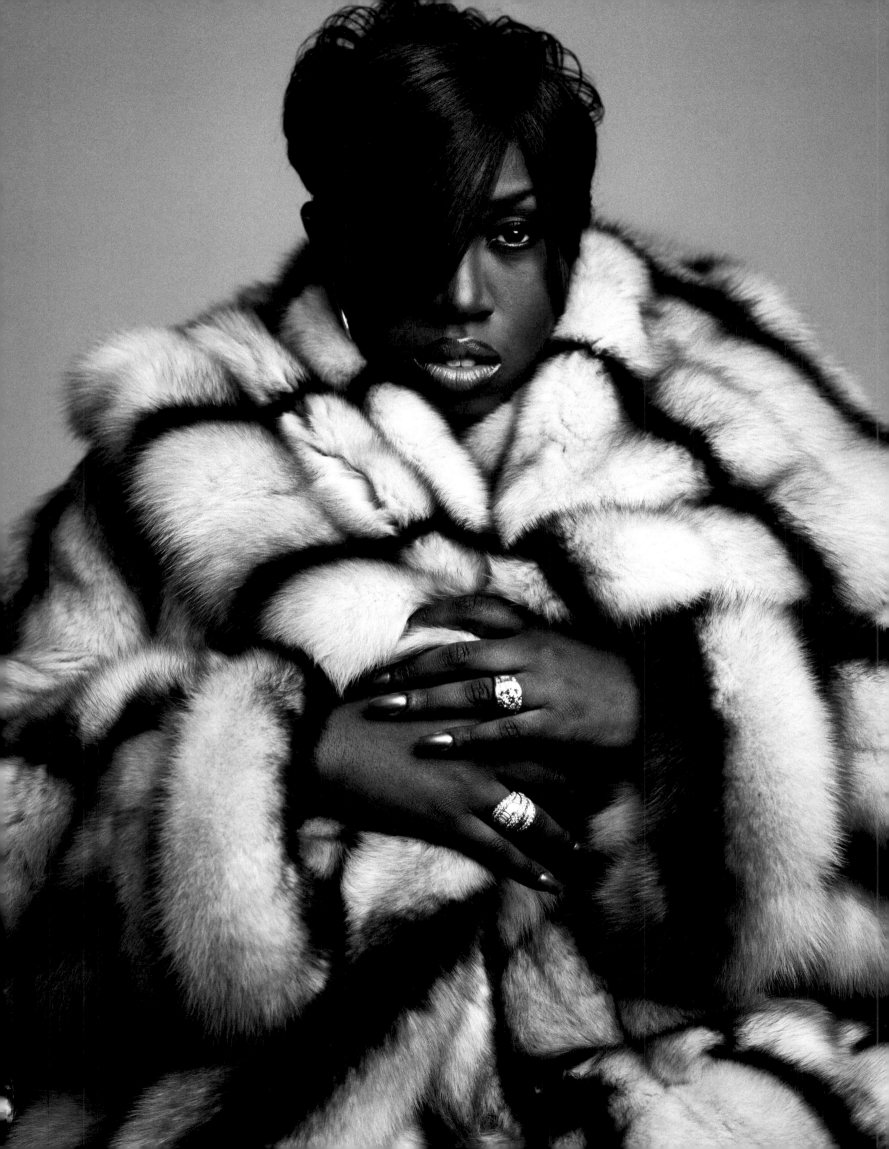

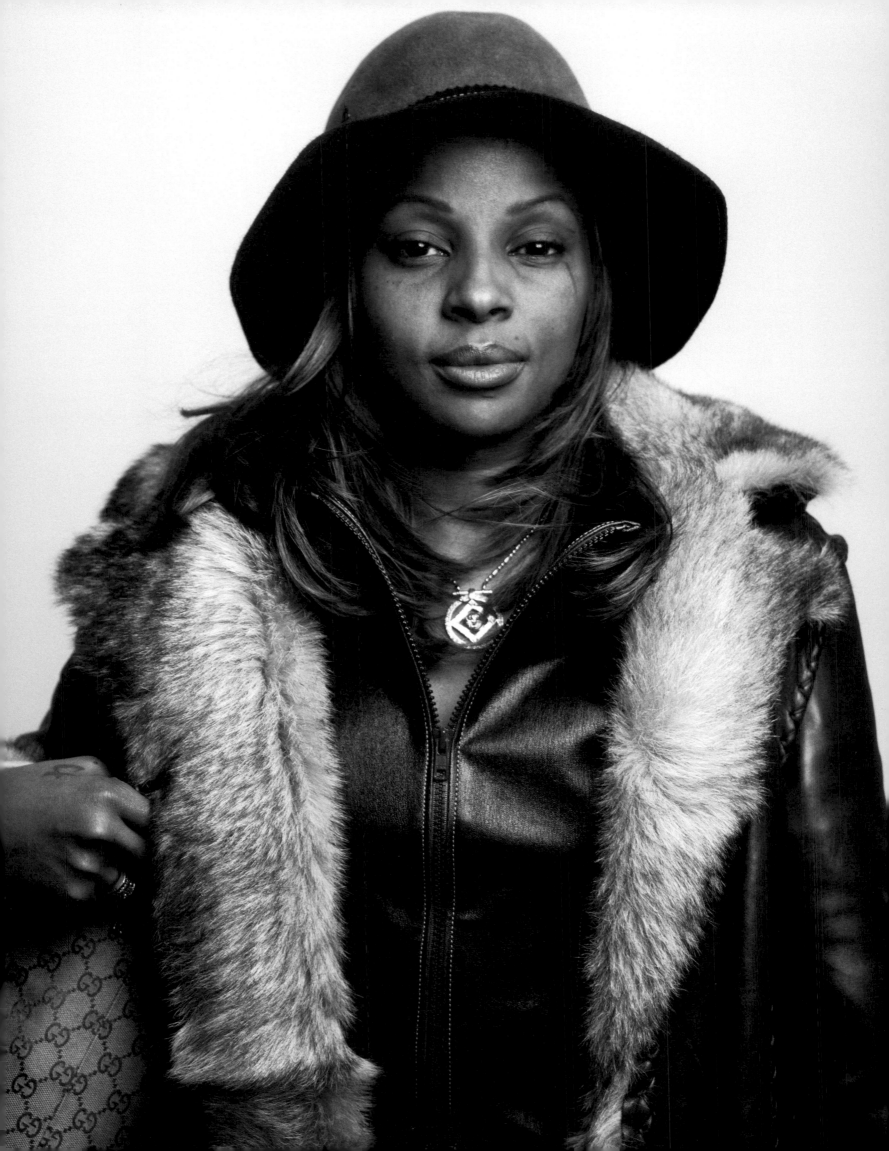

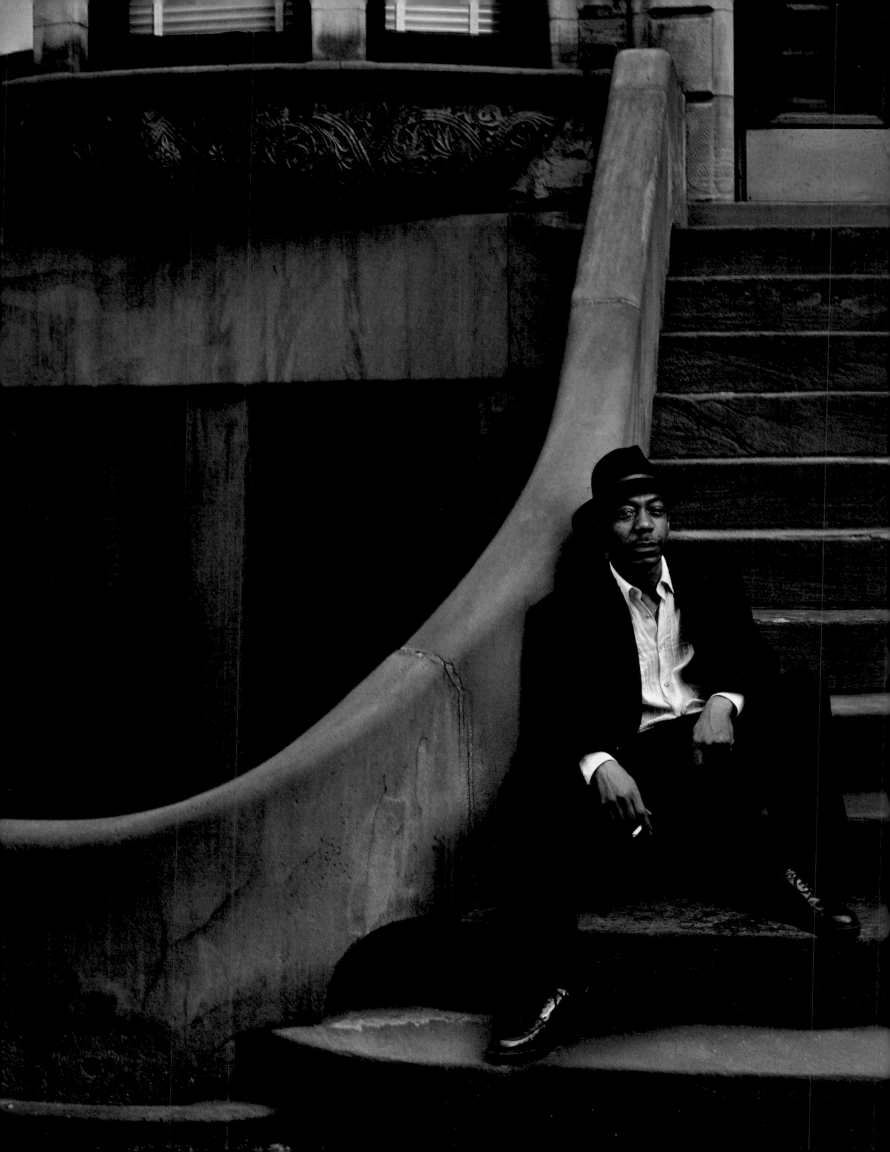

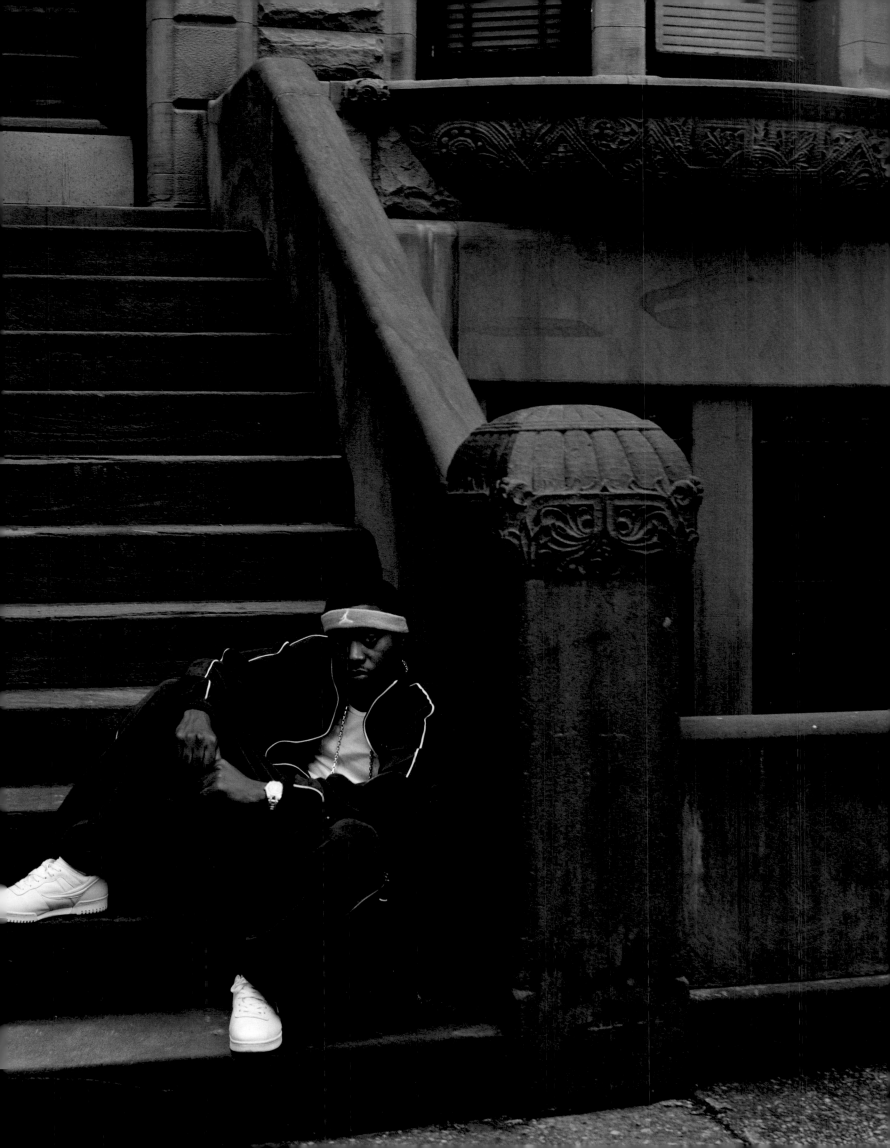

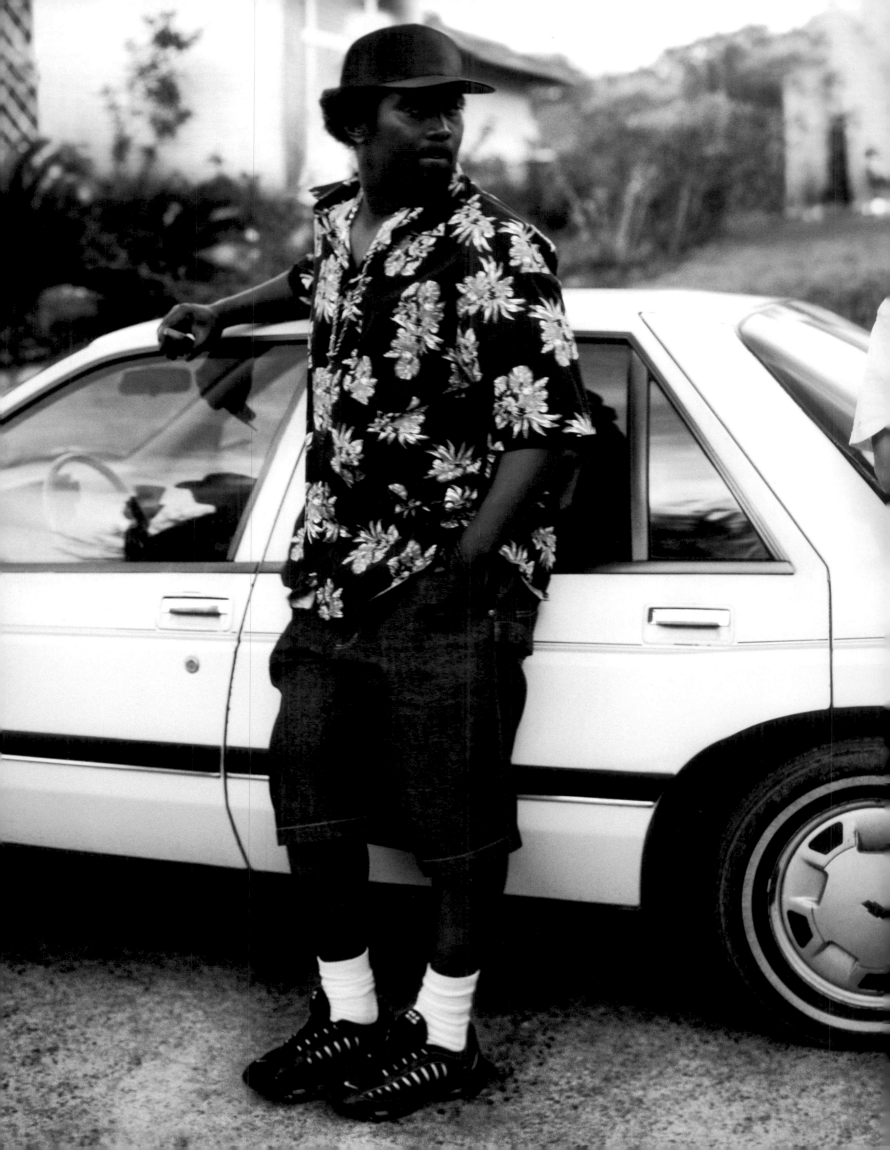

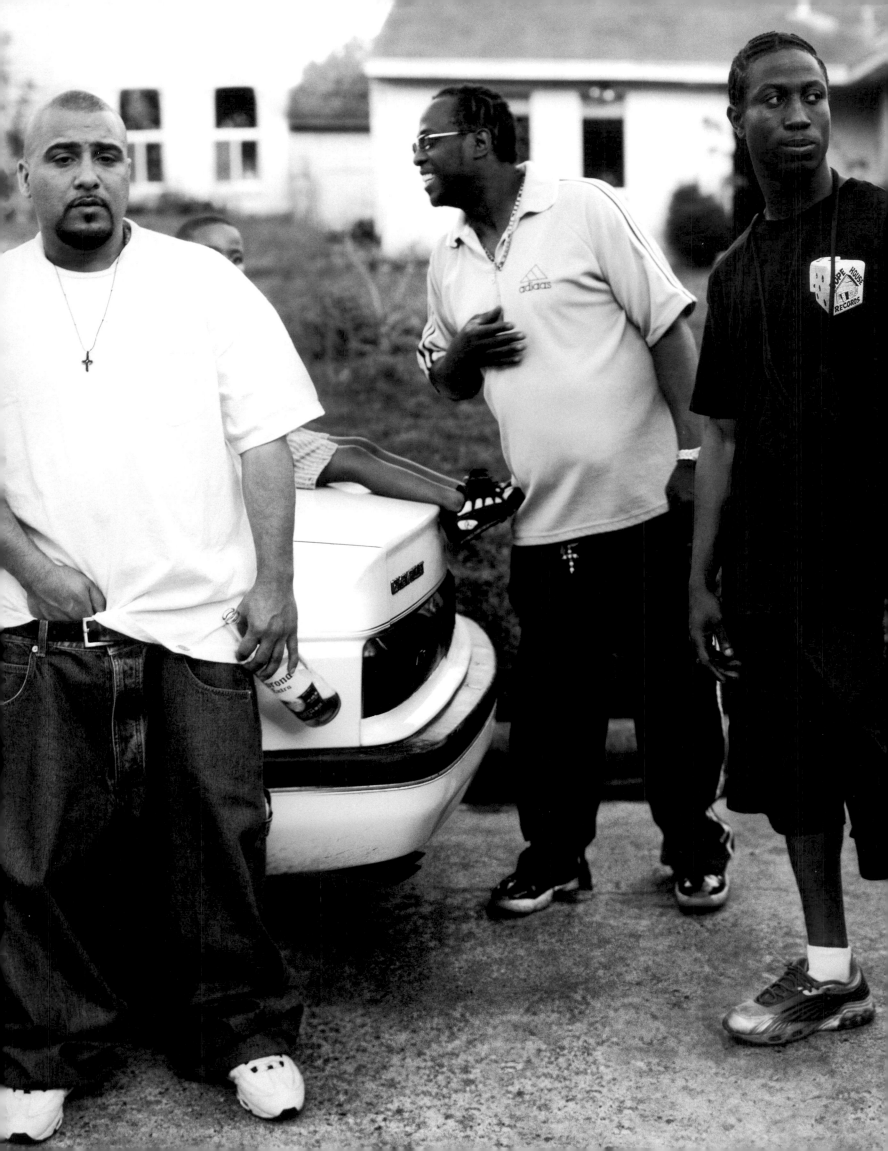

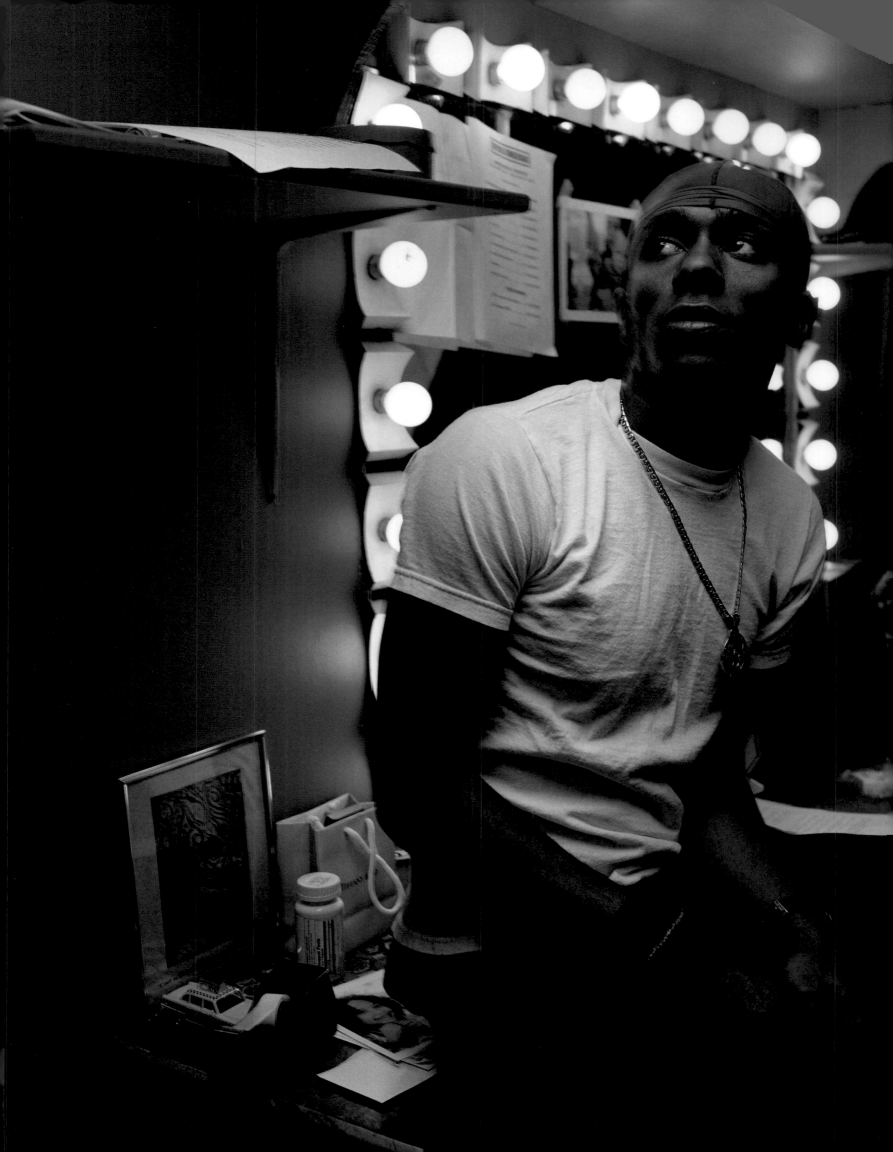

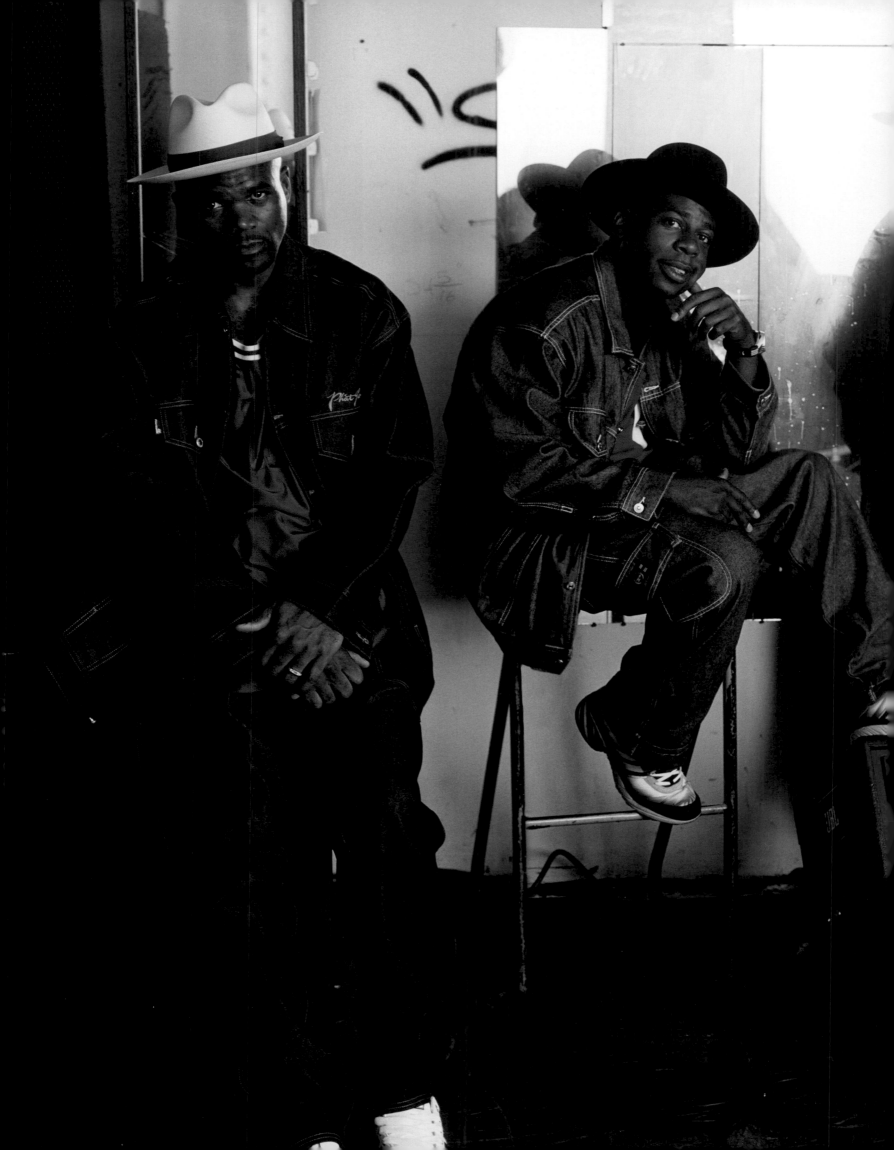

When I was about twenty, I ran into a kid named James. We found we had a mutual interest in all sorts of music, books, film. He was listening to Roland Kirk and Eric Dolphy, reading Rimbaud and Knut Hamsun, watching Bergman films. He'd even been on tour with the Meat Puppets. I had traveled around the U.S. on a bus, lived in New York, played all over the Lower East Side, and run into people like Roger Manning, Kirk Kelly, and the late-eighties anti-folk crowd. I hung around with a guy named Paleface who was a little older than me and looked like Huck Finn. We used to go to all the open mikes together. He taught me Daniel Johnston songs on the sidewalk and let me sleep on his couch. He was a great songwriter, a generous friend, and a big influence on my early stuff, as were Woody Guthrie, Blind Willie McTell, Public Enemy, Iggy Pop, Pussy Galore. I was trying to synthesize what I had heard into something that was mine. ABC No Rio, the Pyramid Club, and Chameleon were where we attempted half-written songs and improvised miasmas. At the time, we were just drinking 40's and trying to make a nuisance of ourselves. But we also got a chance to let our existences and the songs we were hammering out intersect into some kind of breathing organism. I'd been to Europe, stayed with a bunch of Napolitanos. I met an artist named Marcus Krips, who would rope people into performance pieces or start a band four hours before a gig. I remember going to his studio once to visit and ending up playing drums with him in a sawdust basement club, filmed by a local news crew.

By the time I met James, I'd been gigging around and making lo-fi tapes for a while. James had a grand plan to go to Europe

and get out of the American doldrums. This was around the time of the Gulf War and grunge. I'd been in Prague a month after the wall came down and told him about how pristine and out-of-time it was, unsullied by chain stores and bric-a-brac. There weren't even neon signs. The department stores still carried merchandise from 1960. It was a time warp. He decided we should get to Paris any way we could, then head over to Prague and points east. I had no money, but I scraped up a $150 ticket somehow and met him there. He was crashing at a place with about ten people. I found a corner of the floor to sleep on and joined the continental bivouac. There was a park across the boulevard where a bunch of them would go play guitar and drink wine. It was kind of a low-rent version of an Eric Rohmer coming-of-age movie. An American musician, Tim Easton, was one of the habitués of the ground-floor flat. Tim, James, and I decided to go up to the steps of the Sacre Coeur one night to play for some change. We went at dusk and found a place among the crowds of tourists and immigrants on the steps overlooking all of Paris. We put out a hat and sang and played old folk tunes and train songs as loud as we could, just to be barely heard in the Montmartre melee. A busker further up the steps from us was playing "Hey Jude" over and over through a portable sound system and was raking in the cash, with a huge crowd around him singing along "naaah-nah-nah-na-na-na-nahhhh." How could we compete? (The music business plays out the same even on the steps of Montmartre.) After we bought some 1664 beer with the loose coins we'd acquired, the others either went off with some girls they'd met or to some anonymous bush for a hash session. I found myself alone, picking on some ragtime, when I heard distant percussive music. I looked around and followed the sound. Off to the side of the hill I saw a large African man playing a nylon-string acoustic guitar, surrounded by little Moroccan children banging on percussion fashioned out of soda cans and trash. I was struck by how strange and transfixing the music was, and then I wondered what these children were doing outside and

awake at two or three in the morning. They were playing African folk songs, melodic and hypnotic. The singer had a rich, fluid voice and the guitar parts were rhythmic, with lines that countered the circuitous melodies. The children played complex polyrhythms. The singer sang a line and the children sang it back full-voiced in a call and response. After some time, the man noticed me and motioned to play along with them. I picked out a crude repetitive part and tried to blend into the music the best I could. In a while, I didn't even realize I was playing anymore. Songs built for twenty, thirty, forty minutes. I was in suspended animation with no awareness of anything extraneous (no drugs involved). The children and the man seemed to smile a lot, laughing and clapping whenever a song ended. After a few hours it wound down, and I nodded thanks to them. The man reached over and a bunch of the kids jumped up to hug me, laughing and shouting. I watched the sun come up and went looking for my friends.

People always ask me why my music embraces so many styles. Some see it as dilettantism, others as an ironic statement. I've heard it called retroism, cut-and-paste, pastiche, even novelty. For me there's a magnetism to music and it's not necessarily exclusive to any one style. I find it in Hank Williams. I find it in Devo. Joni Mitchell, Caetano Veloso, Nino Rota, Skip James. One would have to shun much of the world to appreciate only one kind of music. They'd also shun experience. The culture surrounding a genre can be as fascinating as the music itself. So defined by its context, sometimes the culture must be examined before an appreciation can be acquired. In preparation for filming one of my videos, I got the idea to incorporate line dancers into the clip. So we went to line-dancing clubs and met and hung out with the regulars. When you stand in the middle of a line-dancing dance floor, with the sound system pumping and lights flashing, Billy Ray Cyrus sounds like Godhead. Of course, one is free to reject or disdain line dancing and Garth Brooks, but if you do you'll never get to experience the fully realized, five-hundred-color, perfumed-and-cologned, neon reality of a line-dancing room, with girls in tight jeans and men with black hats and mustaches militantly synchronized in a bizarre American dance ritual.

I grew up around the early L.A. punk scene, and many of the musicians I knew were artists, painters, and poets who were feeding off the raw possibilities of a new form. The music emitted a sardonic joy, not just the cardboard nihilism and blatant destruction usually depicted. They had names like Tomata du Plenty, Darby Crash, Timex (my godfather), and a self-effacing humor and rejection of commerciality that had less to do with a reaction against the mainstream and suburbia than an affinity with Warhol's Factory or dada. Around the age of twelve I saw a video of four mannequin-looking men dressed in matching black outfits playing odd handheld machines. It was Kraftwerk in all their Germanic precision and glory. I remember feeling that it was one of those rare moments when you hear something completely new. The music was minimal and high tech but somehow funky. It never struck me as soulless machine music. The machines were merely instruments for creating a new aesthetic in sound. Afrika Bambaataa sampled them and they became a component of hip-hop's early evolution. They would spawn an electronic music culture that encompasses the most forward-thinking musicians today, who continually infect the rock and pop world with their experimentalism. As a teenager, seeing Ramblin' Jack Elliott and Dave Van Ronk playing folk-revival music while telling stories and rasping out jokes made all the skeletons of those long forgotten songs reanimate in my mind. The lore and wit in that music changed my perspective and gave me an indication of (and a connection with) a strange and foreboding America gone by.

Employing different styles is a consequence of my own experiences, and I let them emerge in my music, with their inherent humor, freneticism, boredom, and darkness. The holes in the filter are bigger now. The desire to homogenize is waning. Varieties are giving way to varieties. The shape of the wave is stranger than anybody could imagine. I've always wanted to get a better look before it drowned me.

BECK
Los Angeles

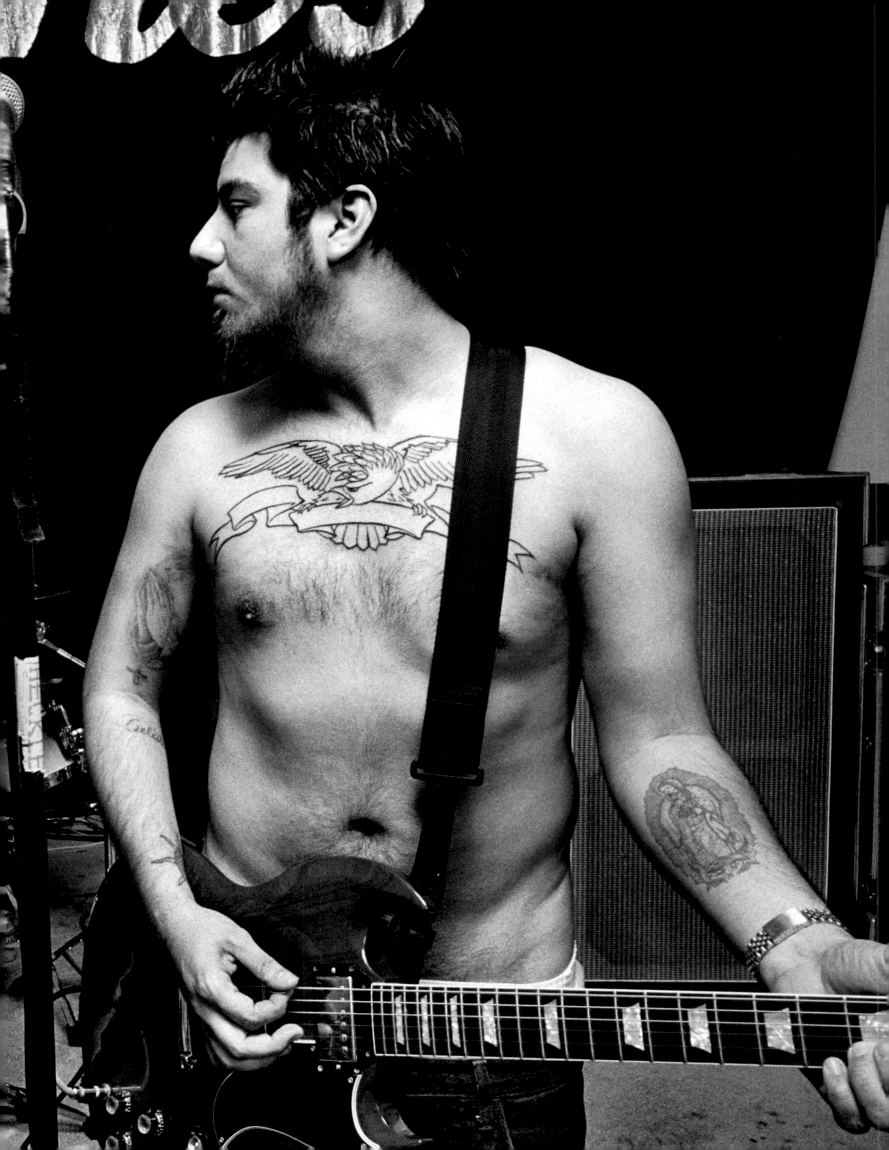

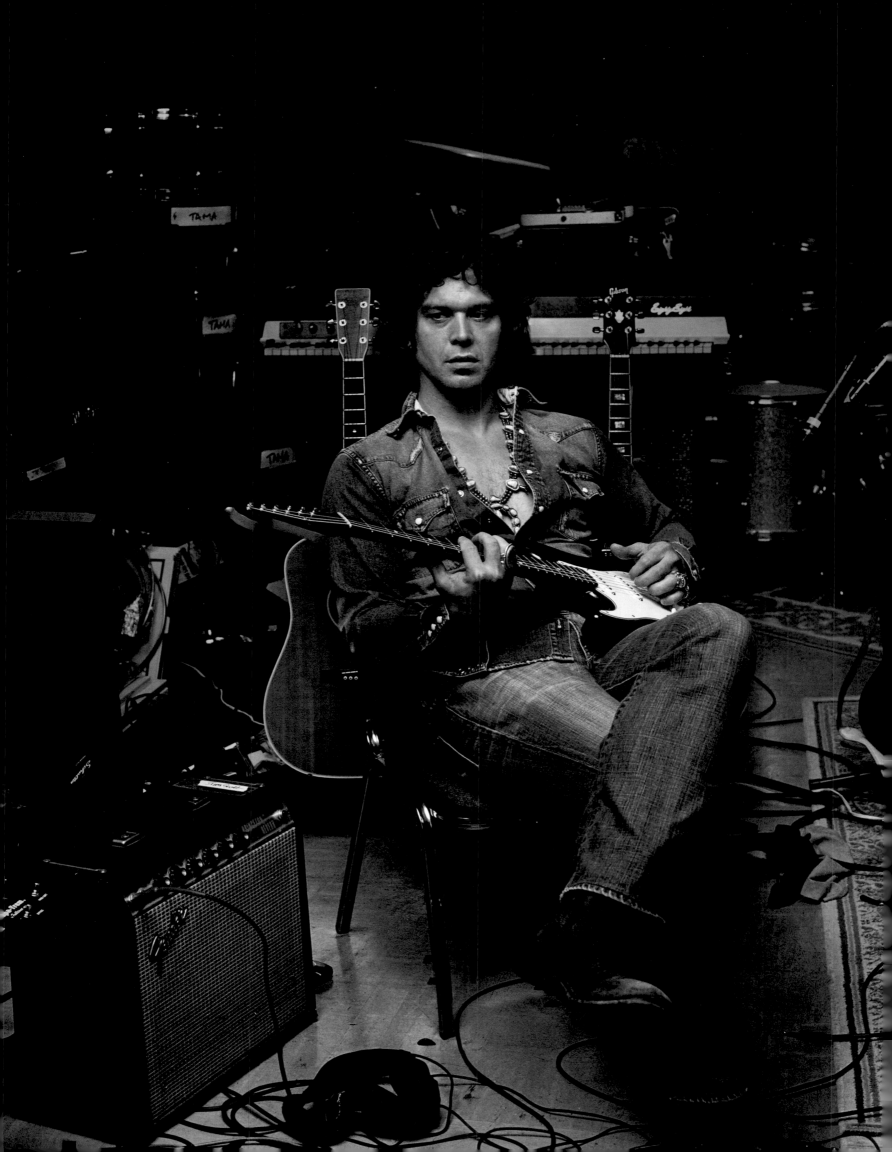

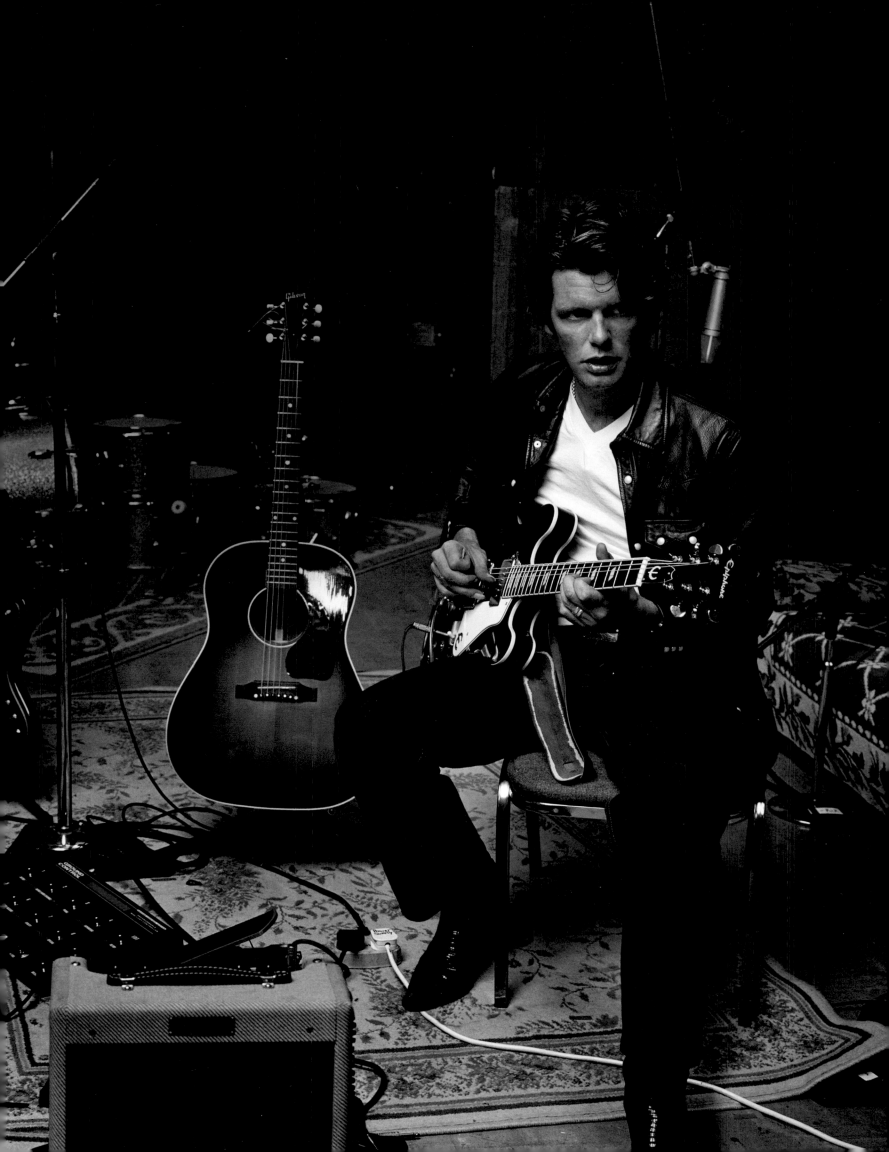

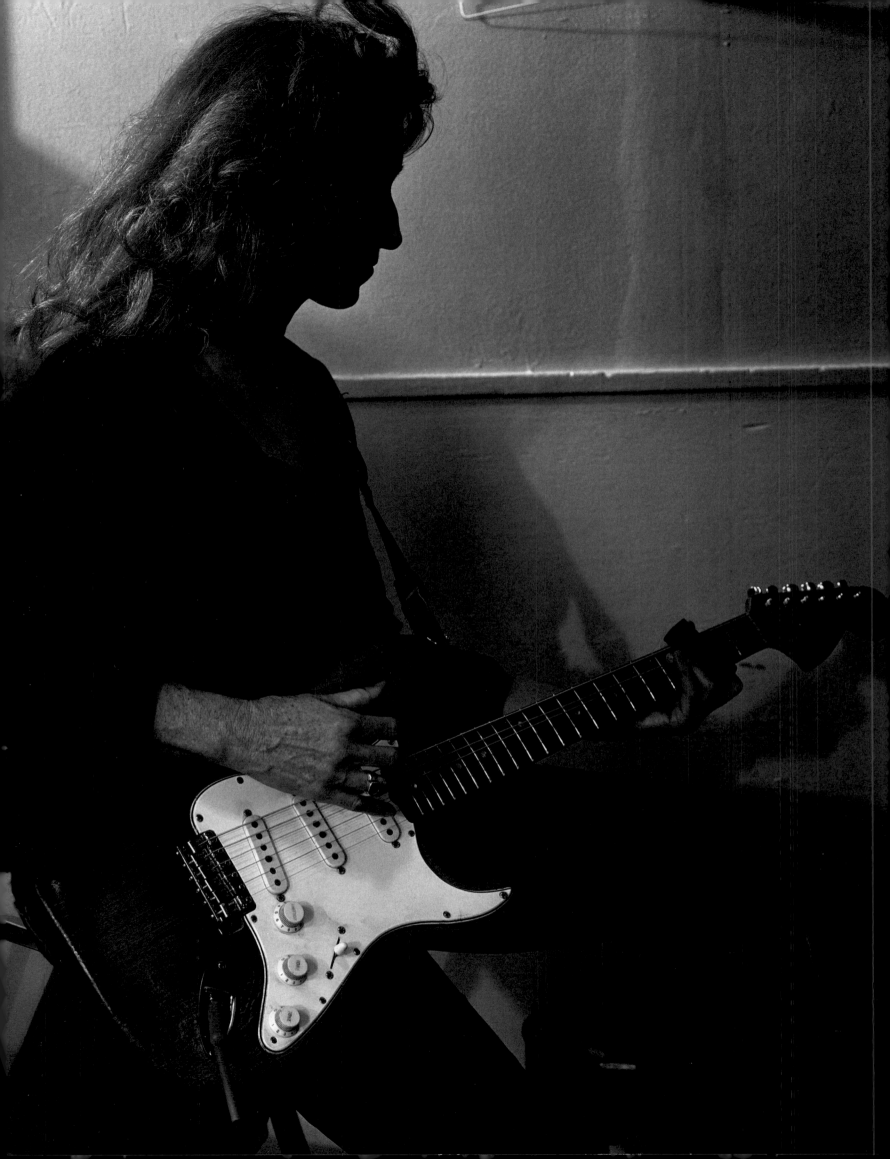

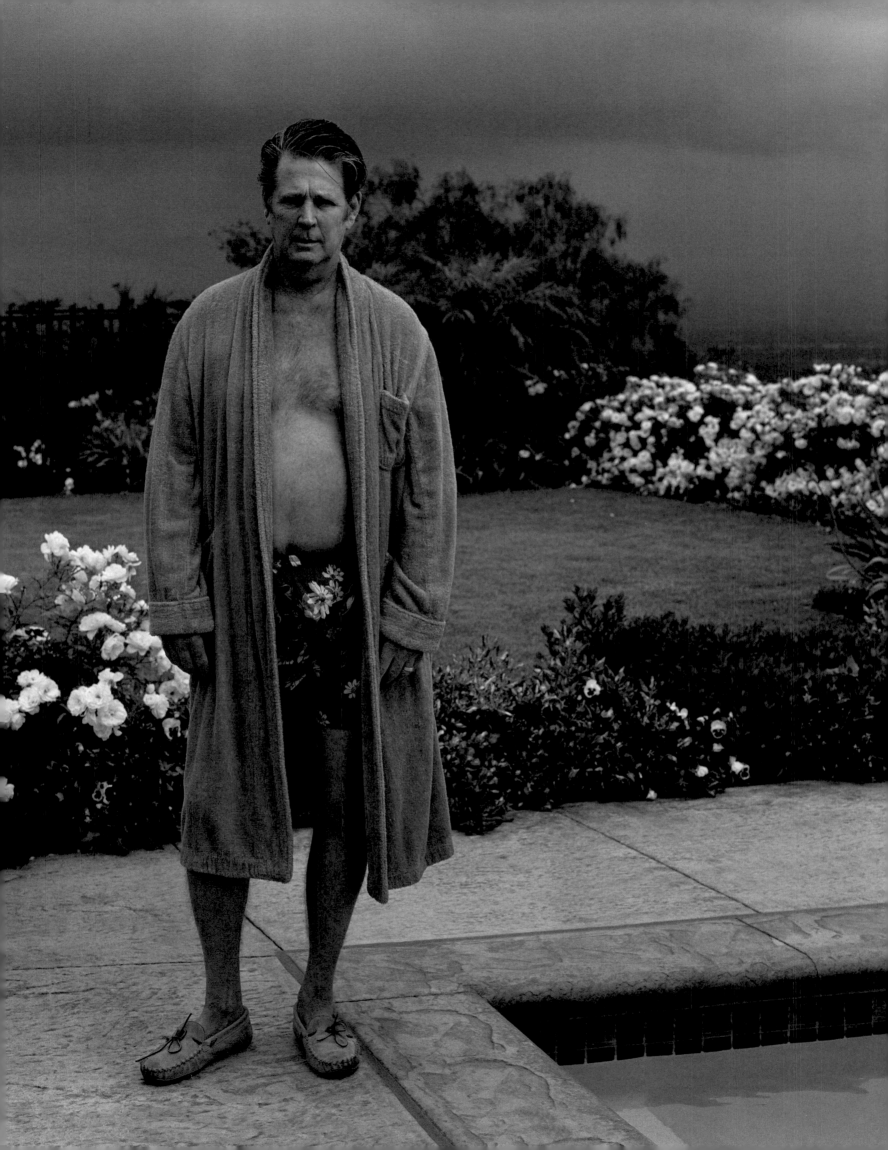

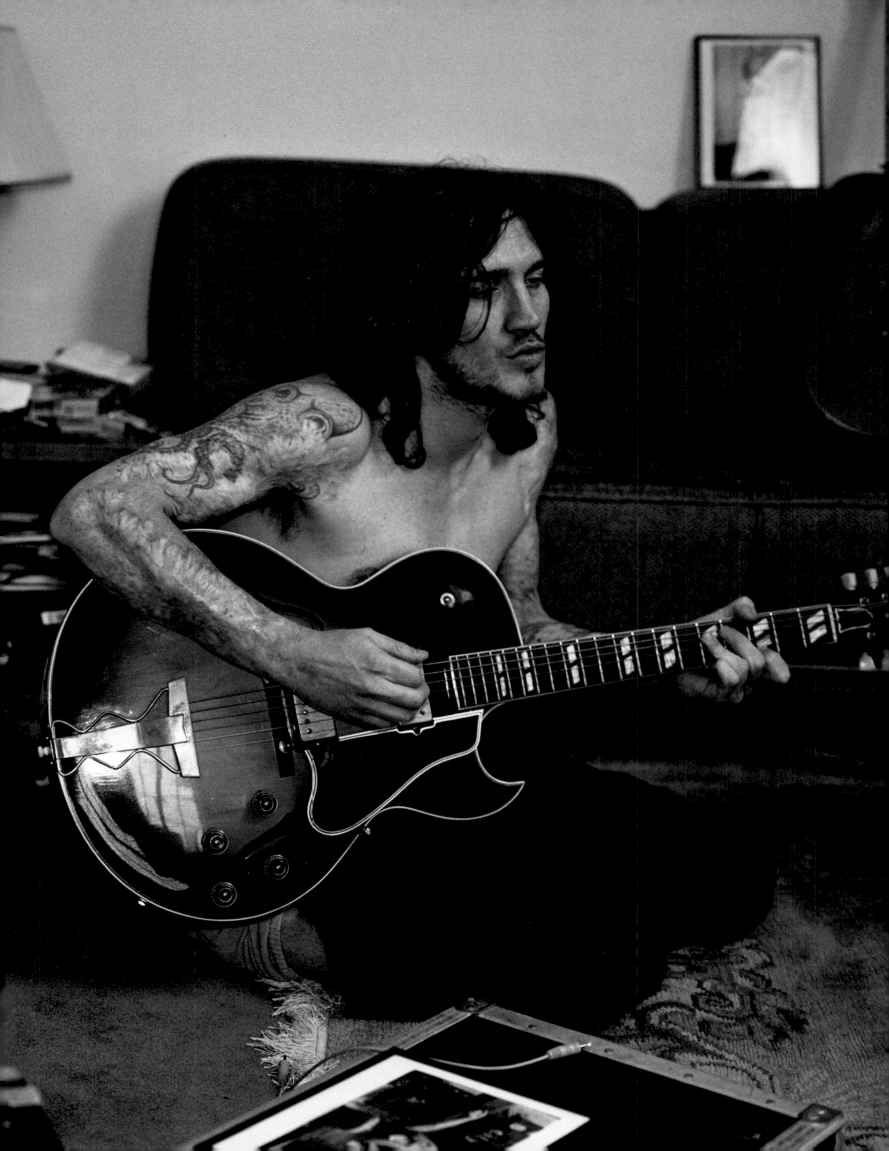

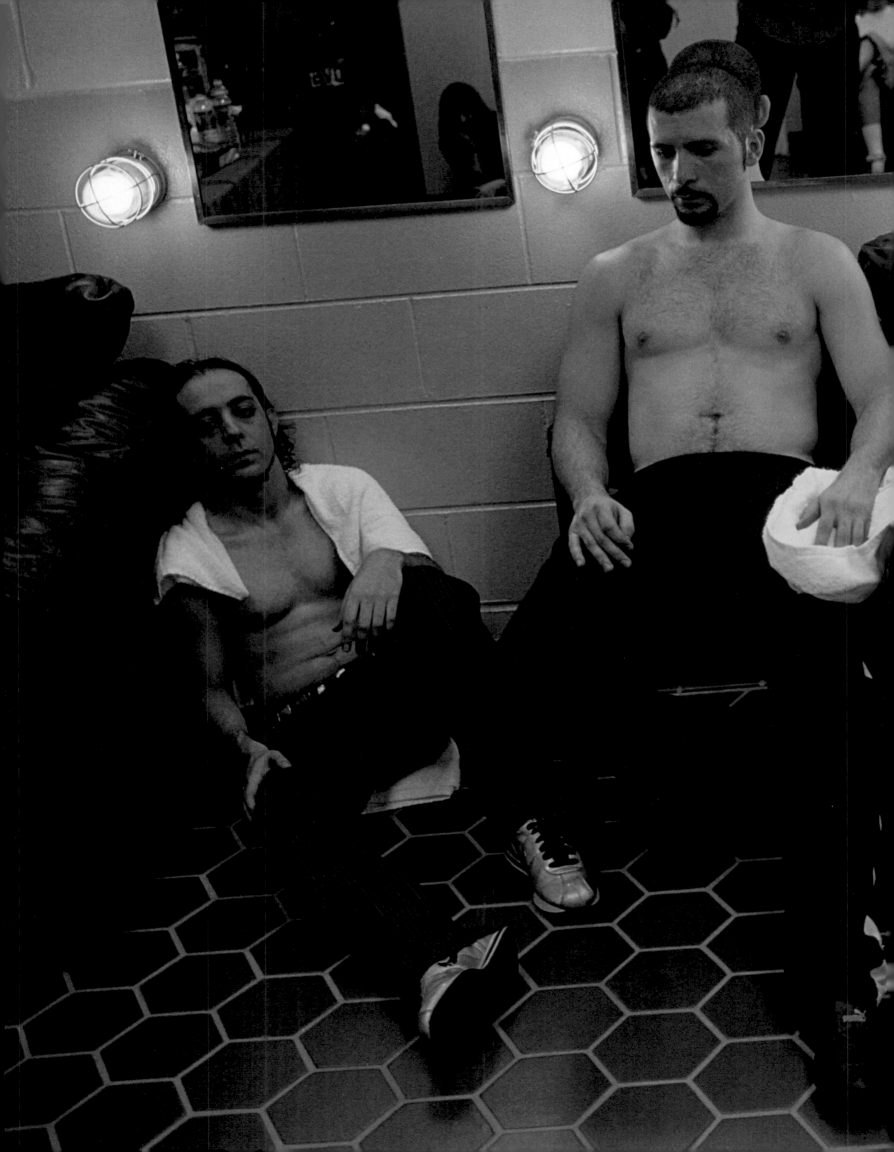

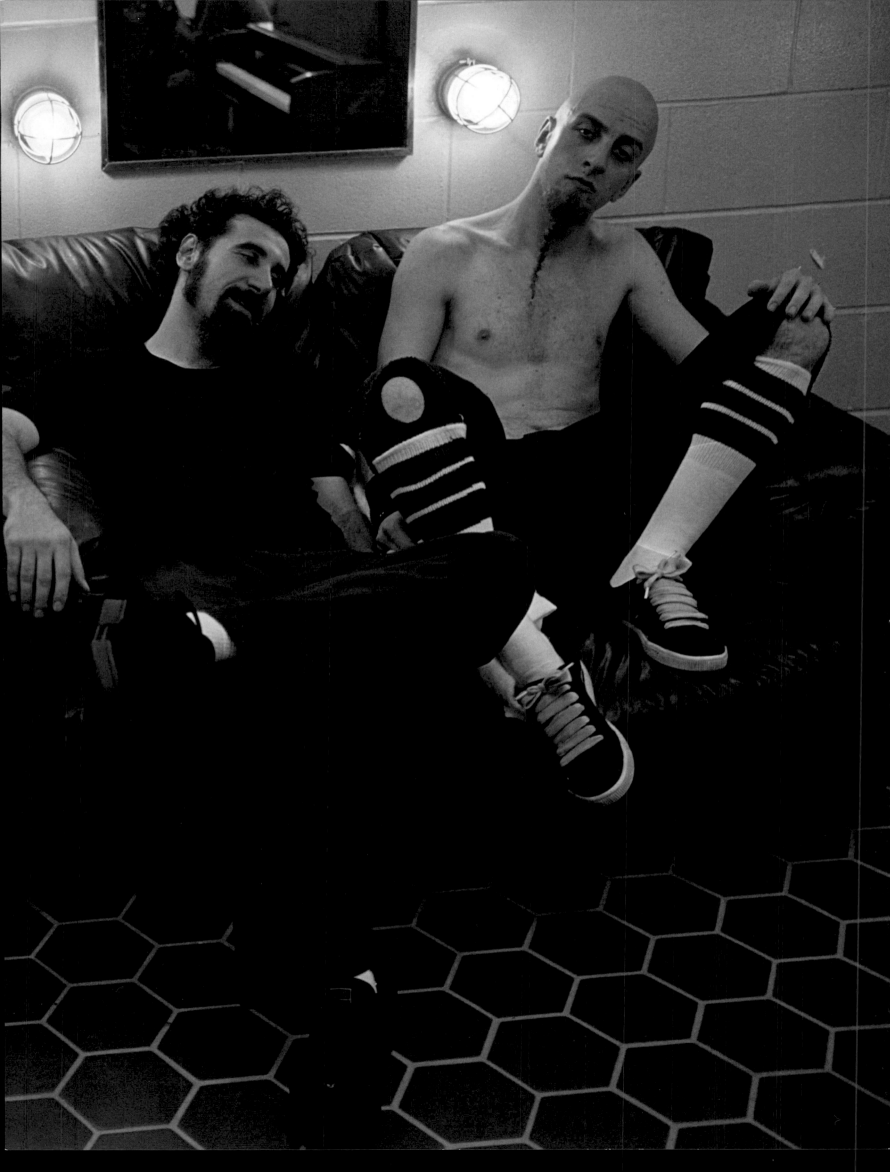

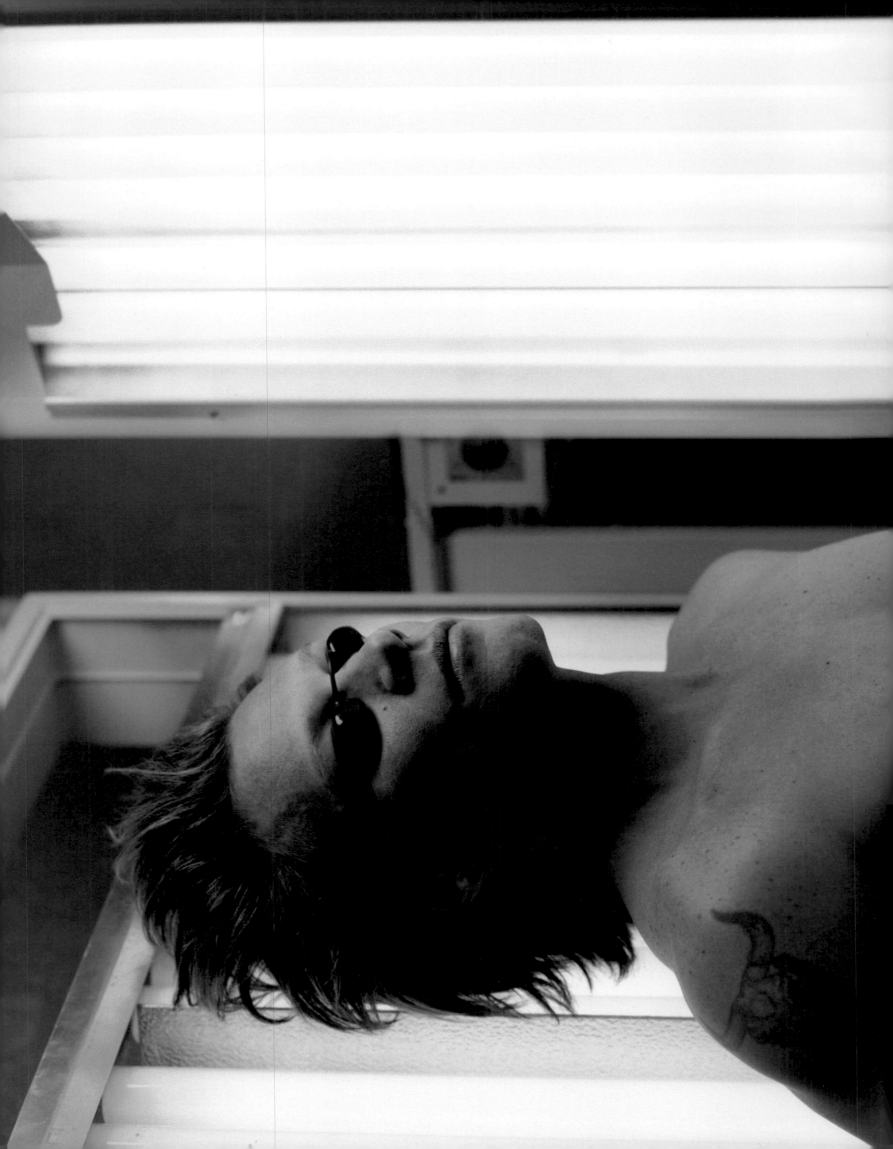

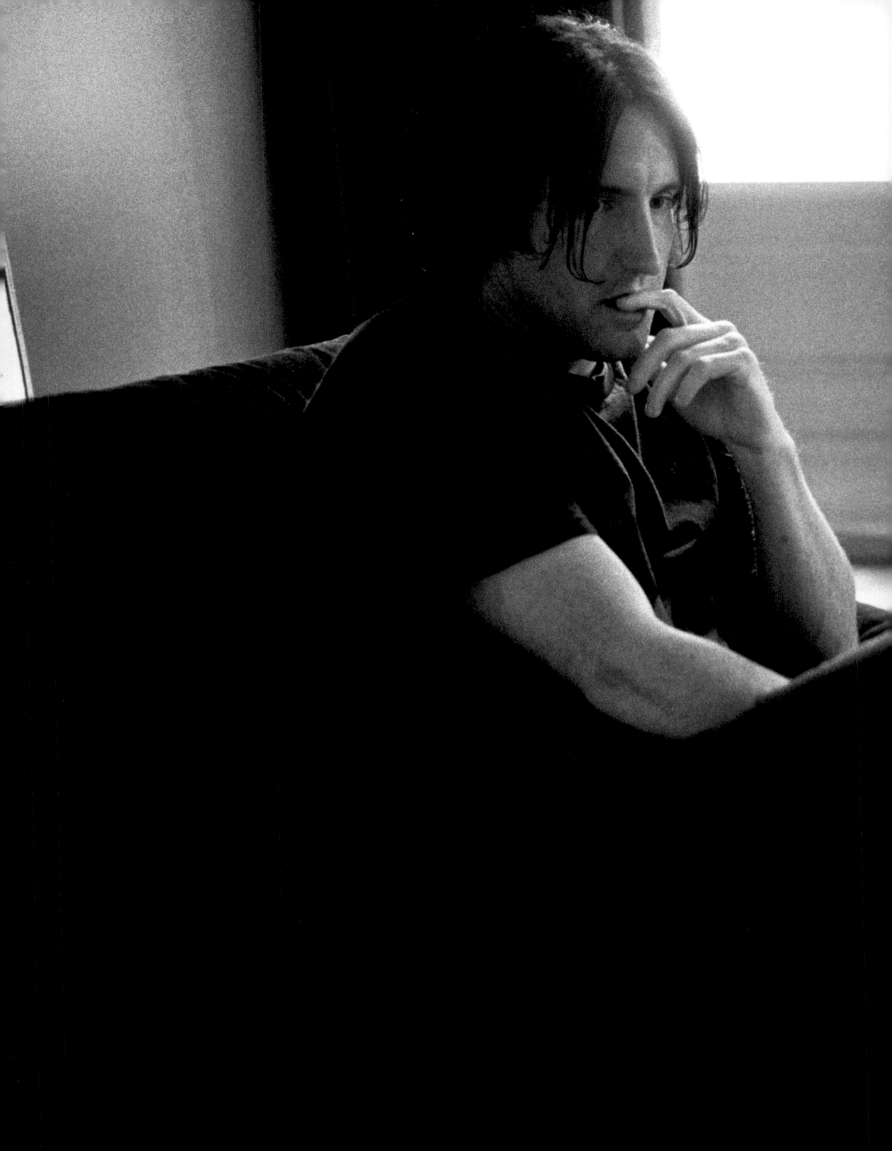

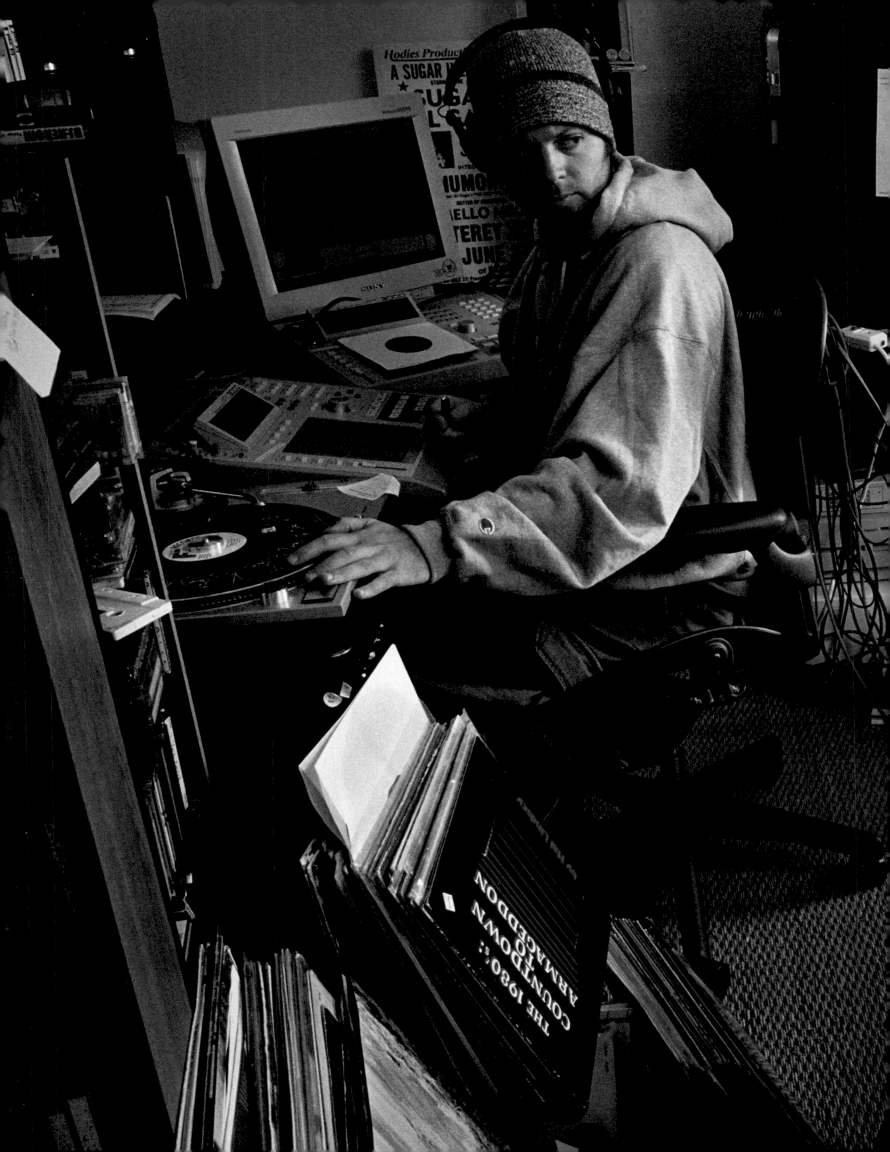

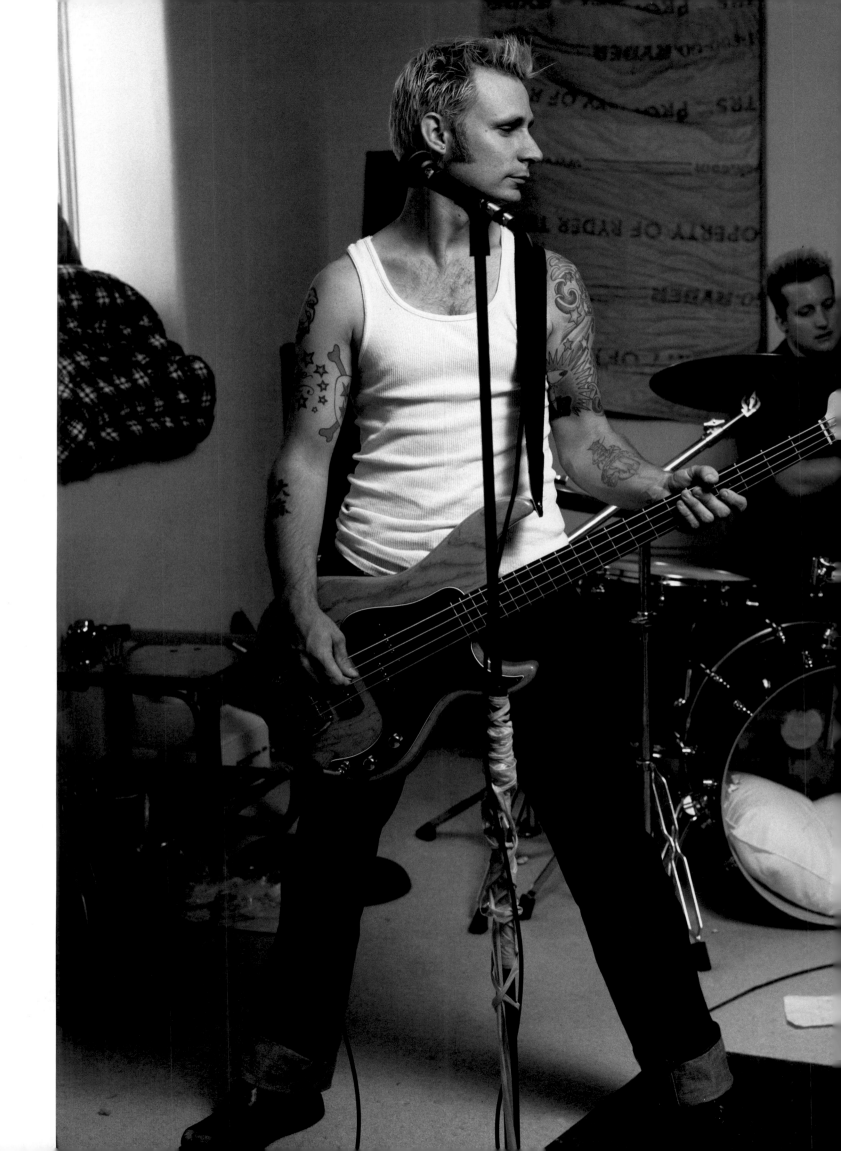

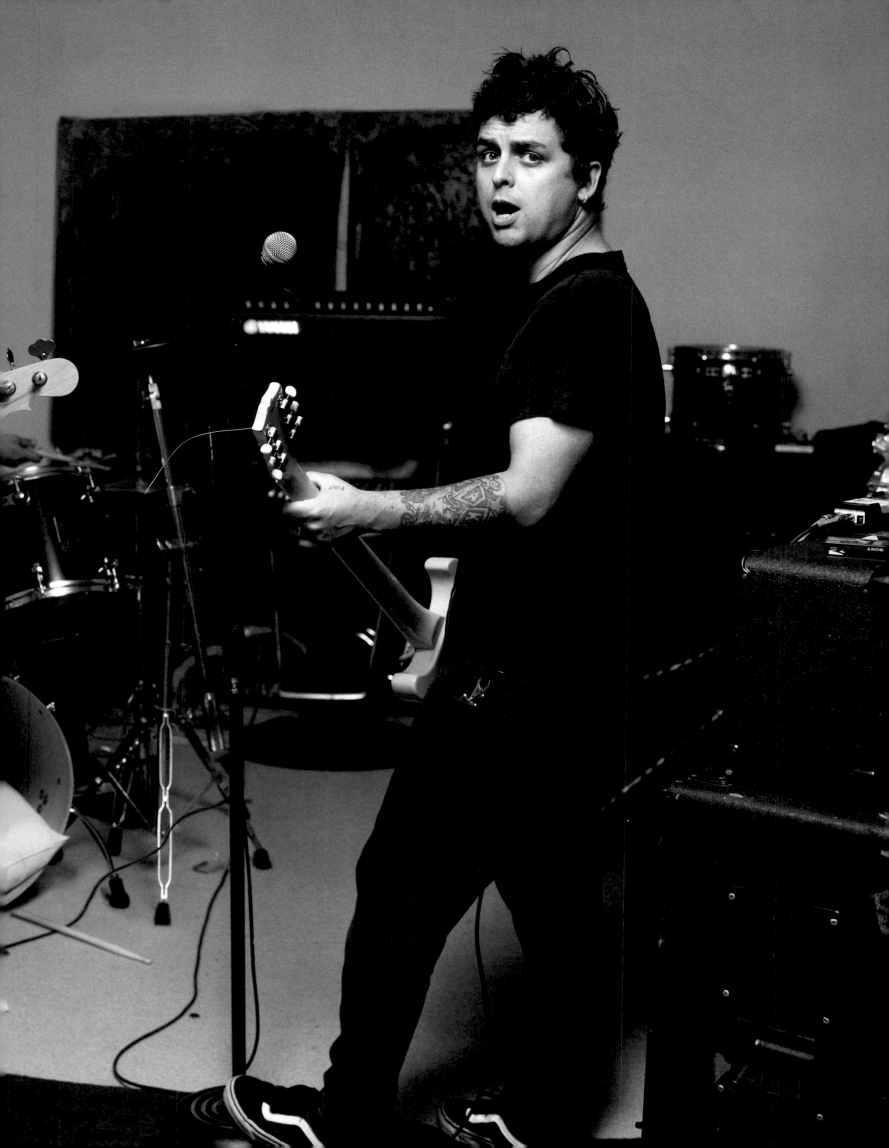

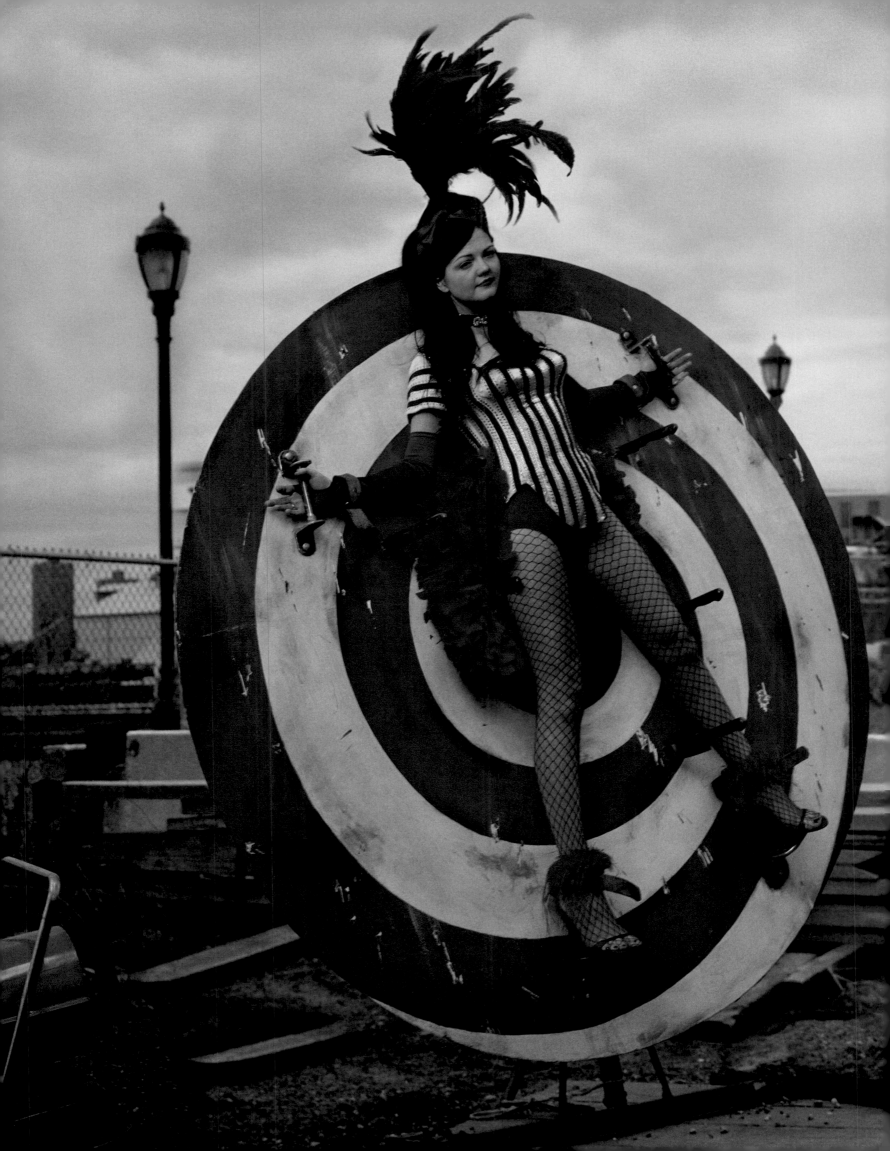

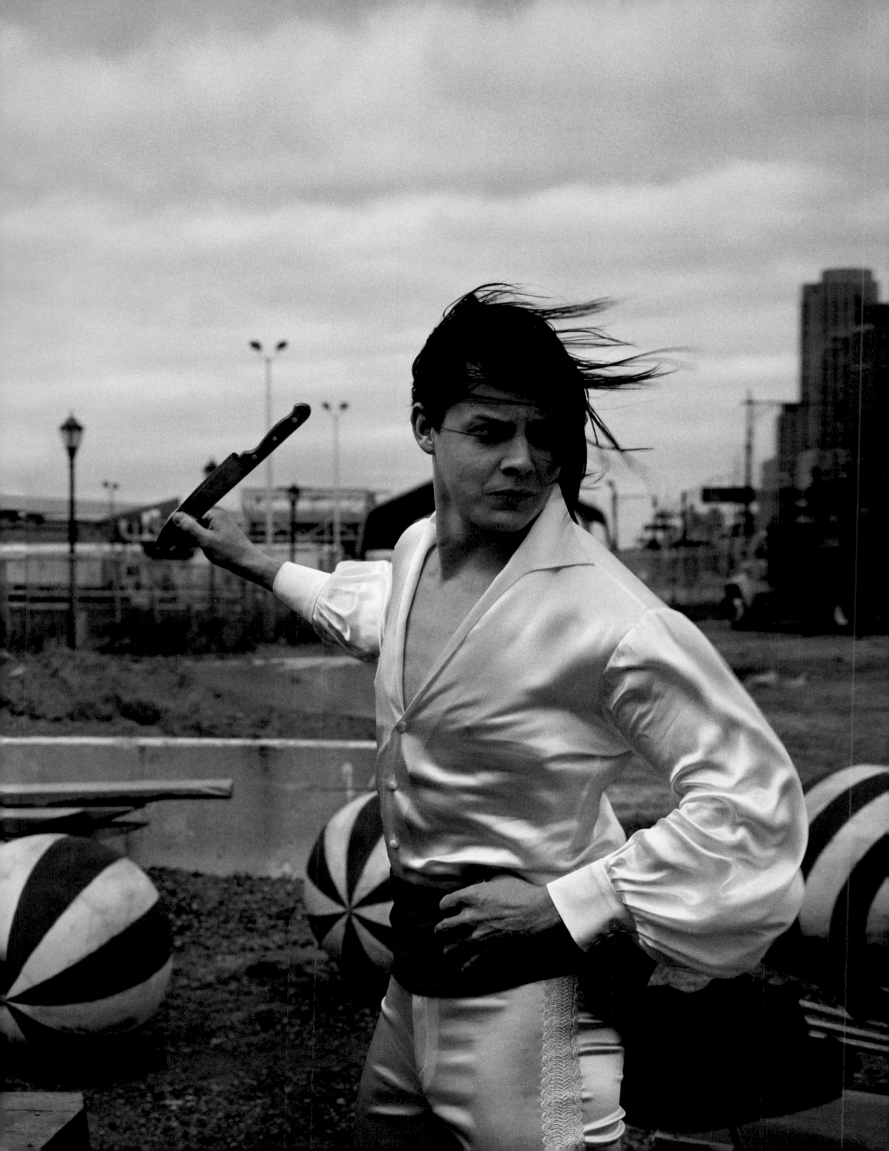

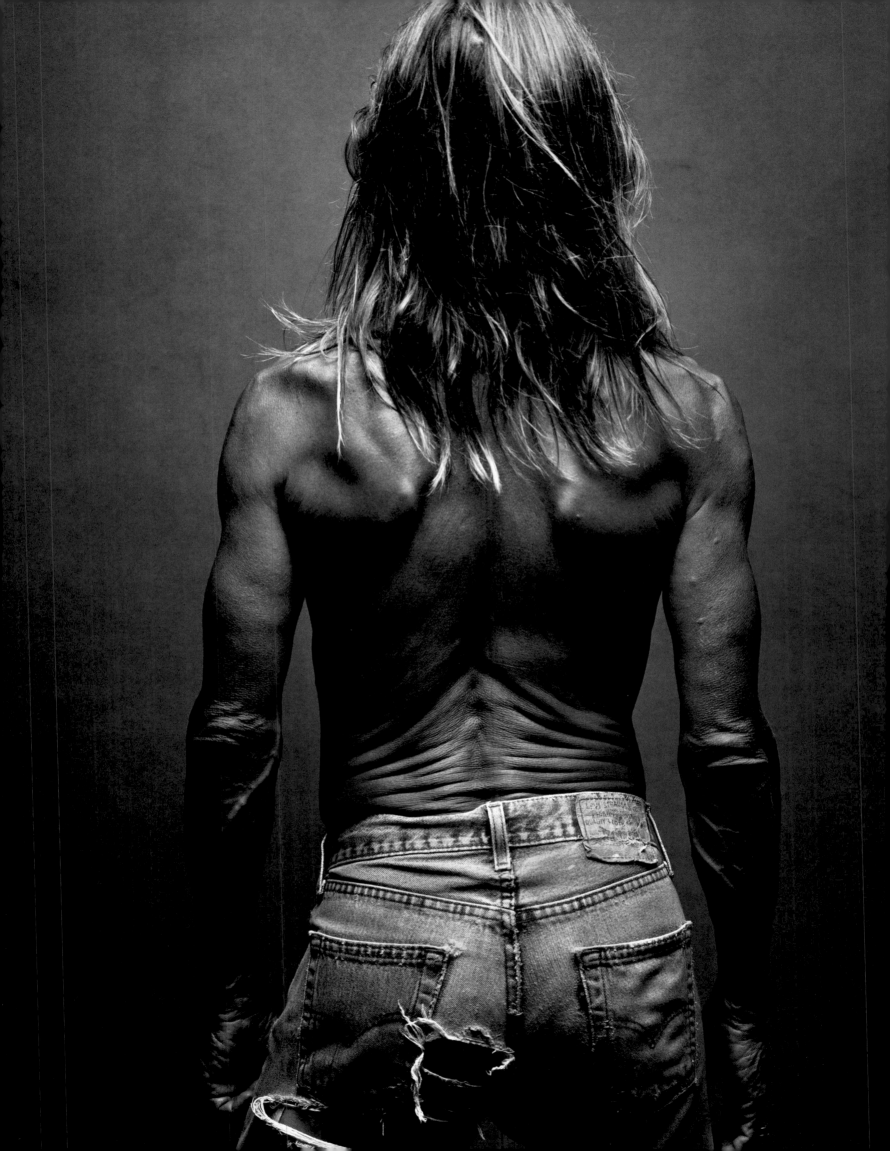

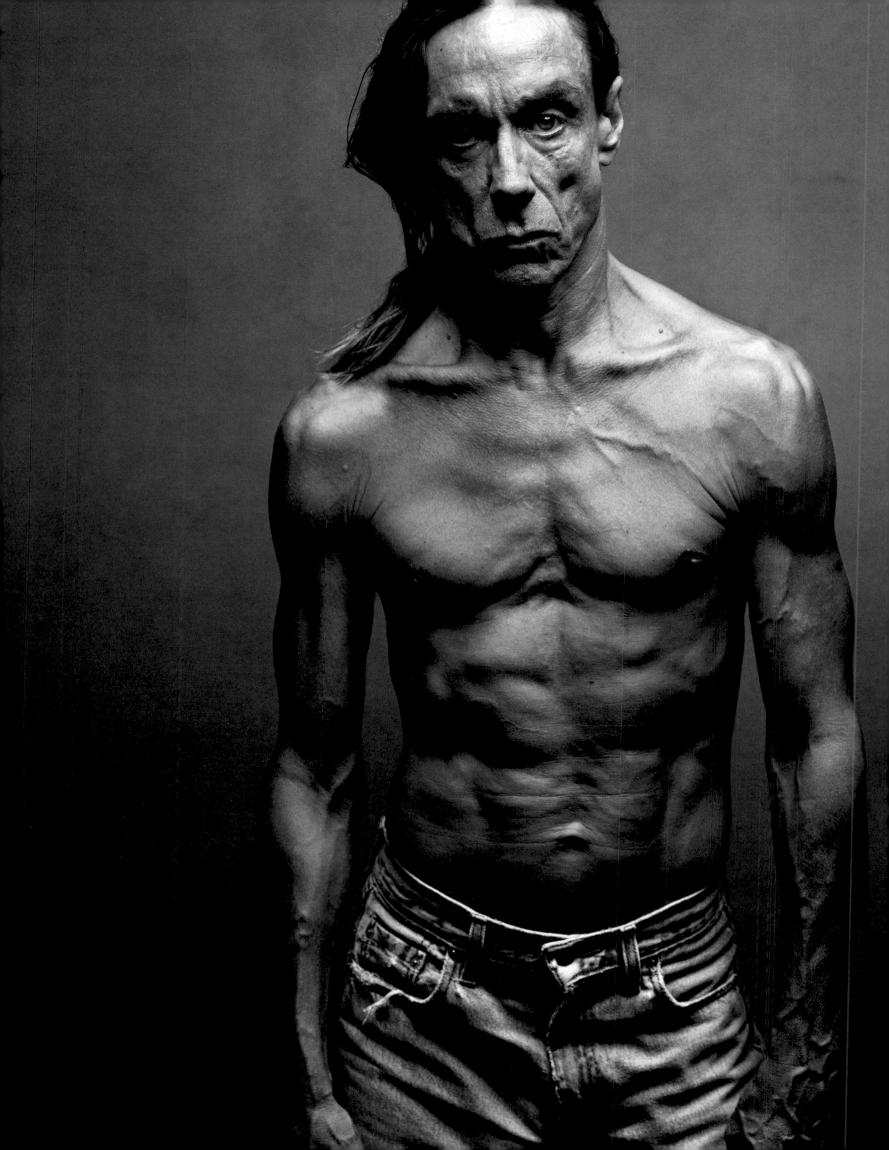

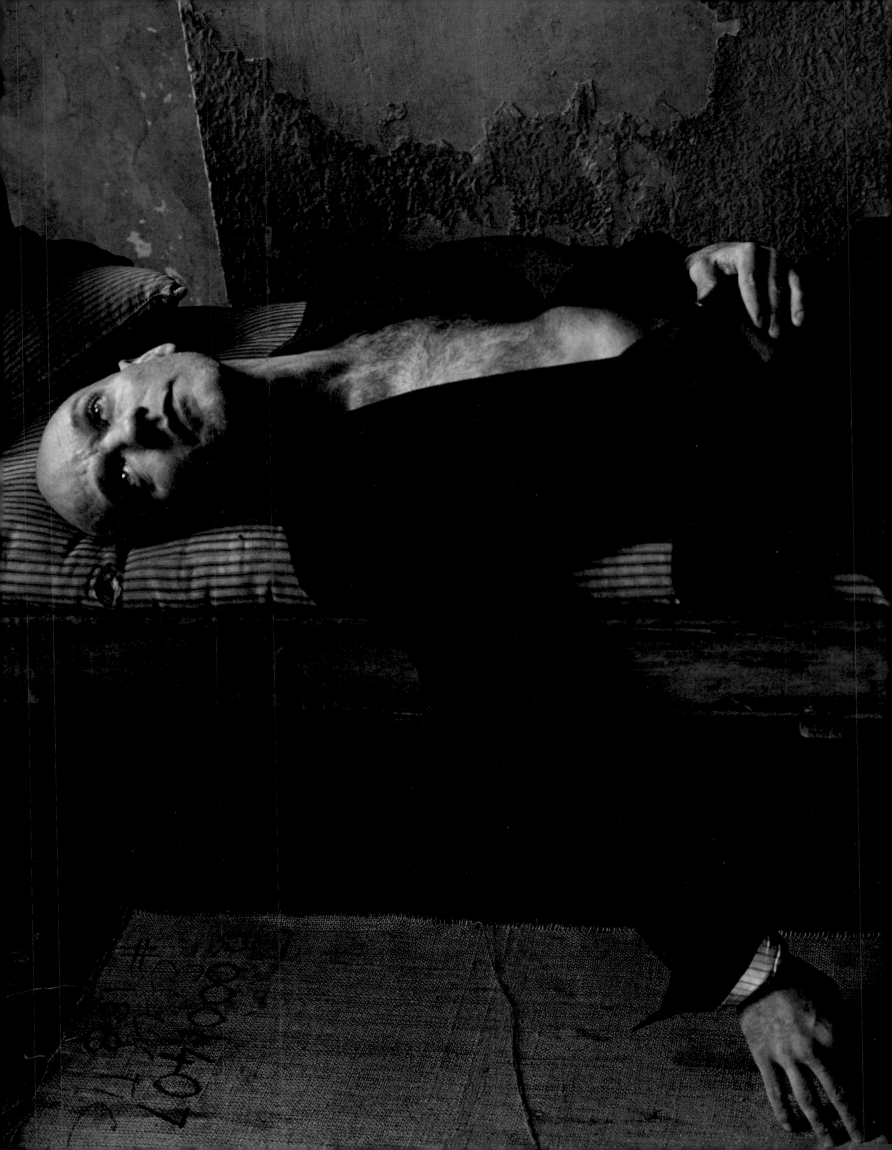

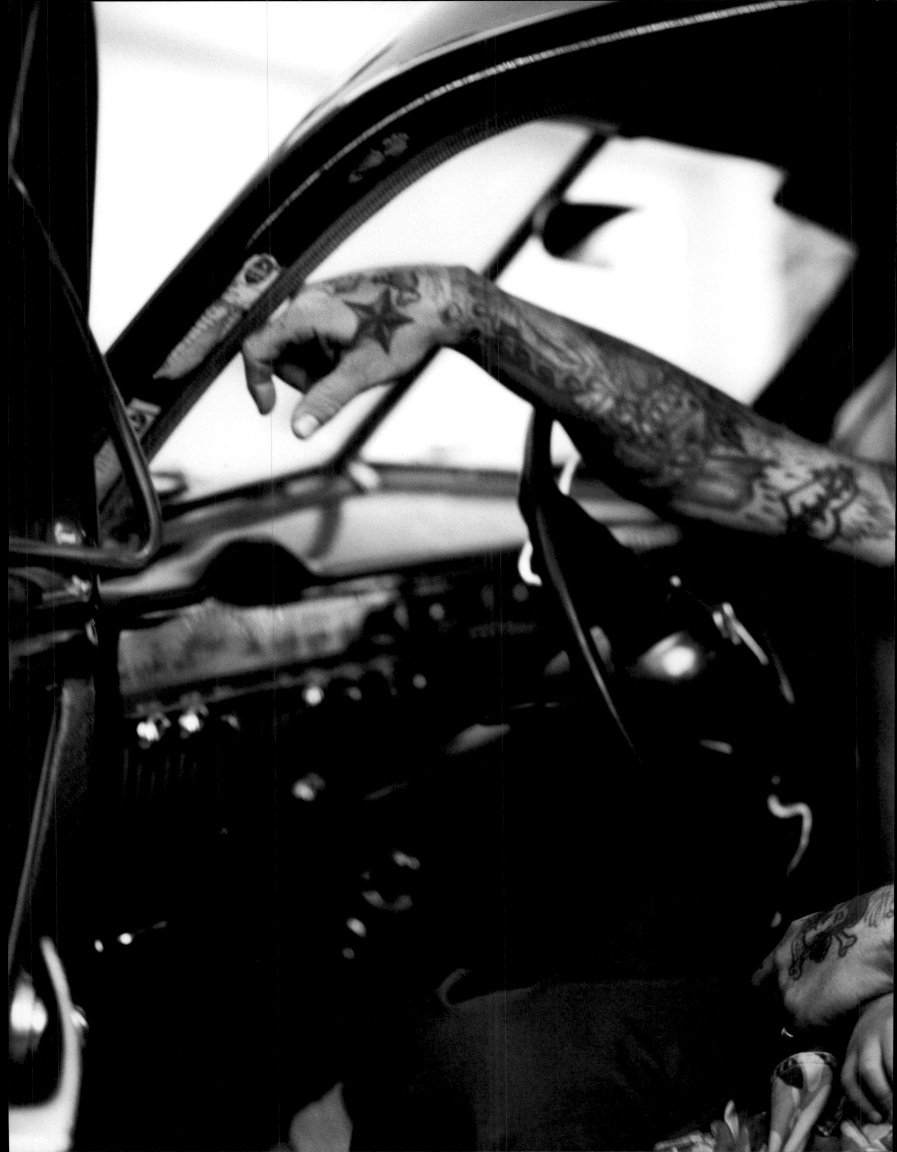

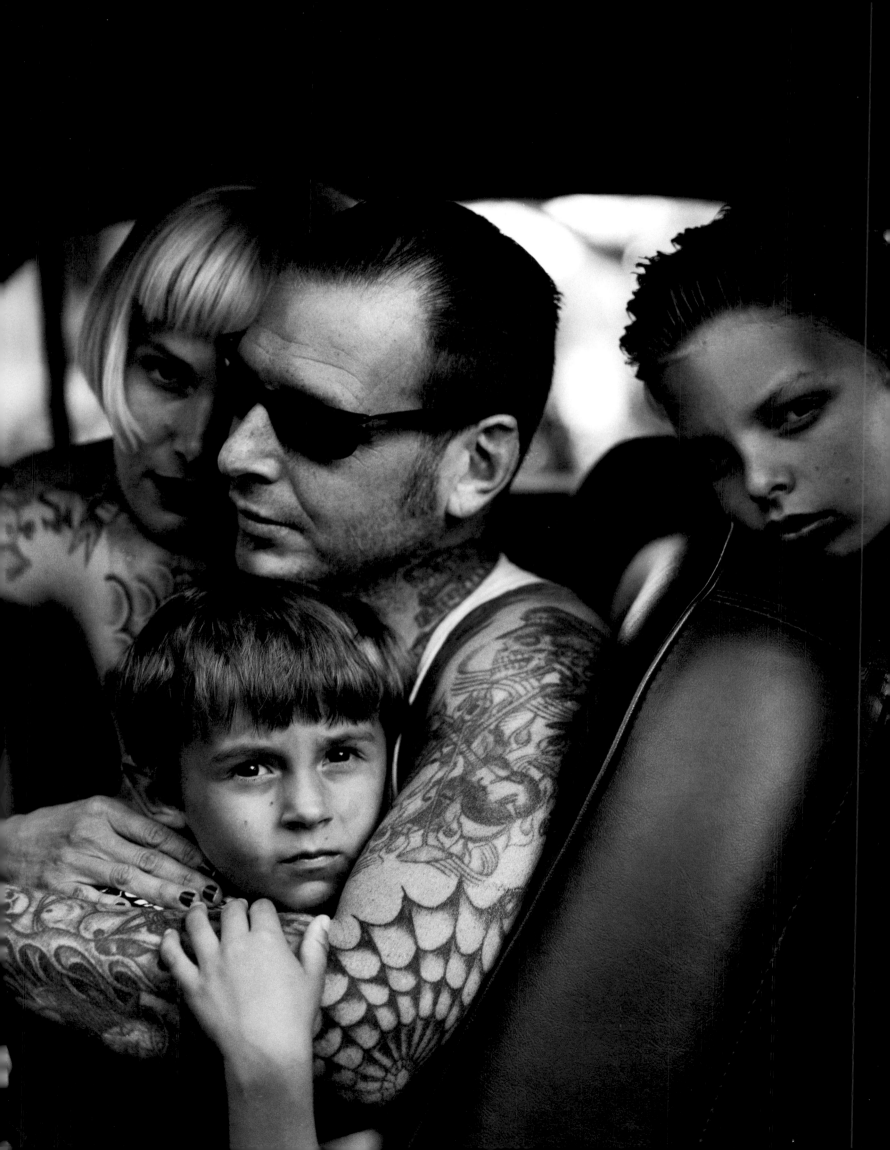

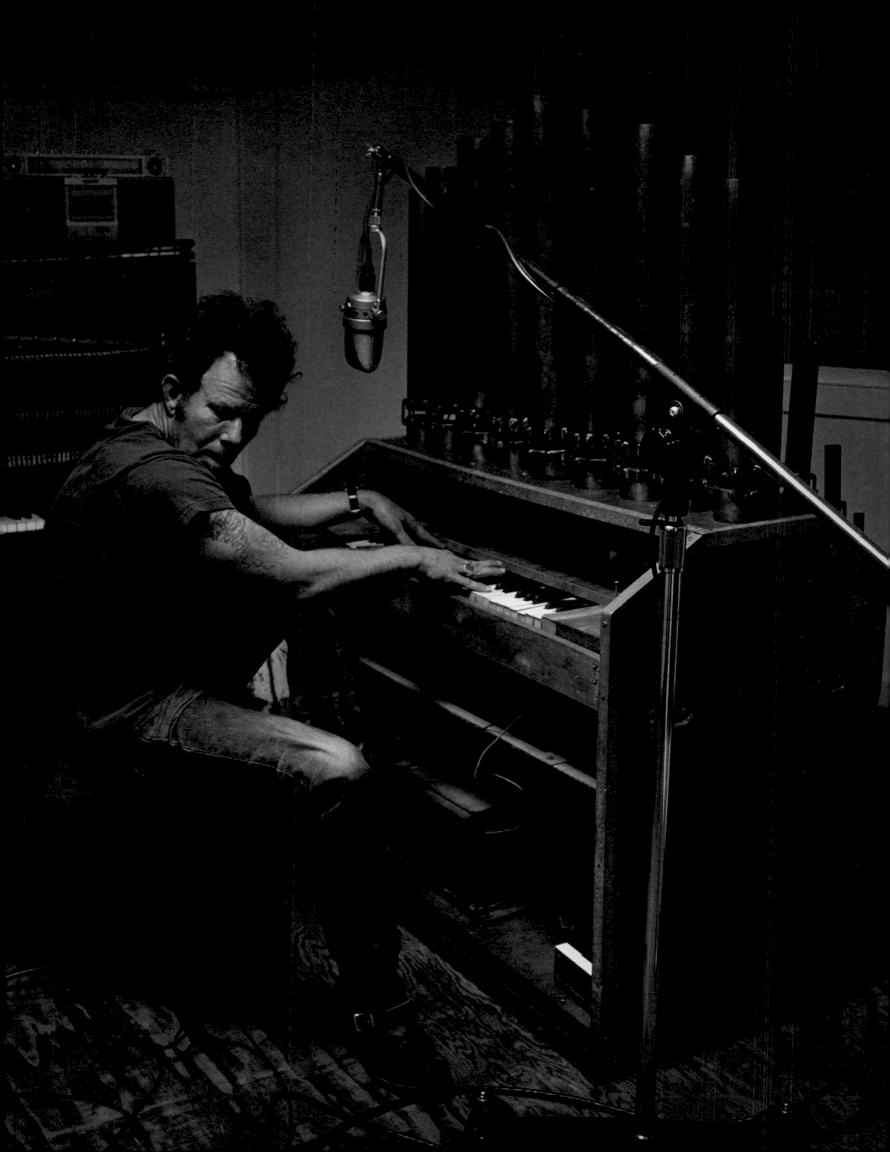

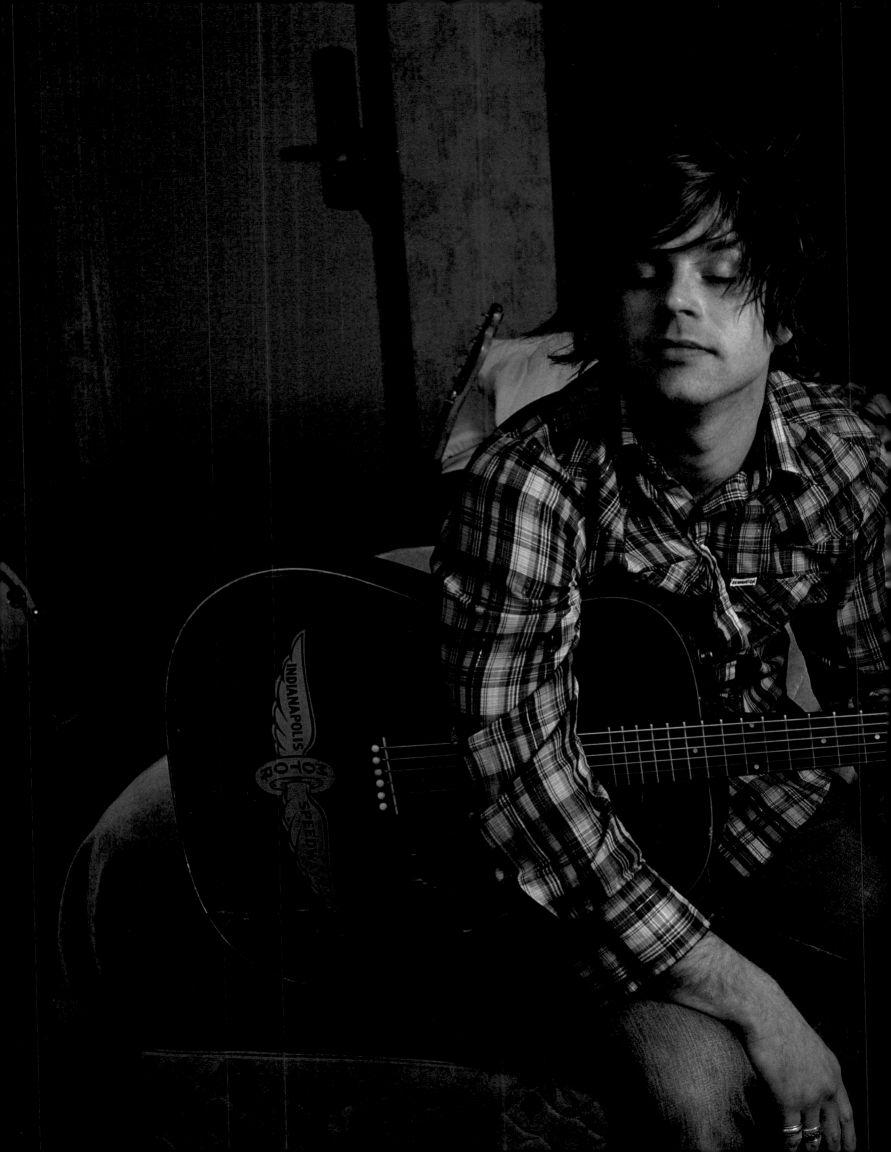

I used to live in hotels. Because I thought it was romantic. Or something. I have an idea of how that sounds, so spare me. I can go on here and reveal that I mean I lived "in" them, as in weeks, sometimes months, eventually for over a year, but—trust me—I know how that sounds, so, again, spare me. I tell myself, and other people, now that I thought it was romantic, but I am beginning to see the lies. They unfold over time like wet newspaper and there's always a little lie left on the page. Lie residue. Like when you lean against a coin or a metal grill long enough. You can see some of the letters or numbers or the indentation, but then that fades out and you're just left with skin. Skin and wet news. Wet cartoons. Unusable crosswords. I didn't live in hotels because I thought it was romantic. That was the fall guy. It was all I knew. Somehow paying up front kept me from the bigger and truly more horrible lie. A fish refuting the sea. My own seventy-dollar-a-day fish tank. I lived in hotels because I could do nothing and everything at once. Somehow all those days of crawling past the front desk into the laundry-room heat, or the snowfields of cars, those singular days, they became uncountable. I was afraid of life running out on me. So I started counting. I started counting and I lost myself some-where and it all meant nothing. The hotel is the easiest time a dreamer like me ever does. That is, until now. Until I write about these things now. And spare me. I know how this sounds.

I save movie ticket stubs. I have hundreds. I have divided them up into several different wallets over time, and I find them in jackets that I might not have worn for a few years. I don't do this because I'm sentimental. When I find one in a jacket and I'm out I usually am finding something for someone and I pull one out. I can retell the exact time of night, where I was, who I was with, what they were wearing and, from time to time, where we sat. I always say it's because I'm sentimental. But that is also a lie. I am not sentimental at all. I save them because I would have no memory without them. What is the story with the gingerbread house and the pieces of bread left to find your way back? Movie stubs are my way back. My way back to

countless bad movies I have digested over the years at the suggestion of a friend or lover. I have never taken anyone to the movies on my own account. I hate the movies. I have never seen one alone. Actually, I went to see one movie alone when I was twenty purely because I had the worst crush on the girl who worked the counter at this hell-hole movie theater and I had a girlfriend so I went alone. I didn't save that ticket stub. This must be the exception. It was a Spanish film and I fell madly in love with the caretaker of the house—a minor role actually—and I believe I made my way home without as much as a second glance at the girl I had come to see. I saw her eyes drifting past me night after night as my lover would roll over to the cool side of the bed and reach for the light. Lying with shoulders back and arms outstretched, the tape leader clicking away on the metal spool.

I would eventually see this same film from the projector room, drowning in a pool of hair and lipstick, peering through the tiny projector-room light box at my Spanish lover. Unknowing idiot college students majoring in farming and English screaming "Focus" in their tired Southern accents. The girl at the theater was not American but not English and she only murmured something inaudible as she came.

Hotels have some secret code, so subtle that it can only be broken if you submit yourself to that kind of routine. In them I have found glamour. I have found power. I have found moxie. The finest being the tall and brutish hotel that sits at the end of Hollywood Boulevard, a stubborn, unchanging coat of windows and soot. A special little hellhole that is unchangeable. Like a cruel fact. As a con man more than an artist, I am obsessed with "fact" because it is unattainable to me, like spirituality for junkies. A pleasant paper trail, a wild-goose chase meant only to throw you off the one that was successfully killing you the last time. I'd much rather chase the carrot an ass full of whiskey and coke than getting all strung out on questions. Questions are far more destructive. There's no room for vanity in questions, and the hours are crap.

There are no rules to living in hotels but one. Do not drink at

the bar. Ever. It implies a relationship. It's kissing-on-the-mouth, hooker-to-john kinda stuff. Plus they always ask questions. Imagine yourself three or four easy half past ten and you reach for a cigarette and out you pull a movie ticket stub. The mystery just wouldn't be the same. It's far easier to tape the Do Not Disturb sign to the doorknob and collect bottles from the liquor store that delivers. If they don't come in, you don't have to explain why the prints of Van Gogh or whoever are riding the spare blankets in the closet. It's just you and the angry word. The truth and the numbers. The counting to one million and the money you're losing you were never gonna use for anything anyway. That kind of money is best squandered because you have to save yourself from trying to save the world. You have to convince yourself there is nothing between you and these songs, or these letters, or the pieces of paper with numbers of people who told you something nice at the shit-hole bar down the street about your shoes that you just wouldn't stop talking to. Accent changing back and forth from fake English to pure wasted drunk fuckface.

You can't save the world but you can save the receipt. Somebody told me that in a taxi cab once and I vaguely remember throwing up out the window someplace in Los Angeles slightly before I checked out for the last time. The car was uttering its disapproval, making its way up Laurel Canyon—or whatever canyon—and it wanted to throw a rod, but over all that screaming laughter from these ridiculous girls in the front it had no choice. The stars that spun above me as I hung my head out the window, drooling mouth, were a warning sign from the past. As if they were saying, we have all died, but if only for you to witness now. How pretty a long and spectacular cosmic death must be. And to go on, and make that kind of noise with light up there in that pool of empty tar, my universe is an asshole, no, an endless sea of assholes at the bar, with movie ticket stubs and a checkout day they will never control.

RYAN ADAMS
New York City

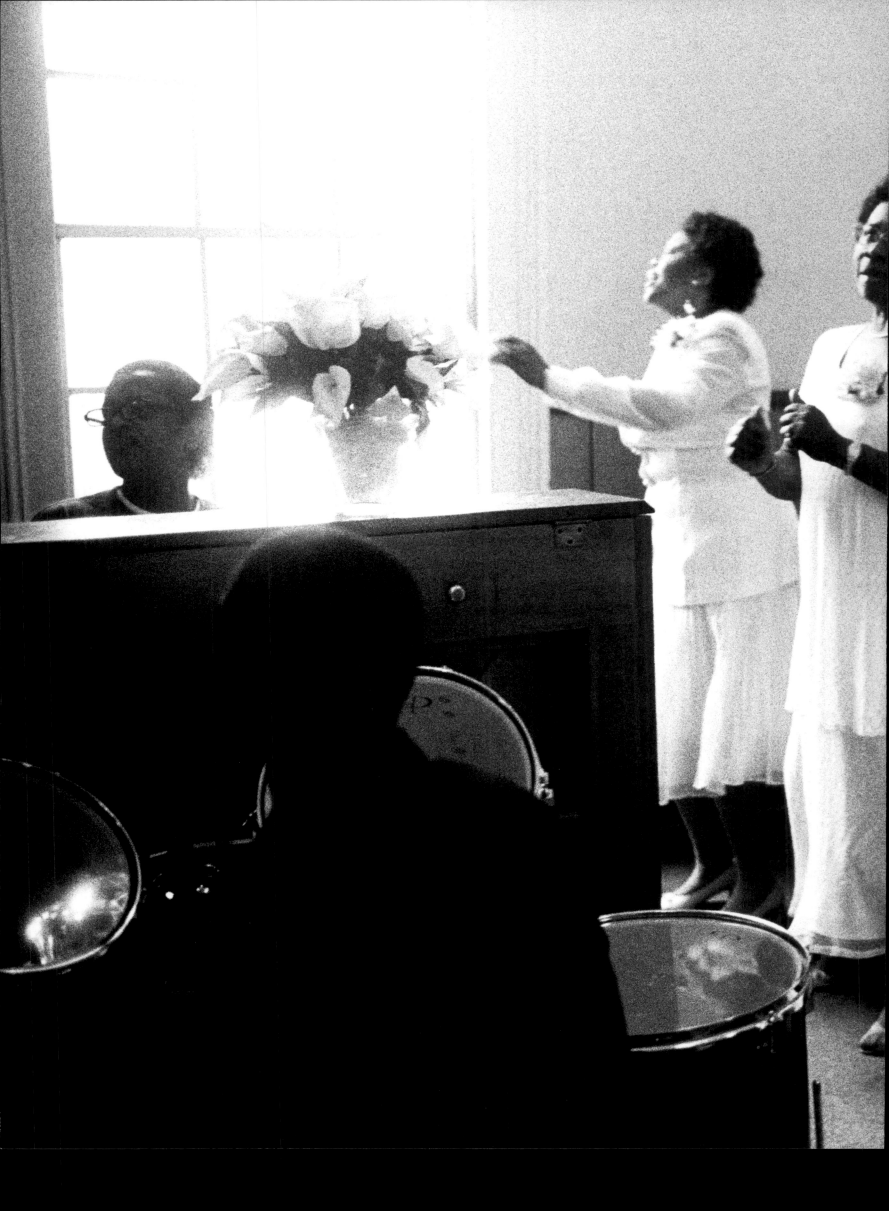

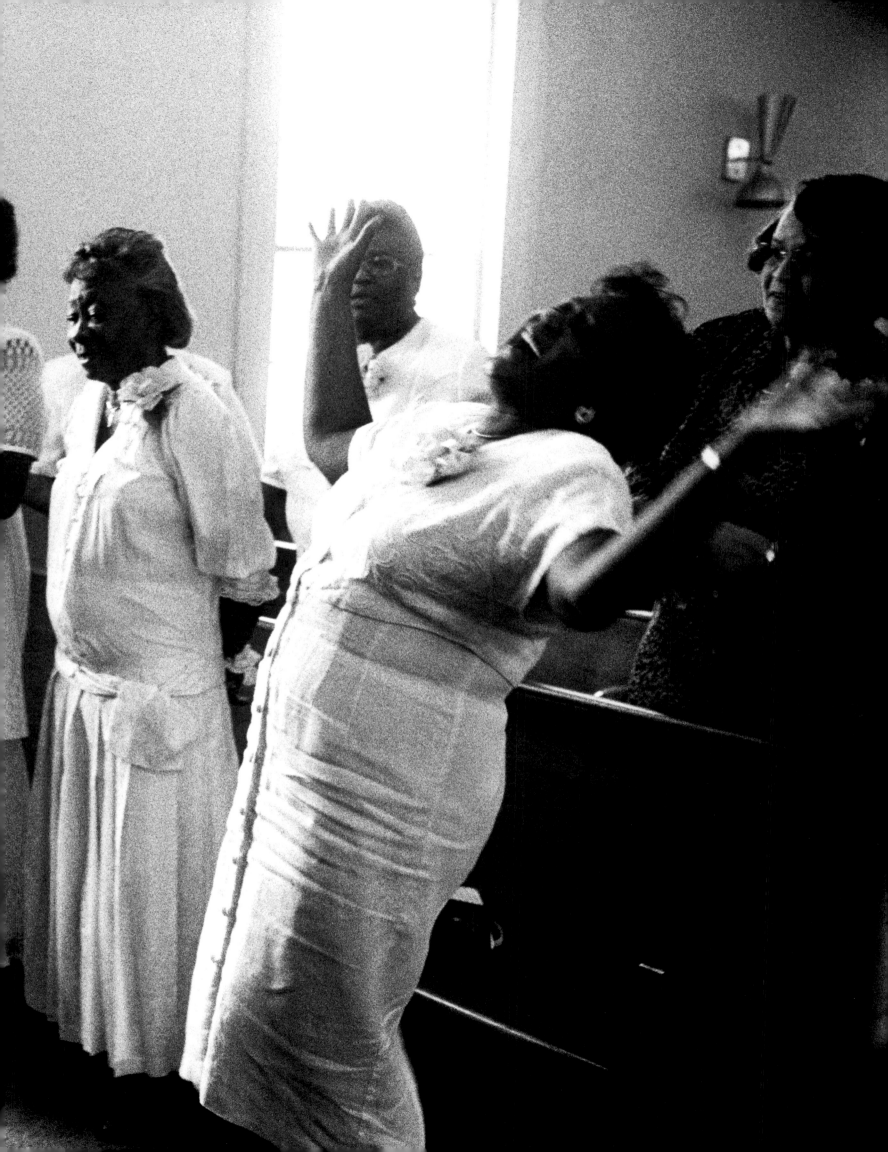

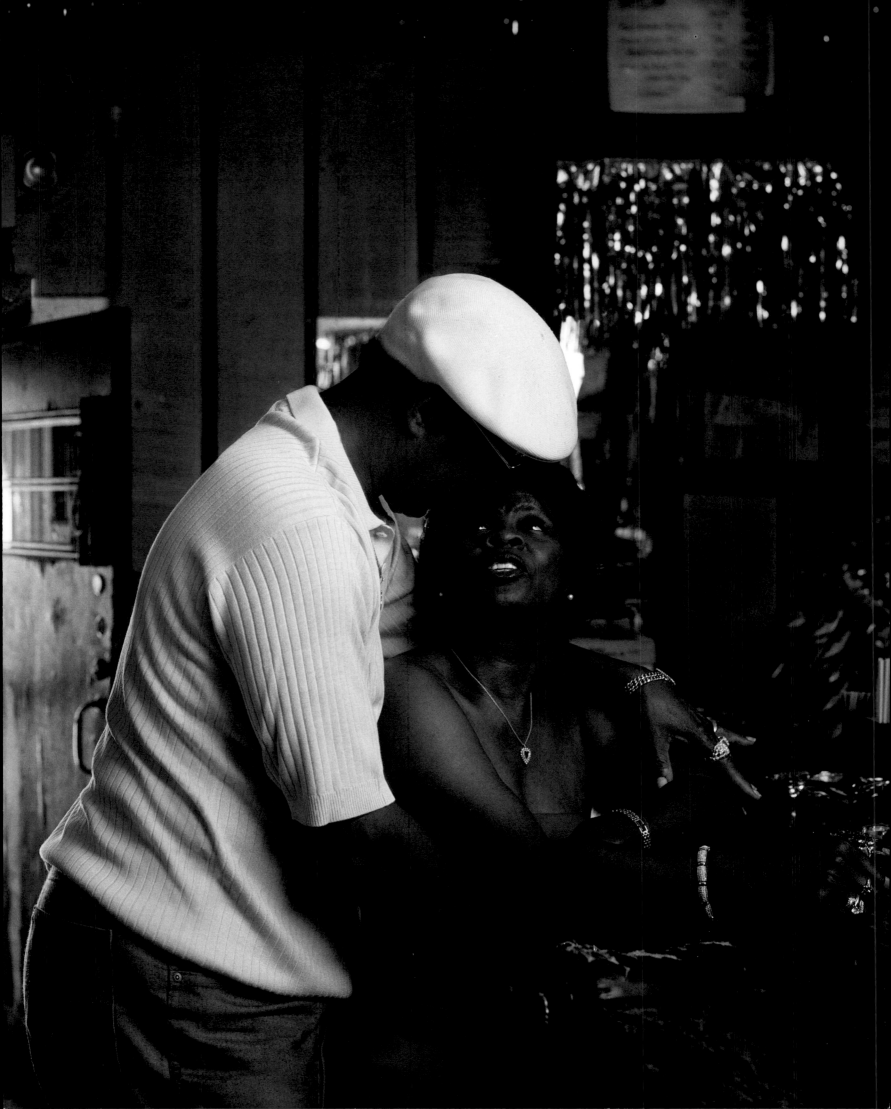

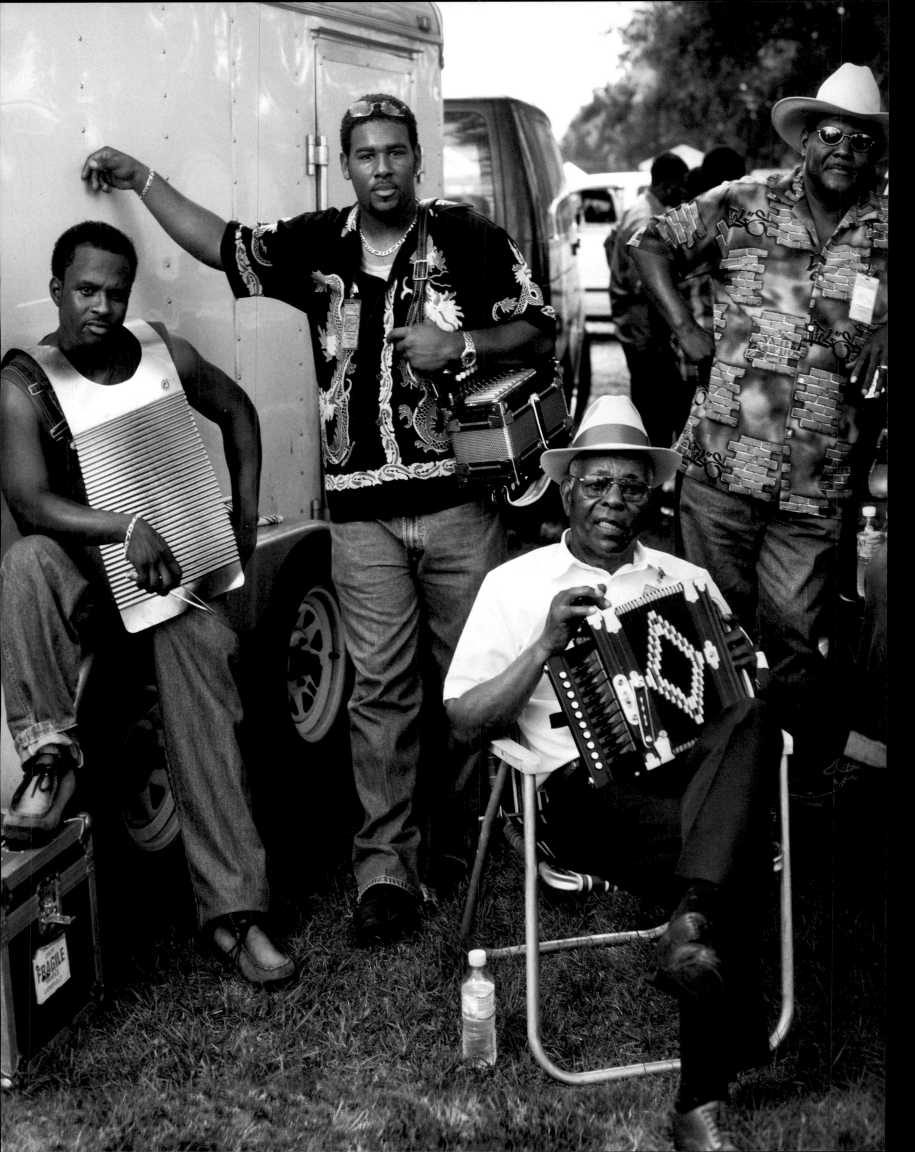

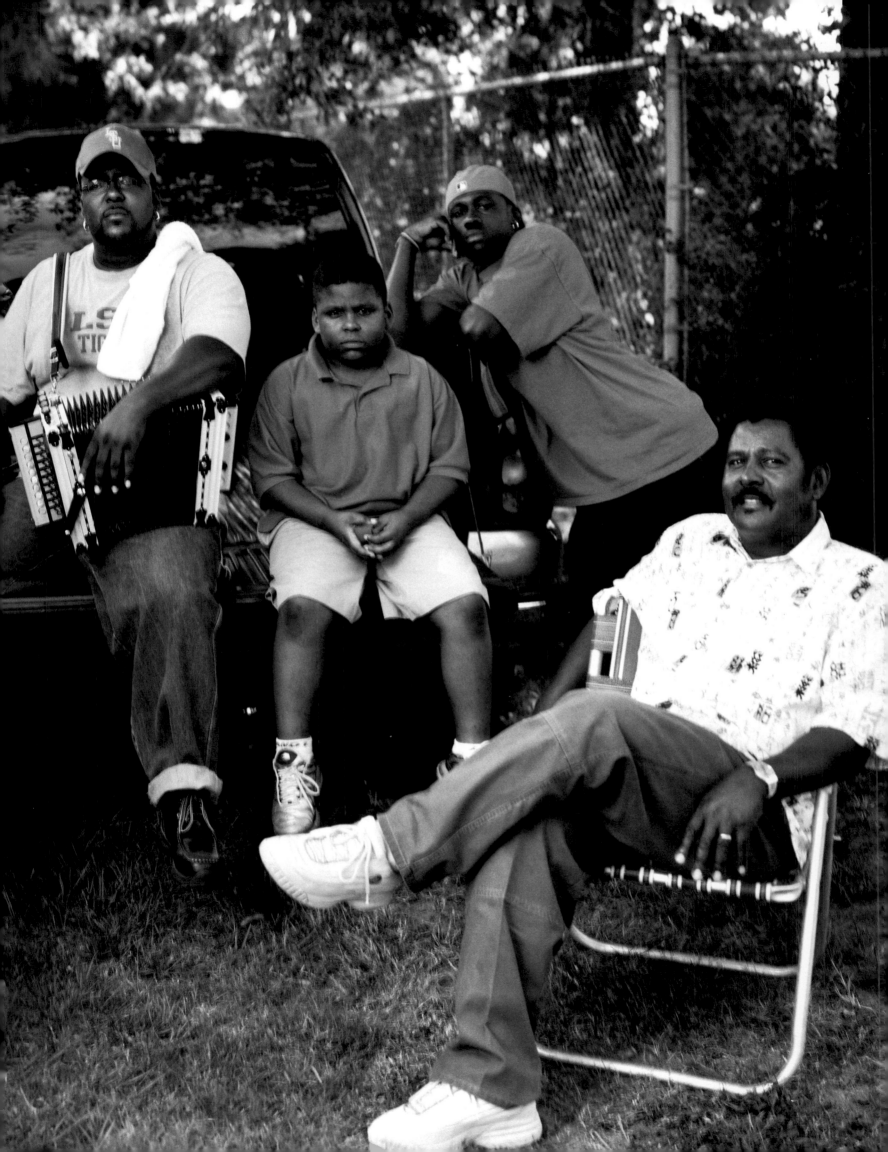

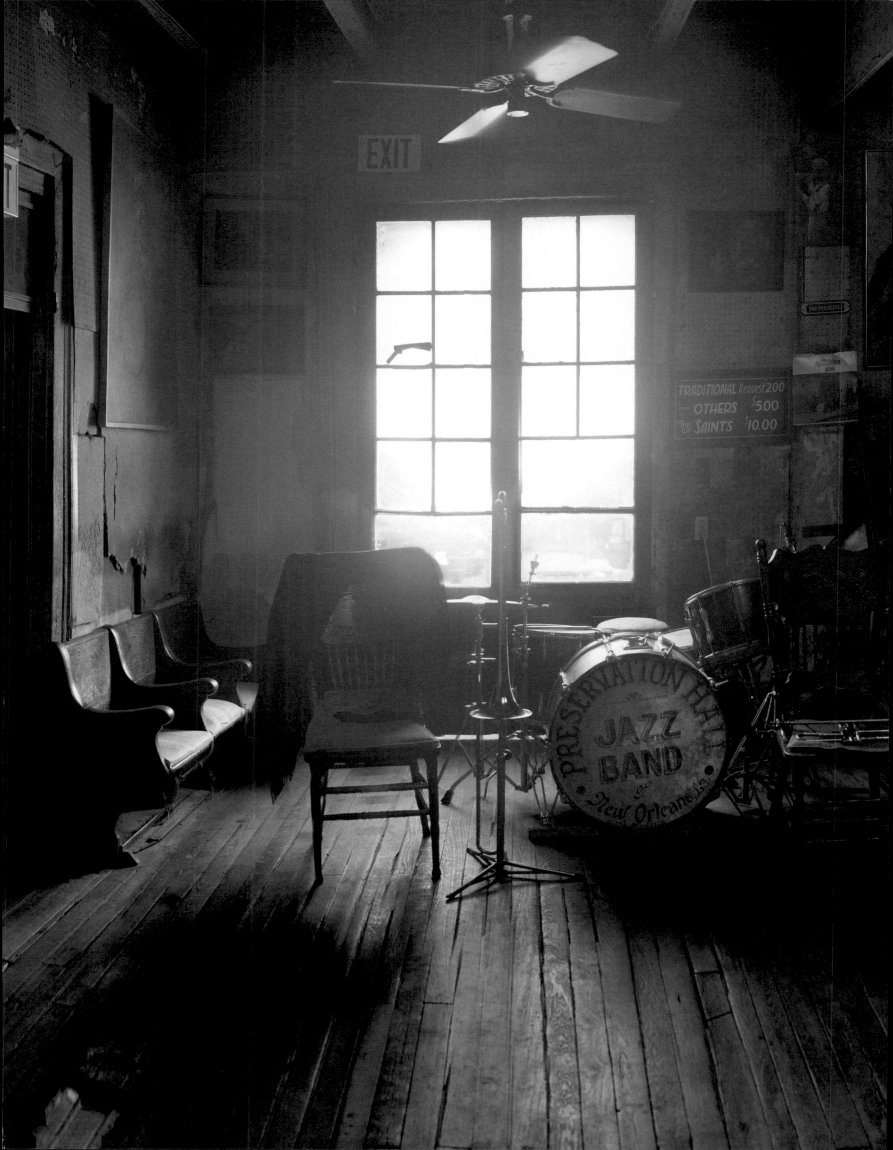

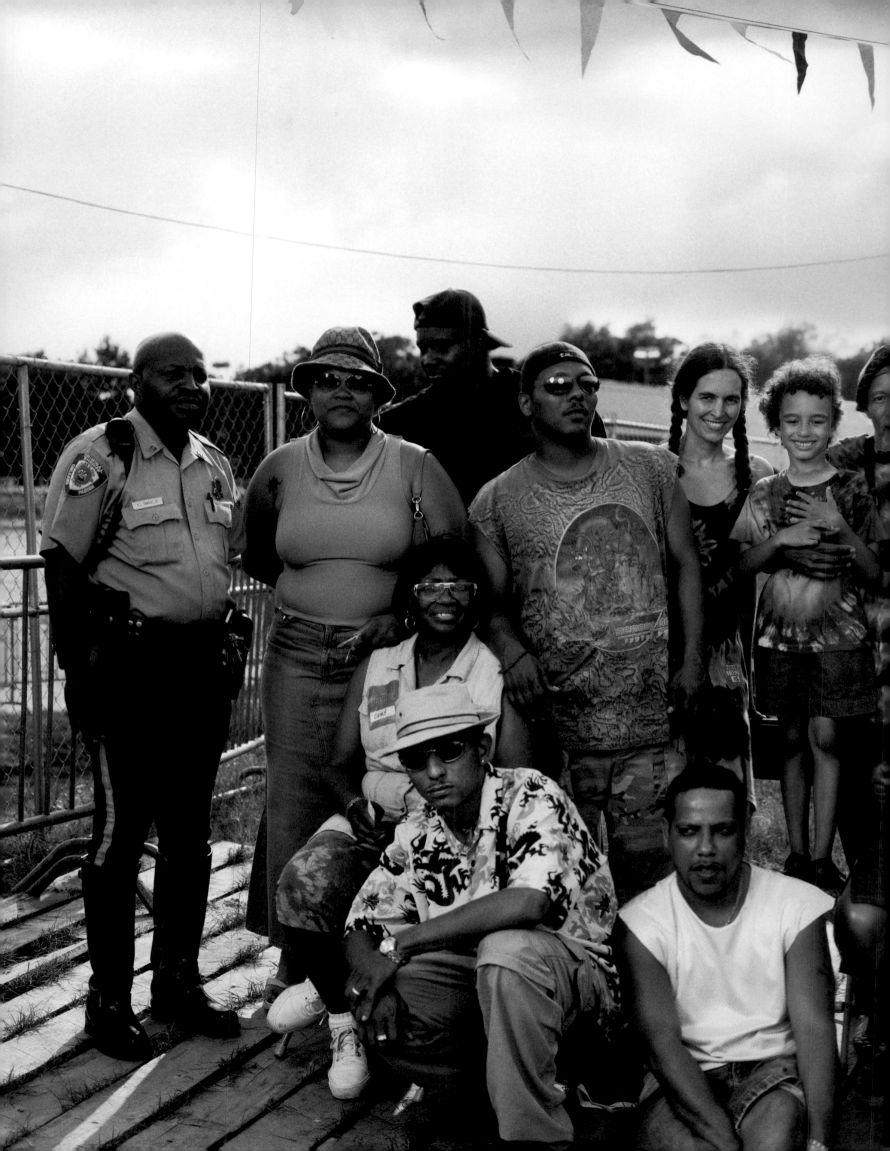

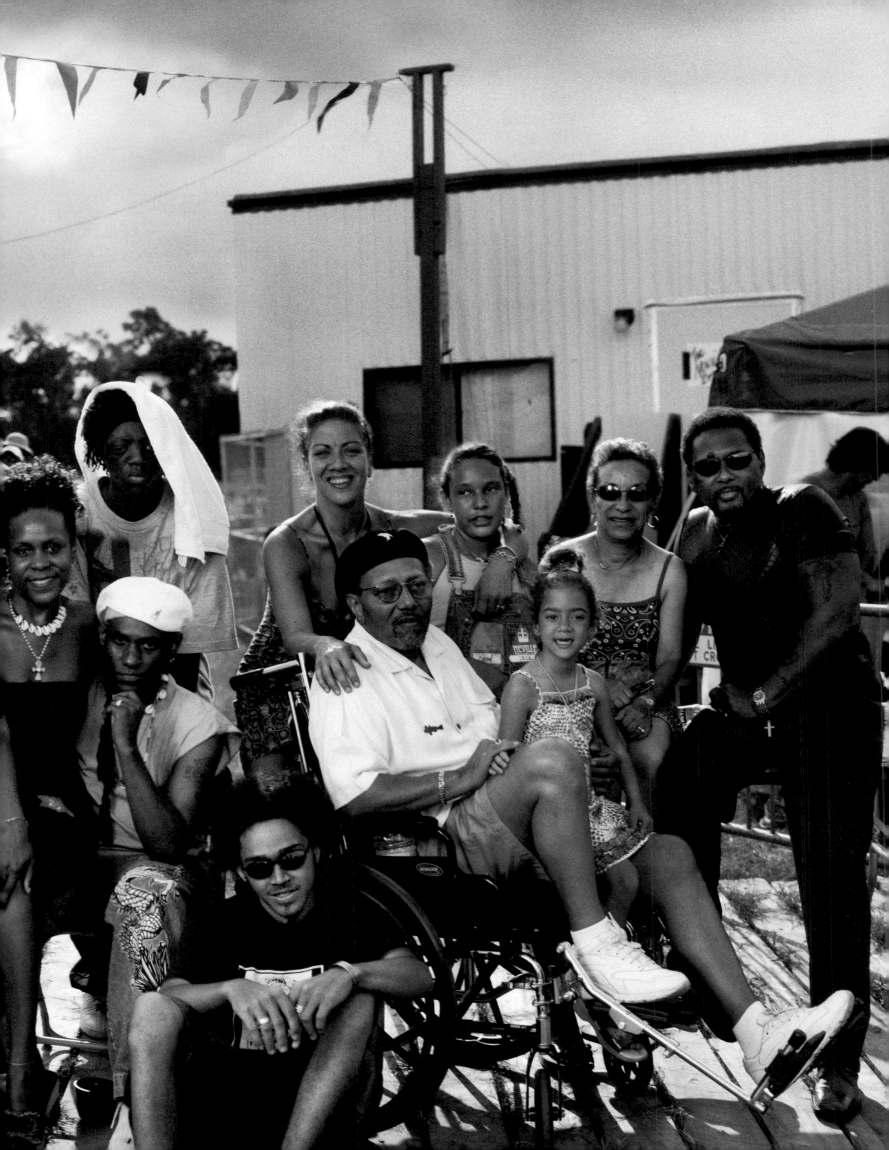

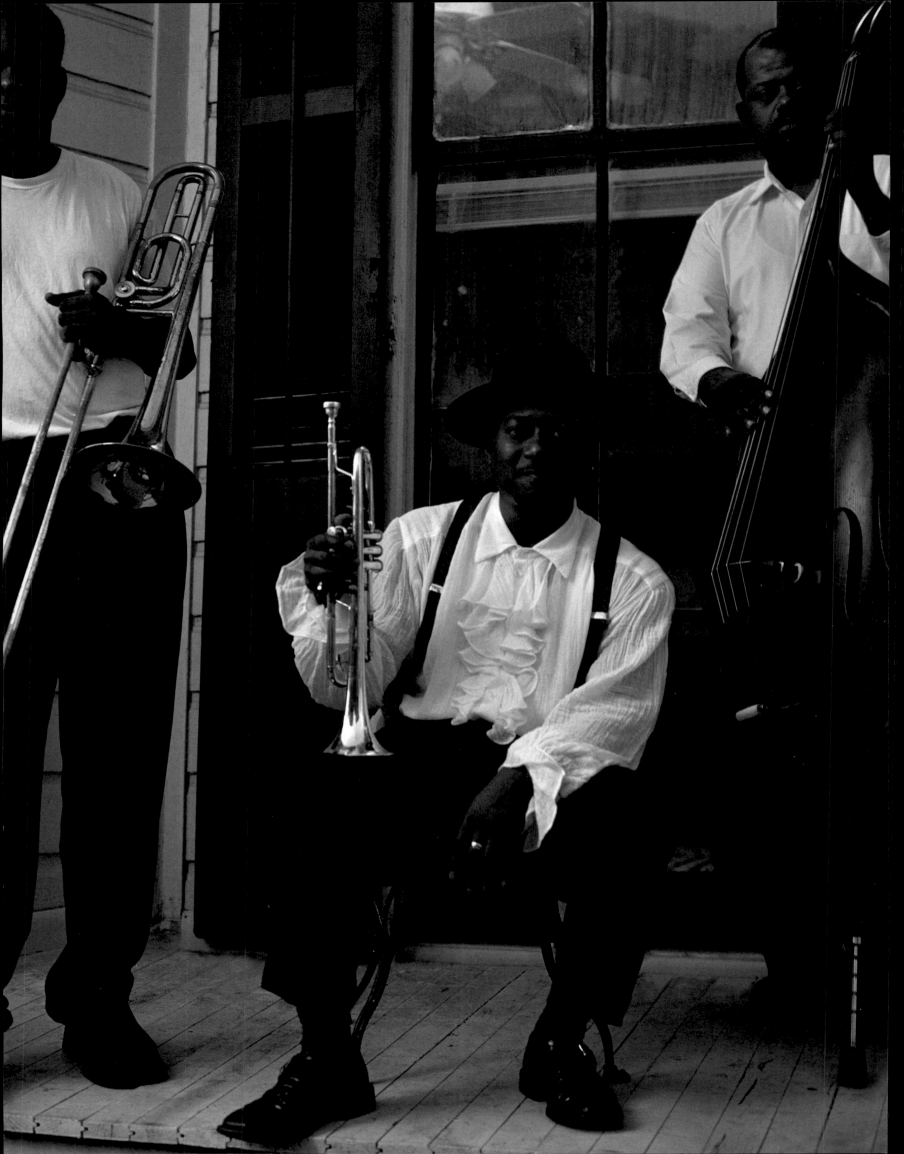

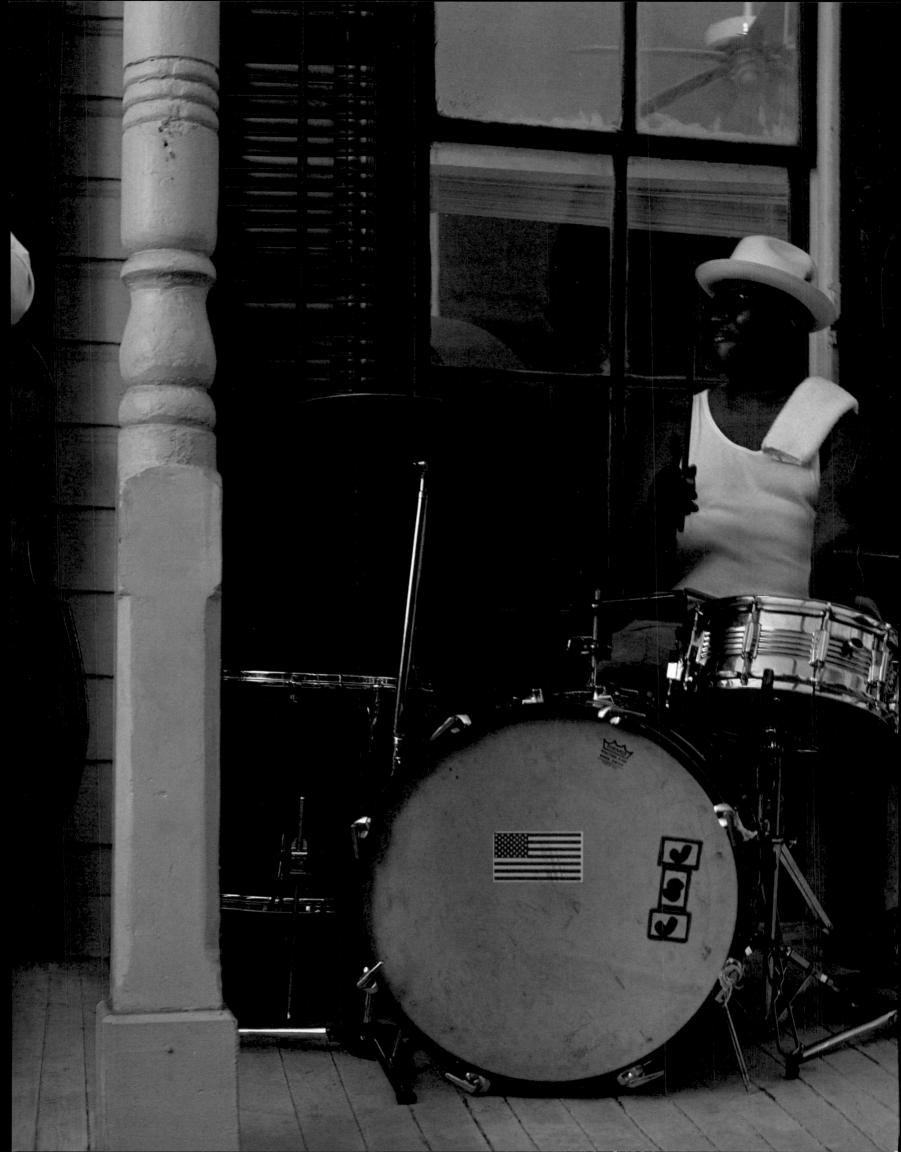

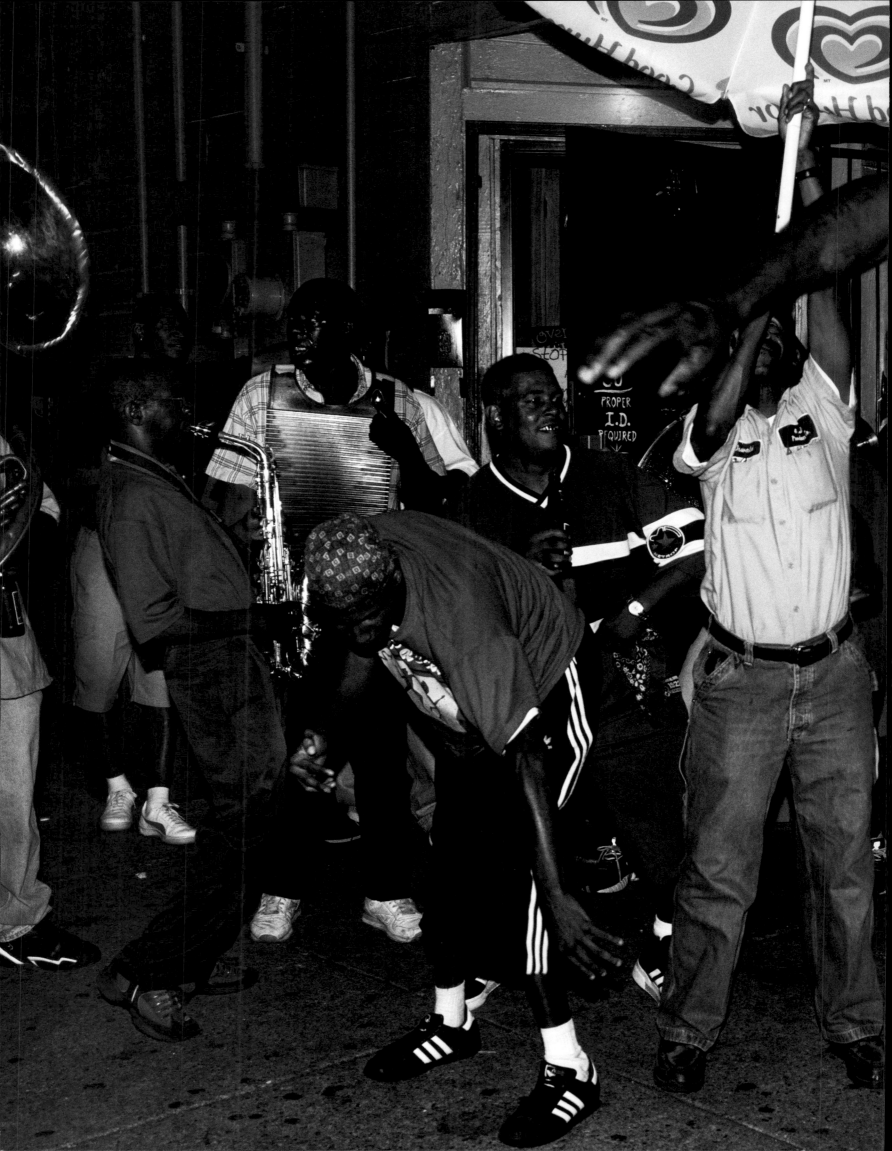

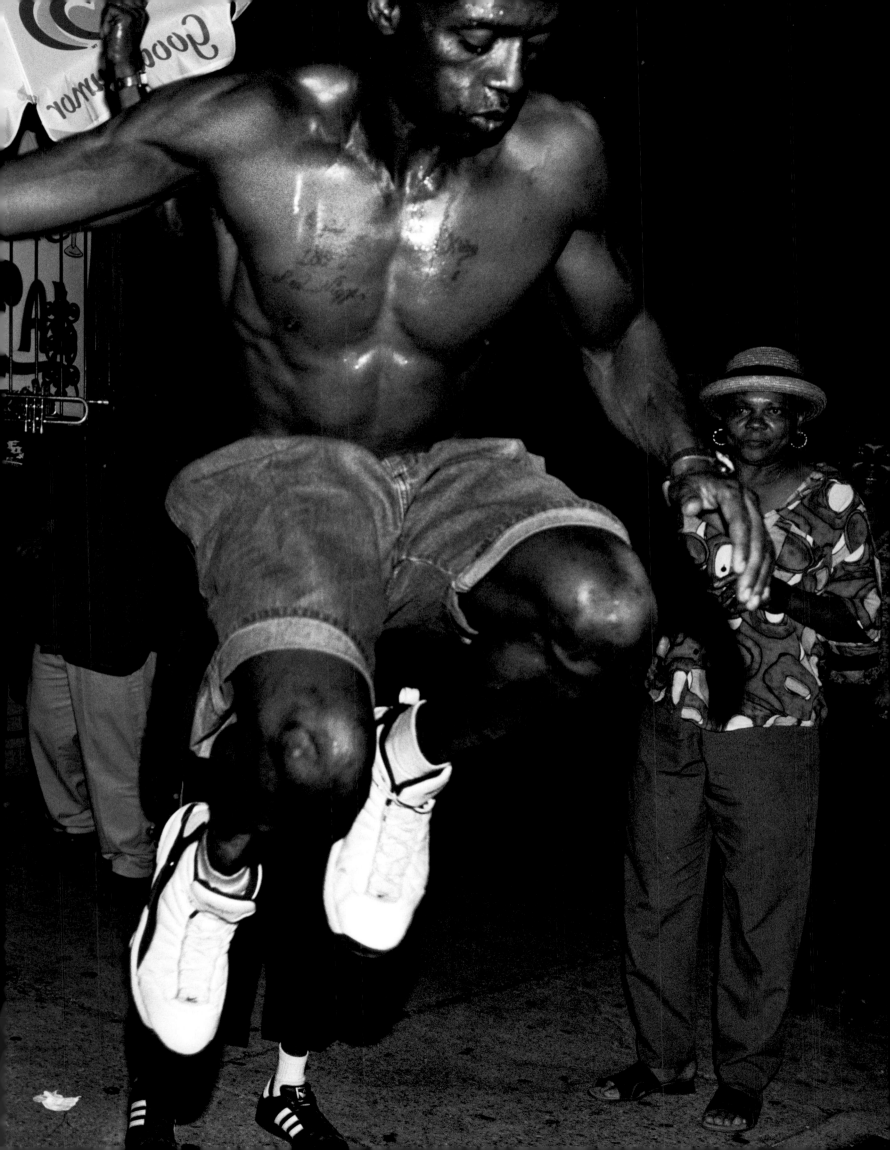

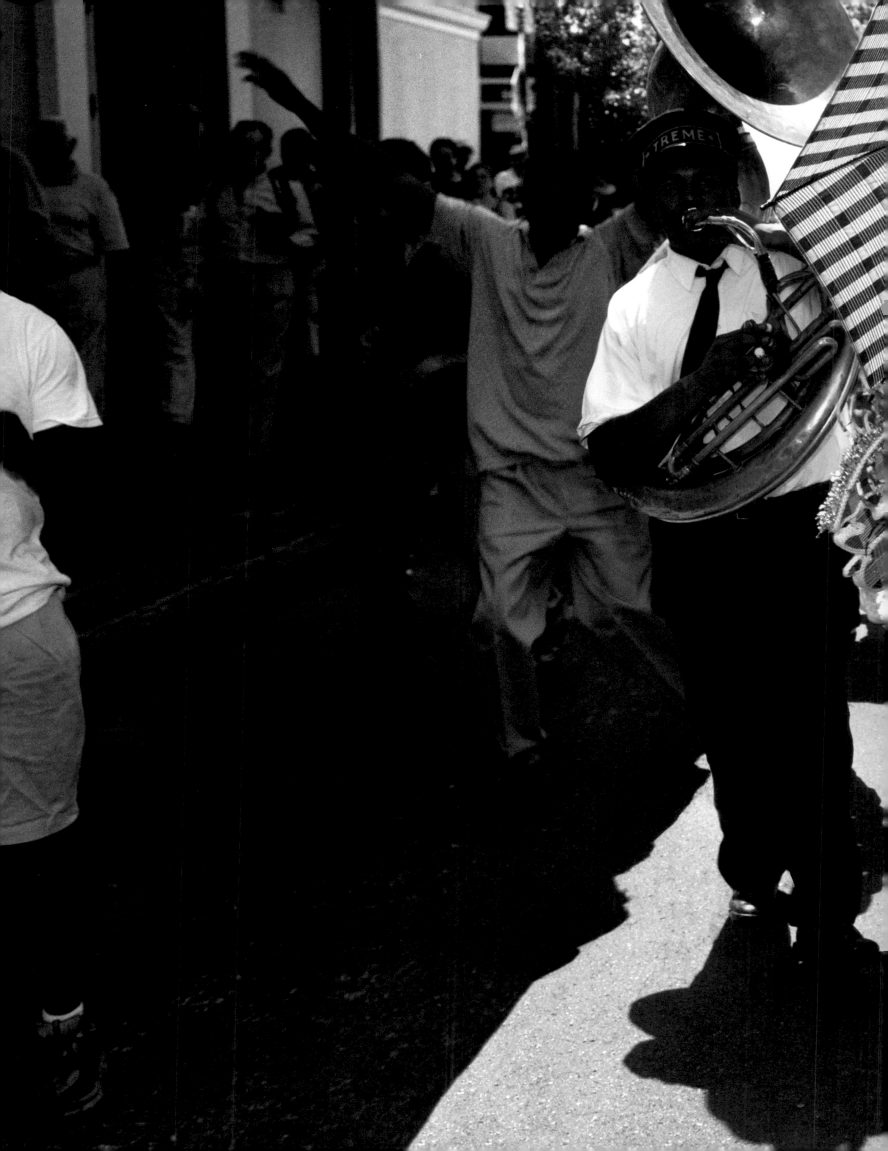

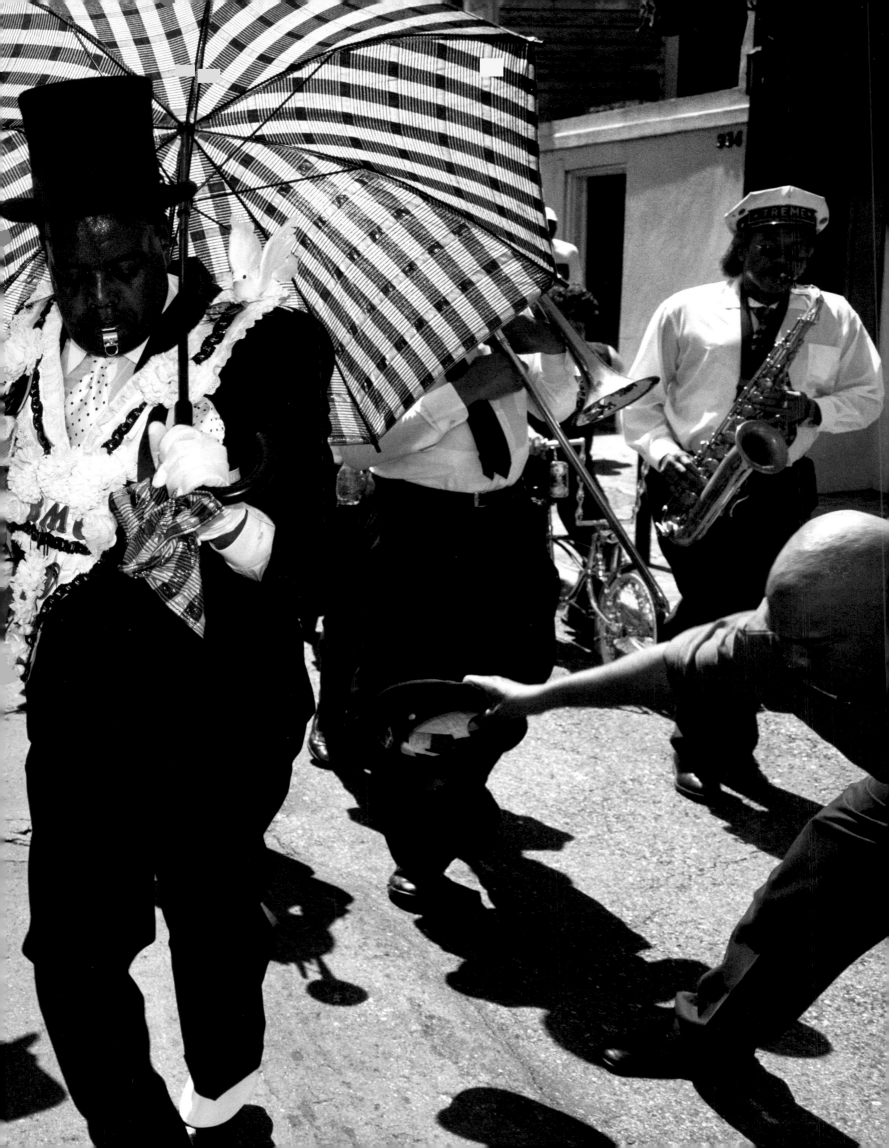

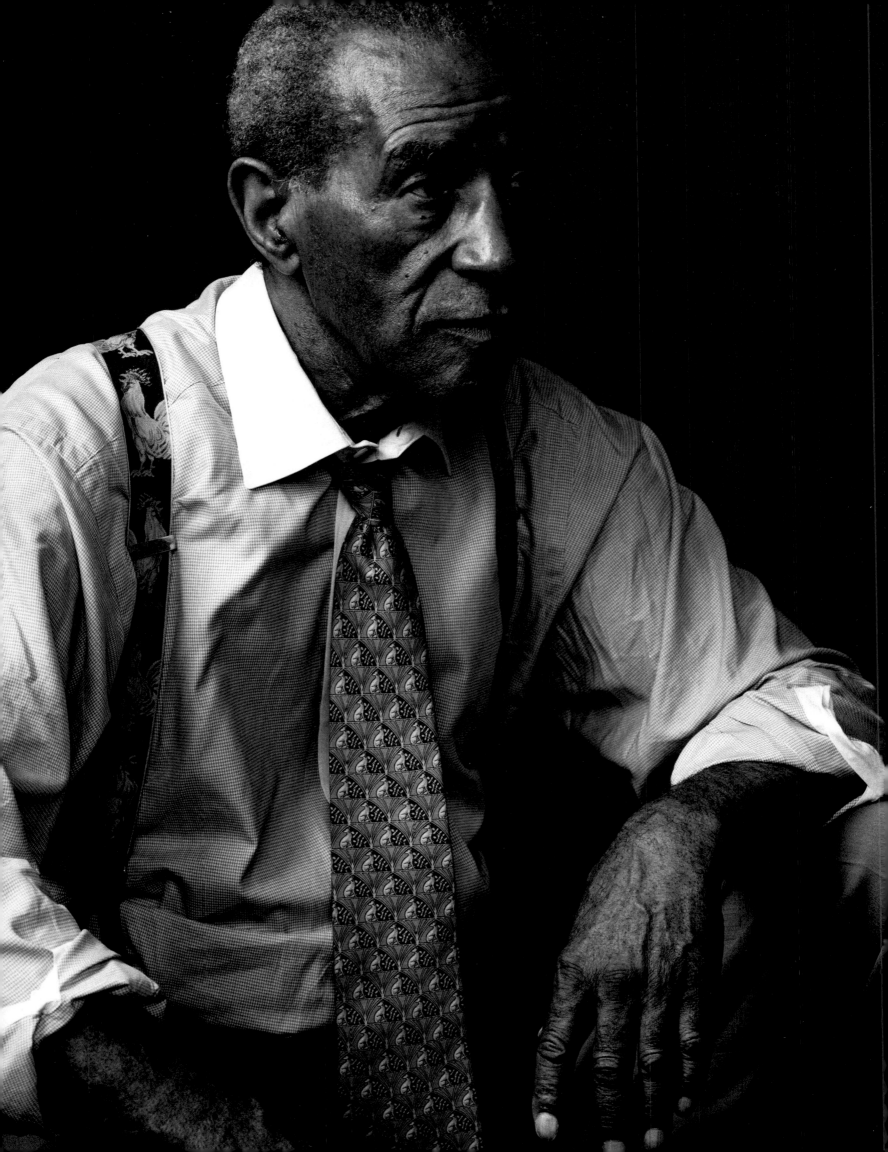

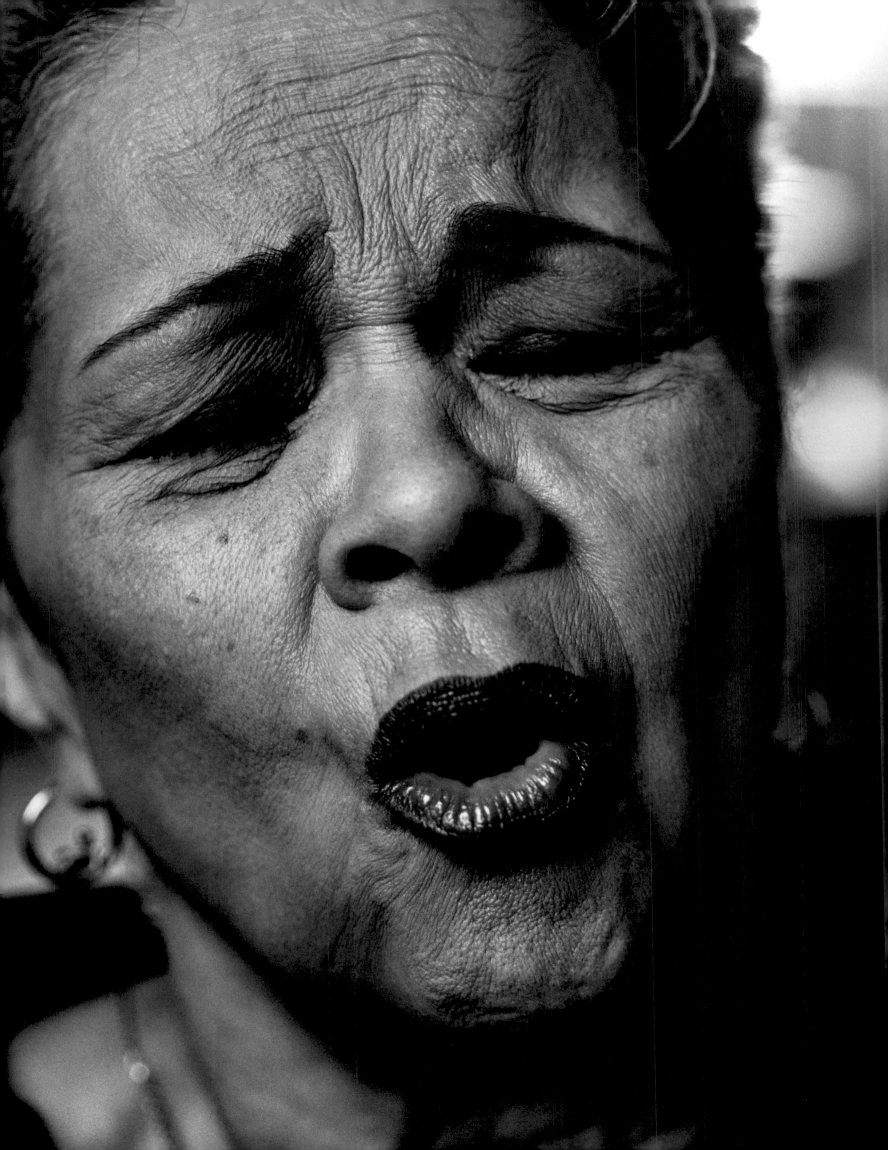

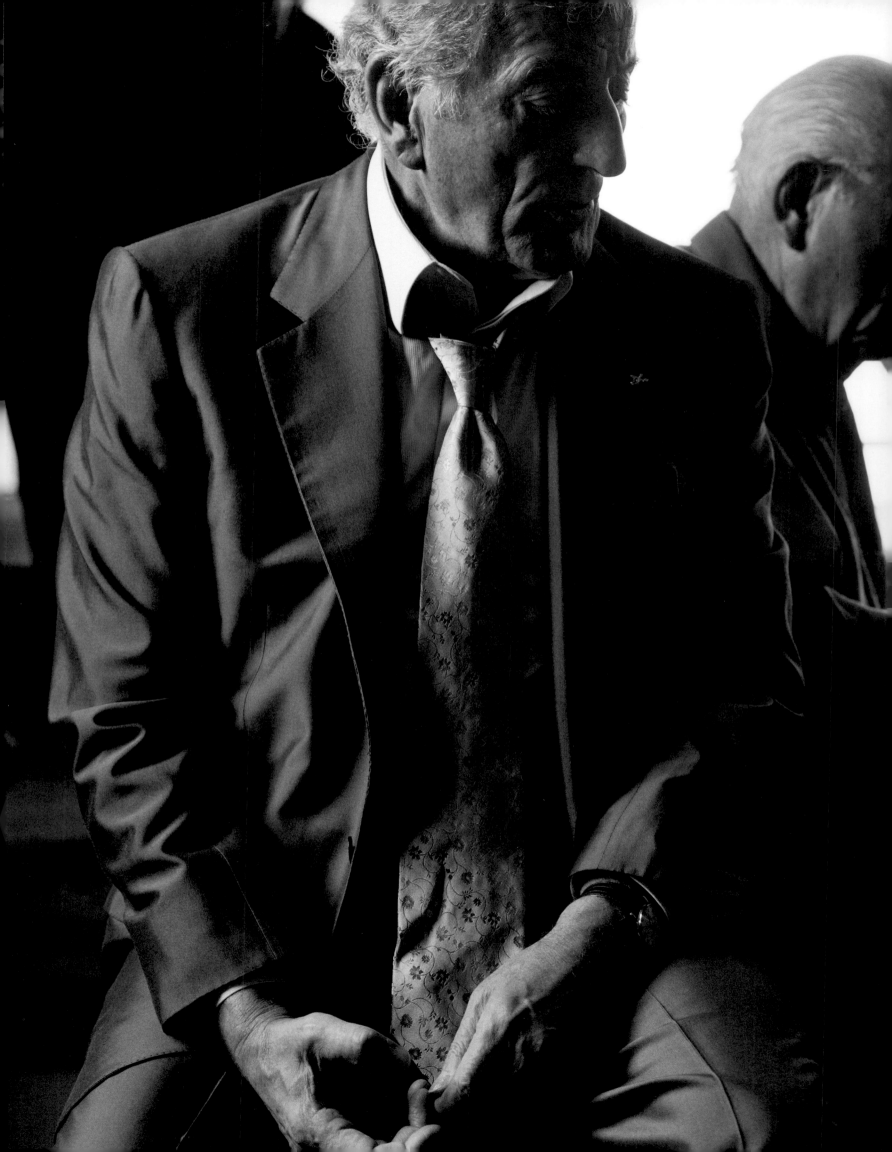

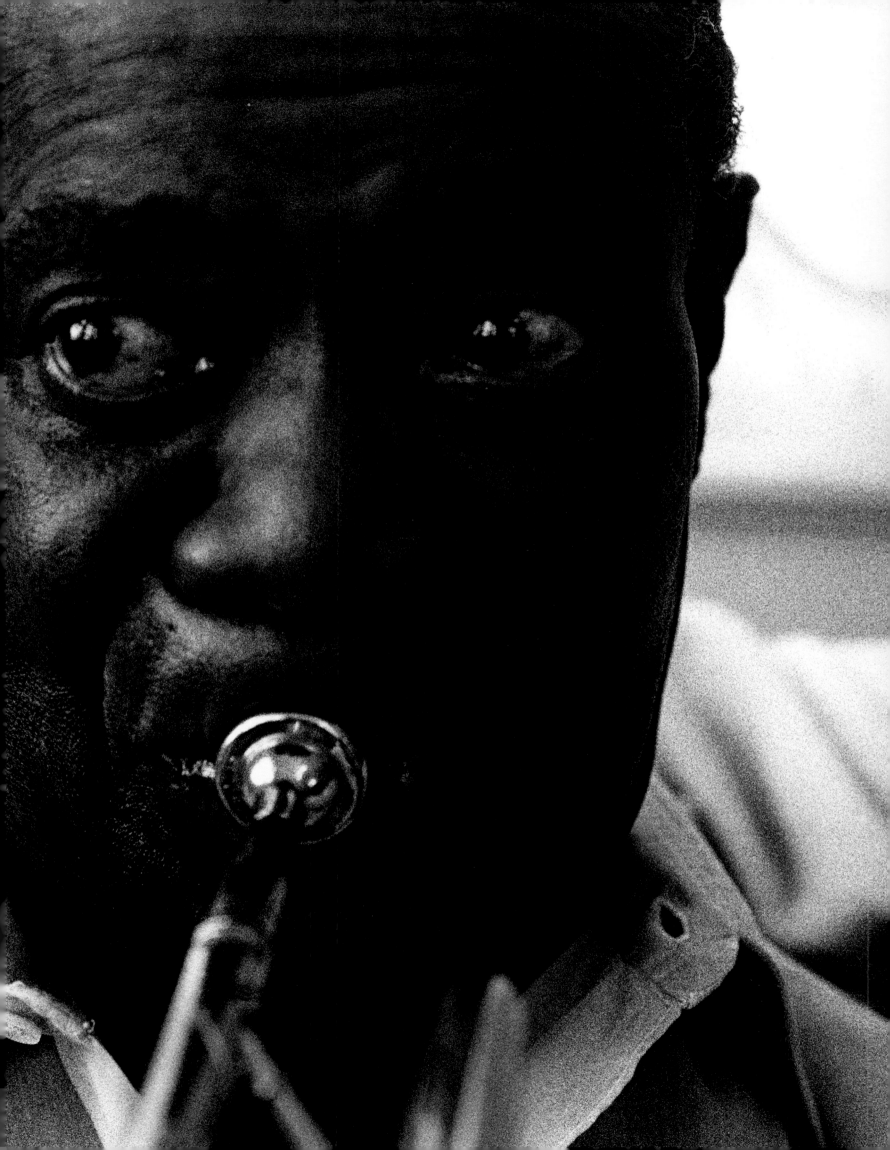

For thirteen years, between 1970 and 1983, I was the principal photographer for *Rolling Stone*. Everyone called *Rolling Stone* a music magazine, although most people knew that it was much more than that. I worked with Hunter Thompson on stories about the national elections and Nixon's resignation. And I worked with Tom Wolfe. *The Right Stuff* came out of *Rolling Stone*. But music was the center of our lives, or at least it seemed that way.

Before I worked for the magazine, I studied painting at the San Francisco Art Institute and took a night class in photography. The reigning aesthetic was personal reportage—Robert Frank and Cartier-Bresson. It was at the height of the Vietnam War, and soldiers who had come back from the war were attending school on the GI Bill. One guy in my photography class, a really, really tough guy, showed us some pictures he'd taken in Vietnam when he was totally stoned. They were of night flares. He was supposed to be holding a gun when the flares went off, but he took these incredible photographs instead.

Rolling Stone hired me after I brought some photographs to the magazine's art director, Robert Kingsbury. There was a picture of a ladder in an apple orchard that I had taken when I was on a work-study program in Israel, and pictures of people who were living on a kibbutz. I also showed him some photographs I had shot the day before at an antiwar rally. This was not the kind of thing that photographers usually took to Kingsbury. He saw a lot of pictures by people who had gone to a concert and used their camera to get to the front of the stage.

It seemed to me that a concert was the least interesting place to photograph a musician. I was interested in how things got done. I liked rehearsals, backrooms, hotel rooms—almost any place but the stage. And even if I was a fan of someone's music, the photograph came first. It was always about taking the picture. There were other photographers who specialized in photographs of musicians—really great photographers. David Gahr, in particular. And Jim Marshall, who probably understood the psyche of a musician better than anyone. He could drink with the musicians and take as many drugs as they did. I couldn't do that without killing myself. But I put in a lot of time with musicians. When I went on the road with the Rolling Stones in 1975, I learned about how music is made. I had an idea at that point about how musicians lived, but not about how the music is made.

That was over twenty-five years ago, and I've done a great deal of work since then. I have learned how to help a moment, how to direct it, and when you just have to accept that it's not going to happen and you should come back another day. The impulse to do this book came from a desire to return to my original subject and look at it with a mature eye. Bring my experience to it. I had something rather ambitious in mind, actually. I wanted to show a Marine marching band, and barbershop quartets, and make it a real American tapestry. It seemed like a good idea to start in the Mississippi Delta, since that's where the music that meant so much to me started. The first person I shot was R. L. Burnside. We got off the plane and went straight over to his house, which was very dark inside—maybe ten f-stops different than outside. It was hard to see at first, and then you could make out people sitting in the corners, and tons of grandchildren. Girlfriends. Brothers. Cousins. R. L. Burnside was just sitting around. Life was going on. A woman was putting cornrows in one of his nephews' hair.

My assistant, Nick Rogers, and my producer, Karen Mulligan, are very friendly people, and when we showed up it was like an instant party. It wasn't like the old days, when it was just

me and my camera. We helped things along by asking Burnside if he would mind playing the guitar. He pulled a lot of stuff out of his garage and they set up some drums and played in the carport. I got many beautiful pictures from that first encounter.

The trips to the Delta didn't feel like work. I didn't have to hope that something would happen. Stuff was happening. In Clinton, a little town not far from R. L. Burnside's house, we were working with Eddie Cotton in a club, and while we were setting up the lights I went outside and he was sitting in a car with his girl. I took the picture that we used in the book. We talked about shooting the next day, which was Sunday, and he said that he couldn't get together until later in the afternoon, because he played the organ in his dad's church. I met him there and took some pictures in the church and then we were standing on the sidewalk and a little girl walked by, looking pretty in her Sunday clothes. I asked Eddie if he knew her, and he laughed and said, "Annie, everyone here is related to everyone else." She was his cousin. We used that photograph too.

I wanted to photograph Rosanne Cash with her father. He had not been well, but he organized a family reunion and birthday celebration for his wife, June Carter, in Hiltons, Virginia, where the original Carter family homes are, and they invited us to come. It turned out to be the last big gathering of the clan before June's death. We ate with them, and they included us in everything. We did some photographs at a picnic, and Rosanne and her father sat on the front porch of June's parents' house, and Rosanne played guitar and sang.

I always try to take pictures in places that mean something. The Carter family porch means a great deal. Several generations of the family have been sitting on that porch. It's not just any porch. I was looking for that kind of detail. A room. Or a chair. One afternoon I went to a juke joint that someone had told me about, thinking that I would like to get a dancing picture. The juke joint was in the middle of a field, and it looked pretty much like it did a hundred years ago, except for the fact that there was

a Lincoln parked in the garage. We knocked on the door, but no one was there, and we were sitting around waiting for somebody to come down the road when I realized that the house was the picture. It was a kind of window on the subject.

The Fisk Jubilee Singers were photographed on the lawn at Fisk University in Nashville because I thought you should see the campus and the trees. But then a couple of years later we heard they were performing in New York and we asked them to come to the studio and sing. And when they did I just started to cry, it was so powerful. They weren't belting it out or anything. They were very controlled. But I was totally unprepared for the beauty of the sound the union of their voices made. I had asked them to come to the studio because I wanted to photograph what singing looks like. I guess I had in the back of my mind Richard Avedon's photograph of Marian Anderson singing. I wanted to see the song. I tried to do this several times. When we went to photograph Ralph Stanley, I asked him to sing "O Death," the song that he won a Grammy for when it was on the soundtrack of *O Brother, Where Art Thou?* I thought, well, this will be great. He has this weathered, worn face, and he'll be singing about death. I thought I would have a photograph of a man wailing. But he started to sing and his mouth was hardly open and his teeth were clenched. Which, I realized, made sense. You aren't going to sing "Hooray, here's death." He sang the whole song all the way through and his mouth was open maybe a quarter of an inch.

I often got something other than what I had anticipated on this project. Something else. Something that moved me unexpectedly. The musicians who played at Placide Adams's funeral in New Orleans, for instance. Their horns were battered and beaten up, and they were so poor that they barely had shoes, but when the procession started the music was so rich and so great that I was walking down the street with my camera, crying. I felt privileged to be able to listen to these people play.

ANNIE LEIBOVITZ
New York City

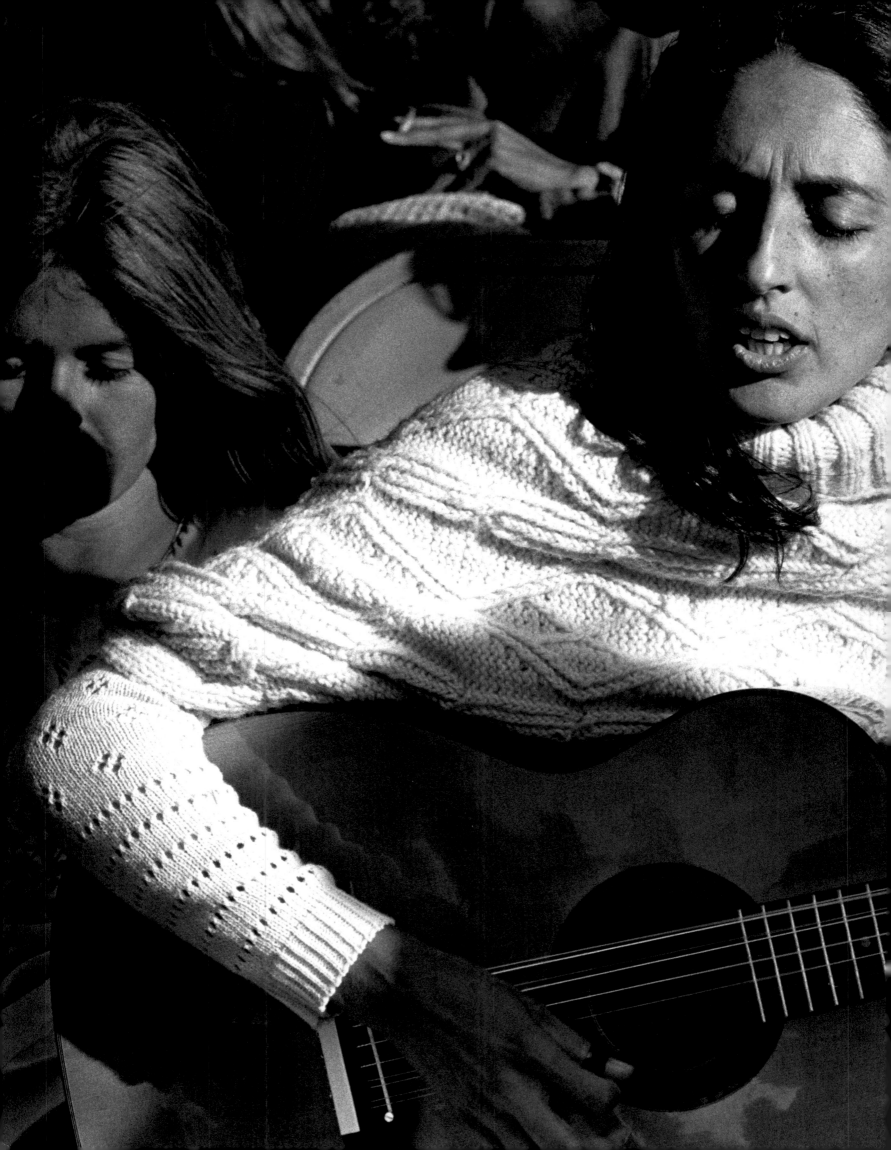

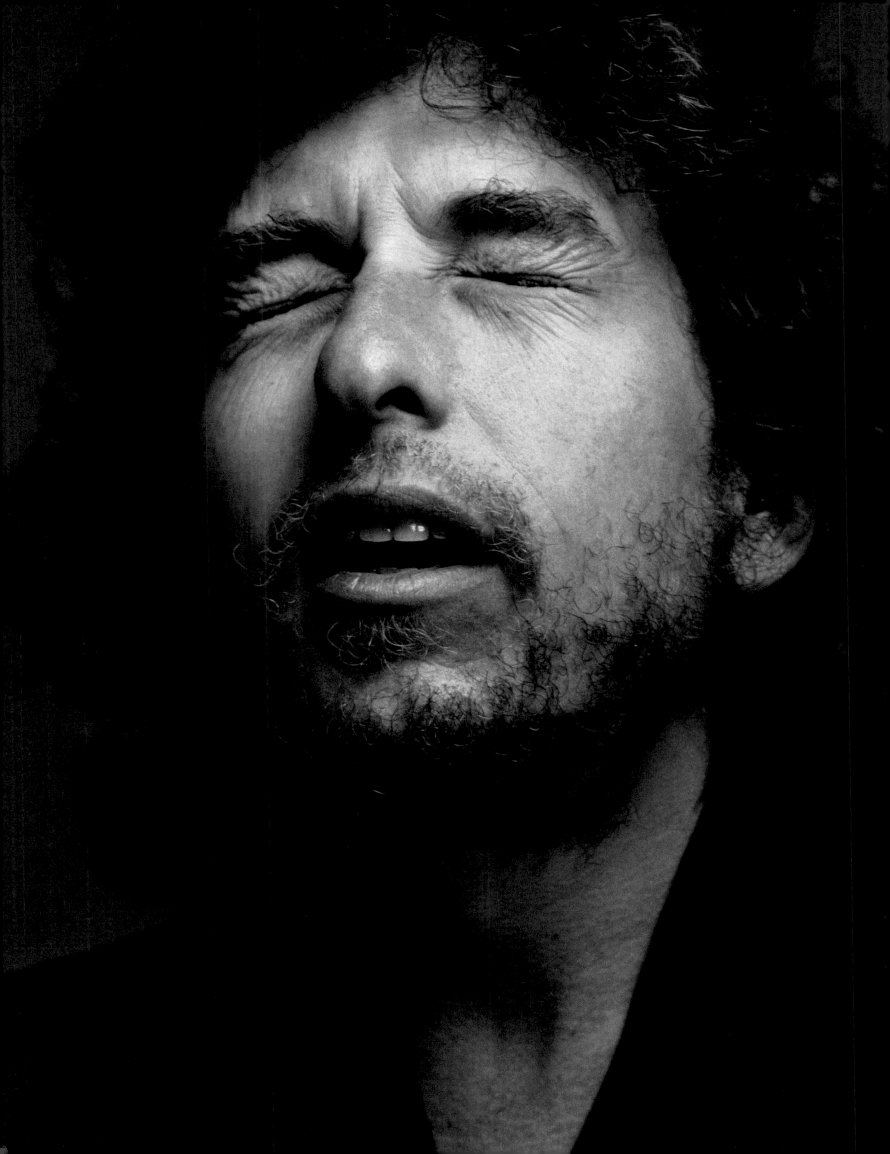

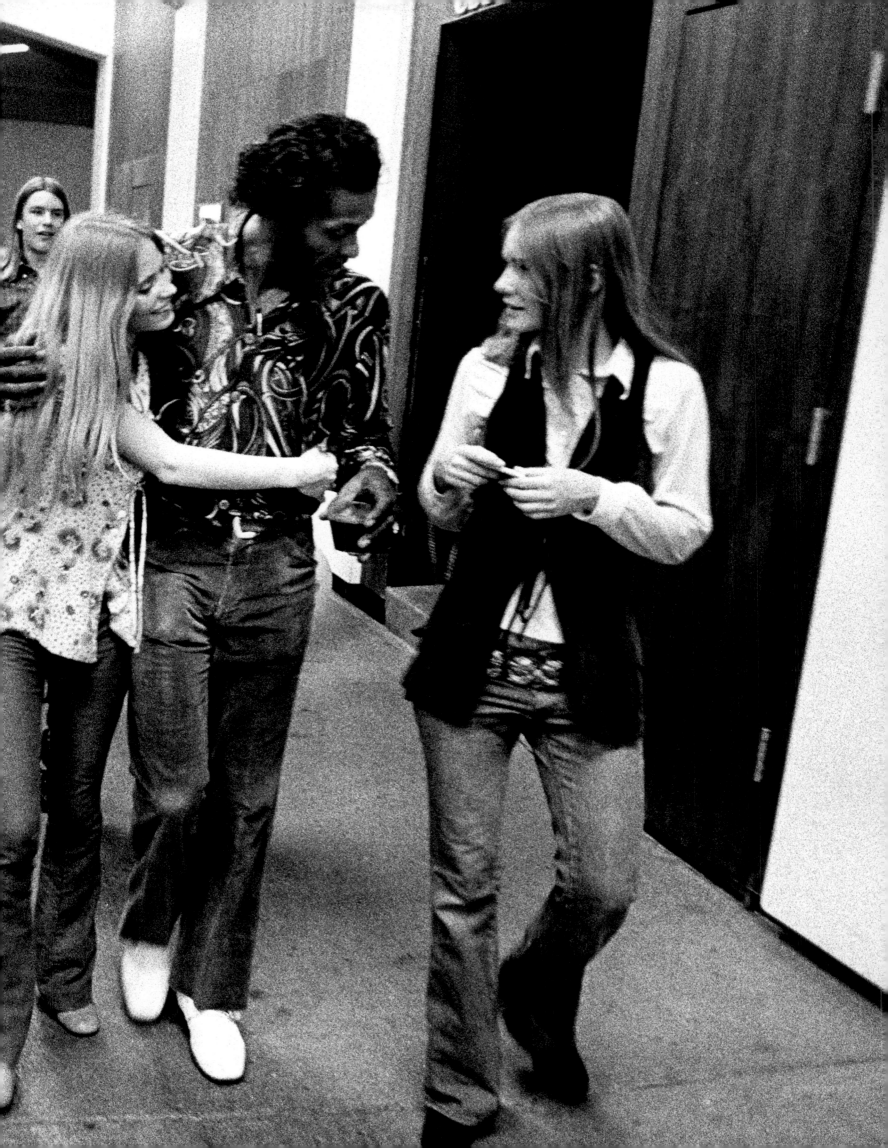

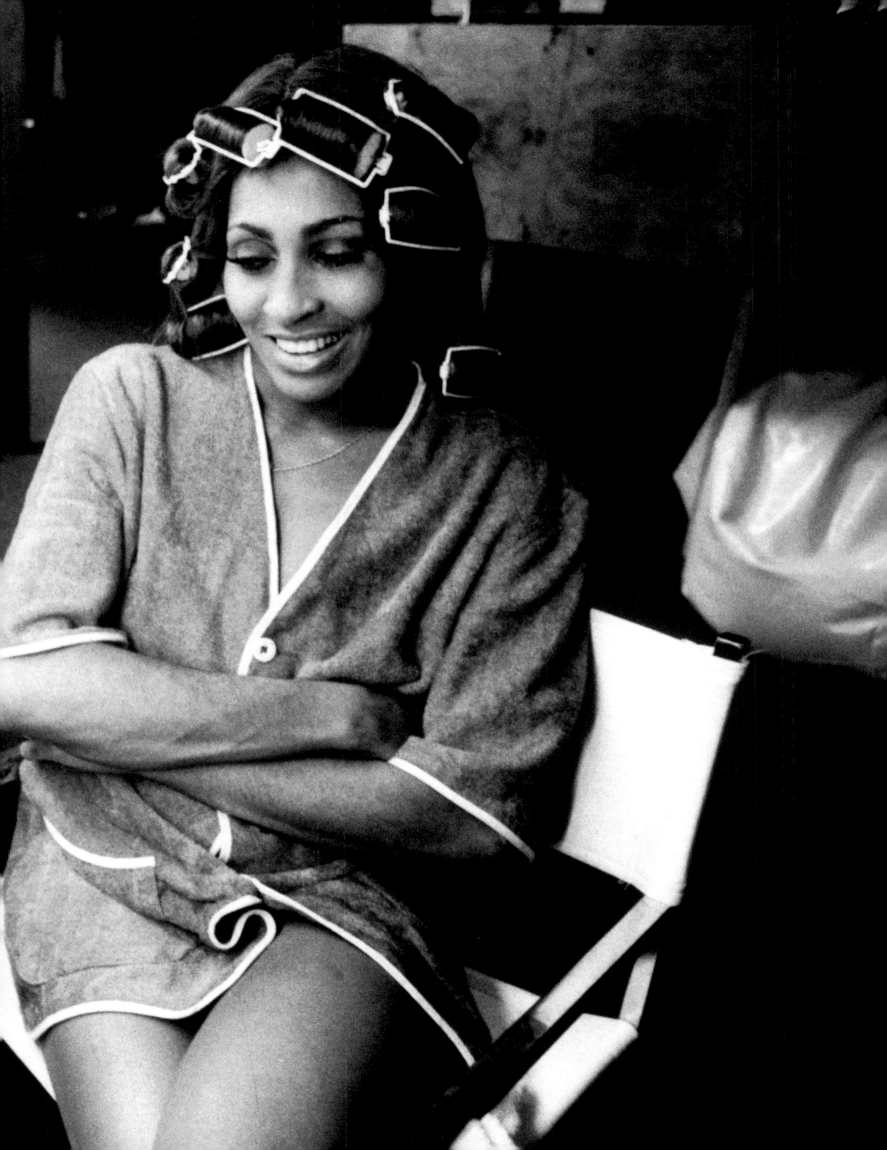

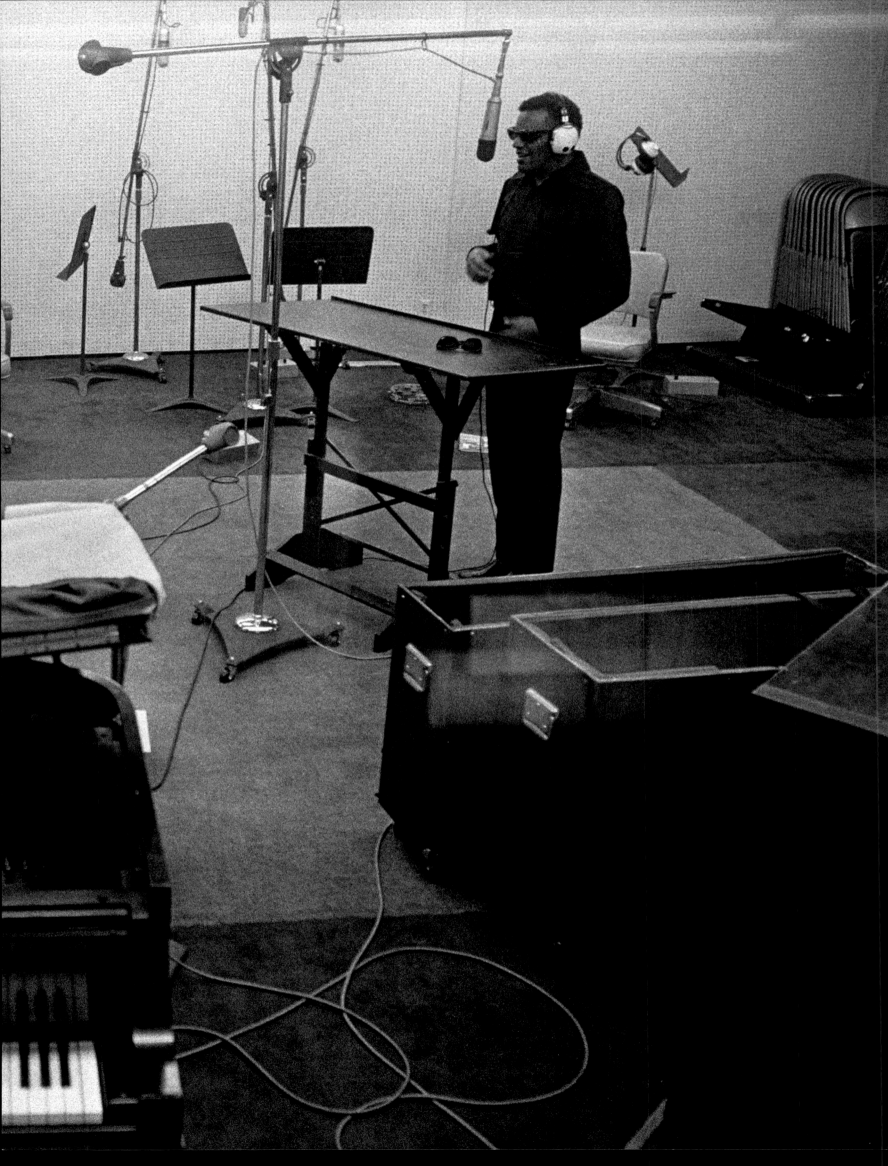

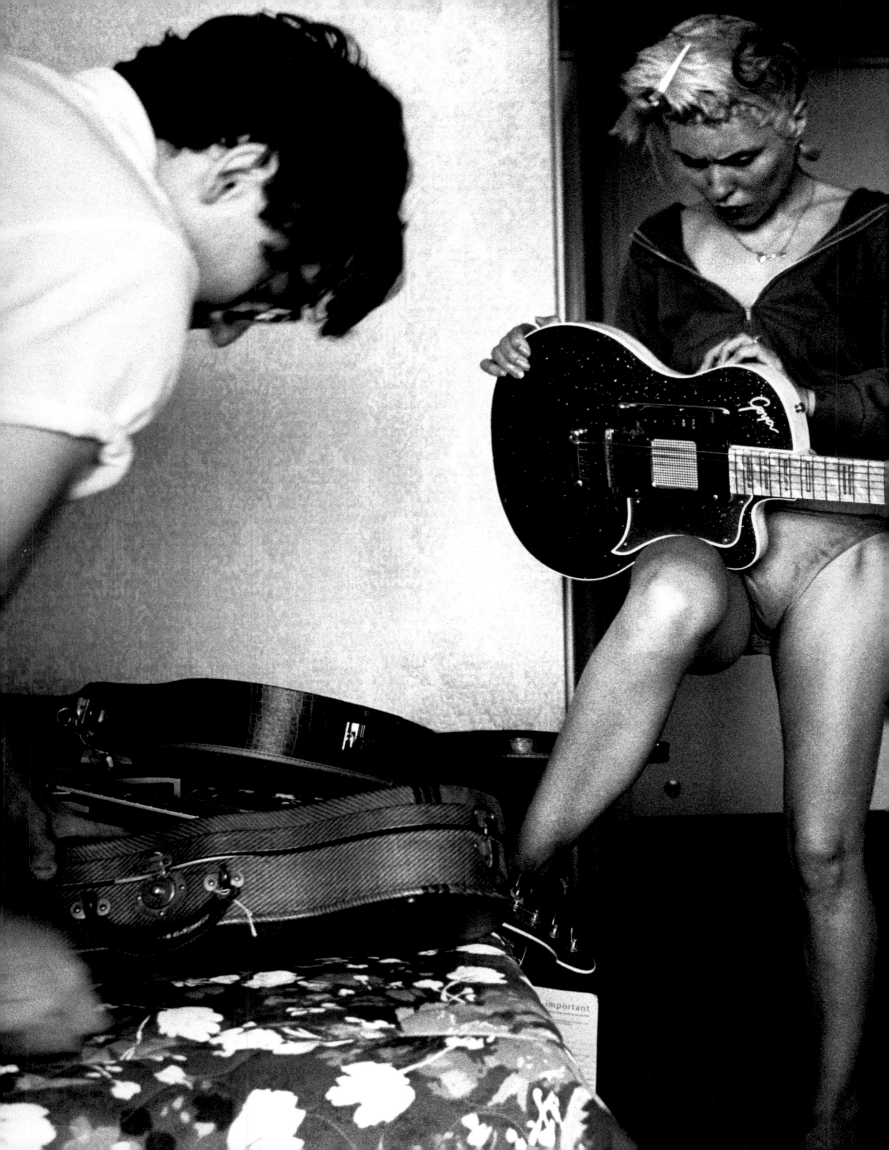

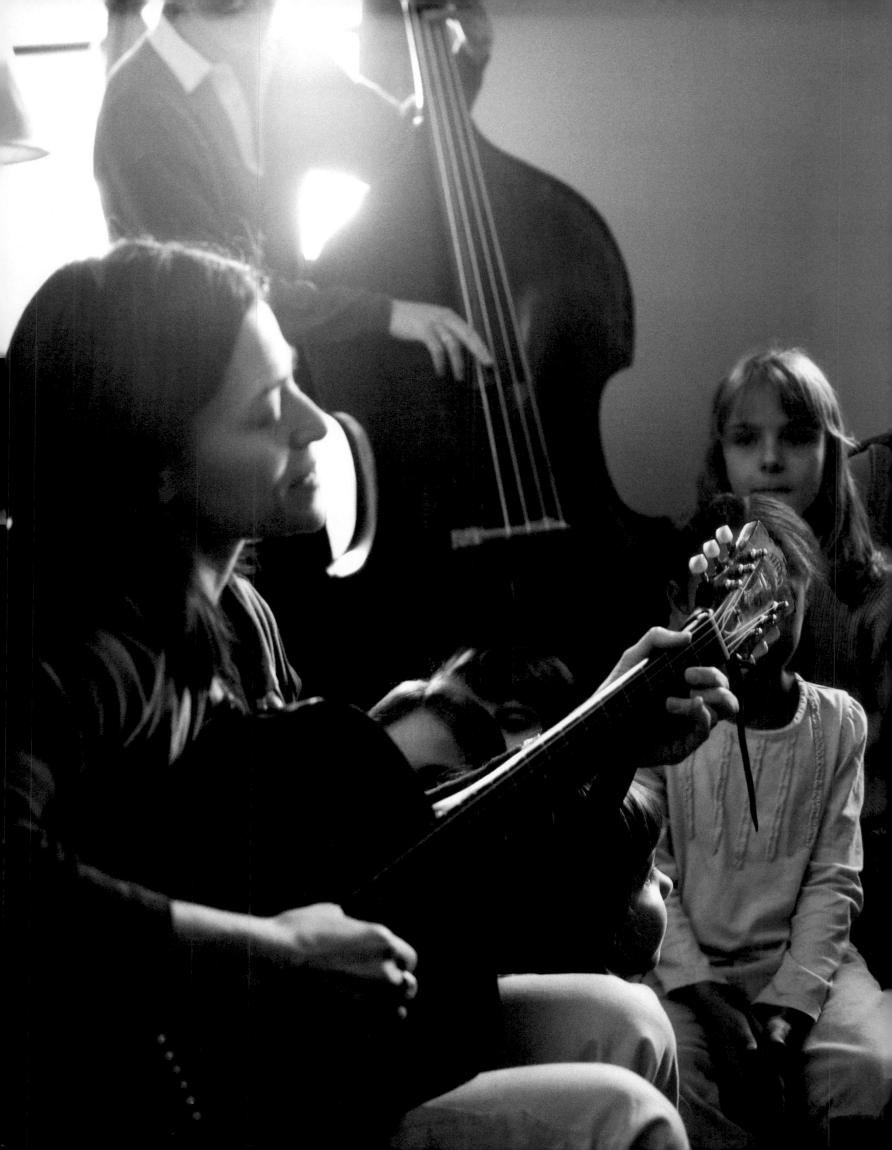

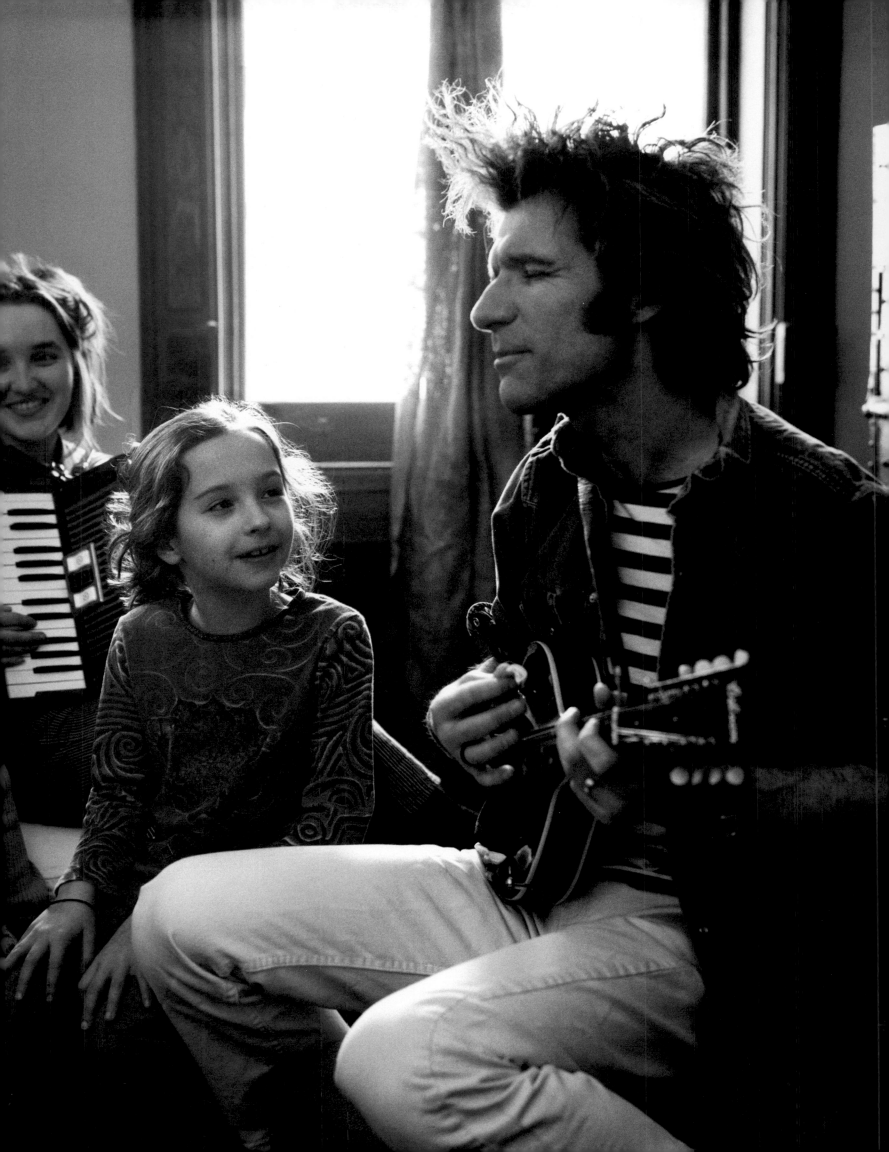

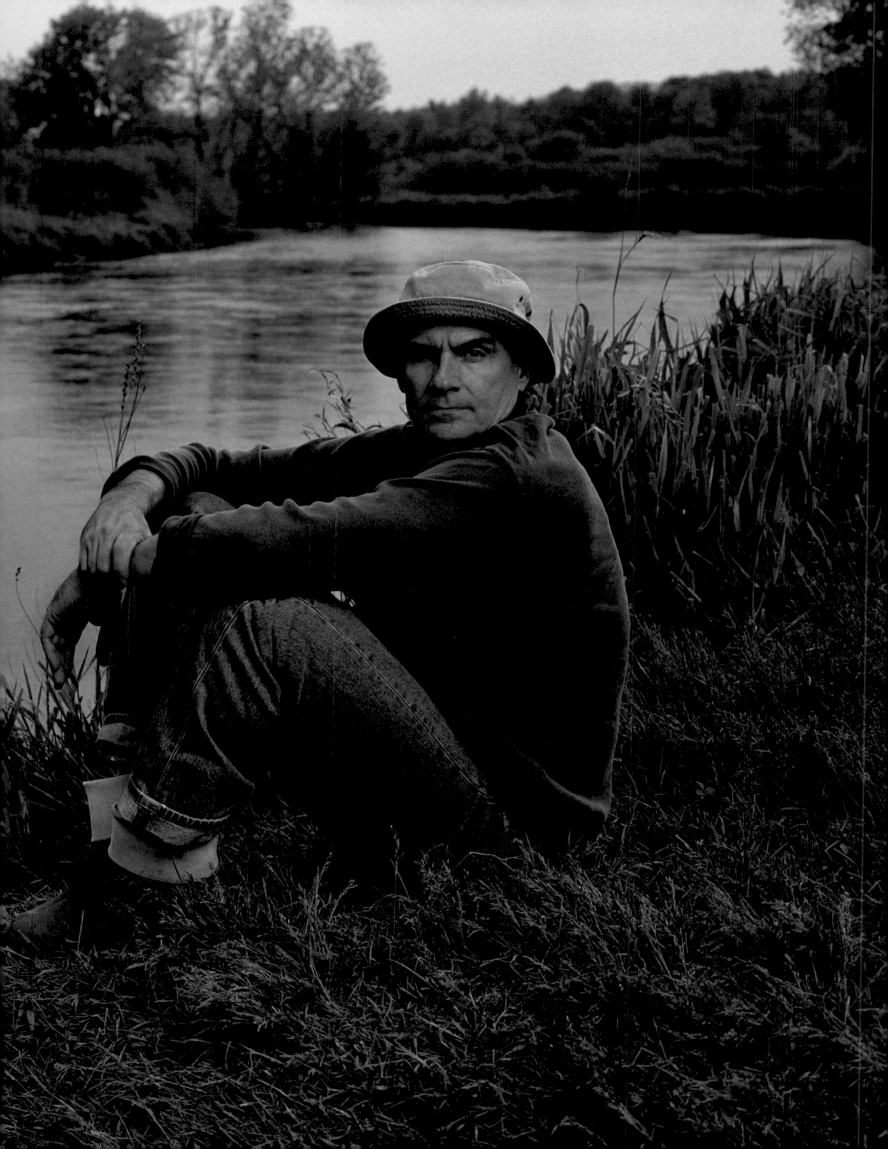

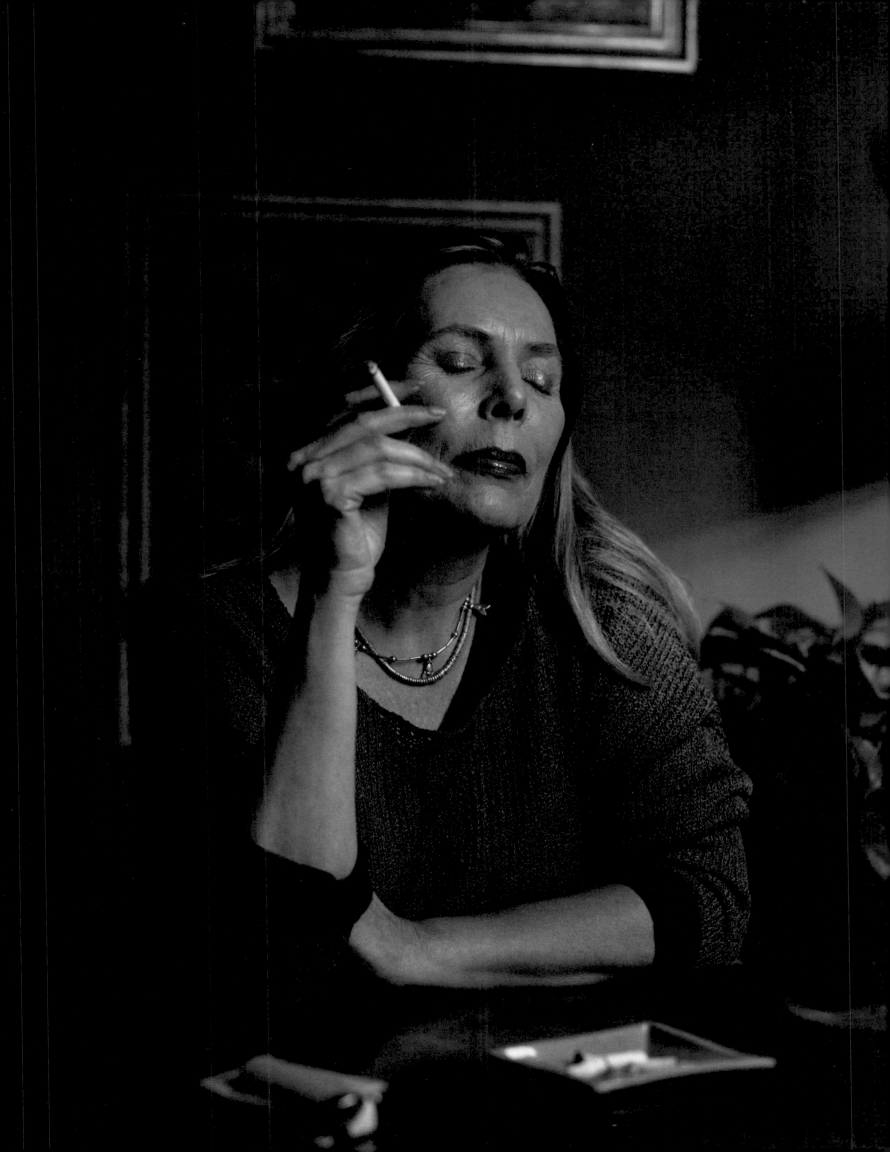

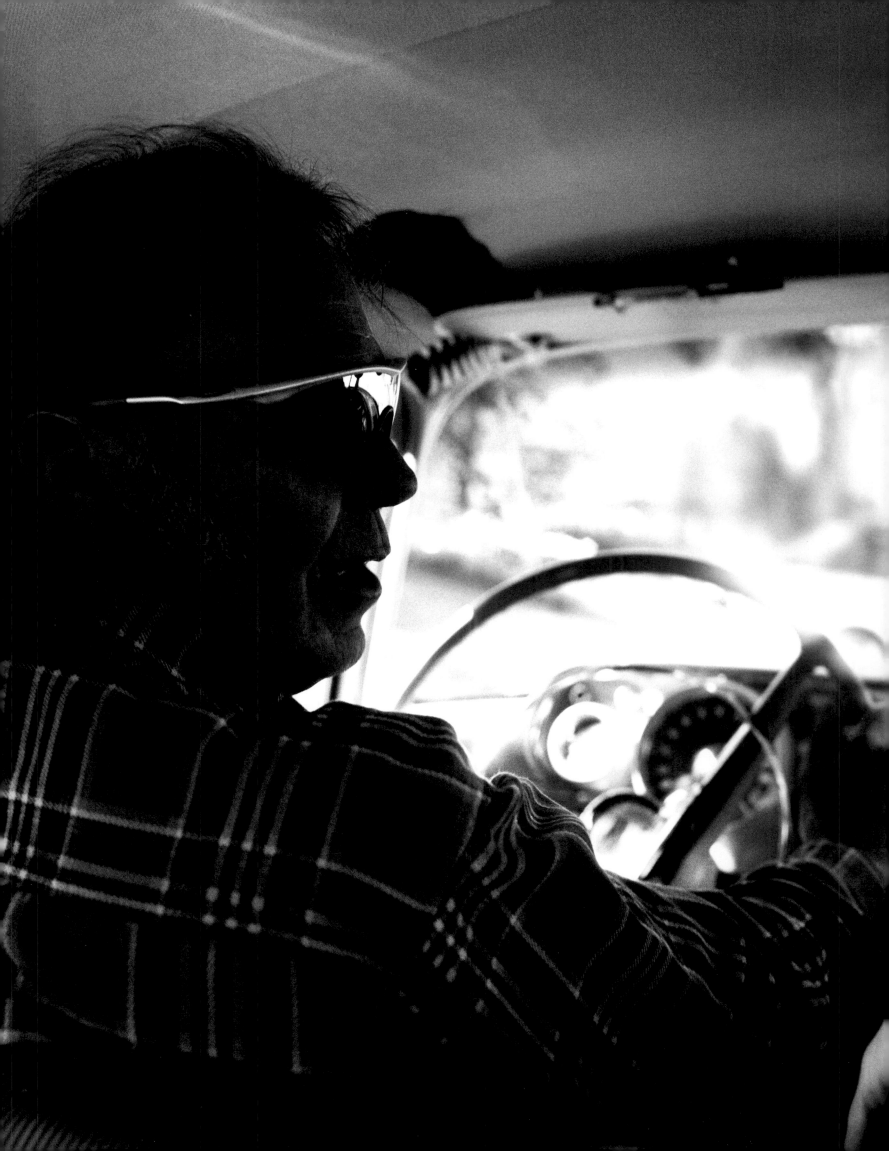

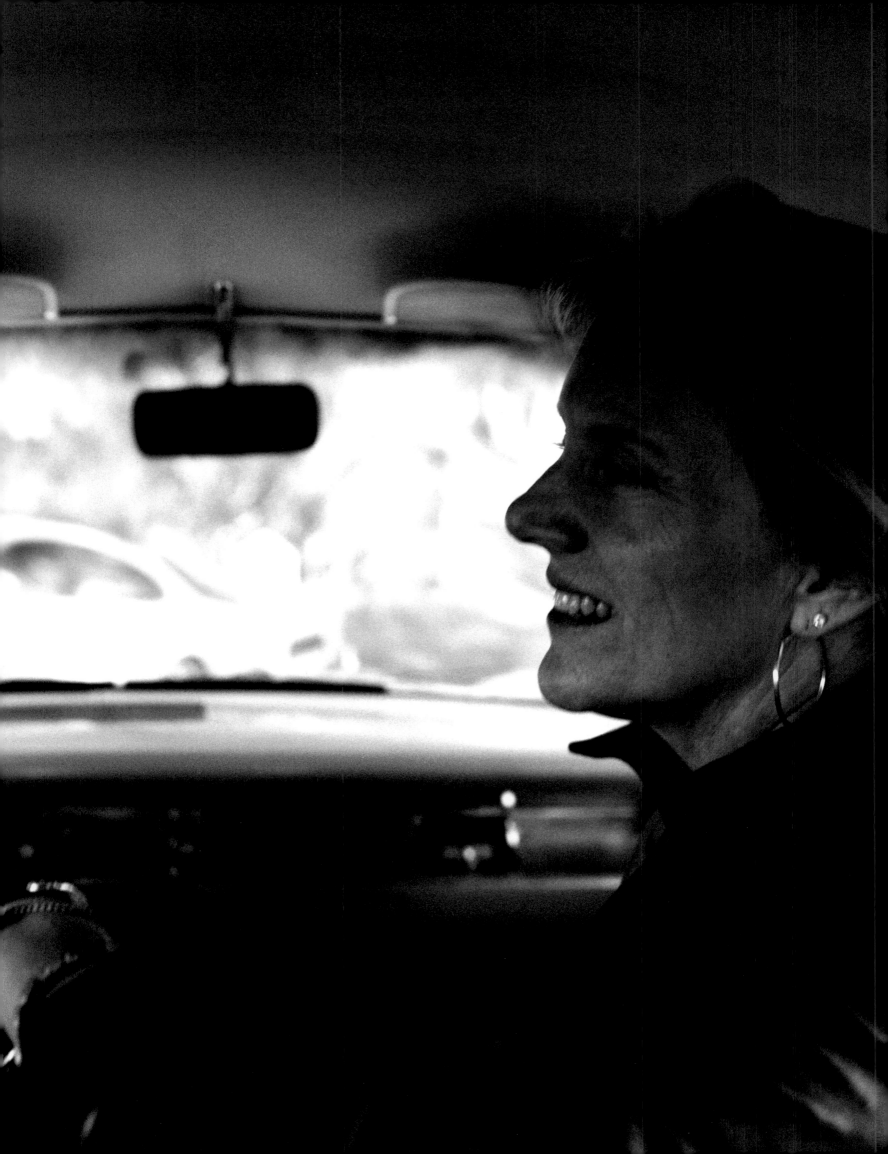

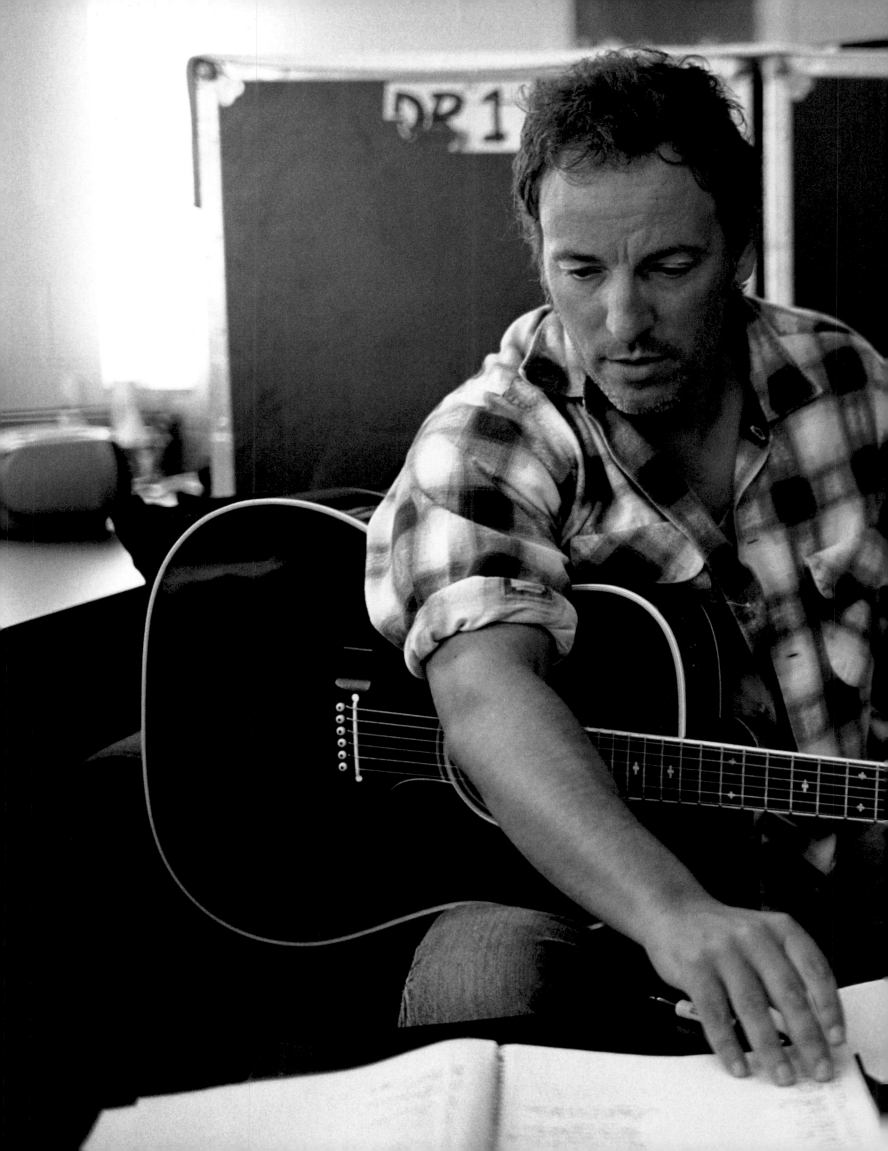

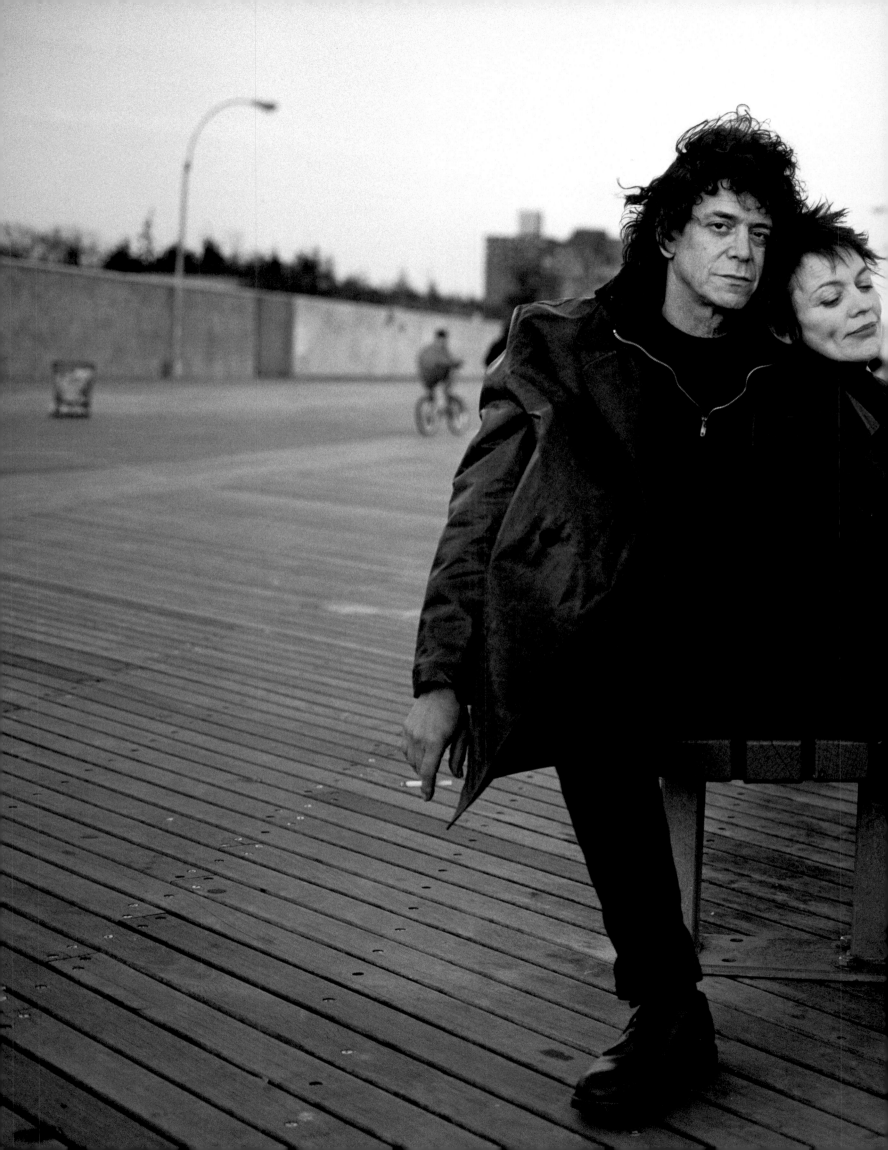

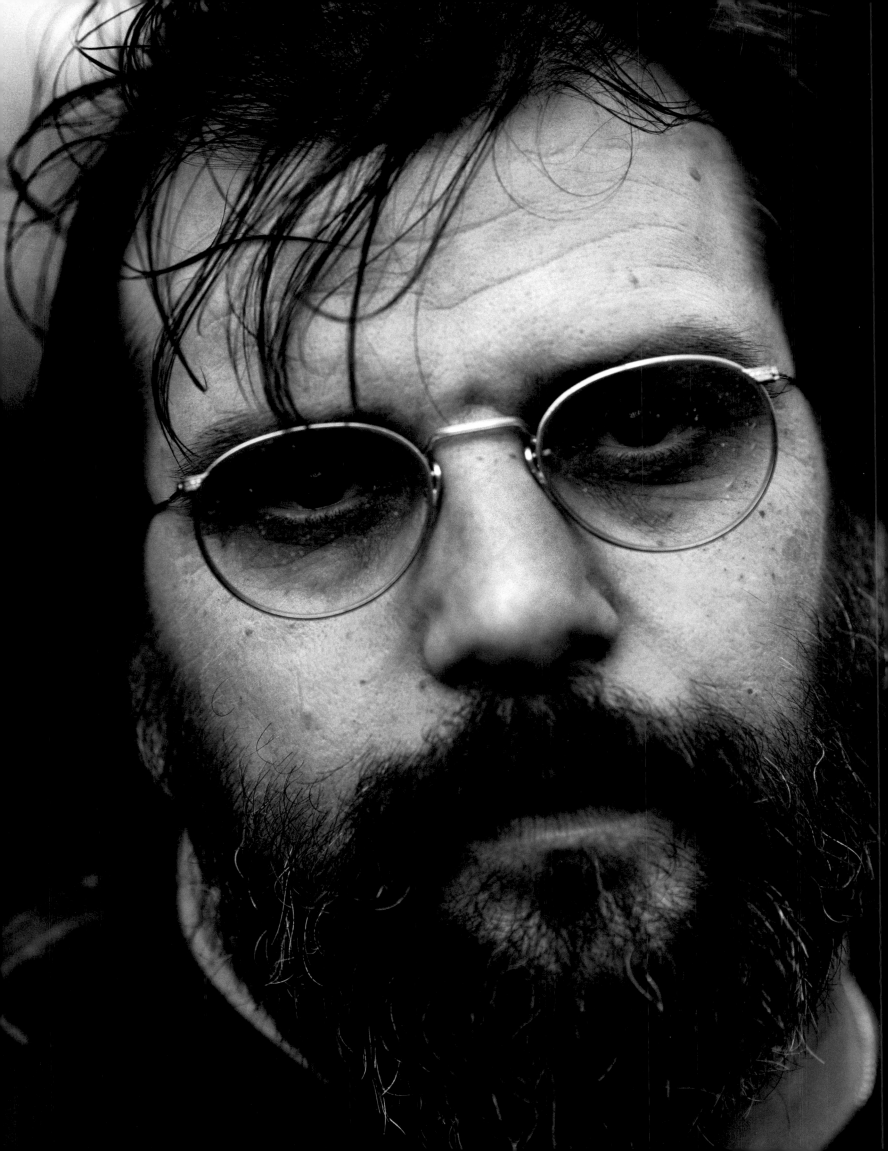

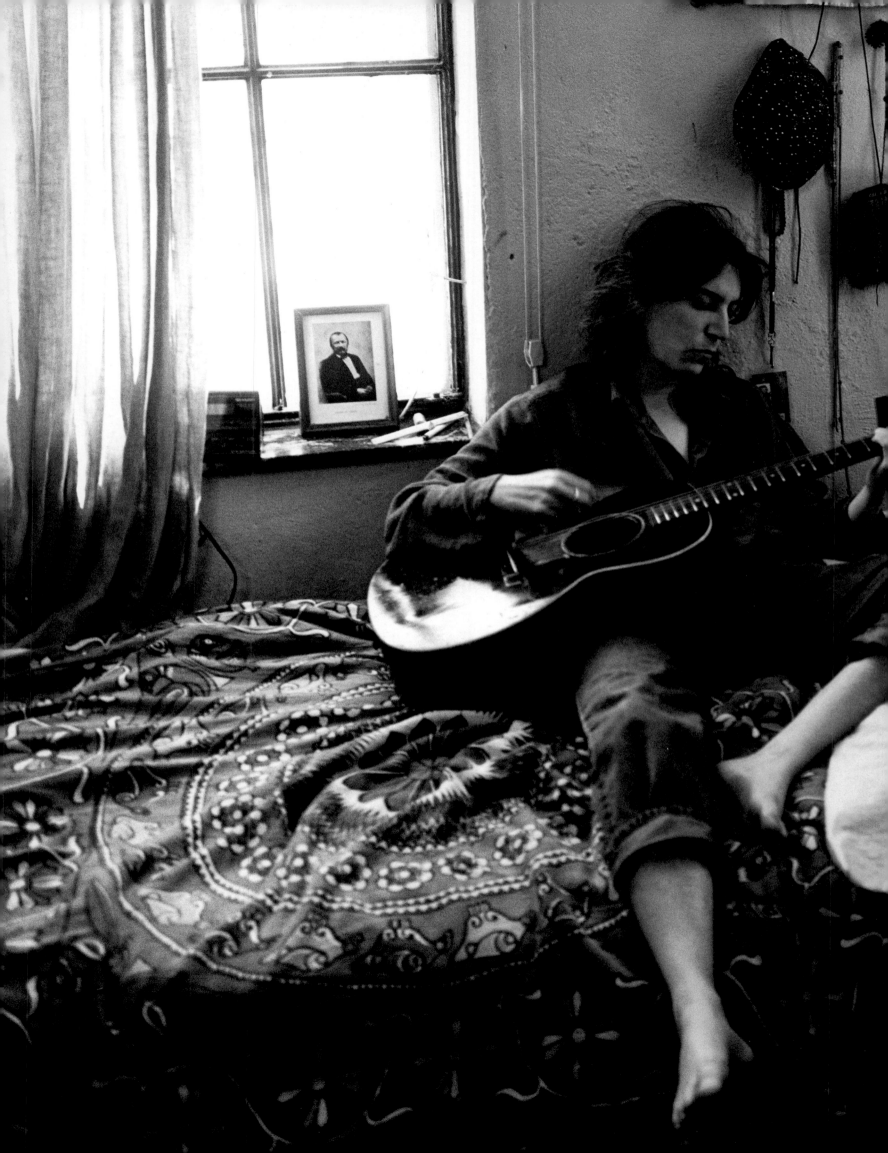

Notes on the Photographs

Cover ELVIS PRESLEY'S TURNTABLE in the Graceland

archives, *Memphis, Tennessee, 2001*. The record on the turntable in Presley's bedroom the day he died, August 16, 1977, was a special acetate copy of songs by the Stamps Quartet, the Southern white gospel group that sang harmony with him at all of his appearances in the last six years of his life. It had been given to him by J. D. Sumner, the leader and manager of the Stamps, who also sang bass. Gospel music was an important influence on Presley. When he was a boy, he listened to religious music at his mother's Pentecostal church and attended all-night concerts given by gospel quartets in Memphis. The only Grammys he received were for his albums of gospel music, and "How Great Thou Art" became one of his signature songs. Presley jammed for hours with the Stamps when their shows were over, and he listened to gospel music as he was going to sleep. The record on the turntable included some of his favorite songs: "I Should Have Been Crucified," "The Lighthouse," "I Can Feel the Touch of His Hand," and "When It's My Time."

4 PETE SEEGER, *Clearwater Revival, Croton-on-Hudson, New*

York, 2001. Seeger is the archetypal American activist folksinger. He was born in 1919 in New York, where his parents were on the faculty of the Juilliard School of Music. He attended private schools in New York and Connecticut and studied sociology for two years at Harvard. His father, who was a musicologist, had introduced him to Alan Lomax, the curator of the folk-song archive at the Library of Congress, and Seeger worked as Lomax's assistant and went on field trips with him. He also toured the country with Woody Guthrie, collecting songs. In the late thirties and early forties Seeger was a member of the Almanac Singers, who composed and performed pro-union and antifascist music. He was drafted in 1942 and spent three years in the army. After his discharge he helped create a songwriters' union and ran the group's magazine from his Greenwich Village apartment. In 1948 he became a founding member of the Weavers, one of the most successful groups in folksinging history. Seeger played banjo and guitar and sang, along with Ronnie Gilbert, Lee Hays, and Fred Hellerman, who also played guitar. Their first single, Leadbelly's "Goodnight, Irene," sold two million copies. Until 1952, when attacks by the House Committee on Un-American Activities forced the Weavers to disband, they produced several hits, including "On Top of Old Smoky," "Guantanamera," and "Wimoweh (The Lion Sleeps Tonight)." The Weavers began working together again in 1955, but Seeger left the group two years later. The HUAC blacklist kept him off television for many years, although he continued to perform on campuses and record prolifically. In the sixties many of his songs were hits for other artists: "Where Have All the Flowers Gone" for the Kingston Trio and Peter, Paul, and Mary; "Turn! Turn! Turn!" for the Byrds. He took part in the 1965 civil rights march on Selma, Alabama, and actively opposed the war in Vietnam. Seeger published his autobiography, *Where All the Flowers Gone*, in 1993 and was awarded the National Medal of Arts and a Kennedy Center Honor in 1994. In 1997 his album *Pete* received the Grammy for Best Traditional Folk Album.

8 PETE SEEGER, *Clearwater Revival, Croton-on-Hudson, New*

York, 2001. Seeger designed his long-neck banjo in 1955 and inscribed it with the words "This Machine Surrounds Hate and Forces It to Surrender." For many years he has been involved primarily in a campaign to restore the ecology of the Hudson River, traveling in the sloop *Clearwater* and giving benefit concerts on the shore.

10 FISK JUBILEE SINGERS, *Fisk University, Nashville, Tennessee, 2000*. In 1871, a student choir from Fisk University, which had been established as the Fisk Free Colored School for emancipated slaves six years earlier, toured the midwestern and northeastern United States to save the school from bankruptcy. The choir was named the Jubilee Singers after a phrase in the Old Testament that refers to the

year of Jubilee, when slaves would be freed. The original group was made up of eight singers and a pianist. At first, most of their repertoire

consisted of popular and classical songs, but they found that slave songs, or spirituals, received an enthusiastic response from white audiences. (African-American music had heretofore been performed by white minstrel musicians in blackface.) During the next few years the group gave hundreds of performances in the United States and Europe, on tours that were rigorous and exhausting. They performed at the White House and sang for Queen Victoria, and the funds they raised were used to construct the school's first permanent building, Jubilee Hall.

12 FISK JUBILEE SINGERS, *New York City, 2003*. The Jubilee
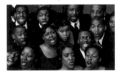
Singers group that performs today is made up of sixteen students who give concerts in Europe and the United States. The group was inducted into the Gospel Music Hall of Fame in 2000.

14 EDDIE COTTON, JR., with Jan Hobson, *Jackson, Mississippi,*
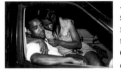
2000. Cotton was born in Jackson, Mississippi, in 1970. When he was two his family moved to Clinton, where his father became the pastor of the local Church of God in Christ, a popular African-American Pentecostal denomination. He began writing songs when he was ten, and sang and played for his father's congregation. Cotton majored in music at Jackson State College but left before graduation to form a band. He plays blues with gospel and soul overtones. His debut album, *Live at the Alamo Theater* (2000), contains original songs and Howlin' Wolf and Little Milton covers.

16 PO' MONKEY'S LOUNGE, *Merigold, Mississippi, 2000*. Great
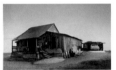
bluesmen such as Robert Johnson, Sonny Boy Williamson, Howlin' Wolf, and B. B. King started out playing in juke joints along the Mississippi Delta, where farm workers came to drink and dance. Po' Monkey's is located in cotton fields two miles down a gravel road, off Highway 61, in William "Po' Monkey" Seeberry's home, a turn-of-the-century sharecropper's shack that Seeberry turns into a juke joint every Thursday night. A hand-painted sign spells out the rules: "No beer bottles. No droopy jeans. $3 at the door. Cold beer and music." Po' Monkey's is one of the last surviving old-fashioned juke joints in the Delta. Competition from riverboat gambling casinos, which were legalized in Mississippi in the early nineties, has accelerated their demise.

18 B. B. KING, *Club Ebony, Indianola, Mississippi, 2000*. Since the
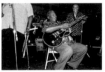
late sixties, when his gifts were recognized by British and then American rock musicians, B. B. King has had a profound influence on popular music. He was born in a sharecropper's cabin near Indianola, Mississippi, in 1925. His parents were separated when he was four, and his mother died when he was nine, leaving him pretty much on his own. He listened to bluesmen like Blind Lemon Jefferson and Arthur "Big Boy" Crudup on the radio, and when he was thirteen began playing his guitar on street corners in Indianola to supplement his earnings as a cotton picker and tractor driver. When he was twenty he went to Memphis, where he stayed with his mother's cousin, the classic Delta blues player Bukka White. In 1948 he appeared on Sonny Boy Williamson's radio show and soon had his own radio spot, on which he sang commercials for a health tonic. He got his first recording contract in 1949, and in the early fifties had several songs on the R&B charts. King toured constantly throughout the fifties and sixties, but it was not until 1968, when he appeared at the Fillmore in San Francisco, that he reached the wide, predomi-

nantly white, audience that made him famous. He toured with the Rolling Stones in 1969 and the following year had his biggest hit, a cover of Roy Hawkins's "The Thrill Is Gone," which won a Grammy. King's idiosyncratic way of playing the electric guitar, making it an extension of his voice, influenced blues guitarists such as Buddy Guy and Otis Rush and countless rock guitarists, including Jimi Hendrix and Eric Clapton. He was inducted into the Blues Foundation Hall of Fame in 1980 and into the Rock and Roll Hall of Fame in 1987. He received the Presidential Medal of the Arts in 1990 and a Kennedy Center Honor in 1995. In 1996 he published his autobiography, *Blues All Around Me*. In 2000, he made an album with Eric Clapton, *Riding with the King*, which sold nearly five million copies.

20 B. B. KING, *New York City, 2000*. In the nineties, King began

opening a series of blues clubs bearing his name, including one on Forty-second Street in New York. He spends most of his time on the road, playing at least two hundred club dates a year.

22 EDDIE COTTON, JR., with his cousins Manisha Heard and

Xavres Good, *Christ Chapel Church of God in Christ, Clinton, Mississippi, 2000*. The Church of God in Christ is one of the largest black Pentecostal churches in the country, with eight million members. Its world headquarters in Memphis includes Mason Temple, where Martin Luther King, Jr., gave his "Mountain-top" speech in 1968, a few hours before he was assassinated.

28 RALPH STANLEY, *Bill Monroe's cabin, Goodlettsville, Tennes-*

see, 2002. Since the death in 1996 of Bill Monroe, Ralph Stanley has been the most revered performer of bluegrass, although Stanley doesn't like to call his music that. For him it is simply "old-time mountain music," from the hills of Appalachia, where he was born in 1927. He and his brother, Carter, formed the Stanley Brothers in 1946 and wrote and recorded many songs, most of them mournful laments like "A Vision of Mother" and "The Lonesome River." Carter died in 1966 and Ralph continued making music as the leader of the Clinch Mountain Boys. He is known for his agile, high tenor voice and fiery three-finger banjo picking. In 2002 he received the Grammy for Best Male Country Vocal Performance for his rendition of "O Death" on the soundtrack to the film *O Brother, Where Art Thou?*, which also drew on other Stanley Brothers songs.

30 EMMYLOU HARRIS, *Franklin, Tennessee, 2001*. Harris was

born in Birmingham, Alabama, her mother's hometown, in 1947. She grew up in a suburb of Washington, D.C., near the base where her father, a marine pilot, was stationed. She wanted to be a folksinger, and spent two years in New York, playing in Greenwich Village clubs. She got married, had a child, was divorced, and in 1971 was back in Washington, living with her parents and playing in bars, when she met Gram Parsons, the influential progressive-country musician. Parsons introduced her to country music, and their collaboration, which ended with his death from a drug overdose in 1973, established the direction of her later work. Harris has an eloquent and distinctive soprano voice and a remarkable gift for harmony, which was first apparent on her two recordings with Parsons, *GP* and *Grievous Angel*. She subsequently recorded duets with many other musicians—including Roy Orbison, Neil Young, George Jones, Ralph Stanley, Willie Nelson, and Bob Dylan—and performed as a trio with Dolly Parton and Linda Ronstadt on two albums. Harris has made over two dozen records and received many Grammys and other awards. She often interprets the work of other songwriters, like Lucinda Williams and Steve Earle, but she wrote most of her own songs on the album *Red Dirt Girl* (2000). She lives in Nashville.

32 JOHNNY CASH with his grandchildren, Aran Schwoebel and
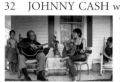
Caitlin Crowell, and his daughter, ROSANNE CASH, *Hiltons, Virginia, 2001*. Johnny Cash was born in 1932 and grew up in Dyess, Arkansas, in the Mississippi Delta, where his father was a sharecropper. In 1955 he was working unsuccessfully as an appliance salesman in Memphis, singing and playing with two friends, Luther Perkins and Marshall Grant, in his spare time, when Sam Phillips of Sun Records gave him a recording contract. Phillips had signed Elvis Presley, Carl Perkins, Jerry Lee Lewis, and Roy Orbison the previous year. He was drawn to Cash's artless bass-baritone voice and his dark and disturbing songs. In 1956, Cash's recording of "I Walk the Line" was the number-one country single and had crossed over onto the pop charts. Cash wrote, recorded, and toured relentlessly, performing regularly in penitentiaries. *Johnny Cash at San Quentin* was for many years the bestselling country album in history. In 1969 he recorded a duet with Bob Dylan, "Girl from the North Country," for Dylan's album *Nashville Skyline*, and become the host of *The Johnny Cash Show*, which ran for two years on ABC. Cash continued to tour and make hits through the seventies, but by the late eighties he was appearing in small venues and his health had declined. He was "rediscovered" in the nineties, and in 1994 his album *American Recordings*, produced by Rick Rubin, received a Grammy as the Best Contemporary Folk Album. Aran Schwoebel is the son of Cash's daughter Tara. Caitlin Crowell is the daughter of ROSANNE CASH and her first husband, the singer-songwriter Rodney Crowell. Rosanne was born in Memphis in 1955, but she grew up in Ventura, California. Her father was rarely at home, and as soon as she graduated from high school she joined him on the road and worked on his tours for three years. She and Crowell were married in 1979, and he produced her first U.S. album, *Right or Wrong*, and then *Seven Year Ache*, which had three number-one country hit songs on it. In 1985 she received the Best Female Country Vocal Performance Grammy for "I Don't Know Why You Don't Want Me," and in 1987 her album *King's Record Shop* had four number-one songs. She and Crowell were divorced in 1992, an experience that was reflected in the themes of her critically acclaimed album *The Wheel* in 1993. Cash moved to New York, where she now records and writes. She is married to the songwriter and producer John Leventhal, with whom she collaborated on *Rules of Travel* (2003), which includes a duet with her father.

34 DOLLY PARTON, *Pigeon Forge, Tennessee, 2002*. Parton
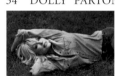
became a country star in the early seventies, and a few years later she had crossed over into mainstream pop stardom, making her clear soprano voice, voluptuous figure, and blond wig recognizable to millions of people. She was born on a farm in the Smoky Mountains of Tennessee in 1946, the fourth of twelve children in a poor family. She appeared at the Grand Ole Opry when she was twelve, and was a regular on a Knoxville television show when she was a teenager. Parton moved to Nashville in 1964, and three years later joined Porter Wagoner's country music show, where she was known as "Miss Dolly." She and Wagoner became a recording duo with many country hits. She stopped working with him in 1974 and recorded her first major pop hit, "Here You Come Again," in 1977. Parton writes many of the songs she records, and several of these have become hits for others. Whitney Houston covered "I Will Always Love You," Emmylou Harris sang "Coat of Many Colors," and Maria Muldaur recorded "My Tennessee Mountain Home." In 1980 Parton was nominated for an Oscar for her work in the film *9 to 5*, in which she costarred with Lily Tomlin and Jane Fonda. Her recording of the *9 to 5* theme song was number one on both the country and pop charts. She has made several other films and had, briefly, her own television show. In 1986 she opened Dollywood, a theme park in her hometown, Pigeon Forge. The Dollywood Foundation develops and administers educational programs for the children of Sevier County, Tennessee, and supports the work of similar programs in the United States and abroad. Parton was inducted into the Country Music Hall of Fame in 1994.

36 PORTER WAGONER at the back door of the Ryman Audito-

rium, *Nashville, 2001.* Wagoner has been a member of the Grand Ole Opry since 1957. He was born in 1927 in the Ozark Mountains of Missouri, and learned to play country music by listening to the radio. When he was a teenager he was featured on a local radio show. In 1951 he got his own program on a station in Springfield, Missouri, and four years later he had a number-one country hit, "A Satisfied Mind." He began hosting a syndicated television show out of Nashville in 1961, establishing his persona as a rhinestone-studded cowboy clad in garish boots, and by the seventies the show was carried by more than a hundred stations. It remained on the air for twenty years. Wagoner added Dolly Parton, who was then unknown, to the program in 1967, and they soon began recording duets together. They had several Top Ten hits, including "The Last Thing on My Mind" and "Just Someone I Used to Know," which won a Grammy in 1969. After Parton and Wagoner stopped performing together in 1974, he became more involved in producing other musicians, not all of them country singers. He was inducted into the Country Music Hall of Fame in 2002.

38 FLACO JIMENEZ, *San Antonio, Texas, 2001.* Jimenez, who

was born in San Antonio in 1939, is a third-generation player of *conjunto*, a Tex-Mex musical style influenced by the waltzes and polkas of nineteenth-century German and Czech immigrants. He plays the accordion, accompanied by a *bajo sexto*—an oversized twelve-string guitar—and bass and drums. Jimenez is a "progressive" player, drawing on country and rock elements, and he sings in both English and Spanish. He has recorded with many other musicians, including Doug Sahm, Bob Dylan, Dr. John, the Rolling Stones, Ry Cooder, Emmylou Harris, Dwight Yoakam, and Buck Owens. He has received five Grammy awards.

40 GEORGE JONES in his tour bus, *Franklin, Tennessee, 2002.*

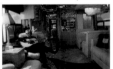

Jones's multi-octave vocal technique and emotionally authentic delivery are legendary. He was born in 1931 and grew up near the Gulf town of Beaumont, Texas. From the beginning his life was dramatic, lending credibility to his melancholy ballads about heartbreak and human weakness. His father drank heavily and was often violent. Jones began singing in a Pentecostal church and when he was in his early teens earned money performing on the streets of Beaumont for change. He finished the seventh grade, left home, joined the marines, and was married and divorced by the time he was twenty. He recorded a few songs, emulating the style of Hank Williams, and in 1955 had his first country hit, "Why Baby Why." By the late fifties and early sixties he was enormously popular, with songs like "White Lightning" and "The Windows Up Above," but his success was accompanied by excessive drinking and drug use. In 1975 a stormy five-year marriage to Tammy Wynette ended in divorce, although they continued to record and perform together. In the eighties, with the help of his fourth wife, Nancy, Jones remedied his substance-abuse problems, and he continues to perform and tour. He was inducted into the Country Music Hall of Fame in 1992 and in 1996 published his autobiography, *I Lived to Tell It All.* He received a Grammy for Best Male Country Vocal Performance in 1999, and was awarded a 2002 National Medal of Art.

42 THE DIXIE CHICKS, *Kemper Arena, Kansas City, Missouri,*

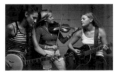

2003. The original Dixie Chicks was a neo-cowgirl quartet that was popular in Texas in the early nineties. The later Dixie Chicks is a trio who became country music superstars in spite of doing—or perhaps because they did—unconventional things, like playing their own instruments and singing irreverent songs about wives who poison their abusive husbands ("Goodbye Earl"). Lead

singer Natalie Maines (b. 1974 in Lubbock, Texas) joined two members of the original group, Emily Robison (b. 1971 in Pittsfield, Massachusetts) and Martie Maguire (b. 1969 in York, Pennsylvania), in 1995. Maines is the daughter of the producer and steel-guitar player Lloyd Maines, who played with Joe Ely, and she brought a brashness and a pop-rock sensibility to the trio. The other two members, who are sisters, play traditional instruments, the banjo (Robison) and the fiddle (Maguire). Their first album together, *Wide Open Spaces* (1998), sold more than ten million copies, as did *Fly,* which they released in 1999. They won three Grammys and several country-music awards, and in 2001 sued their label, Sony, for "systematic thievery." The suit was settled out of court. In the meantime, the Chicks had recorded material for a new album, *Home,* which was heavily influenced by bluegrass. It was released in the summer of 2002 and won three Grammys. The Dixie Chicks achieved a certain notoriety in the spring of 2003 when Maines alienated some of their country-music constituency by criticizing the Bush administration's intention to invade Iraq. All three members of the group live in Texas.

44 RAMBLIN' JACK ELLIOTT and ODETTA, *The Bitter End,*

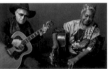

New York City, 2000. Ramblin' Jack was born Elliott Charles Adnopoz in Brooklyn in 1931. His father was a doctor. Inspired by cowboy movies, he ran away from home when he was fifteen and joined a rodeo, where he learned to play the guitar. In the early fifties he lived in Greenwich Village and sang and played in coffeehouses and clubs. He met Woody Guthrie and lived with the Guthrie family in Brooklyn for a time, then worked in Europe, performing American music that often included Guthrie songs like "Pretty Boy Floyd." By this time he had become Ramblin' Jack. He returned to the United States, and has for many years traveled around the country, appearing at folk festivals and giving concerts. He met Bob Dylan through Woody Guthrie, and Elliott's influence can be heard in Dylan's early work. Ramblin' Jack's performances include long spoken sections during which he tells stories while he strums the guitar, and it has been said that the "Ramblin'" in his name refers as much to his narrative style as to his actual traveling. He inspired many younger musicians, including Jackson Browne, John Prine, Kris Kristofferson, and Tom Waits. In 1995 his album *South Coast,* which included folk classics he had recorded in other versions, won a Grammy. He received the National Medal of Arts in 1999. ODETTA was born in Birmingham, Alabama, in 1930 but grew up in Los Angeles. She studied music at Los Angeles City College, and her first professional experience was as a member of a touring company of *Finian's Rainbow.* She was almost twenty when she heard folk music in clubs in California and taught herself to play the guitar. Her performances in San Francisco and then in New York, at the Blue Angel, brought her to the attention of Pete Seeger and Harry Belafonte, who supported her early on. She sang "If I Had a Hammer," "He's Got the Whole World in His Hands," and "Sometimes I Feel Like a Motherless Child" in a rich, powerful voice that shaped the songs dramatically. Odetta was active in the civil-rights movement, marching with Martin Luther King, Jr., in Selma and singing at the marches on Washington. She has made many records, toured widely, and influenced countless singers, including Joan Baez, Janis Joplin, and Bob Dylan, who said he bought his first acoustic guitar because of her. She received a medal from the National Endowment for the Arts in 1999.

46 DON WALSER and the Pure Texas Band, *Broken Spoke dance*

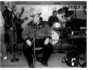

hall, Austin, Texas, 2001. Walser, with his agile tenor voice and mean yodel, scrupulously upholds the traditions of Western swing and Texas honky-tonk, which in the late nineties made him so cool that he recorded with the Kronos Quartet. He was born in the little west Texas town of Brownfield in 1934. He learned to sing and play the guitar by listening to the radio and duplicating what he heard, and he played in bands, on and off, from the time he was sixteen. He started working in the oil fields when he was fifteen, and in 1957 became a career member of the National Guard, first as a mechanic and then as

an administrator. He performed on weekends until his retirement in 1994, when he recorded his first album, *Rolling Stone from Texas*. He had been living in Austin for ten years by then and had developed a cult following, including the members of the Butthole Surfers, who shared a club date with him. In 1998 he made *Down at the Sky-Vue Drive-In,* which included songs of Jimmie Rodgers and the Louvin Brothers, and a collaboration with the Kronos Quartet on Oscar Hammerstein's "Rose Marie." In 2000 he was the subject of a documentary film, *Pavarotti of the Plains,* and was awarded a National Heritage Fellowship from the National Endowment for the Arts.

48 LONGHORN STEER, *Dripping Springs, Texas, 2001.*
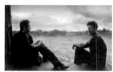
Dripping Springs is a little town (pop. slightly over 1,000) about twenty-five miles west of Austin. The area was settled by farmers in the middle of the nineteenth century. Willie Nelson held his famous Fourth of July picnics there for over twenty years, starting in 1972.

50 ROBERT EARL KEEN and LYLE LOVETT, *Dripping*
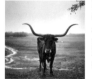
Springs, Texas, 2001. Keen and Lovett met at Texas A&M University, where they were both students and where they began their musical careers. They have become two of the most popular singer-songwriters in Texas. ROBERT EARL KEEN was born in a suburb of Houston in 1956. He formed a bluegrass band at Texas A&M, and after he graduated, with a degree in English, he moved to Austin, where he worked in bars and clubs and made his first record, *No Kinda Dancer* (1984). He spent a few years in Nashville, earning a living as a songwriter, and moved back to Texas in 1987, settling in Bandera, an hour west of San Antonio. He has made several albums, and his songs have been covered by many other musicians, including Lovett, Nanci Griffith, the Dixie Chicks, George Strait, and the Highwaymen—Waylon Jennings, Kris Kristofferson, Willie Nelson, and Johnny Cash—who named one of their albums, *The Road Goes on Forever,* after a Keen song. LYLE LOVETT was born in 1957 in Klein, a farming community north of Houston that was named after his great-great grandfather, a German immigrant who settled there in the 1840s. He studied journalism at Texas A&M and began writing songs and performing in coffeehouses and clubs. Even though his first album, *Lyle Lovett* (1986), contained five country-and-western hits, it drew on other styles of music, including folk, rock, and jazz. His second album, *Pontiac* (1988), was even more eclectic. Lovett began touring and recording with His Large Band, which includes guitars, a cellist, a pianist, horns, and a gospel singer. He has won four Grammys, including Best Male Country Vocalist in 1989 (for *Lyle Lovett and His Large Band*) and Best Country Album (*The Road to Ensenada*) in 1998. His album *Step Inside This House* (1998) is a tribute to Texas songwriters, including Robert Earl Keen. Lovett has a second career as an actor, most notably in several of the films of Robert Altman.

52 WILLIE NELSON, *Luck Ranch, Spicewood, Texas, 2001.* One

of the most prolific singer-songwriters in the history of American music, Nelson (b. 1933) was raised in Abbott, Texas, about twenty-five miles north of Waco. When he was six years old he began playing the guitar and writing songs, and by the time he was ten he was performing in local dance halls. He worked as a bible salesman, a tree-trimmer, and a DJ in Vancouver, Washington, and Fort Worth before moving to Nashville, where he sold his songs (he sold "Night Life" for a hundred dollars). Many of the songs, like "Crazy," recorded by Patsy Cline, and "Hello Walls," sung by Faron Young, became hits. Nelson recorded several albums of his own but was not commercially successful as a singer until the mid-seventies, when he made *Red Headed Stranger,* a concept album about a killer on the run. By then he had grown long hair and a beard and was living in Austin, where he was the central figure in a group of progressive-country musicians who were known as the Outlaws. *Wanted! The Outlaws,*

with Nelson, Waylon Jennings, Tompall Glaser, and Jessi Colter, was the first country album to sell a million copies. Nelson's annual Fourth of July picnic, which was started in Dripping Springs, Texas, in 1972, was for years one of the country's most popular music festivals, and the Farm Aid concerts that he helped found have raised millions of dollars. Nelson has a distinctive, whiskey-flavored tenor voice that he uses like a jazz musician, and in live performances he and his band, the Family, improvise. He has recorded over a hundred albums, several of them, such as *Stardust* (1978), consisting of pop standards. He was a Kennedy Center honoree in 1998 and received a Grammy Lifetime Achievement Award in 2000.

58 THE NORTH MISSISSIPPI ALL-STARS, *Coldwater, Missis-*
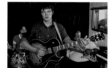
sippi, 2000. The core of the All-Stars, who play a punky electric version of hill-country blues, is two white boys from Memphis in love with the classic sounds made by black musicians like Mississippi Fred McDowell, R. L. Burnside, Othar Turner, and Junior Kimbrough, who are at least two generations older than they are. Luther Dickinson, vocals and guitar (b. 1973), and Cody Dickinson, drums (b. 1976), are the sons of Jim Dickinson, a well-known Memphis producer and pianist who has worked with Ry Cooder, the Rolling Stones, and Bob Dylan, among many other interesting musicians. They persuaded their parents to move to a trailer in a little town about forty miles south of Memphis, and as soon as Luther could drive they headed over every weekend to Junior Kimbrough's juke joint in Holly Springs. Othar Turner, the venerable fife player, became Luther's mentor, and in 1998 Luther produced Turner's first full-length record, *Everybody Hollerin' Goat.* He also produced *From Senegal to Senatobia* (2000), a collaboration with Turner and some Senegalese musicians from Chicago. The brothers had formed the All-Stars in 1996 with Chris Chew, bass (b. 1973), a friend with a gospel-music background. Their first record, *Shake Hands with Shorty* (2000), got rapturous reviews from mainstream critics in national newspapers and magazines, as did *51 Phantom* (2001) and *Polaris* (2003). Rootsy but not retro, the critics said. "It's not really blues. It's rock and roll," Luther said.

60 JUNGLE ROOM, *Graceland, Memphis, Tennessee, 2001.* In

1957, Elvis Presley bought Graceland, a colonial-style limestone mansion that was built in 1939. In the mid-sixties, he added a den to it, the Jungle Room, which has shag carpeting on the floor and ceiling, a waterfall, ceramic tigers, and fur-covered furniture. He used it as a recording studio and made his last two studio-session albums there. Over six hundred thousand people visit Graceland every year.

62 DUANE EDDY and LES PAUL, *Mahwah, New Jersey, 2000.*
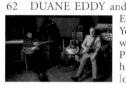
Eddy was born in 1938 in Corning, New York, and began playing the guitar when he was five. He moved with his family to Phoenix, Arizona, in 1951, dropped out of high school, and began performing with local dance groups. The producer Lee Hazlewood became his mentor, and Eddy recorded nearly twenty hits for him in the fifties, including "Rebel Rouser" and "Forty Miles of Bad Road." Eddy's "twangy" guitar style was extremely influential on, among others, George Harrison. In 1977, Harrison, Paul McCartney, and Ry Cooder helped produce his album *Duane Eddy.* He was inducted into the Rock and Roll Hall of Fame in 1994. LES PAUL was born in Waukesha, Wisconsin, in 1915. He became interested in electronics when he was a boy, around the time he learned to play the harmonica, the guitar, and the banjo. When he was seventeen he was playing for a radio-station band, and in the thirties he formed the Les Paul Trio, which was a regular on Fred Waring's radio show in New York. By 1941, Paul had built a prototype of a solid-body electric guitar. He moved to Los Angeles, where he constructed a studio in his garage and developed such recording techniques as close-miking.

echo delay, and multitracking. In the late forties he married the singer Mary Ford, and they recorded several hit songs together, including "Mockin' Bird Hill" and "Vaya Con Dios." In 1952 the Gibson guitar company began marketing Les Paul guitars. Paul built the first eight-track tape recorder and invented overdubbing. He was inducted into the Rock and Roll Hall of Fame in 1988 and received a Grammy for his technical achievements in 2001.

64 STAX RECORDS REUNION: Donald "Duck" Dunn, Steve
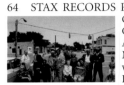
Cropper, Booker T. Jones, Eddie Floyd, Carla Thomas, William Bell, Estelle Axton, Al Bell, Deanie Parker, Yvonne Staples, Mavis Staples, David Porter, Isaac Hayes, with neighborhood boys, Marrigus Ingram, Darryl Bolton, Marquel Combs, and Dedrick Gray, *Memphis, Tennessee, 2002.* Between 1960, when Rufus and Carla Thomas recorded "'Cause I Love You" in the Stax Records studio in an old theater on East McLemore Avenue in Memphis, and 1975, when the company went bankrupt, Stax was the principal purveyor of the "Memphis sound," a soulful fusion of white country music and black gospel, backed up by a simple rhythm section and horns. Stax was founded by Jim Stewart and his sister, Estelle Axton. (The company's name was formed by combining the first two letters in each of their last names.) It was a casual, family operation. Booker T. Jones was a high-school student who hung around the record shop Estelle had set up in the old theater lobby. He formed what would become the house band, Booker T. and the MGs, which included Steve Cropper on guitar and Donald "Duck" Dunn on bass. In 1962, "Green Onions," a tune they fooled around with during empty studio time, became a number-one hit. Otis Redding, who had been hired as the driver for a band from Georgia, used the leftover time during a session to record "These Arms of Mine," which went to number twenty on the R&B charts. William Bell, a soul singer who had worked with Rufus Thomas's band in the fifties, came to Stax as a songwriter and performer. Eddie Floyd also wrote songs for many Stax artists, and in 1966 his own demo of "Knock on Wood," written for Redding, was released and reached number twenty-eight on the charts. The unknown Sam and Dave teamed up with the young writing team of Isaac Hayes and David Porter, and together they produced songs like "Hold on, I'm Comin'," Sam and Dave's first number-one record. In 1967, the company's top acts went on a European tour and were treated like superstars. Otis Redding and Booker T. and the MGs introduced the Memphis sound to a new audience at the Monterey Pop Festival that year. But Redding was killed in a plane crash a few months later, and in 1968 Atlantic Records, which had always distributed Stax, was sold, along with the company's master recordings. The following year Isaac Hayes recorded *Hot Buttered Soul,* which would become the best-selling record in the company's history, and the Staple Singers signed on with the label and had several gospel-soul crossover hits. Stax was owned briefly by Gulf & Western, but became independent again in 1970, and Al Bell, the company's vice-president, became a co-owner and then chairman and director. The company folded in 1975, and the building that housed it was demolished in 1989. After many years as a weedy lot, it is now the site of the Stax Museum of American Soul Music, directed by Deanie Parker.

66 ARETHA FRANKLIN'S FIRST HOME, *Memphis, Tennessee,*

2002. Franklin was born in Memphis in 1942. Her father was the Reverend C. L. Franklin, the pastor of the New Salem Baptist Church, which was then quite small, with a membership of only two hundred and fifty people. Her mother, Barbara, was the church pianist. In 1946, the Franklins moved to Detroit.

68 ARETHA FRANKLIN, *Bloomfield Hills, Michigan, 1993.* The Queen of Soul. She grew up in Detroit, where her father, Reverend Franklin, was the charismatic leader of the large New Bethel Baptist Church congregation. Jesse Jackson called him "the most imitated soul preacher in history." He was also a famous gospel singer, and Aretha often accompanied him on preaching tours. She made her

first recordings singing with her father when she was a teenager. She
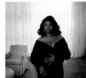
also became an unwed mother in Detroit, and had had two children by the time she was seventeen. In 1960 she moved to New York, where John Hammond signed her to a recording contract with Columbia. But Franklin didn't have a great deal of success until 1967, after her Columbia contract had expired and she had signed with Atlantic. Her first album on the new label was *I Never Loved a Man the Way I Love You,* which made her almost immediately one of the best-loved singers in the country. The opening cut, "Respect," was number one on both the pop and R&B charts and won two Grammys. It was interpreted as reflecting the Zeitgeist in terms of black activism, feminism, and sexual liberation. She sold millions of influential albums during the next few years, recording songs such as "(You Make Me Feel Like) A Natural Woman," "Chain of Fools," "Think," and "Spirit in the Dark," which were defined by her remarkable two-octave jumps, whoops, call-and-response gospel styling, and sensual R&B phrasing. In 1987 she won a Grammy for Best Female R&B Vocal Performance and became the first woman to be inducted into the Rock and Roll Hall of Fame.

70 HANK WILLIAMS III, *Nashville, 2000.* Except for his tattoos
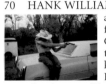
and braid, Hank III looks remarkably like his famous grandfather, who died in the back of a Cadillac on January 1, 1953, at the age of twenty-nine, the victim of alcohol and pain-killers, twenty years before Hank III was born. He sounds like him too, or can when he wants to, as he does on "I'm a Long Gone Daddy," his contribution to *Timeless,* the Hank Williams covers album released in 2000, on which Keith Richards sings "You Win Again." Hank III was born Shelton Hank Williams. He grew up in Nashville, mostly, listening to KISS and Black Sabbath and playing drums in punk bands. His first two albums, *Risin' Outlaw* (1999) and *Lovesick, Broke and Driftin'* (2002) show off his honky-tonk side. In performance he and his five-piece band do a honky-tonk set and then a sort of country-metal set.

72 LUCINDA WILLIAMS, *Austin, Texas, 2001.* Williams (b.
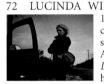
1953) grew up in the South, where her father, a college professor and poet, taught at a succession of schools. She began to perform in clubs in Austin and Houston, and in 1988 released *Lucinda Williams,* the album that established her reputation as a singer-songwriter. Her greatest commercial and critical success came ten years later with *Car Wheels on a Gravel Road,* which won a Grammy for Best Contemporary Folk Record. Williams's mournful, bittersweet songs have been covered by many other singers, including Mary Chapin Carpenter ("Passionate Kisses"), Emmylou Harris ("Sweet Old World"), and Tom Petty ("Changed the Locks"). In 2002 she received a Grammy for Best Female Rock Performance for "Get Right with God," a single from her album *Essence.* Her seventh album, *World Without Tears,* was released in 2003.

74 JUNE CARTER CASH and JOHNNY CASH at the house of
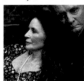
Maybelle and Ezra Carter, *Hiltons, Virginia, 2001.* Johnny Cash and June Carter were married in 1968. It was a second marriage for both. She had been singing with him since the early sixties, and she co-wrote one of his biggest hits, "Ring of Fire," which is about their relationship. June Carter was born in Maces Spring, Virginia, in 1929, two years after her mother, Maybelle, and her uncle and aunt, A. P. and Sara Carter, made their first recordings of Appalachian songs for the Victor Talking Machine Company. The legendary Carter Family later performed on popular radio shows broadcast all over the country, and June and her two sisters toured with their mother as Mother Maybelle and the Carter Sisters. June was a gifted comedian and actress as well as a singer. She and Johnny Cash had a son, John Carter Cash. She died of heart failure on May 15, 2003.

80 HIGHWAY 61, *Greenville, Mississippi, 2000.* U.S. Highway 61

follows, more or less, the Mississippi River north from New Orleans to Minneapolis, but the legendary part of it runs for about two hundred and fifty miles along the Mississippi Delta, between Vicksburg and Memphis. At the crossroads with Highway 49, just outside of Clarksdale, Robert Johnson sold his soul to the Devil in exchange for his guitar-playing skills. The Delta Blues Museum is in Clarksdale. Memphis Minnie, Charlie Patton, Muddy Waters, Howlin' Wolf, Son House, and Sonny Boy Williamson all lived nearby at one time or another. Many archetypal Delta juke joints and cafes were on Nelson Street in Greenville, where the Delta Blues Festival is held every year.

82 JOHNNIE BILLINGTON with his students Jarvis Cole,

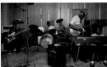

Ranreco Freeman, and Brian Freeman, *Lambert, Mississippi, 2001.* Billington was born in 1935 in Crowder, Mississippi, a small Delta town about twenty miles east of Clarksdale. He began playing the guitar when he was ten. He left the Delta in 1954 and eventually moved to the Chicago area, where he owned an automobile repair shop and played with local bluesmen, including Muddy Waters and Elmore James. In the late seventies he returned to Mississippi and settled in Clarksdale, where he opened another automobile repair shop and also began teaching children to play the blues, using his shop as a rehearsal space. In 1992 his informal school became the Delta Blues Education Program, a not-for-profit organization staffed by volunteers. Billington is the primary teacher and artistic director. He and some of his students perform as JB and the Midnighters.

84 EDDIE CUSIC, *Leland, Mississippi, 2000.* Cusic was born near

Leland in 1926. He learned to play the guitar when he was a child by watching musicians at juke joints and by practicing on a modified diddley bow, a piece of wire attached to the wall of his house. In the early fifties he formed a band, the Rhythm Aces, that played electric blues. It included Little Milton, who would later become famous and would acknowledge Cusic's influence on his guitar playing. Cusic served in the army, and when he returned home he toured with his band for a while, but he became discouraged by the financial difficulties that went with being a musician in the Delta during that period, and he stopped playing altogether. He became a mechanic with the Department of Agriculture. When he retired in 1989 he began performing again, this time alone, with an acoustic guitar. He released his first and only album, *I Want to Boogie,* in 1998.

86 JOHN LEE HOOKER, *Los Altos, California, 2000.* Hooker's

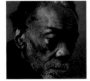

hypnotic, driving guitar work and gruff singing inspired sixties blues-rock musicians in England and America. He was born in 1917 near Clarksdale, Mississippi, one of eleven children in a sharecropping family. His stepfather was a blues singer and guitarist, and he taught Hooker how to play what he called "country boogie"—a one-chord, rhythmic, foot-stomping style. Hooker left home in the early thirties and worked for a while in Memphis, then moved to Cincinnati and Detroit, where he recorded his first single, "Boogie Chillen," in 1948. It hit number one on the R&B charts. He began playing an electric guitar in 1949, although in the late fifties and early sixties he cut down on its amplification or used an acoustic guitar to accommodate the tastes of the patrons of folk clubs. In 1970 he moved to northern California. He appeared in a number of concerts with Bonnie Raitt in the seventies and continued to play in clubs throughout the eighties. In 1989 he recorded *The Healer,* which contained "I'm in the Mood," a duet with Raitt that won a Grammy. Hooker was inducted into the Rock and Roll Hall of Fame in 1991. He opened a club, the Boom Boom Room, in San Francisco in 1997

and released the album *Don't Look Back,* which won a Grammy. In 2000 he received a Grammy Lifetime Achievement Award. He died at his home in Los Altos, California, on June 21, 2001.

88 CEDELL DAVIS, *Como, Mississippi, 2000.* Davis plays guitar in

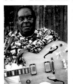

an absolutely unique style, picking and strumming with his left hand and using his right hand to press a metal knife on the strings of the neck. He was born in 1927 in Helena, Arkansas, a town on the west side of the Mississippi, twenty-five miles north of Clarksdale. He had polio when he was ten, and his hands were crippled, particularly his right hand, so he turned the guitar around and learned to play left-handed. He borrowed a butter knife from his mother and used it as a slide. He played in juke joints for many years, and he and Robert Nighthawk worked as partners in St. Louis in the fifties and early sixties. In 1957 Davis was badly injured in a police raid at a tavern. He has been largely confined to a wheelchair since then. In 1994 he made two solo albums, *CeDell Davis* and *Feel Like Doin' Something Wrong,* and in 2002 he recorded *When Lightnin' Struck the Pine,* which also features Peter Buck, the R.E.M. guitarist.

89 JESSIE MAE HEMPHILL, with Sweetpea, *Como, Mississippi,*

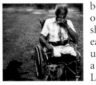

2000. Jessie Mae Hemphill is the granddaughter of the renowned north Mississippi hill-country maestro Blind Sid Hemphill, who could play, as he told Alan Lomax, "guitar, fiddle, mandolin, snare drums, fife, bass drum, quills, banjo, and organ." Blind Sid Hemphill was also a composer and singer of note, and Jessie Mae began to play drums with him when she was nine. Women drummers are rare in north Mississippi, but Hemphill is an unusual woman. She was one of the few female blues singers who played electric guitar, and she wrote her own songs. She supplied percussion with leg bells and a tambourine tied to her foot. She didn't shout the blues but sang in a mellifluous style that complemented her rhythmic guitar playing. Hemphill was born in Como in 1933. She played on Beale Street in Memphis and in bars all over Mississippi and made her first recording in 1979 for a small record company established by an ethnomusicologist at Memphis State University. The recordings were sold locally. In the early eighties, while Hemphill was on tour in Europe, a French record company gathered her music together for an album called *She-Wolf.* She won the Blues Foundation's W. C. Handy award for Best Traditional Female Blues Artist in 1987 and 1988 even though she had not yet released an album in the United States. Her first American album, *Feelin' Good,* was released in 1990 and won the W. C. Handy award for Best Acoustic Album. She had a stroke in the early nineties and more or less retired from performing.

90 WILLIE FOSTER, *Greenville, Mississippi, 2000.* Foster was born on a cotton farm near the small Delta town of Leland, Mississippi, in 1921. His family were sharecroppers. When he was eight years old he earned money pumping water for mules and used two weeks' pay—twenty-five cents—to buy a harmonica in a drugstore. He moved to St. Louis when he was eighteen and got his first paying job as a musician there in the early fifties, playing harmonica in a trio. He performed with Muddy Waters and other blues musicians in Chicago and traveled with Waters' band. Foster made his first recordings in the mid-fifties, but returned to Mississippi in the early sixties and did not record again until 1993, when he began to tour around the United States and abroad with his band, the Rhythm and Blues Upsetters. His final album was *Live at Airport Grocery,* which was released in 1999; by then he was legally blind and had lost both legs from illness. He died on May 20, 2001, a few hours after performing at a private party in Jackson, Tennessee.

92 ABIE "BOOGALOO" AMES, *Greenville, Mississippi, 2000.* Ames was born in Athens, Georgia, in 1918. He began to teach himself to play the piano when he was four, learning songs by listening to

the radio. His family moved north when he was young, and he grew up in Detroit, where he formed a group that performed locally. He

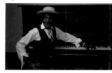

toured Europe with Louis Armstrong and worked as a bandleader in the forties and as a studio musician. In the sixties he returned to the South and settled in Greenville, Mississippi. He was well known in Delta clubs and was an influential teacher of blues and jazz. One of his students, Eden Brent, who had a degree in music from the University of North Texas, became his partner, and they performed as a duo for almost twenty years. They appeared together at the Kennedy Center in 2000. In 2001 Ames collaborated with Cassandra Wilson on her album *Belly of the Sun.* He died in Greenville on February 4, 2002.

94 KENNY MALONE KIMBROUGH, his cousin Sharonie

Kimbrough, Gary Burnside, Sonya Jackson, and Bobby Readus, *Holly Springs, Mississippi, 2000.* Kenny Malone Kimbrough (b. 1966) is the son of the late Junior Kimbrough, whose intense, mantra-like songs and primal electric-guitar style were revealed to a wide audience in the early nineties, when Robert Palmer recorded his work for *Deep Blues,* a documentary film on the music of the north Mississippi hill country. Junior Kimbrough was an influential musician, but he was also well known for the juke joint he ran in Holly Springs. It was an important gathering place for blues players, neighbors who came to dance, and, in the late nineties, tourists. Junior died in 1998, and Kenny and his brother David ran the juke joint until early 2000, when it burned down. Kenny, who plays drums, began to perform with his father when he was thirteen. He and Gary Burnside, the son of R. L. Burnside, have a group called the Soul Blues Boys.

96 R. L. BURNSIDE with his grandson Cedric Burnside, his

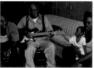

great-granddaughter Shundrianna Jackson, and her stepfather, Mitchell Jackson, *Holly Springs, Mississippi, 2000.* Burnside was born in 1926 in Harmontown, in the North Mississippi hill country. His family were sharecroppers. When he was a teenager, a neighbor, the great bluesman Fred McDowell, taught him to play the guitar. Burnside moved to Chicago in the forties and worked in a foundry along with his cousin's husband, Muddy Waters. After two of Burnside's brothers and his father were killed in Chicago, he went back to Mississippi, where he worked again as a sharecropper. He killed a man in the sixties and spent six months in jail. Burnside performed for years in local juke joints and recorded on small labels but wasn't known to a wider public until 1992, when he appeared in the documentary film *Deep Blues.* Since then he has made several albums, including *Too Bad Jim* (1994); *A Ass Pocket of Whiskey* (1996), with the New York punk trio Jon Spencer Blues Explosion; *Wish I Was in Heaven Sitting Down* (2000), which was edited and looped as if it were a hip-hop record; and *Burnside on Burnside* (2001), a live album. He and his band toured with the Beastie Boys in the mid-nineties, and he has appeared on two compilations of music from *The Sopranos.* He received the 2003 W. C. Handy award from the Blues Foundation for Traditional Male Artist of the Year.

98 CEDRIC BURNSIDE, *Holly Springs, Mississippi, 2000.* R. L.

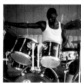

Burnside's grandson Cedric (b. 1978) plays the drums with his grandfather and is a member of a band led by Kenny Brown, who also plays rhythm guitar with Cedric and R. L. Burnside. Cedric brings a hip-hop influence to their music.

100 HUBERT SUMLIN and PINETOP PERKINS, *Maple Leaf Bar, New Orleans, 2003.* Sumlin was Howlin' Wolf's guitarist for twenty years, and his imaginative playing influenced, among others,

Jimi Hendrix, Eric Clapton, and Keith Richards. He was born in 1931 in Greenwood, Mississippi, the youngest of thirteen children. When

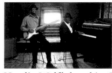

he was eight years old, his mother spent a week's wages on his first guitar. He began playing in clubs when he was twelve, and by the time he was seventeen he was touring with James Cotton, who had been a childhood friend. In 1954, Sumlin joined Howlin' Wolf's band in Chicago and, at Wolf's request, stopped using a pick and developed a unique finger-picking technique. Many of their classic recordings—for instance, "Killing Floor," "Backdoor Man," "Shake for Me," and "Red Rooster"—were covered by such artists as the Rolling Stones, Led Zeppelin, and Hendrix. Sumlin retired for a time after Howlin' Wolf died, in 1976, but returned to music in the eighties. JOE WILLIE "PINETOP" PERKINS was born in Belzoni, Mississippi, in 1913. He began his career as a guitarist, but he was stabbed in the arm and the injury forced him to change instruments. He became a pianist and played for five years with Sonny Boy Williamson on the *King Biscuit Time* radio show, toured with Robert Nighthawk and Earl Hooker, and worked with B. B. King in Memphis. In 1969 he replaced Otis Spann in Muddy Waters' band. Perkins won a W. C. Handy award every year between 1992 and 2001. In 1998, he and Hubert Sumlin recorded *Legends,* a mix of traditional Delta blues and electric-guitar-based rock, which was nominated for a Grammy. Perkins was inducted into the Blues Hall of Fame in 2003.

102 OTHAR TURNER, *Gravel Springs, Mississippi, 2000.* Turner

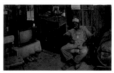

was the conservator of African-American fife-and-drum music, which predates the blues. He was born in 1908 and grew up in the north Mississippi hill country, chopping cotton and plowing fields. When he was a teenager he began playing a tin tub and then drums, and taught himself how to make and play a cane fife. Turner earned enough money performing at local picnics to buy a farm in Gravel Springs, where he and his wife raised four children. The great bottleneck guitar bluesman Fred McDowell lived nearby, and the two men played together. Turner directed the folk archivist Alan Lomax to McDowell, and in the late seventies Lomax recorded Turner's music. Turner made his fifes from bamboo growing on the bottomland of his farm, and he and his family formed the Rising Star Fife and Drum Band. He appeared on several blues anthologies and made his first full-length record album, *Everybody Hollerin' Goat,* in 1998 and *From Senegal to Senatobia* in 2000. Turner received many honors, including a National Endowment for the Arts Heritage award and the Smithsonian Lifetime Achievement award. He died at his home in Gravel Springs on February 27, 2003.

106 THE ROOTS: Kyle Jones (Scratch), human beatbox; James

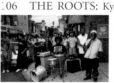

Gray (Kamal), keyboards; Ahmir Khalib Thompson (?uestlove), drums; Leonard Nelson Hubbard (Hub), bass; Tarik Trotter (Black Thought), vocals; *Philadelphia, Pennsylvania, 2000.* Tarik Trotter (b. 1973) and Ahmir Thompson (b. 1971) formed the Roots in 1987, when they were attending Philadelphia's High School for the Performing Arts. Trotter rapped over Thompson's drums. Hubbard (b. 1965) joined them on their first album, *Organix,* which didn't fit into the burgeoning gangsta rap scene, since they actually play instruments and have a jazzy, funky soul sound. The Roots toured rigorously and established a wide fan base for their improvisational concerts. Gray (b. 1976) and Jones (b. 1972) first recorded with the group on *illadelph halflife* (1996). They won a Grammy in 2000 for the single "You Got Me," on *things fall apart.* In 2002 they released *Phrenology.*

108 DR. DRE, *Encore Studios, Burbank, California, 2001.* The influential hip-hop producer Dr. Dre (b. Andre Young in 1965) was raised in South Central Los Angeles. In 1987, with the rappers Eazy-E and Ice Cube, he founded the group NWA (Niggaz with Attitude), which pioneered gangsta rap. Their hit songs "Straight Outta

Compton" and "Fuck tha Police" were sonically and lyrically powerful expressions of a nihilistic vision. Dr. Dre left NWA in 1992 and cofounded Death Row Records with Marion "Suge" Knight. In 1993 he made *The Chronic*, named after a particularly potent strain of marijuana, which sold three million copies and won two Grammys. He produced Snoop Doggy Dogg's *Doggystyle* (1993), which was the first debut album to enter the *Billboard* chart at number one the first week of its release. Dr. Dre performed a duet with Tupac Shakur on "California Love" in 1996. He left Death Row that year and recorded a single, "Been There, Done That."

110 RAKIM, EMINEM, and DR. DRE, *Los Angeles, 2002*. In 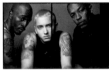 the mid-eighties, Rakim and his partner, the DJ Eric B., introduced a minimalist rapping style, with staccato rhythms, tight rhymes, and a steely delivery. Rakim (b. William Griffin in 1968), the nephew of the R&B singer Ruth Brown, is from Wyandanch, Long Island. He met Eric B. in 1985 and they soon cut their first single, "Eric B. for President." They worked together for seven years, releasing thirteen singles and four albums, and establishing the style in which the lyricist is the star. Rakim and Eric B. broke up in 1992, and Rakim subsequently made two solo albums. EMINEM (b. Marshall Mathers in 1972) is also primarily a lyricist, focusing on words. And like Rakim, he raps about rapping. He grew up in Detroit and by the time he was fourteen he had chosen his stage name (based on the initials of his real name), had started writing lyrics, and was battling his enemies at school with raps. He performed at open-mike nights in Detroit in the early nineties, married his high-school sweetheart, and had a daughter. His wife left him, and in 1997 he made *The Slim Shady EP*, which included a rap in which he talks to his daughter while driving around in a car with her mother's corpse in the trunk. The record brought him to the attention of Dr. Dre, who asked him to come to Los Angeles, where they made *The Slim Shady LP* in 1999. It sold more than three million copies and won two Grammys. In 2000 *The Marshall Mathers LP* sold more than two million copies in the first week it was in stores. Eminem raps about raping his mother on that one. He had become the most successful rapper of his time, and in 2002 he made a semi-autobiographical film, *8 Mile*, starring himself as a rapper obsessed with being the best.

112 SEAN "P. DIDDY" COMBS with his sons, Justin and Christian, *Two Trees Stables, Bridgehampton, New York, 1998*. Combs was born in 1969 and was raised in Mount Vernon, New York, by a single mother who encouraged his interest in business. He attended Howard University, where he promoted hip-hop events and soon secured an internship at Andre Harrell's Uptown Records. He became the company's director of A&R and produced records for several hip-hop stars, including Mary J. Blige, but he was fired in 1992. Combs then formed Bad Boy Records and signed up Craig Mack and Christopher "Notorious B.I.G." Wallace, both of whom quickly made hit records. He produced music by many other stars of the hip-hop and R&B worlds, including Lil' Kim, Mariah Carey, and Aretha Franklin, but he was also embroiled in the East Coast–West Coast rap wars that would lead to the deaths of Tupac Shakur and Combs's friend Wallace. Wallace's second album, which was released posthumously, sold over four million copies, and Combs's own debut album, *No Way Out* (1997), which included an homage to Wallace, "I'll Be Missing You," sung with Wallace's widow, Faith Evans, sold over five million copies. Combs has become more celebrated than the artists he produces, and he has been involved in several high-profile public incidents, including a shooting in a New York nightclub in 1999 for which he was found not guilty of all charges. Shortly after his acquittal, Combs changed his performing name from Puff Daddy to P. Diddy and released a gospel album, *Thank You*, and a hip-hop album, *The Saga Continues*. He also designs a line of clothes, Sean John.

114 NELLY, *New York City, 2002*. Nelly is Cornell Haynes, Jr. He 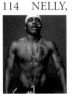 was born in 1978 in Austin, Texas, and grew up in St. Louis, Missouri, where he excelled at baseball and dabbled in drug dealing. His parents were divorced, and his mother, who was a manager at a local McDonald's, was several times forced by circumstances to send him to live with relatives. In 1993 he and five friends started a rap group, the St. Lunatics, and they have continued to work together. Nelly's first album, *Country Grammar* (2000) sold more than six million copies, making him an overnight sensation. His singsong delivery and melodic use of St. Louis colloquialisms distinguish him from more hard-edged rappers. His second album, *Nellyville*, was number one on the charts and won two Grammys in 2003.

115 MISSY "MISDEMEANOR" ELLIOTT, *New York City, 1999*. Elliott was born in Portsmouth, Virginia, in 1971. She was raised in a middle-class, albeit violent and abusive, household, and when she was thirteen she and her mother moved out. Missy and three girlfriends formed a singing group, Sista, and Elliott began writing songs with Tim Mosely, a friend from Portsmouth known as Timbaland, who is still her collaborator. She moved to New Jersey and then New York and worked as a songwriter and arranger and performed as a guest artist. Elliott has written hits for Aaliyah, Whitney Houston, and Mariah Carey. In the mid-nineties, Elektra gave her a recording contract and her own label, Gold Mind. Her first solo album, *Supa Dupa Fly* (1997), produced by Timbaland, debuted at number three on the pop charts, sold over a million copies, and received three Grammy nominations. Two years later, "Hot Boyz," on her album *Da Real World*, became the highest charting rap single in the history of *Billboard*. It was number one for eighteen weeks. Elliott, who is a producer and businesswoman as well as a performer, sings about sex, money, and power from the female point of view. In 2002 and 2003 she received a Grammy for Best Female Rap Solo Performance.

116 MARY J. BLIGE, *New York City, 1999*. Blige (b. 1971) was raised by a single mother in a housing project in Yonkers, New York. She sang in a church choir and listened to R&B and soul music when she was growing up. A karaoke-style tape that she had made in a shopping mall was heard by Andre Harrell, the founder of Uptown Records, who had the young producer Puffy Combs work with Blige on a record that became *What's the 411?* It was released in 1992 and sold nearly three million copies. Blige has a raw and warm mezzo soprano voice that she uses in an R&B style over hip-hop beats, although her later albums have a more soulful sound. She is often called the Queen of Hip-Hop Soul.

118 OLU DARA and NAS, *New York City, 2002*. The jazz musi- cian and composer Olu Dara was born Charles Jones in Natchez, Mississippi, in 1941. He joined the navy when he was eighteen and was sent to the Caribbean and Africa, and finally, in 1963, to New York City, where he has lived ever since. He played the trumpet with several jazz groups, including Art Blakey & the Jazz Messengers, and in the seventies was a leading member of the jazz "loft" scene. In the early eighties he formed two groups, the Okra Orchestra and the Natchezsippi Dance Band. He was a sideman on more than fifty albums and also worked with African-American theatrical companies and modern-dance groups. In 1998 he played guitar and cornet and sang on his first solo album, *In the World: From Natchez to New York*, which blended jazz with blues and African swing. His second album, *Neighborhoods* (2001), also fused several musical styles in often lighthearted songs with strong story lines. Olu Dara's son, the rap star NAS, who was born Nasir Jones in 1973, collaborated with him on his first album. Nas was raised by his mother, a postal worker who was separated from his father, in the violent

Queensbridge housing projects. He dropped out of school in the ninth grade and in 1994 made his first album, *Illmatic,* which was acclaimed for its dense, poetic language. His second record, *It Was Written* (1996), was number one on the *Billboard* charts.

120 CARLOS COY (SOUTH PARK MEXICAN), center, with
neighborhood friends, Terrence Rayme, Steven Pratt, and Timy Neville, *Houston, Texas, 2001.* Coy was born in a working-class Hispanic neighborhood in Houston in 1971. When he was in the sixth grade, his family moved to the South Park section of the city, which is predominantly African-American. He became the South Park Mexican, a nickname that he used a few years later when he began recording rap songs. Coy was a crack dealer before he was a musician, and his early raps were about crack. He sold the tapes himself, first out of his backpack and then at flea markets and car shows all over Texas. He had found a niche—Tex-Mex gangsta rap—and he was so successful that he started his own label, Dope House Records. In 2000 he negotiated a half-million-dollar advance for a production and distribution deal from Universal and released *Time Is Money* and *The Purity Album,* which received critical acclaim from the mainstream press. But Coy's affiliation with Universal ended after the release of *Never Change* in November 2001. In the meantime, he had been arrested for molesting a nine-year-old girl, a friend of his daughter's. He was convicted and sentenced to forty-five years in prison and a ten-thousand-dollar fine.

122 MOS DEF, *Ambassador Theater, New York City, 2002.* Born
Dante Terrell Smith in Brooklyn in 1973, Mos Def attended a performing-arts high school in New York and acted in commercials and on television with Bill Cosby and Nell Carter while practicing raps in city parks. He recorded the rap album *Mos Def and Talib Kweli Are Black Star* in 1998 and *Black on Both Sides* the following year. In 2001 he formed a hip-hop rock band, Black Jack Johnson, named after the first black man to win the world heavyweight boxing championship. He has appeared in several movies, including *Monster's Ball* (2001), *Brown Sugar* (2002), and *The Italian Job* (2003). He starred in Suzan-Lori Parks's *Topdog/Underdog* on Broadway in 2002 and received an Obie for his work in her play *Fucking A* in 2003.

124 RUN-D.M.C., *Complete Music Services recording studio, New*
York City, 2000. Legions of kids, many of them white kids, discovered rap music through Run-D.M.C. in the mid-eighties. The group brought hip-hop out of the ghetto and into the pop mainstream. Run-D.M.C. was made up of three young men from Hollis, a middle-class community off the Grand Central Parkway in Queens. Run, a nickname drawn from the phrase "running off at the mouth," was Joseph Simmons (b. 1964). D.M.C. was Darryl McDaniels (b. 1964). Their DJ was Jason Mizell (b. 1965), otherwise known as Jam Master Jay. The group looked tough, with matching Adidas suits, big glasses, black fedoras, untied sneakers, and gold chains, and their music was louder and harder and more dissonant than what had preceded it, but their lyrics were benign compared to the transgressive rapping that would follow them. Their third album, *Raising Hell* (1986), released by Def Jam Records, which was co-founded by Run's brother, Russell Simmons, was the first rap album to reach number one on the R&B charts and the first to sell well over a million copies. Run-D.M.C. was the first rap group to appear on the cover of *Rolling Stone.* In 1994, Run became Reverend Run, an ordained Pentecostal minister of the Zoe Ministries, a church on upper Riverside Drive in Manhattan, and Jason Mizell became a deacon in the church. The group kept on touring throughout the nineties, and in 2001 released an album, *Crown Royal.* Jam Master Jay founded the Scratch DJ Academy and taught DJ techniques to young people. He was shot and killed in the lounge of his recording studio in Hollis on October 30, 2002.

130 BECK, *Los Angeles, 2001.* Beck Hansen was born in Los
Angeles in 1970. His father, David Campbell, was a music arranger and composer who played bluegrass. His maternal grandfather, Al Hansen, was a member of the Fluxus group of artists, who in the sixties and seventies rejected "professional" art in favor of events like happenings. Beck grew up in East Los Angeles. He quit school in the ninth grade, worked at odd jobs, and performed in local clubs and coffeehouses, including the Troy Café, which was operated by his mother, Bibbe, and his stepfather. He moved to New York in 1989 and played folk music in clubs there, but he was back in L.A. in the early nineties. In 1992 he recorded "Loser" in a friend's living room. West Coast radio stations began playing it, and the song became an unexpected Top Forty hit. (The chorus went: "I'm a loser, baby, so why don't you kill me.") Beck's first album, *Mellow Gold* (1994), drew on folk, blues, hip-hop, and punk-rock traditions. Two years later, with his fourth album, *Odelay,* Beck won Grammys for Best Alternative Performance and Best Male Vocal Performance. He has incorporated a variety of styles and techniques into his music—including sampling—often ironically, although his seventh album, *Sea Change* (2002), consisted primarily of straightforward folk-and-country tinged ballads.

132 STEPHEN CARPENTER, ABE CUNNINGHAM, and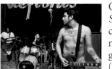
CHINO MORENO of the DEFTONES, *Sacramento, California, 2001.* The Deftones came together in their hometown of Sacramento in the late eighties, playing in a garage. Lead singer Camillo "Chino" Moreno (b. 1973), bassist Chi Cheng (b. 1970), guitarist Stephen Carpenter (b. 1970), drummer Abe Cunningham (b. 1973), and Frank Delgado (b. 1970), on the turntable, play neo-metal music influenced by hip-hop and seventies-style rock. They released their first album, *Adrenaline,* in 1995, followed by *Around the Fur* (1997), *White Pony* (2000), and *Deftones* (2003).

134 CHARLIE SEXTON and DOYLE BRAMHALL II, *Los*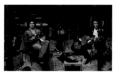
Angeles, 2003. Sexton was born in San Antonio in 1968. His parents moved to Austin when he was four, and he began listening to music in local clubs with his mother when he was very young. He was performing before he was a teenager, toured with Joe Ely's band, and recorded his first album, *Pictures for Pleasure,* when he was sixteen. By that time he had played with Don Henley, Ron Wood, Keith Richards, and Bob Dylan. His single "Beat's So Lonely" was a Top Twenty hit. In the early nineties he was a member of the Austin band Arc Angels, with Doyle Bramhall II, and then formed the Charlie Sexton Sextet, which made *Under the Wishing Tree* in 1995. He worked with Lucinda Williams on *Car Wheels on a Gravel Road* (1998) and *Essence* (2001), and played guitar in Bob Dylan's band from 1999 to 2003. DOYLE BRAMHALL II's father was a drummer, guitarist, songwriter, and producer best known for his work with Stevie Ray Vaughan. By the time he was sixteen, the younger Bramhall (b. 1968) was playing guitar with Jimmie Vaughan's Fabulous Thunderbirds and soon formed Arc Angels, which released one album and disbanded. Bramhall made a self-titled solo album in 1996. His fierce, wrenching guitar playing on his second album, *Jellycream* (1999), brought him to the attention of Eric Clapton, with whom he subsequently recorded and toured. Clapton and B. B. King covered two of his songs on their album *Riding with the King* (2000).

136 BONNIE RAITT, *Bottom Line, New York City, 2003.* Raitt
plays bottle-neck guitar and sings blues, R&B, and pop in an emotionally precise contralto voice that can shout or croon. The daughter of the Broadway singer John Raitt, she was born in 1949 in Burbank, California. She was a student at Radcliffe in the late sixties, majoring in Social Relations and African Studies and performing in Cambridge coffeehouses. She dropped out after two

years and began playing with blues musicians like Howlin' Wolf, Mississippi Fred McDowell, Son House, Muddy Waters, and John Lee Hooker. She made her first album in 1971, and although she was critically well received and her records sold respectably, it was not until 1989, when she released *Nick of Time,* that she had a big commercial success. The album sold four million copies and Raitt received four Grammys. Her next album, *Luck of the Draw* (1991), received three more Grammys. She has collaborated with many other musicians, including B. B. King, Ladysmith Black Mambazo, Cesaria Evora, Tony Bennett, and Willie Nelson. She worked with musicians from Zimbabwe and Mali on her album *Silver Lining* (2002). Raitt is a Quaker and a political activist. She co-founded the Rhythm and Blues Foundation, which assists pioneering musicians who have suffered from unfair record-company practices, and she has campaigned against war, apartheid, and the devastation of the environment. She was inducted into the Rock and Roll Hall of Fame in 2000.

138 RICK RUBIN, *Los Angeles, 2001.* Rubin has been one of the

most high-profile producers in the record business since the mid-eighties. He was born on Long Island in 1963 and was a student at New York University in 1984 when he and a friend, Russell Simmons, founded Def Jam Records. One of their first records was L. L. Cool J's "I Need a Beat," which was cut in Rubin's dorm room and sold over a hundred thousand copies. Def Jam was instrumental in bringing rap into the mainstream. In 1986, the company released both the Beastie Boys' *Licensed to Ill,* the first rap album to top the charts, and Run-D.M.C.'s *Raising Hell.* Rubin and Simmons parted in 1988, and Rubin moved to Los Angeles, where he formed a company that became American Recordings. Most of his clients were heavy-metal and rock bands, and in 1991 he produced the Red Hot Chili Peppers' *Blood Sugar Sex Magik.* But Rubin has eclectic tastes, and in 1994 he began working with Johnny Cash on the "American Recordings" series, the first installment of which won the Grammy for Best Contemporary Folk Album. He produced Mick Jagger's solo album *Wandering Spirit* (1993), Tom Petty's *Wildflowers* (1994), Donovan's *Sutras* (1998), and Nusrat Fateh Ali Khan's *Final Studio Recordings* in 2001.

140 BRIAN WILSON, *Beverly Hills, California, 2000.* Brian

Wilson (b. 1942) was nineteen when he and his brothers, Dennis and Carl, their cousin Mike Love, and a neighbor, Al Jardine, recorded "Surfin'" on a local Los Angeles label. They called themselves the Beach Boys, and their sleek harmonies and reassuring lyrics about an idealized life in Southern California were immediately popular. Brian became the band's producer in 1963, with the album *Surfer Girl,* and under his guidance the Beach Boys became one of the most successful and influential American bands of all time. Brian sang in a pure falsetto, backed by violins and increasingly sophisticated orchestrations inspired by Phil Spector's wall of sound. The Beach Boys turned in hit after hit: "Little Deuce Coupe," "Fun, Fun, Fun," "Help Me Rhonda," "California Girls." Their album *Pet Sounds* (1966) inspired the Beatles' *Sgt. Pepper's Lonely Hearts Club Band.* "Good Vibrations," from the album *Wild Honey,* was a number-one hit the following year. But Brian had stopped touring with the band in 1964, and he became increasingly reclusive. Others participated in the production of the Beach Boys' records after *Wild Honey,* and the songs Brian contributed became more and more pensive. He returned briefly to the stage in 1983, and in 1988, the year that the Beach Boys were inducted into the Rock and Roll Hall of Fame, he released a solo album. He began touring again in the late nineties and in 2000 performed *Pet Sounds* with a symphony orchestra. The Beach Boys received a Grammy Lifetime Achievement Award in 2001.

142 JOHN FRUSCIANTE, *Chateau Marmont, Los Angeles, 2002.* Frusciante (b. 1970) became the guitarist for the funk-metal band the Red Hot Chili Peppers in 1989, after they had gained notoriety for

sexually allusive performances in their underwear and for wearing socks on their penises on a record cover. He replaced the band's orig-

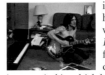

inal guitarist, Hillel Slovak, who died from a heroin overdose. In 1991 the band released what was then their most successful album, *Blood Sugar Sex Magik,* but Frusciante resigned from the group the following year, in the middle of a tour, and released two solo albums during a period in which he was heavily addicted to drugs. He rejoined the band in 1998 after he had received treatment for his addiction, and in 1999 they released *Californication,* on which Frusciante played and sang harmony. *Californication* sold over five million copies.

144 JON BRION, *Los Angeles, 2003.* Brion (b. 1964) grew up in

New Haven, where his father directed the marching band at Yale. His mother was a jazz singer. He taught himself to play several instruments when he was a child, dropped out of high school when he was seventeen, and worked at a variety of jobs in recording studios. Brion lived in Boston in the late eighties, formed a band, and played guitar with Aimee Mann in the group 'Til Tuesday. He moved to Los Angeles in the early nineties and became established as a prolific songwriter, arranger, producer, and "multi-instrumentalist." He has produced albums for Mann, Fiona Apple, Rufus Wainwright, and Macy Gray, among many others, and has provided the soundtracks for such movies as *Magnolia* and *Punch-Drunk Love.* Brion gives a one-man show every Friday night at Largo, a small but influential club in West Hollywood. He performs with a variety of stringed instruments, a turntable, a drum kit, and exotic electronic devices like the Optigan, an organ-like instrument that produces orchestrated chords in various musical styles. He is usually joined by guest artists. In 2001 Brion released a solo album, *Meaningless.*

146 SYSTEM OF A DOWN, *PNC Bank Arts Center, Holmdel,*

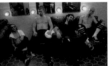

New Jersey, 2002. In 1995, System of a Down became the most popular rock band on Sunset Strip since Guns N' Roses played there a decade earlier. Serj Tankian (b. 1967), singer and keyboardist, using money he'd earned as the CEO of a software company, and guitarist Daron Malakian (b. 1975), who also sings, had recruited Shavo Odadjian (b. 1974), on bass, and the drummer John Dolmayan (b. 1972) to form a politically progressive band that played a fusion of heavy metal, funk, and traditional Armenian music. All of the members of the band are Armenian-American, and all but Dolmayan went to the same high school in Los Angeles, although none of them knew one another. The producer Rick Rubin saw their show, signed them to his American Recordings label, and produced their first album, which included songs protesting mandatory drug sentencing and police brutality, and condemning the Armenian genocide during World War I. "Sugar" and "Spiders" were radio hits, and the album sold over a million copies. The band toured with Ozzy Osbourne's Ozzfest, and their next album, *Toxicity,* was number one the week it came out, just before September 11, 2001. The day after the attacks on the World Trade Center and the Pentagon, Tankian posted an article entitled "Understanding Oil" on the band's website. The radio shock jock Howard Stern called for a boycott of *Toxicity,* which subsequently sold three million copies. The first single, "Chop Suey!," and the title track were both in the Top Ten, and "Aerials" went to number one.

148 JON BON JOVI, *Rumson, New Jersey, 2000.* John Francis

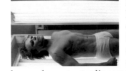

Bongiovi, Jr., was born in Perth Amboy, New Jersey, in 1962. When he was twenty-one he was working in a recording studio in New York, sweeping floors and going out for coffee. At night, with an assortment of musicians who were also working there, he used empty studios to record a demo tape of a song he had written, "Runaway." A DJ for a Long Island station put the song on a

compilation of amateur musicians, and the station gave it a lot of air-play. The song became a hit, and Bongiovi got a record contract. His name was changed to Jon Bon Jovi, and he formed a band called Bon Jovi, which released its first album in 1984. They went on tour in tight leather pants and big hair, and made another album. Their third album, *Slippery When Wet* (1986), was a number-one hit and sold twelve million copies. Bon Jovi played pop metal at sold-out concerts and became one of the most successful mainstream rock bands of the eighties. Jon Bon Jovi's soundtrack album for the movie *Young Guns II*, in which he had a small part, was nominated for an Oscar and a Grammy in 1990, and he appeared in several other films. He made headlines when he cut his hair short in the early nineties. Bon Jovi gave a free concert for five hundred thousand people in Times Square in September, 2002. Jon Bon Jovi lives in New Jersey with his wife, with whom he attended high school, and their three children.

150 TRENT REZNOR, *New Orleans, 2002.* Reznor writes,

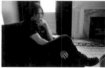

arranges, performs, and produces all of the material for Nine Inch Nails. He was born in Cleveland, Ohio, in 1965 and grew up in a small town in Pennsylvania. He dropped out of college and made a demo tape that got him a record contract, and his first album, *Pretty Hate Machine* (1989), had three hits on college radio, including "Head Like a Hole." It sold a million copies, in part because Reznor promoted it on the road for three years, although the video for a single from the album, "Sin," was refused by MTV because it had images of genital piercing and similar activity. *Broken*, an EP he released in 1992, won a Grammy for Best Metal Performance, although it, too, had a controversial video, which showed a man being sexually tortured and ground into pulp by a machine. Reznor worked on his next album, *Downward Spiral* (1994), in the house in Los Angeles in which Charles Manson's followers had murdered Sharon Tate. The album debuted at number two and sold five million copies. In 1999 he released *The Fragile*, a double CD that was named album of the year by *Spin* magazine. Reznor produced the soundtracks to Oliver Stone's *Natural Born Killers* and David Lynch's *Mulholland Drive,* and collaborated with the artist Bill Viola on a CD/DVD of Nine Inch Nails' concert tour in 2000.

152 DJ SHADOW, *Mill Valley, California, 2001.* Josh Davis (b.

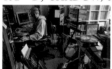

1973) grew up in Hayward, a lower-middle-class suburb of San Francisco. As DJ Shadow, he gained attention in the early nineties with his "sampled" collages of jazz, funk, classical, soul, soundtracks from movies and sitcoms, spoken-word albums, found voices, and pretty much any other kind of recorded sound, some of it "scratched" and some of it simply reordered. The result was new compositions with elaborate orchestrations. Davis's montages are based on his formidable record collection, which he is constantly adding to. He made his first album, *Endtroducing,* in 1996, and in 1998 a collection of his early work, *Preemptive Strike,* was released. His third album, *The Private Press,* came out in 2002. His work has influenced groups, like Radiohead, that play their own music, although Davis considers the use of original music for his own compositions "cheating."

154 GREEN DAY, *Oakland, California, 2001.* In 1994, Green Day

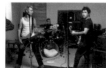

emerged out of the punk-rock scene in Berkeley to become one of the most popular bands in the world. The album they released that year, *Dookie,* has sold over twelve million copies. Billie Joe Armstrong (vocals and guitar), Mike Dirnt (bass), and Tre Cool (drums) were all born in 1972 and grew up in working-class East Bay neighborhoods. Armstrong and Dirnt formed a band when they were fourteen. They named the group Green Day—a reference to a day spent smoking marijuana—in 1989, and Tre Cool (whose real name is Frank Edwin Wright III) joined them when their original drummer left. They had released two albums on an independent label when

their guitar-based, post-punk, post-Nirvana sound got them a contract with Reprise. *Dookie* was nominated for four Grammys and won for Best Alternative Performance. The band has released several more albums, including *Warning* (2000), which has a folk-rock flavor; *International Superhits* (2001); and *Shenanigans* (2002).

156 THE WHITE STRIPES, *New York City, 2003.* The band is a

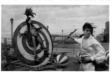

duo. Jack White writes the songs, plays guitar and piano, and sings. Meg White is the drummer and occasionally sings also. Their music is heavily influenced by the blues, with homages to sixties and seventies rock, and their albums emphasize lo-tech production techniques. They claim to be brother and sister, but various rock critics and reporters say that there is proof that Jack's family name is Gillis and that he took Meg's last name when they were married in 1996, and that they were divorced in 2000. In any case, they were born circa 1975 and grew up in Detroit, where Jack worked as an upholsterer. They became the White Stripes in 1997, produced two critically acclaimed albums, and had a hit record, *White Blood Cells,* in 2001, the year that raw rock trumped glitzy, puerile pop. Their second album, *De Stijl,* was named after the aesthetically austere philosophy of a group of early-twentieth-century Dutch artists, among them Mondrian, and Jack has said that they think of the band as an art project, although their success has come from the visceral effects of the songs. Their fourth album, *Elephant,* was released in 2003.

158 IGGY POP, *Miami, Florida, 2000.* James Osterberg was born

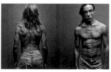

in Ypsilanti, Michigan in 1947. He was given the nickname Iggy when he was in high school, playing drums for a garage band called the Iguanas. He dropped out of the University of Michigan in 1966, and the next year formed a band, the Stooges, with the guitarist Ron Asheton and his brother Scott, who played drums. The Stooges were an anarchistic Detroit group that prefigured the New York punks. They played twenty-five-minute sets that consisted of a single improvisational piece, during which Iggy, who was the lead singer, would give a frenetic, acrobatic performance that usually included some kind of self-mutilation. The Stooges signed a contract with Elektra Records in 1968 and made three albums, the last of which, *Raw Power*, was produced by David Bowie for Columbia in 1973. The group disbanded the next year. By then Iggy's performances had become legendary psychodramas that involved rolling in glass and walking on the audience. He began recording as a solo artist in 1977 with two albums produced in collaboration with Bowie, *The Idiot* and *Lust for Life*. In 1983 he and Bowie co-wrote "China Girl," which became a hit for Bowie. Iggy continued to record and perform, and in 1990 had his first Top Forty hit, "Candy." In 1997 *Nude and Rude: The Best of Iggy Pop* was released. Iggy and the other two original Stooges were reunited at the Coachella Music and Arts Festival in Indio, California, in April 2003.

160 MICHAEL STIPE, *New York City, 2003.* As the lead singer

and principal songwriter for R.E.M., Stipe became an icon of American alternative rock. He was born in Decatur, Georgia, in 1960. His father was in the Army, and the family moved several times when Michael was growing up. He was a shy boy who was absorbed in music, especially that of Patti Smith, Television, and other American punk bands. Stipe was studying painting and photography at the University of Georgia in 1980 when he formed R.E.M. with the guitarist Peter Buck, the bassist Mike Mills, and the drummer Bill Berry. The band released its first single, "Radio Free Europe," the following year. R.E.M.'s first three albums—*Murmur* (1983), *Reckoning* (1984), and *Fables of the Reconstruction* (1985)—mixed a jangly pop sound reminiscent of the Byrds with darkly evocative lyrics that Stipe often sang in a barely comprehensible mumble. *Document* (1987), the band's fifth record, sold over a million copies

thanks to the single "The One I Love," and in 1988 the band signed with Warner Bros. Their second album on the label, *Out of Time* (1991), produced the hit singles "Losing My Religion" and "Shiny Happy People." It sold more than four million copies, as did *Automatic for the People* (1992), which included the hits "Everybody Hurts" and "Man on the Moon." Stipe directed the band's videos and formed an independent film production company, Single Cell. In 1997, Berry left the band for medical reasons, but the remaining three members continued to tour and record with other drummers. Stipe has produced such films as *Velvet Goldmine,* by Todd Haynes, *Being John Malkovich,* by Spike Jonze, and *American Movie,* by Chris Smith. He is an outspoken advocate of environmental conservation, animal rights, and other socially conscious political causes.

162 MIKE NESS with his wife, Christine, and children, Julian and

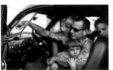

Johnny, *Santa Ana, California, 2003.* In 1979, Ness (b. 1962) cofounded Social Distortion, a Southern California punk band. They released their first album, *Mommy's Little Monster,* four years later. By that time they were well known for their belligerent attitude and sometimes violent performances, and Ness's heroin addiction and self-destructive behavior was threatening to destroy the band. He quit using drugs and alcohol in 1985, and began touring and recording again with a reconfigured version of Social Distortion. Their album *White Light, White Heat, White Trash* (1996) contained the song "I Was Wrong," a number-five modern-rock hit. Bruce Springsteen sang backup and played guitar on Ness's first solo album, *Cheating at Solitaire* (1999), which contained Johnny Cash and Hank Williams covers.

164 TOM WAITS, *Pocket Studio, Forestville, California, 2001.*

Waits (b. 1949) was raised in Southern California, where his parents were schoolteachers. He rose to prominence as a singer-songwriter in the early seventies, establishing a rough-hewn persona that was equal parts Charles Bukowski, Lord Buckley, and Hoagy Carmichael. The urban demimonde he evoked in his gravelly baritone was inhabited by hookers and petty criminals and rootless wanderers. Waits signed a recording contract with Elektra/Asylum in 1972, and although his debut album, *Closing Time,* did not sell well, it contained a song, "Ol' 55," that was covered by the Eagles. Waits has enjoyed his greatest success as a songwriter, and musicians such as Bruce Springsteen ("Jersey Girl") and Rod Stewart ("Downtown Train") have covered his songs. Early in the eighties, he began to work in films. He contributed songs to Francis Ford Coppola's *One from the Heart,* for which he was nominated for an Oscar in 1982, and has acted in such movies as *Ironweed, Down By Law, Dracula,* and *Short Cuts.* The 1982 album *Swordfishtrombones* marked a radical creative departure for Waits; filled with strange instrumentation and frightening imagery, it owed as much to Captain Beefheart and Bertolt Brecht as to the down-and-out, boozy balladry of his earlier albums. This new sound informed *Rain Dogs* and *Frank's Wild Years,* the latter of which was created in collaboration with his wife, the playwright Kathleen Brennan. In the nineties, he began to work more frequently in the theater. He collaborated with William Burroughs and the director Robert Wilson on the opera *The Black Rider* in 1990. In 1992 his album *Bone Machine* won a Grammy, as did a blues album, *Mule Variations,* in 1999. *Mule Variations* was his first album of popular music in seven years, and it was followed by *Blood Money* and *Alice,* both released in 2002.

166 RYAN ADAMS, *Hollywood Hills Best Western Hotel, Los*

Angeles, 2002. Adams was born in Jacksonville, a small town on the coast of North Carolina, in 1974. He dropped out of high school and wrote songs, sang, and played guitar in a post-punk band called Patty Duke Syndrome. In 1994 he formed the alternative-country band Whiskeytown, which recorded three albums. On his first solo

recording, *Heartbreaker* (2000), Adams composed songs around the theme of lost love and sang in a raspy tone that evoked the early Dylan. His second album, *Gold* (2001), drew on a wider palette—pop, rock, and blues—and was nominated for a Grammy. All of his work, including *Demolition* (2002), is defined by poetically expressed melancholy and longing.

172 MT. MORIAH MISSIONARY BAPTIST CHURCH

CHOIR, Annie Marshall, Marian Harvey, Jean Briggs, Annie Franklin, Dolores Sippio, Amanda Boutee; pianist Richard Stewart, *New Orleans, 2002.* Mahalia Jackson was born in New Orleans in 1911, and when she was a girl she was a prominent member of the junior choir at Mt. Moriah Missionary Baptist Church, which was founded in 1875.

174 IRMA THOMAS with her husband and manager, Emile

Jackson, *the Lion's Den Lounge, New Orleans, 2002.* Thomas is the quasi-official Soul Queen of New Orleans. She and Jackson own the Lion's Den, where Thomas performs with her band, the Professionals. She was born in Ponchatoula, Louisiana, in 1941, and grew up in New Orleans. As a child she sang in the Mount Everest Baptist Church choir, and gospel music had a lasting influence on her work. (Today she sings in the choir of the oldest First African Baptist Church in Louisiana.) She was married when she was fourteen, worked as a dishwasher and waitress, and had four children by the time she was twenty. In 1959 she recorded "You Can Have My Husband, But Please Don't Mess with My Man" for a local label. It reached number fifteen on the national R&B charts, and she began working with Allen Toussaint, who was just beginning his legendary career as a producer. In 1964 she recorded "Time Is on My Side," which was shortly thereafter covered by Mick Jagger in a version that is remarkably similar to Thomas's. That same year she recorded her biggest hit, "Wish Someone Would Care," which she wrote. She continued to work in local clubs and lounges and to tour the South, but work dried up, and in 1970 she moved to California, where she sold automobile parts in Montgomery Ward stores in Los Angeles and Oakland. She moved back to New Orleans in 1975, met and married Jackson, and renewed her career. In 1991 her live album, *Simply the Best,* was nominated for a Grammy, and in 1998 *Sing It!,* a collaboration with the singers Tracy Nelson and Marcia Ball, was also nominated.

176 DR. JOHN with his wife, Cat Rebennack, *Southampton, New*

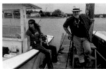

York, 2002. Dr. John was born Malcolm Rebennack, Jr., in New Orleans in 1940. His father had an appliance store in which records were sold, and by the time Malcolm was eight he knew a great deal about hillbilly and black music. He hung around a local recording studio and was taught to play the guitar by musicians in Fats Domino's band. Other musicians taught him to play the piano, and he became a session player when he was in his teens. In the late fifties he worked as a record producer and played in strip clubs and blues houses on Bourbon Street. He was primarily a guitarist until he was shot in the hand and was no longer able to bend the strings, and in the early sixties he became an organist and pianist. A few years later he spent two years in prison on drug charges, and when he was released he moved to Los Angeles, where he worked for several pop producers, including Phil Spector. His Dr. John the Night Tripper persona—based on an actual nineteenth-century hoodoo conjurer—appeared in 1968, when he made an album called *Gris-Gris,* which drew on Creole chants and psychedelic imagery, augmented in live performances by a costume that included a feathered headdress and Mardi Gras–style clothing. In 1973 he released *In the Right Place,* which was based on the blues and early rock, and it produced a Top Ten hit. He received his first Grammy in 1990, for a

duet with Rickie Lee Jones on his album *In a Sentimental Mood*. A second Grammy came two years later, for *Goin' Back to New Orleans*, on which he was backed by several well-known New Orleans musicians, including Al Hirt and the Neville Brothers. In 2001 he released *Creole Moon*, a collection of blues, funk, soul, and swamp-rock songs. All his records draw on the culture of Louisiana, even though he has lived in New York and Easthampton for many years.

178 ARDOIN FAMILY, *Crawfish Festival, Breaux Bridge, Louisiana, 2002.*

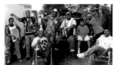

The first Ardoin recording was made in New Orleans in 1929 by Amédé Ardoin, who sang and played the accordion with a Cajun fiddler. Amédé is often referred to as the Robert Johnson of Creole music. His cousin Bois Sec performed all over the world, including at the 1966 Newport Folk Festival, and did much to popularize the predominantly African-American, rural Louisiana music that became known as zydeco. Bois Sec's children—Morris, Lawrence, Russell, and Gustav—formed the legendary Ardoin Family Band, and his grandsons, Chris, Sean, and Dexter, have integrated a more urban sound into zydeco, incorporating elements of reggae, funk, and soul music.

180 PRESERVATION HALL, *New Orleans, 2002.*

In 1961, two jazz lovers, Sandra and Allan Jaffe, bought a building in the French Quarter in New Orleans that had been an art gallery in which the owner permitted musicians to rehearse. The musicians who had been playing there regularly became the Preservation Hall Jazz Band, and the hall became one of the principal institutions for maintaining the traditions of New Orleans jazz. Its members range in age from the late twenties to the late eighties. Benjamin Jaffe, Sandra and Allan's son, plays bass in the band and manages the hall.

182 NEVILLE FAMILY, *New Orleans Jazz and Heritage Festival, 2002.*

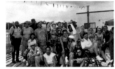

Three generations of the Neville family have been involved with music in New Orleans, but the best-known manifestation is the Neville Brothers (Art, keyboards and vocals, b. 1937; Charles, flute and saxophone, b. 1938; Aaron, vocals and keyboards, b. 1941; and Cyril, vocals and percussion, b. 1948), which was formed in 1977 and has sold millions of records, including *Fiyo on the Bayou* (1981) and *Yellow Moon* (1988). The family is an ethnic mix of African, American Indian, and Creole, and the Neville Brothers' funky music, with its exquisite four-part harmonies, draws on several styles: rhythm and blues, jazz, soul, reggae, rock, and zydeco. Art was the first family member to become prominent, in 1954, when his band, the Hawkettes, recorded the classic "Mardi Gras Mambo"; Aaron became famous in 1967, with the ballad "Tell It Like It Is"; Charles played the saxophone in several jazz bands; and they all got together in 1976, with their younger brother Cyril, as the backup group for the Wild Tchoupitoulas, a New Orleans "tribe" of black Indians led by their uncle George "Big Chief Jolly" Landry. Each of the brothers has had several solo projects, including Aaron's recent gospel albums, and the wider family has contributed vocal and instrumental backup.

184 KERMIT RUFFINS (trumpet) and the Barbecue Swingers, Corey Henry (trombone), Kevin Morris (bass), and Alfred Weston (drums), *New Orleans, 2002.*

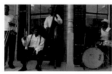

Ruffins was born in New Orleans in 1964. He cofounded the ReBirth Brass Band when he was eighteen, and the group recorded seven albums of swing standards and original songs and toured widely. Ruffins began singing and composing with the ReBirth Brass Band, and in 1992 he formed the Barbecue Swingers. That year he recorded *World on a String* with a group of New Orleans musicians, including Ellis Marsalis on piano. Since 1995 he has also led a seventeen-piece jazz orchestra.

186 NEW BIRTH BRASS BAND, *New Orleans, 2003.*

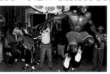

The band consists of young musicians who fuse hip-hop, funk, gospel, blues, rock, soul, and jazz with traditional New Orleans brass-band sounds. In 1997 they released *D-Boy* and appeared on the compilation *Christmas in New Orleans.*

188 JAZZ FUNERAL FOR PLACIDE ADAMS, led by the Treme Brass Band and the Black Men of Labor social organization, *New Orleans, 2003.*

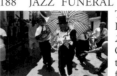

Jazz funerals are unique to New Orleans, where they originated in the early twentieth century, fusing West African funerary practices, the European custom of brass-band celebrations, and a then new musical style, jazz. The funerals encompass two very different moods. There is a somber march, traditionally to the grave site, accompanied by hymns or other down-tempo music. The procession returning from the cemetery is joyous, with musical improvisations by the band. Bystanders along the parade route join the official mourners in a flamboyant display of dancing. The funerals are traditionally sponsored by a social club or benevolent association led by a grand marshall, and the club members are distinguished by decorative sashes and hats and other ornamentation. Some of the participants carry colorful umbrellas. Placide Adams was a member of a renowned musical family in New Orleans. He grew up in Algiers, across the Mississippi River from the French Quarter, and joined the family band as a drummer when he was thirteen. In later life he was known as a traditional New Orleans jazz bass player and as the leader of the Onward Brass Band. Adams died on March 30, 2003, at the age of seventy-three, a few weeks before he and his band were to appear at the thirty-fourth annual New Orleans Jazz and Heritage Festival.

190 MILES DAVIS, *New York City, 1989.*

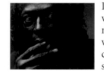

Davis was born in Alton, Illinois, in 1926 and raised in East St. Louis, where his father was a dentist and his mother a music teacher. He began playing the trumpet when he was a teenager and was working in local clubs by the time he was a sophomore in high school. He went to New York to study at the Juilliard School and began playing with Charlie Parker, who became his mentor. Davis soon dropped out of Juilliard. He played with Parker's quintet on the 1945 Savoy session recordings and in 1949 and 1950 collaborated with Gil Evans on the influential *Birth of the Cool* sessions, which also included Max Roach and Gerry Mulligan. A serious addiction to heroin reduced Davis's recording output in the early fifties, but by 1955 the Miles Davis Quintet, with saxophonist John Coltrane, pianist Red Garland, bassist Paul Chambers, and drummer Philly Joe Jones, had become the most important jazz group in the country. Davis's seminal album *Kind of Blue* was recorded in 1959. He continued to produce hit albums and win Grammy awards throughout the sixties and to work with musicians who would go on to lead their own groups, including Wayne Shorter, Herbie Hancock, and Chick Corea. In 1970 he turned to a fusion of jazz and rock that alienated some fans but recruited others; the album *Bitches Brew* was in the Top Forty on the pop charts and won two Grammys. Davis broke both ankles in a car accident in 1972, and by 1975 he had stopped recording and performing. His early-eighties comeback record, *The Man with the Horn,* was a resounding success, and he received six more Grammy awards, including one for Lifetime Achievement in 1990. He was widely regarded as a musical genius, was the subject of numerous memoirs, biographies, and critical studies, and continued to record until his death, in 1991.

192 DAVE BRUBECK, *Wilton, Connecticut, 2002.* Brubeck (b. 1920) grew up on a cattle ranch in Northern California, where he began playing the piano when he was four. He graduated with a degree in music from the College of the Pacific in Stockton, California, and, after serving in the army, studied composition on the G.I. Bill under Darius Milhaud at Mills College. Milhaud's ideas about

polytonality and polyrhythms had a profound influence on Brubeck's work. He and other Milhaud students formed the Dave Brubeck 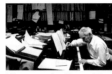 Octet, which in 1951 led to the creation of the Dave Brubeck Quartet, with the alto saxophonist Paul Desmond. The quartet was enormously popular, and in 1954 Brubeck was on the cover of *Time* magazine in an article heralding a new jazz age. The group's album *Time Out* (1960) was a bestseller and introduced a wide public to Brubeck's musical explorations. It included "Take Five," which was composed by Desmond, and "Blue Rondo a la Turk," by Brubeck. After the quartet broke up in 1967, Brubeck played with other musicians, including Gerry Mulligan, and he formed a band with his sons Darius, Chris, and Dan. He has also composed orchestral and chamber works, oratorios, and ballet scores.

194 MAX ROACH, *New York City, 2001.* Roach established the 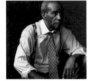 trap drum set as a solo instrument. He was born in North Carolina in 1925 and grew up in the Bedford-Stuyvesant section of Brooklyn, where he played with gospel groups. He studied music theory and composition at the Manhattan School of Music and began performing at a nightclub in Harlem with a group of musicians that included Thelonius Monk and Charlie Parker. He made his first recording, with Coleman Hawkins, before he was twenty. Roach was the leading bebop drummer of the forties and fifties. He was a member of Charlie Parker's quintet from 1947 to 1949 and played with Dizzy Gillespie, Duke Ellington, Stan Getz, Donald Byrd, Freddie Hubbard, and Sonny Rollins, among others. He formed a quintet with the trumpet player Clifford Brown in 1954, and after Brown's tragic death in 1956 he continued to lead the group. In 1960 the National Association for the Advancement of Colored People commissioned him to commemorate the one-hundredth anniversary of the Emancipation Proclamation, and he composed the jazz suite *We Insist! Freedom Now!* He formed the percussion orchestra M'Boom and worked in the theater, winning an Obie for his score for three Sam Shepard plays staged at LaMama in New York. In 1972 he became a professor of music at the University of Massachusetts at Amherst, and in 1988 he received a MacArthur Foundation fellowship. He has played with the avant-garde musicians Archie Shepp and Cecil Taylor and with hip-hop groups. He was named a Commander of the Order of Arts and Letters by the French government.

196 ETTA JAMES, *Riverside, California, 2003.* Etta James was 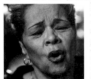 born Jamesetta Hawkins in Los Angeles in 1938. Her mother was fourteen when she was born, and Jamesetta was raised in foster homes until she was twelve, when she went to live with her birth mother in San Francisco. She had sung in a Baptist Church choir since she was five, and in San Francisco she came to the attention of the bandleader Johnny Otis, who in 1953 brought her and two friends back to Los Angeles to record "Roll with Me Henry," a response to Hank Ballard's R&B hit "Work with Me Annie." The song was retitled "Wallflower" and became a Top Ten R&B hit. Otis gave Hawkins the name Etta James, and she became one of the most popular members of his show in the mid-fifties. In 1960, James signed a contract with Chess Records in Chicago and soon was an R&B superstar, with hits like "All I Could Do Was Cry" and "My Dearest Darling." Her signature songs were recorded for Chess: "At Last," "In the Basement," "I'd Rather Go Blind," and "Tell Mama." James was beset by personal problems, including heroin addiction and abusive lovers, which she discussed frankly in her autobiography, *Rage to Survive* (1995), but her career revived after she opened for the Rolling Stones on their 1981 world tour, and she has toured regularly and recorded more than a dozen albums since the beginning of the nineties. They have ranged from interpretative pop to rock and roll to straight blues. She was inducted into the Rock and Roll Hall of Fame in 1993, and in 1995 was presented with her first Grammy, for *Mystery Lady,* an album of Billie Holiday songs.

198 TONY BENNETT and RALPH SHARON, *Venetian Room,* 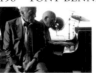 *Fairmont Hotel, San Francisco, 2001.* Bennett and Sharon, his longtime accompanist and musical director, performed "I Left My Heart in San Francisco" during their engagement at the posh Nob Hill supper club the Venetian Room in 1962. They recorded the song on an album of the same name, which won Grammys for Record of the Year and Best Pop Male Vocal. Bennett was born Anthony Dominick Benedetto in Astoria, Queens, in 1926. In 1949, Bob Hope saw him in a club in Greenwich Village, where he was working with Pearl Bailey, and asked him to sing in his act at the Paramount. Hope changed Benedetto's name to Tony Bennett. He had several hit singles in the fifties, including a remake of Hank Williams's "Cold, Cold Heart," and became one of the foremost interpreters of American popular songs. His work has always been influenced by jazz, and he has collaborated with many jazz musicians, including Bill Evans. Bennett's career waned in the seventies and eighties, but in 1986 his son Danny became his manager and he found a new audience. He received Grammys in the Traditional Pop Vocal Performance category in 1992, 1993, 1994, 1996, 1997, 1999, and 2003. Bennett published his autobiography, *The Good Life,* in 1998. RALPH SHARON was born in London in 1923 and made his debut as a pianist with Ted Heath's big band in 1946.

200 ANITA O'DAY, *Stein on Vine studio, Los Angeles, 2001.* O'Day 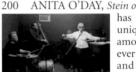 has a distinctive sense of phrasing and a unique vocal instrument that places her among the greatest jazz singers who have ever lived. She was born in Chicago in 1919 and began performing when she was twelve. She was a dance marathon contestant and a chorus girl, and in 1939 was hired to sing in a small jazz club. O'Day joined Gene Krupa's big band—where she insisted on appearing in a band jacket and a short skirt rather than the customary gown and gloves—and had several hits in the forties, then began performing in the bebop style in small venues. In 1955, her album *This Is Anita,* which is generally considered to be a masterpiece, was the first album produced by the new Verve label. Her relationship with Verve, which lasted until 1962, produced several elegant, ambitious recordings. O'Day became an international star after her appearance in Bert Stern's documentary film about the 1958 Newport Jazz Festival, *Jazz on a Summer's Day.* By then she had a serious heroin habit, and in 1966 she overdosed and nearly died. During the seventies she found a new audience at the Berlin Jazz Festival and in clubs in Greenwich Village and West Hollywood. Her experiences with drugs and alcohol are detailed in a memoir, *High Times, Hard Times,* published in 1981. She lives in Los Angeles and still records and performs.

202 NORAH JONES, *New York City, 2003.* Jones was born in New York City in 1979. She and her mother moved to Texas when she was four, and she grew up there. (Her father, with whom she had little contact until she was an adult, is the sitarist Ravi Shankar.) She attended the Booker T. Washington High School for the Performing and Visual Arts in Dallas and then studied jazz piano at the University of North Texas. In 1999, she moved back to New York, began playing the piano and singing in downtown clubs, and signed a recording contract with Blue Note Records. Her first album, *Come Away with Me* (2002), for which she wrote the title song, contains elements of jazz, soul, country, and blues. It sold six million copies and won eight Grammys, including Album of the Year.

204 EARTHA KITT, *New York City, 1998.* Born on a South Carolina cotton plantation in 1927, Eartha Mae Kitt was sent to Harlem to live with an aunt when she was eight. She is of mixed race and suffered prejudice from both whites and blacks. When she was sixteen she won a scholarship to the Katherine Dunham Dance School, and later toured North America and Europe with Dunham's dance troupe. Kitt remained in Paris to establish herself as a singer before

returning to the United States, where she performed in the Blue Angel nightclub for a record twenty weeks. In 1951, she played Helen of

Troy in Orson Welles's production of *Faust.* (Welles proclaimed her to be "the most exciting woman alive.") Kitt starred with Sammy Davis, Jr., in *Anna Lucasta,* took dance classes with James Dean, and had several hit records, including a sultry rendition of "C'est Si Bon." In the sixties she portrayed Catwoman on the *Batman* television series. Her career has been marked by political controversy: in 1967 she was banned from the White House after criticizing the government's involvement in Vietnam within earshot of Lady Bird Johnson, and in 1974 she performed a series of concerts in South Africa that upset critics of apartheid. Kitt's slinky, lecherous, slightly unearthly persona is undimmed by time; in recent years she has appeared as herself in television shows such as *Oz* and *Roseanne,* appeared in several films, and contributed voiceover work to *The Emperor's New Groove, The Wild Thornberries,* and even New York City's taxicabs. Kitt returned to Broadway in 2001 with *The Wild Party.* She has published a series of memoirs, including, in 1993, *I'm Still Here: Confessions of a Sex Kitten.*

206 LOUIS ARMSTRONG, *Queens, New York, 1971.* Armstrong

is perhaps the most influential jazz musician who ever lived. He was born in poverty in New Orleans in 1901 and was sent to the Colored Waifs Home when he was twelve. He learned to play the cornet there, and when he was released he supported himself by hawking papers and selling coal. He listened to bands in local clubs and was befriended by Joe "King" Oliver, who gave him a cornet. By 1917 he was playing in bars in the Storyville red-light district of New Orleans. He joined Oliver's Creole Jazz Band in Chicago as a trumpeter in 1922, and two years later left for New York, where he made dozens of recordings with blues singers, including Bessie Smith's classic "St. Louis Blues." Armstrong moved back to Chicago and began recording with the Hot Five and the Hot Seven, and by 1930 his remarkable technique as a trumpet player and his innovative singing (he more or less invented scat) had made him a widely imitated star. He toured frequently in the United States and in Europe with his orchestra and recorded with popular musicians like the Mills Brothers, Tommy Dorsey, and Ella Fitzgerald. Armstrong made his Hollywood film debut in 1936 in *Pennies from Heaven,* which starred Bing Crosby. In the late forties he formed a small group, the Louis Armstrong Allstars, which became one of the most popular bands in the history of American music. He appeared in over fifty films, including *Cabin in the Sky* (1943), *High Society* (1956), and *Hello, Dolly!* (1969). In 1968 he recorded "What a Wonderful World," which became a number-one hit. He died in Queens on July 6, 1971.

212 JOAN BAEZ, *Big Sur, California, 1971.* Baez was born in

Staten Island, New York, in 1941. Her mother was Irish and her father was a physicist of Mexican extraction. She grew up in California and graduated from high school in Palo Alto, then moved to Massachusetts, where her father taught at MIT. The folk revival was just beginning, and Baez performed in coffeehouses in the Boston-Cambridge area. She appeared at the Newport Folk Festival in 1959, singing unadorned traditional songs in a pure soprano voice that gained much attention. The following year she recorded her first album. She had already begun to perform at benefits for charities and in behalf of civil rights, and throughout the sixties and seventies she was a leading figure in the antiwar movement. In 1968 she married David Harris, an antiwar activist, shortly before he was sent to jail for refusing to register for the draft. They had a son, Gabriel. Baez has released over thirty albums, including the bestselling *Any Day Now* (1968), a two-record collection of songs by Bob Dylan. Her most successful single was a version of the Band's "The Night They Drove Ol' Dixie Down" (1972). She and her sister, Mimi Fariña, wrote most of the songs on *Come from the Shadows* (1972), and Baez has continued

to write much of her own material. In 1987 her autobiography, *And a Voice to Sing With,* was a bestseller. She was a cofounder of the Institute for the Study of Nonviolence in Carmel, California, and continues to actively support the work of such organizations as Amnesty International, the Central Committee for Conscientious Objectors, and Human Rights Watch.

214 BOB DYLAN, *Los Angeles, 1977.* Dylan was born Robert

Zimmerman in Duluth, Minnesota, in 1941, and raised in nearby Hibbing. He went to New York in 1961 and began to appear regularly in Greenwich Village clubs, which led to a recording contract with the producer John Hammond at Columbia Records. His first album, a set of folk and blues standards, was followed by *The Freewheelin' Bob Dylan,* a collection of original material that included "Blowin' in the Wind." Successive albums contained introspective and impressionistic ballads as well as protest songs. Then, in 1965, Dylan shifted musically. That March, he released *Bringing It All Back Home,* an album with one side of acoustic material and one side of relatively raucous rock and roll. This horrified folk purists, who were further antagonized when Dylan performed at the Newport Folk Festival in July backed by the Paul Butterfield Blues Band. "Like a Rolling Stone" hit number one on the pop charts that summer, shortly before Dylan released *Highway 61 Revisited,* his first full-fledged rock record. By 1966, when he recorded *Blonde on Blonde* in Nashville, Dylan had sold more than ten million albums, and many of his songs, including "Don't Think Twice, It's All Right," "Mr. Tambourine Man," "It's All Over Now, Baby Blue," and "Just Like a Woman," had become rock-era standards. A motorcycle accident in the summer of 1966 sent Dylan into seclusion in Woodstock, New York, where he recorded more than a hundred rock, folk, and blues songs with the Band, some of which were released in 1975 as *The Basement Tapes.* In the late sixties Dylan produced country-inflected music on records such as *John Wesley Harding* and *Nashville Skyline.* In 1979, he announced that he had become a born-again Christian. Like his turn toward rock and roll, this was met with confusion and derision by many fans, but a number of his songs from that period have become gospel standards. In the mid-eighties he released a pair of strong albums, *Infidels* and *Empire Burlesque,* that appeared to be largely secular. He was inducted into the Rock and Roll Hall of Fame in 1989 and received a Grammy Lifetime Achievement Award in 1991. On October 16, 1992, Columbia Records marked the thirtieth anniversary of his first album with Bobfest, an all-star concert at Madison Square Garden. In 1998 he received three Grammys for *Time Out of Mind,* a dark, dense set of songs about mortality. In 2001 his "Things Have Changed," a song written for the soundtrack of the film *Wonder Boys,* won an Oscar. The following year, *Love and Theft,* which rose to number five on the pop charts, received the Grammy for Best Contemporary Folk Album. Since 1990, Dylan has performed live almost constantly.

216 JERRY GARCIA, *San Francisco, 1974.* As the best-known

member of the Grateful Dead, Jerry Garcia did more than any other musician to create and maintain the communal, countercultural spirit associated with the rock music of the sixties; at the same time, his band became a huge industry that captured the imagination of generations of fans. Born in San Francisco in 1942, Garcia began playing the guitar when he was fifteen. In 1964 he was a member of a bluegrass group, Mother McCree's Uptown Jug Champions, along with future Grateful Dead bandmates Bob Weir and Ron "Pigpen" McKernan. The group became the Warlocks in 1965 and acted as the house band for Ken Kesey's Acid Tests. A year later, they adopted the name the Grateful Dead. The Dead melded folk and rock with bluegrass and trippy psychedelia. (They were supported at first by Owsley Stanley, the outlaw LSD chemist, who developed their extraordinary live sound system.) They lived communally in the Haight-Ashbury section of San Francisco, gave free concerts, and became known for long, improvisational instrumental jams.

They appeared at the Monterey Pop Festival in 1967 and Woodstock in 1969. The Dead toured almost constantly, and their most fervent fans, who came to be known as Deadheads, crisscrossed the country to see as many shows as possible. Garcia battled heroin addiction and diabetes throughout his life, and he maintained a fairly low profile throughout the eighties, though he continued to tour. In 1987, the band had a pop breakthrough with *In the Dark,* a studio album that managed to capture the infectious spirit of their stage shows. But Garcia's problems with drugs increased, and in the summer of 1995 he entered a rehabilitation facility. He died in his sleep of a heart attack on August 9, 1995.

218 CHUCK BERRY and BO DIDDLEY, *Cow Palace, San* 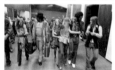 *Francisco, 1972.* Bo Diddley and Chuck Berry are founding fathers of rock and roll. BO DIDDLEY was born Elias Otha Bates in McComb, Mississippi, in 1928. His mother was a young teenager, and he was raised by a cousin, who moved the family to the south side of Chicago in the mid-thirties. He studied classical violin (the local Baptist church subsidized his lessons) until he was fifteen, and taught himself to play the guitar, developing the distinctive, syncopated backbeat that would become the basis of rock music. He learned to build guitars at a vocational high school, where he also formed a trio that played on street corners and in bars. He had a gift for electronics and he souped up his guitar with a series of large amplifiers. In 1955 he made a demo of two songs he had written, and Chess recorded and released them as a single, with "Bo Diddley" on the A side and "I'm a Man" on the B side. The record was almost immediately a hit. Diddley began touring, strutting and shimmying onstage with his guitar between his legs. He had an aggressively sexual stage persona that was extremely successful. Many of his songs were later covered by white rock musicians. Diddley's own career did not flourish long, for which he has expressed some bitterness, although he has toured often with younger white artists, such as Tom Petty and the Clash. He was inducted into the Rock and Roll Hall of Fame in 1987 and presented with a Grammy for Lifetime Achievement in 1998. CHUCK BERRY (b. 1926) grew up in a middle-class black neighborhood in St. Louis. His parents were deeply religious Baptists. He began playing the family piano when he was very young and listened to music on records and on the radio. He later recalled being particularly affected by Nat King Cole's precise diction. A largely self-taught guitar player, Berry performed at parties when he was a teenager. When he was seventeen he and two friends were arrested for committing several robberies on a cross-country joy ride, and he spent three years in a reformatory in Missouri. He played guitar in a trio in the early fifties and gained attention for his mesmerizing stage presence, which was notable for what was to become his trademark "duck walk." In 1955, on a visit to Chicago, he gave Chess Records a tape of a song he had written, a variation on a hillbilly tune. The song became "Maybelline," Chess's first national hit. Berry had several subsequent hits, including "School Days," "Sweet Little Sixteen," and "Johnny B. Goode." His witty lyrics about cars and adolescent sex appealed to young white audiences, and many of his songs were later covered by other musicians, including the Beatles and the Rolling Stones. In 1961, Berry was tried and convicted for violating the Mann Act, which prohibits transporting women across state lines for purposes of prostitution. He was imprisoned for twenty months. Berry felt, with some justification, it seems, that he had been hounded for racist reasons, and he later exhibited hostility toward whites who had achieved success with his songs. He was inducted into the Rock and Roll Hall of Fame in 1986 and was a Kennedy Center honoree in 2000. President Bill Clinton, who presented Berry with the Kennedy Center award, called him "one of the twentieth century's most influential musicians."

220 TINA TURNER, *San Francisco, 1971.* Anna Mae Bullock was born in 1939 in Nutbush, Tennessee, where she honed her voice singing in church choirs. She met the bandleader and guitarist Ike Turner in 1956 and became a backup singer for his Kings of Rhythm band. He changed her name to Tina, and, although they were not yet

married, they recorded together as Ike and Tina Turner in 1960. Their first song, "A Fool in Love" was number two on the R&B charts. Ike's 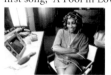 group became the Ike and Tina Turner Revue, with Tina as the lead singer, supported by three backup singers, the "Ikettes," who played counterpoint to her athletic, aggressively sexual stage persona. The revue opened for the Rolling Stones in 1969 and was an extremely successful touring group, but Ike and Tina didn't have a big recording success until 1971, with a cover of Creedence Clearwater Revival's "Proud Mary." It sold a million copies, reached number four on the pop charts, and won a Grammy. In 1976, Tina ended the marriage after years of abuse so intense she later required surgery to correct damage to her sinuses. Despite a plum role as the Acid Queen in the Who's *Tommy* in 1975, her career faltered, but in 1984, after signing a contract with Virgin Records, she mounted a full-scale comeback, first with a cover of Al Green's "Let's Stay Together," and then with the album *Private Dancer,* which also included the title track and "Better Be Good to Me." It garnered three Grammy awards. Tina starred opposite Mel Gibson in *Mad Max: Beyond the Thunderdome* (1985) and contributed a hit song, "We Don't Need Another Hero," to the soundtrack. Her bestselling autobiography, *I, Tina* (1986) was made into a film, *What's Love Got to Do With It,* in 1993. Ike, who was in jail on drug charges in 1991 when he and Tina were inducted into the Rock and Roll Hall of Fame, objected to her account of the marriage. Tina moved to the south of France in the late eighties and continued to record and perform until 2000, when she announced her retirement.

222 RAY CHARLES, *Los Angeles, 1972.* Ray Charles invented 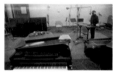 modern soul singing. Born in 1930, in Albany, Georgia, he lost his sight gradually from glaucoma and was entirely blind by the age of seven. He studied music using Braille at the Florida School for the Blind in St. Augustine, and after he graduated supported himself as a journeyman musician. Charles moved to Seattle, where he worked in nightclubs and made his first recordings in 1949. Three years later, he signed a contract with Atlantic, and in 1954 he recorded the landmark single "I Got A Woman," a song that fused the directness of the blues and the emotional fervor of gospel to more sophisticated arrangements. Other hits followed, including "Drown in My Own Tears," "Lonely Avenue," and "What'd I Say," which amplified the gospel element of his work with a call-and-response section. In 1962 his *Modern Sounds in Country and Western Music,* which included "I Can't Stop Loving You," was a number-one pop album, and played a pivotal role in widening the audience for the Nashville Sound. Charles remained immensely popular throughout the sixties, with songs such as "Busted," and "You Are My Sunshine." He influenced a generation of rock and soul singers, and artists as diverse as Joe Cocker, Sly Stone, and Van Morrison display a substantial debt to him. He was inducted into the Rock and Roll Hall of Fame in its first year, 1986.

224 CHRIS STEIN and DEBORAH HARRY, *Indianapolis,* 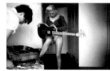 *Indiana, 1979.* Stein (b. 1950) grew up in Brooklyn. Harry (b. 1945) grew up in Hawthorne, New Jersey. They met in the fall of 1973, and he soon began playing guitar with the Stillettoes, the glitter-rock band she was singing in. The Stillettoes morphed into a new group, Blondie, which was led by Stein and Harry, who became a couple. By early 1975 they were regulars at CBGBs, the club on the Bowery that had become the city's punk-rock center, although their material was more pop than that of most of the other CBGBs bands, and Harry was much more glamorous than other performers on the scene. They recorded their first album, *Blondie,* in 1976, and toured with David Bowie and Iggy Pop. They had a hit in England with their second album, *Plastic Letters* (1977), but didn't become commercially successful in the United States until 1979, when the disco song "Heart of Glass," on their *Parallel Lines*

album, became a number-one hit. In 1980, "Call Me," from the film *American Gigolo,* also hit number one. Blondie had two more songs at the top of the charts: "The Tide Is High" (1980), a cover of a reggae classic, and "Rapture" (1981), an early exercise in hip-hop. The band split up in 1982, and Harry recorded solo albums and worked in the theater and in films, including David Cronenberg's *Videodrome* (1982) and John Waters's *Hairspray* (1988). Stein was ill for several years with a rare skin disease, and when he recovered he formed a record label and acted as a producer. He and Harry separated romantically in 1987, but they continued to work together. She performed with a jazz band, the Jazz Passengers. Blondie reunited in 1998 and recorded *No Exit.*

226 DAN ZANES, at right, with band members Barbara Brousal, Yoshinori Waki, and Cynthia Hopkins. His daughter, Anna Zanes, is second from right, with her friends Sophia Mockler, Lucas Mockler, Asha Norman-Hunt, and Alison Hall, *Brooklyn, New York, 2003.*

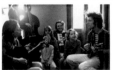

Zanes and his band, the Rocket Ship Revue, play music for children and their families. Zanes was born in New Hampshire in 1961 and grew up near Concord. He attended Phillips Academy in Andover, Massachusetts, and Oberlin College, which he dropped out of after a year to found a rock band, the Del Fuegos. The band, which included Dan's brother, Warren, was based in Boston, where they established a reputation in local clubs and then toured extensively in the United States and Europe. They recorded four albums between 1984 and 1989 and broke up in 1991. Zanes and his wife moved to upstate New York, where he made a solo album, *Cool Down.* His daughter was born in 1995, and the family moved to Brooklyn, where Zanes began playing and taping music for their friends. He formed a record company and in 2000 made his first album for children, *Rocket Ship Beach,* which included guest artists such as Suzanne Vega and Sheryl Crow. This was followed by *Family Dance* (2001), with Rosanne Cash, Loudon Wainwright III, and others, and *Night Time!* (2002), with Lou Reed and Aimee Mann. The Rocket Ship Revue performs songs like the Carter Family's "Keep on the Sunny Side," American folk songs, cowboy songs, dance tunes, and their own compositions. Their concerts occur before bedtime.

228 JAMES TAYLOR, *Lenox, Massachusetts, 2002.* Taylor was born in Boston in 1948 and grew up in Chapel Hill, North Carolina. His father was dean of the University of North Carolina Medical School. When he was a teenager, Taylor was sent to a private boarding school for boys, and he became severely depressed. He spent ten months in a psychiatric hospital, McLean, and began writing songs. In 1966 he went to New York City, where he and a friend formed a band that played regularly in a club in Greenwich Village. Taylor became addicted to heroin, and in 1968 moved to London, where Apple Records, the company founded by the Beatles, produced his first record, *James Taylor.* Paul McCartney and George Harrison played backup on one cut. Taylor returned to America and in 1970 released *Sweet Baby James,* an album of confessional soft-rock songs that included his first Top Ten single, "Fire and Rain." In March 1971 he was on the cover of *Time* magazine, and his version of Carole King's "You've Got a Friend" hit number one that year. Taylor married the singer Carly Simon, with whom he had two children, and through the seventies had several hits, including "Country Road" and "How Sweet It Is (To Be Loved By You)." His subsequent records have sold consistently, and he tours regularly. He was divorced from Simon in 1982 and had two subsequent marriages. Taylor gave up drugs and alcohol in 1984. *Hourglass* (1997) sold over a million copies and won a Grammy for Best Pop Album. He was inducted into the Rock and Roll Hall of Fame in 2000.

230 JONI MITCHELL, *Bel Air, California, 1999.* Like Bob Dylan and Neil Young, Mitchell has explored many genres in her long career as a singer-songwriter, absorbing elements of jazz and world music and collecting a devoted group of fans. Born Roberta Joan Anderson

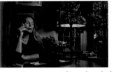

in Ft. McLeod, Alberta, Canada, in 1943, she was hospitalized by polio when she was nine and, contrary to her doctors' expectations, recovered fully. She taught herself to play the guitar and began performing in folk clubs in Toronto in the early sixties. In 1965, she married another folksinger, Chuck Mitchell, and the couple performed together in Toronto and then Detroit. The marriage was dissolved, but Joni stayed in Detroit, where her good notices led to engagements in New York. She signed a recording contract in 1967, and the following year Judy Collins had a huge hit with Mitchell's "Both Sides Now." Several other singers also had successes with Mitchell songs, including Tom Rush with "The Circle Game." Mitchell's third album, *Ladies of the Canyon,* sold a million copies, and her next album, *Blue,* released in 1971, became one of the most influential folk-rock records of the early seventies. But Mitchell, typically contrary, followed it up with the eclectic *For the Roses,* the jazzy *Court and Spark,* and the African-inflected *The Hissing of Summer Lawns.* Throughout the late seventies, she recorded primarily with jazz artists, including Charles Mingus in 1979, and in the eighties and nineties she intermittently returned to pop-folk while exploring electronic and symphonic music. In 2002 she claimed she had retired from the music industry, which she called "a cesspool" in an interview with *Rolling Stone* magazine, but *Travelogue,* an ambitious double album that recast many of her earlier compositions with the help of a seventy-piece orchestra and top jazz players, was released anyway.

232 NEIL YOUNG and his wife, Pegi, *Woodside, California, 2003.*

Neil Young has spent more than three decades firmly rooted in folk rock while detouring into country, hard rock, and even electronic music. Born in Toronto in 1945, he moved to Winnipeg with his mother following her divorce from his father, a prominent sportswriter. In high school, he started to play both rock and folk, establishing along the way relationships with other up-and-coming Canadian performers such as Joni Mitchell and Stephen Stills. In 1966, after attempting a career as a solo folk artist, he joined the Mynah Birds, a band that also included future funk superstar Rick James; the group recorded a handful of failed singles, and Young moved to Los Angeles, where he reunited with Stills to form the seminal folk-rock group Buffalo Springfield. Internal tension eventually forced Young to leave the group, and in 1969 he released a pair of albums, his eponymous, mostly acoustic debut and *Everybody Knows This Is Nowhere,* a denser, louder effort recorded with the band Crazy Horse. Young was a star at once, the heir to Bob Dylan, and his early-seventies *After the Goldrush* (1970) and *Harvest* (1972) remain classics. During that period, he also occasionally joined Crosby, Stills, and Nash. Since then, he has recorded prolifically, both with Crazy Horse and without. In the eighties, he released several albums that confounded fans, most notably *Trans* (1983), in which his vocals were fed through a computerized processor known as a vocoder. His career took on new life with the album *Freedom* (1989) and a series of highly praised recordings: *Ragged Glory* (1990), *Harvest Moon* (1992), and *Sleeps with Angels* (1994). Young was also recognized as a godfather of sorts to the grunge movement, and particularly to the Seattle-based band Pearl Jam, who admired his plainspokenness, his aversion to glamour, and his dedication to loud guitar noise. Young and his wife Pegi founded the Bridge School, a facility for physically challenged and speech-impaired children in San Francisco (two of Young's sons have cerebral palsy). Young recorded a gentle, largely acoustic set (*Silver and Gold,* 2000), a soul record with Booker T. and the MGs (*Are You Passionate, 2002),* and a Crazy Horse project he categorizes as a "musical novel" (*Greendale,* 2003).

234 BRUCE SPRINGSTEEN, *Philadelphia, Pennsylvania, 1999.* Springsteen is the rock-and-roll star as populist bard. He was born in a working-class community in southern New Jersey in 1949. He began playing the guitar when he was thirteen, and worked in bands when he was in high school and during the following several years. In 1972 he auditioned for the producer John Hammond, who signed

him to a ten-record contract with Columbia. His first album was *Greetings from Asbury Park, N.J.,* followed by *The Wild, the Innocent* 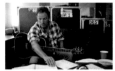 *and the E Street Shuffle,* with the E Street Band. Springsteen's songs were detailed, melancholy narratives of small-town life, presented acoustically or as hard-driving, rhythm-and-blues-inflected rock anthems. He was a brilliant live performer, and his concerts were dramatically shaped and operatic in their intensity. In 1975, his third album, *Born to Run,* went almost immediately into the Top Ten. Springsteen appeared on the covers of both *Time* and *Newsweek.* A dispute with management kept him from recording for three years, but then he produced *Darkness on the Edge of Town* (1978), *The River* (1980), and *Nebraska* (1982), a stark acoustic album that he made at home, originally as a demo tape. This was followed by *Born in the U.S.A.* (1984), the record that made him a megastar. It had several hit singles—including "Dancing in the Dark," which won a Grammy—and sold fifteen million copies. The title song was about the hardships and disappointments experienced by a Vietnam vet, but the music was uplifting, and Ronald Reagan, who was then campaigning for president, praised it as an expression of patriotism. (Springsteen explained to audiences and civic groups that he had not intended the song to be interpreted in this way.) His subsequent work included several more introspective, intimate albums, as well as *Tracks* (1998), a four-CD boxed set of mostly previously unreleased performances. In 1994 he won four Grammys for "Streets of Philadelphia," the title song to the movie *Philadelphia.* Springsteen's reflections on current events include "American Skin" (2000), a song about the shooting of an innocent West African immigrant by New York City police, and *The Rising* (2002), an album that addresses the personal toll taken by the attacks on the World Trade Center on September 11, 2001. *The Rising* won three Grammys. Springsteen was inducted into the Rock and Roll Hall of Fame in 1999.

236 LOU REED and LAURIE ANDERSON, *Coney Island, New York, 1995.* Reed was born in Freeport, Long Island, in 1942. His songwriting skills were first recognized when he was fifteen and his composition "So Blue" came to the attention of the disc jockey Murray the K. After moving to New York City, Reed became a contract songwriter and formed the Primitives, a band that included John Cale. The addition of Mo Tucker and Sterling Morrison led to the formation of the Velvet Underground, which fused Reed's commitment to rock and roll with Cale's more experimental tendencies. In 1965 the band's most ardent supporter, Andy Warhol, introduced them to the singer and actress Nico, with whom they recorded their seminal debut album, which included such songs as "I'm Waiting for the Man," "Heroin," and "Venus in Furs." Nico left after one album, but the band continued to perform and recorded classics such as "Pale Blue Eyes," "White Light/White Heat," "Sweet Jane," and "Rock and Roll." In 1970, Reed began a solo career; David Bowie produced his second album, *Transformer,* which contained the hit "Walk on the Wild Side." Throughout the seventies, Reed released aggressively experimental work, often angering fans and critics alike; *Metal Machine Music* (1975) was a double album that consisted of nothing but guitar noise. He enjoyed a comeback of sorts in the late eighties with the album *New York,* a song cycle about Manhattan, and has continued to record; in 2002 he released *The Raven,* a two-disc set about the life and work of Edgar Allen Poe. LAURIE ANDERSON was born in Chicago in 1947. She studied violin and performed in the Chicago Youth Symphony, attended Barnard College, and received a graduate degree in sculpture from Columbia University. In the early seventies, she taught art history and Egyptian architecture at City College of New York; at around the same time, she began to stage public performances, and by 1976 was appearing regularly at museums and concert halls. Anderson's work combined music, language, and visual projections. In 1981, she recorded "O Superman," an eleven-minute audio performance built around a droning vocal sample. It was a huge hit in Britain, reaching number two on the pop chart, and Warner Bros. signed her to a recording contract. She

released *Big Science* and then *Mister Heartbreak,* which included collaborations with Peter Gabriel and Adrian Belew. Throughout the eighties and nineties, Anderson performed in complex electronic settings on stage, in film, and on CDs. *Live at Town Hall NYC* is a recording of performances staged less than two weeks after the 2001 terrorist attacks on New York City.

238 STEVE EARLE, *Franklin, Tennessee, 2001.* Earle was born in an army hospital in Fort Monroe, Virginia, in 1955 and grew up in San Antonio, Texas. His father was an air-traffic controller. He began playing the guitar and writing songs when he was twelve years old. Four years later he left home and went to Houston, where he performed in local clubs and met one of his musical mentors, the singer-songwriter Townes Van Zandt. When Earle was nineteen he moved to Nashville and became part of a bohemian world of young songwriters, including Guy Clark, who was the second major influence on his early career. He became a solo artist in 1982, and in 1986 recorded *Guitar Town,* an influential country-rock album of gritty songs about working-class rebels and outcasts. *Copperhead Road* (1988), an eclectic, hard-rocking album with bluegrass and Celtic influences, deals with the subjects of Vietnam veterans and Appalachian marijuana growers. Earle spent time in jail on drug charges in 1994, and was sent to a detoxification center where he was successfully rehabilitated. After his release in 1995 he made an acoustic album, *Train A Comin',* that was nominated for a Grammy. Earle's subsequent records include *The Mountain* (1999), with the Del McCoury bluegrass band; *Transcendental Blues* (2000), which draws on the Beatles, blues, rock, Celtic music, and bluegrass; and *Jerusalem* (2002), which includes several overtly political songs, including one in which the narrator is John Walker Lindh, the American who fought for the Taliban in Afghanistan. Earle is the co-founder and co-owner of a record label, E-Squared, and campaigns actively against the death penalty.

240 PATTI SMITH, *St. Clair Shores, Michigan, 1996.* In the early seventies, Patti Smith stood in front of her band in skinny jeans and a ripped T-shirt and sang and screamed about desire and transcendence. She was a rock-and-roll shaman. And she was a girl. It was an unfamiliar combination then and it's not so common now. Smith was born in Chicago in 1946 and grew up in a working-class neighborhood in southern New Jersey. She moved to New York in 1967, where she met Robert Mapplethorpe, who was then an art student. They became roommates, and Smith and he worked on art projects and she began writing poems. On February 10, 1971, she performed her poetry at St. Mark's Church in lower Manhattan, accompanied by a friend, Lenny Kaye, who used an electric guitar to simulate a stock-car crash. Smith and Kaye began working together, and in 1974 they recorded what some consider to be the first punk-rock record, a 45 with "Piss Factory" on one side and a version of "Hey Joe" on the other. They formed a band, the Patti Smith Group, which helped establish CBGBs, a club on the Bowery, as the focal point of American punk rock. Smith was the first CBGBs regular to get a recording contract, and in 1975 she released *Horses,* which is on most lists of the greatest rock albums of all time. Mapplethorpe took the cover photograph. For the next four years the band toured and gave intense, improvisatory performances, and Smith released three more albums, including *Easter* (1978), which contained her only Top Forty hit, "Because the Night." In 1979 she married the ex-MC5 guitarist Fred "Sonic" Smith, and they moved to St. Clair Shores, a suburb of Detroit, where they had two children. Fred Smith died in 1994. A year later, Patti toured with Bob Dylan, and in 1996 she released *Gone Again,* which contained several songs that were homages to her husband. She and Lenny Kaye and their former drummer, Jay Dee Daugherty, formed a new band that continues to record and perform. A two-CD retrospective of her recordings and live performances, *Land: 1975-2002,* was released, and she published a comprehensive collection of her lyrics, *Patti Smith: Complete.*

Index of Subjects

Megan Steinman, this book is dedicated to you, because you believe in the music.

Thank you Janie and Jann Wenner.

The book was a way of life for all of us for four years, especially for Karen Mulligan, who produced it. Thank you.

Thanks to the staff of my studio, Catharina Burkley, Brett Egan, Michael Fisher, Hasan and Baha Gluhic, David Jacobs, Nicole LePage, Toby Moore, Ellen Moses, Milton Rosa-Ortiz, and Mona Talbott, and to my assistants, Paul Gilmore, Michael Murphree, Henrik Olund, Nicholas Rogers, Thanut Singhasuvich, and Wayne Wakino.

Thanks to Jeffrey Smith and Robert Pledge, Bruce Pask and Kim Meehan, Rick Floyd, Yolanda Cuomo, Andy Young, Ben Greenman, Sarah Larson, Deane Zimmerman, Doug Bernheim, Robert Walsh, and Sarah Chalfant.

We had help and advice from coast to coast. In the Delta, Charles Franklin Farmer, Adam Smith, Maude Schuyler Clay, and Jack Stevens; in New Orleans, David and Jessica McCarty, Quint Davis, Morgan Clevenger, Ben Sandmel, Matthew Goldman, and Patrick Finney; in Louisiana, Reese Fuller; in Memphis, Deanie Parker; in Nashville, Tameron Hedge; in Tennessee, Ed Richardson; in San Francisco, Tom Hoynes; in Los Angeles, Victoria Brynner and Anne Donnellon; in New York, Ernie Liberati; and in Texas, Christina Patoski.

I am grateful to Jane Sarkin, Kathryn MacLeod, Aimee Bell, David Harris, and Susan White at *Vanity Fair*. And especially to Graydon Carter for his generous support.

Lisa Robinson's advice and expertise were invaluable.

Thank you David Felton.

Thank you, Ann Godoff, for giving me more time. And Andrew Wylie for asking for it.

Sharon DeLano pulled it together.

As usual, I owe almost everything to Jim Moffat.

Susan Sontag, thank you for your ideas and your relentless concern.

A.L.

Random House Production Director: Katherine Rosenbloom

ISBN 0-375-50507-5
Library of Congress Cataloging-in-Publication Data is available.

Printed in the United States of America on acid-free paper

Random House website address: www.atrandom.com

987654321
First Edition

MERIDIAN PRINTING PROJECT DIRECTOR: DANIEL FRANK
SEPARATIONS: PASCAL DANGIN FOR BOX LIMITED
DESIGN: JEFF STREEPER